THE IMAGE OF THE BLACK IN WESTERN ART

A PUBLICATION OF MENIL FOUNDATION, INC.

THE IMAGE OF THE BLACK IN WESTERN ART

LADISLAS BUGNER General Editor

THE IMAGE OF THE BLACK IN WESTERN ART

IV

FROM THE AMERICAN REVOLUTION TO WORLD WAR I

2

BLACK MODELS AND WHITE MYTHS

HUGH HONOUR

Distributed by

HARVARD UNIVERSITY PRESS

Cambridge, Massachusetts, and London, England

Composition: Geraldine Aramanda using TEX
Technical Consultant: Arvin C. Conrad
Typesetting: TEXSource, Houston, TX
Printing and binding: Dai Nippon, Tokyo

Designed by Hanspeter Schmidt.

Printed in Japan.

ISBN 0-939594-17-X Part 1
 0-939594-18-8 Part 2
LC 76-25772

TABLE OF CONTENTS

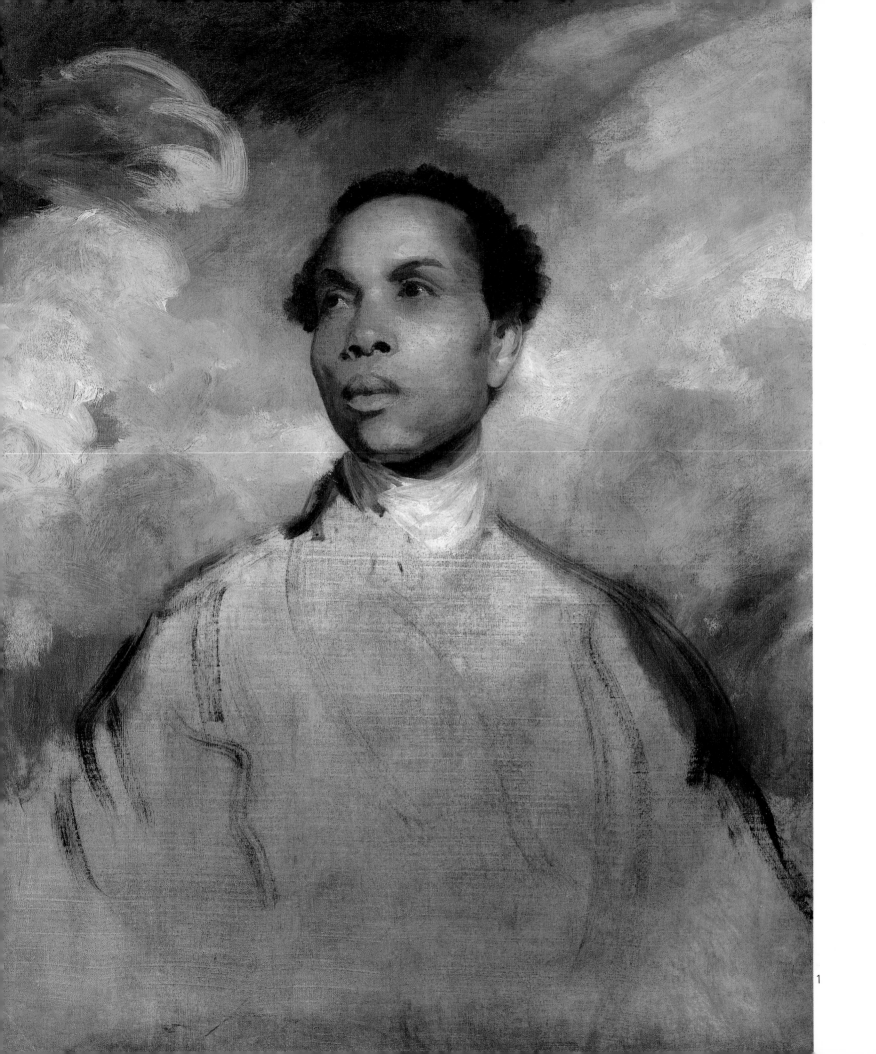

1

I

STUDIES

In Paris in 1800 Marie-Guilhelmine Benoist exhibited at the Salon what is perhaps the most beautiful portrait of a black woman ever painted. It was fig. 2
entitled *Portrait d'une négresse*, and the sitter was probably a servant brought back from the Antilles by the artist's sailor brother-in-law.[1] But there is not the least suggestion of servitude in the painting. The black woman is completely at her ease in this warmly humane and noble image. With perfect poise and self-confidence she looks at us with a gaze of reciprocal equality. The painting is, moreover, a masterpiece of visual sensitivity, the soft black skin being exquisitely set off by the crisp white, freshly laundered cotton headdress and drapery. Few, if any, European images of non-Europeans are as calmly and clear-sightedly objective. Marie-Guilhelmine Benoist almost certainly painted the work on her own initiative (it remained in her possession for nearly two decades), and one is tempted to see in it some further significance beyond the artist's evident personal interest in the sitter. The date provides the essential clue. For it was painted during that brief period between the emancipation decree of 1794 and the restoration of slavery in 1802 when a black *citoyenne* was "free and equal," that is to say as free as and equal to any French woman. The painting must surely have been intended at least partly as a tribute to the French emancipation of slaves and as a celebration of the hopes expressed in numerous emancipation prints, several of which represented females.[2] Might the artist have gone even further, perhaps, taking the words *Moi égal à toi* inscribed on the prints as an augury for the emancipation of all women? There are traces of feminism in the history of the abolitionist movement in which women played a notable part.[3]

When the painting was first exhibited, a critic remarked of the artist: "It is easy to see by the purity of the design that she is a pupil of David."[4] It

1. Joshua Reynolds. *Study of a Black Man*. Ca. 1770. 78.7 × 63.7 cm. Houston, Menil Foundation Collection.

7

has, indeed, the sharp focus, the unaffected grace, and the sense of intimate rapport between the artist and sitter, as well as the firmness and delicacy of line and subtlety of color that distinguish such portraits by Jacques-Louis David as that of *Madame de Verninac* painted in the previous year. Whether or not Benoist saw the woman as an embodiment of "liberty," she portrayed her as an individual, living, feeling, fellow human being.[5] This memorable image differs from David's portraits only in so far as it represents an anonymous sitter—*une négresse*. At a time when portraits were still valued mainly as visual records of people whose personalities or achievements were known to those who commissioned them (if not always to the public at large), it seems to have been admired simply as a demonstration of pictorial accomplishment. As such, presumably, it was acquired by the crown for the recently founded museum of contemporary French art in the Luxembourg in 1818, transferred to the Louvre after Benoist's death in 1826, and reproduced in an engraving in 1829.[6]

The anonymity of the subject links this work with a number of portrait heads of blacks painted with similar concern for the individuality of the sitters if rarely with as much aplomb. That by Joshua Reynolds is among the most notable. It has been said to represent either one of his own servants or fig. 1 Francis Barber, given lasting fame by James Boswell as "the faithful negro servant" of Samuel Johnson who treated him almost as a son.[7] There is however no indication of the social status of the man whose proud head, silhouetted against swirling clouds, is painted from a rather low viewpoint. He differs markedly from the blacks who figure as attendants, wearing livery or fanciful turbans, in formal portraits of the time, including several by Reynolds himself.[8] Nor was he depicted with the emphasis Reynolds placed on exoticism in his portraits of other non-Europeans, the Tahitian *Omai* and the Chinese boy, *Wang-y-Tong*. Blacks had ceased to appear exotic to the English: there were said to be some 15,000 in London in 1772 (more than in any other European city).[9] They remained nevertheless conspicuously apart from the majority of the population. Whether the subject of the painting by Reynolds was a member of his own household or that of his close friend Samuel Johnson, or even a model hired for the occasion, he was portrayed as a familiar and yet also an alien figure.

There were of course precedents for portrayals of blacks in the work of artists by whom Reynolds was influenced—Rubens, van Dyck, and Rembrandt. Reynolds had one such painting optimistically attributed to Paolo Veronese in his own collection.[10] But whereas most of them had been sketches for figures in subject pictures, Reynolds's painting on a canvas of the size he normally adopted for half-length portraits, especially those of his personal friends, seems to have been conceived as an independent work of art, though left unfinished. When put up for auction in the posthumous sale of his studio it was entitled *Study of a Black Man's Head* and bought by the notable amateur painter Sir George Beaumont who believed it to represent Reynolds's servant, but probably valued it mainly for its pictorial qualities.[11] Reynolds was the first English writer known to have used the word *studies* for paintings executed primarily as a means of acquiring skill or knowledge. In 1769—at about the time he painted this head—he urged students at the Royal Academy to remember that the paint brush, and not the pen or crayon, "is the instrument by which [they] must hope to

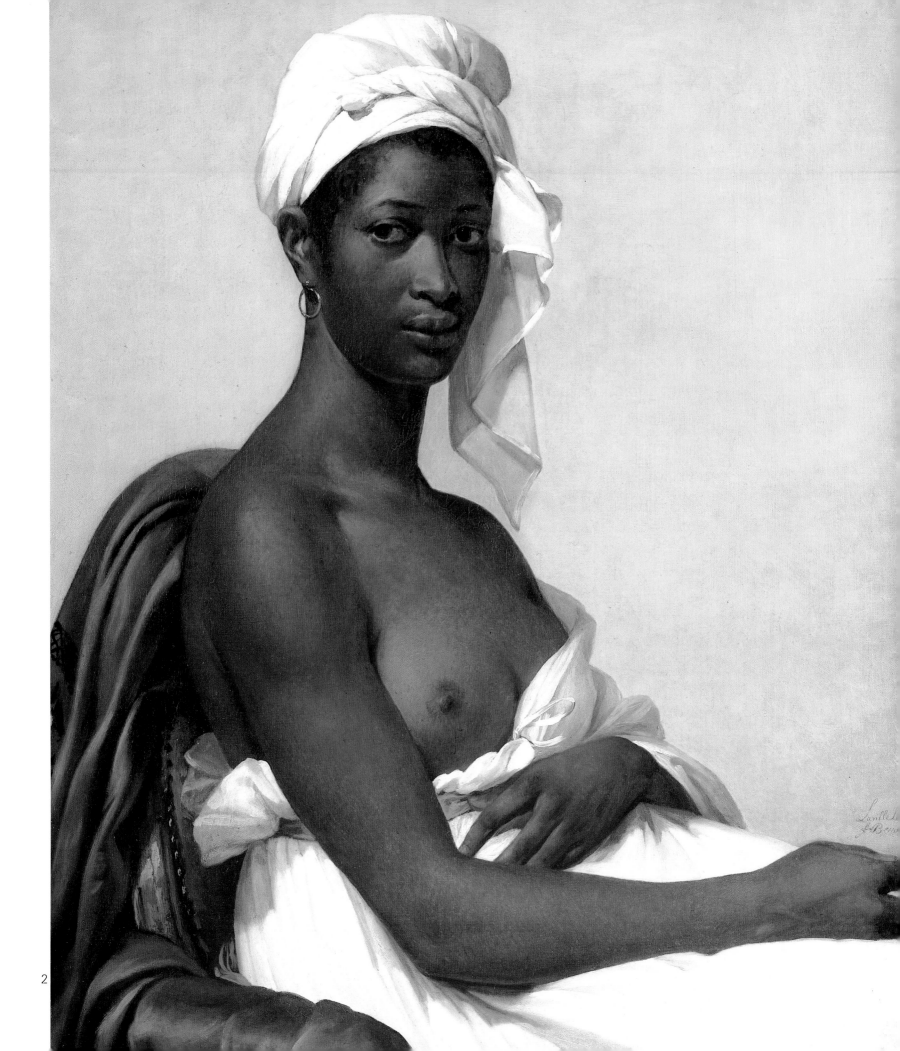

2

obtain eminence," adding the recommendation, very surprising at this date (and seldom noticed): "What, therefore, I wish to impress upon you is, that whenever an opportunity offers, you paint your studies instead of drawing them."[12] Rubens, van Dyck, and artists of the Venetian school painted their studies, he went on to remark. He also, more conventionally, advocated the practice of selective copying of works by old masters as a means of "learning to colour." His "black man's head" was subsequently to be copied by a number of less expert hands, presumably as exercises in the art of painting studies and coloring.[13]

The portrait of a black with a frank gaze and engaging smile, painted fig. 3 in London by the American John Singleton Copley, is clearly another study from life. When it was sold with other works from Copley's studio after the death of his son (Lord Lyndhurst) in 1864, it was catalogued as *Head of a Favourite Negro.* Very fine, introduced in the picture of 'The Boy Saved from the Shark'."[14] The black in *Watson and the Shark*[15] of 1778 has necessarily a different expression from the portrait, which is surely more than a preliminary sketch, even if the same model, a "favourite Negro" servant in the Copley household, posed for both.[16] The portrait is painted with the greater freedom of brushwork permitted in studies and also with more assurance, which suggests that it may be somewhat later in date. Although unfinished, it has every right to be regarded as an independent work of art. Yet one is bound to ask why Copley portrayed this man, and Reynolds his own or his friend's black—and not a white—servant. Was it only because a black is picturesque, in the simplest meaning of the word, and thus a subject peculiarly suitable for a pictorial exercise when an "opportunity offered?" Or did these artists have some deeper, perhaps barely conscious, urge to explore and lay bare their feelings or absence of feelings about people of a different color? The portrayal of a black by a white artist is a kind of image of otherness even when it suggests that the difference is no more than literally skin-deep. "It is custom alone determines our preference of the colour of the Europeans to the Æthiopians, and they, for the same reason, prefer their own colour to ours," Reynolds had written in an essay on relative standards of beauty contributed to Samuel Johnson's column in a London newspaper in 1759.

> I suppose no body will doubt, if one of their Painters was to paint the Goddess of Beauty, but that he would represent her black, with thick lips, flat nose, and woolly hair; and, it seems to me, he would act very unnaturally if he did not: For by what criterion will any one dispute the propriety of his idea? We, indeed, say that the form and colour of the European is preferable to that of the Æthiopian; but I know of no reason we have for it, but that we are more accustomed to it. It is absurd to say, that beauty is possessed of attractive powers, which irresistibly seize the corresponding mind with love and admiration, since that argument is equally conclusive in favour of the white and the black Philosopher.
>
> The black and white nations must, in respect of beauty, be considered as of different kinds, at least a different species of the same kind, from one of which to the other, as I observed, no inference can be drawn.[17]

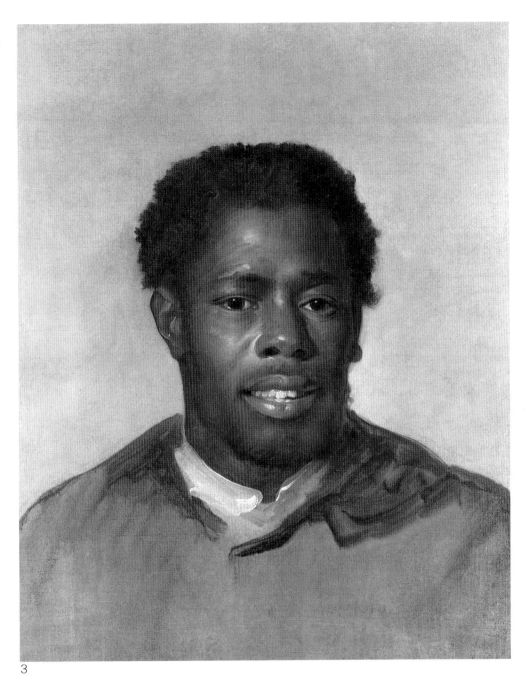

3

His conclusion was that the "works of nature, if we compare one species with another, are all equally beautiful; and that preference is given from custom, or some association of ideas." This was a reply to the philosophical theory of the sublime and beautiful recently propounded by Edmund Burke who had argued that blackness induced terror in the mind of the observer for physiological reasons.[18] But Reynolds was more deeply concerned with the artistic problem of "distinguishing between accidental blemishes and excrescences which are continually varying the surface of Nature's works, and the invariable general form which Nature most frequently produces, and always seems to intend in her productions"[19]—in other words *natura naturans* or the ideal. An artist was, he held, obliged to study both the common face of nature and the masterpieces of art that penetrated below its surface. His portrait of a black seems to have been an essay in what he

called the "art of seeing nature,"[20] painted for himself and abandoned once its primary purpose, the depiction of the man's face, had been accomplished.

The history of images of blacks was determined by the artists who created them, though their significance was conditioned by the views of the public for which they were created. They thus reflect changes in artistic style as well as mental attitudes. In the second half of the eighteenth century intellectual and artistic changes were synchronized as a result of the application of the ideas of the Enlightenment to aesthetics and the call for a new art based on supposedly immutable, eternally valid principles—truthful, rational, and morally elevating. Rococo airs and graces, shimmering colors, and effects of fleeting movement were gradually eliminated from paintings with pretensions to be serious works of art. Blacks depicted as exotically clad figures of fantasy were thus excluded. But there was little room for more objective images of them in an art dedicated to European aesthetic ideals which also had ethical significance. As the word *Enlightenment* alone is enough to reveal, the identification of darkness with irrationality, evil, and ugliness—whiteness with truth, goodness, and beauty—persisted and was indeed strengthened by the arrogation of superiority on the part of European thinkers. Marie-Guilhelmine Benoist's *Portrait d'une négresse*, painted in the last year of the century, is an unusual if not unique celebration of the beauty of a black woman rendered in the "high" neoclassical style originated by David. It nevertheless provoked the scorn of a satirical reviewer who commented in verse:

> A qui se fier dans la vie,
> Après une pareille horreur!
> C'est une main blanche et jolie
> Qui nous a fait cette *noirceur*.[21]

But, like so many works of its time—including those by David himself—it is also a portent of further changes in aesthetic attitudes. By the time the engraving after it was published in 1829, *études* or studies of blacks had acquired a kind of academic status.

AESTHETICS AND RACIAL THEORIES

Aesthetic preferences may always have conditioned the attitudes of whites to blacks, but their rationalization in the age of the Enlightenment influenced the development of racial theories which emerged out of otherwise objective attempts to categorize natural phenomena. When Carl Linnaeus, the founder of systematic taxonomy, turned from plants to animals, he described human beings together with apes, the sloth, and bats as primates, distinct from "secundates," in the larger class of mammals. There were four varieties distinguished by geographical location (European, African, Asian, and American), by skin color and other physical features, the predominance of one or other of the four "humours" of ancient Greek philosophy, and also psychological characteristics. Thus, *Homo afer* the African had, he declared, black skin, black, curly hair, an apelike nose, and swollen lips; was phlegmatic, crafty, and careless; ruled by authority. The European, on

the other hand, had white skin, blonde hair, blue eyes, was sanguine, very intelligent, a discoverer, and ruled by religious custom.[22] Nordic Europeans in fact provided the norm from which the inhabitants of other continents deviated, according to his system.

The arbitrariness of some of Linnaeus's defining features was noted by contemporaries who also complained that his great *Systema naturæ* was essentially no more than a system of nomenclature. It evaded the much discussed issues of monogenesis and polygenesis and presented an only generalized view of the order believed to underlie nature. Georges Louis Leclerc de Buffon, the greatest French zoologist of the century, questioned the Linnean notion of species entirely distinct from one another, and although he subsequently changed his mind, continued to see them as parts of an infinitely complex structure of relationships. In his multivolume *Histoire naturelle* he set species and their varieties in a hierarchically ordered system with, not simply a man but a white man, at the summit. The people of Europe and western Asia—Caucasians of later categorization—were quite simply "the whitest and best-built men on Earth."[23] Blacks he ranked at the bottom of the human scale as the ugliest of men, "as ugly as monkeys," he wrote, comparing them with pongos on the next step of the descending ladder.[24]

In the visual arts of course the superior beauty of Europeans was similarly unquestioned at a moment when painters and sculptors were seeking to recapture the idealism of antique statues. According to Johann Joachim Winckelmann, the physical beauty of the ancient Greeks accounted for the excellence of their art. The ancient Egyptians had been handicapped by their own physical appearance "which lacked the features that could stimulate the artist through an ideal of higher beauty." He instanced their prominent cheekbones, large flattened noses, clumsy hands, large feet, and the darkness of their skins.[25] Color was less important to him than form. "Color contributes to beauty, but is not beauty itself, and in general may be deemed subordinate to form," he wrote in 1764. "A black may be called beautiful if his features are beautifiul. Travelers declare that daily contact with blacks removes the repugnance of the color, and their beauty is revealed. Just like the color of metals, like the black and green basalts, the beauty of antique heads is not dependent upon their darkness."[26] Here he was in accord with philosophers who regarded color as merely superficial: by the end of the century it was declared to be superfluous for visual representation by Kant, and deceptive by Schiller.

Taxonomists also recognized that color was of minor account when classifying plants or animals, including the human species. Differences in human skin color, explained mainly by reference to climatic conditions, were also difficult to classify apart from those at either end of the spectrum. The attention of taxonomists was fixed on anatomy, the structure beneath appearances, especially the peculiarities of cranial formation. Skulls could be compared with one another more easily than skins, and they could also be classified with the aid of a system for measuring "facial angles" or degrees of prognathism devised by the Dutch anatomist Petrus Camper. Thus at the very moment when silhouette portraits were becoming fashionable throughout Europe and, at a higher artistic level, painters were concentrating on outline, the profiles of blacks began to assume as much

4. Petrus Camper. Illustration for *Verhandeling van Petrus Camper over het natuurlijk verschil der wezenstrekken in Menschen . . .*, 1791. Copper engraving by Reinier Vinkeles dated 1768 and 1785. 275 × 460 mm.

5. Daniel Nikolaus Chodowiecki. Illustration for Johann Caspar Lavater, *Physiognomische Fragmente zur Beförderung der Menschenkenntniß und Menschenliebe*, 1775–78. *Nationalgesichter. Ein Spanier, Holländer, Mohr, Virginier*. 1775. Etching by Johann Heinrich Lips. 202 × 177 mm.

6. Illustration for Julien Joseph Virey, *Histoire naturelle du genre humain*, 1824. *Espèces. Blanche; Nègre Eboë; Orang. (Singe)*. Etching by Mme Migneret. 126 × 80 mm.

importance as their pigmentation. Not until 1864—perhaps significantly after the great revaluation of colorism in painting—did Paul Broca publish the first scale of skin colors, with thirty-four shades ranging from the blondest of Europeans to the darkest of Africans.[27]

Camper was inordinately proud of his discovery of the facial angle and recorded in detail how he made it.[28] In the course of his education at the University of Leiden, he had received some instruction in painting and, at the age of eighteen in 1740, been set to copy a picture with the figure of an African which he found unsatisfactory: "In his colour, he was a Black; but his features were European."[29] The same fault appeared in prints after many other artists, only one of whom, Cornelis Visscher, seemed to him to "have followed nature, and to have properly characterised Moors." He therefore began to collect skulls of men and animals, to study their similarities and differences, and to compare them with the heads of antique statues which he regarded as the touchstones of human beauty. He wrote:

> When in addition to the skull of a Negro, I had procured one of a Calmuck [or Mongolian] and had placed that of an ape contingent to them both, I observed that a line, drawn along the forehead and upper lip, indicated this difference in national physiognomy; and also pointed out the degree of similarity between a negroe and the ape. By sketching some of these features upon a horizontal plane, I obtained the lines which mark the countenance, with their different angles. When I made these lines to incline forwards, I obtained the face of an antique; backwards, of a negroe; still more backwards, the lines which mark an ape, a dog, a snipe, &c.[30]

In 1768, when he wrote the first draft of his dissertation on the facial angle, he drew an "assemblage of craniums, and profiles of two apes, a negroe and a Calmuck" which, he remarked, "may perhaps excite surprise."[31] fig. 4

Although the prognathism of some African heads had often been noticed and delineated before, Camper was the first to suggest that it could be expressed geometrically as a measurable facial angle. For thinkers of the Enlightenment, with their faith in mathematics and geometry as the only sure means of investigating the mechanism of what they assumed to be a rationally constructed universe, measurement had crucial importance. The notion that only that which is quantifiable or measurable is real is implicit in all their systems of taxonomy (that of Linnaeus was based on the number of stamens and pistils of flowers). To his own satisfaction, and that of many of his contemporaries, Camper devised the means not only of classifying skulls but of determining their relative positions in a hierarchical order of nature. He was careful to dissociate himself from such "evolutionists" of the time as Lord Monboddo.

> The striking resemblance between the race of Monkies and of Blacks, particularly upon a superficial view, has induced some philosophers to conjecture that the race of blacks originated from the commerce of the whites with ourangs and pongos; or that these monsters by gradual improvements, finally became men. This is not the place to attempt a full confutation of so extravagant a notion.[32]

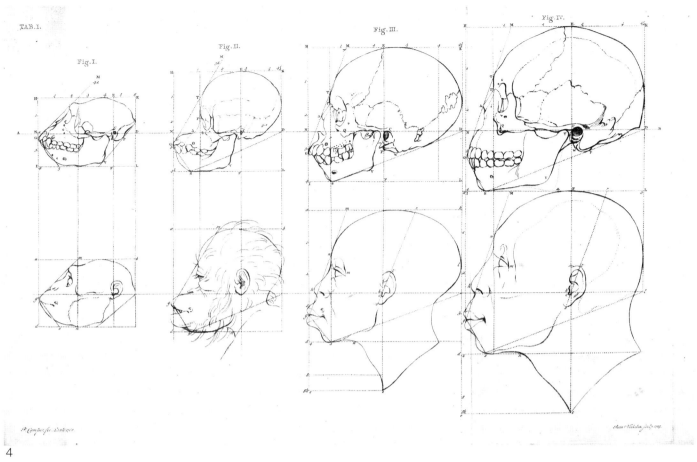

TAB.I.

Fig.I.

Fig.II.

Fig.III.

Fig.IV.

4

5

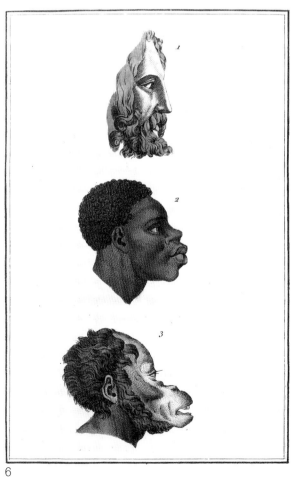

6

15

Nor did he draw any but physiological conclusions from his illustrations. But he had transformed the traditional view that anthropoid apes resembled men—the idea of the "parody of man" expressed artistically in *singeries*—into an apparently scientific demonstration that Africans, and only Africans, were physically akin to apes. Like the pointer of a gauge, however, the line of the facial angle indicated the place of a suppositional "Negro" in both a scale of aesthetic values ranging from the heads of antique statues to those of apes, and a chain of being that descended, as Buffon wrote, "by almost insensible degrees from the most perfect creatures to the most formless matter."[33] And this reduction of human diversity to a series of geometrical diagrams, which was one of the foundations of physical anthropology as practiced for more than a century, had the no doubt unintentional effect of relating the commensurable to such incommensurable factors as intelligence, affective capacity, sociability, and manual dexterity. At the same time, as we have seen,[34] the English Abolitionist Society's emblem (a profile) and diagram of a slave ship reduced blacks to depersonalized slaves.

It had of course been commonly believed since antiquity that human personality could be discerned from facial features, especially those resembling animals with well-defined characteristics—the proud and fearless lion, the crafty fox, or the lascivious goat. Such similarities were illustrated in Giovanni Battista della Porta's *De humana physiognomonia* first published in 1586 and several times reprinted.[35] A far more sophisticated and widely embracing system of physiognomic categorization was developed by the Swiss pastor Johann Caspar Lavater in *Physiognomische Fragmente zur Beförderung der Menschenkenntniß und Menschenliebe* which was first published in 1775–78 and soon won immense popularity throughout the West—reprinted, expanded, contracted, and translated in a bewildering number of editions. From the idea of a beautiful soul in a beautiful body Lavater attempted to create a science which could deduce a person's virtues and vices from the fixed osseous parts of his or her skull and, to a lesser extent, the whole anatomy. He was concerned mainly with Europeans, but in the fourth volume of his work he reproduced among other ethnic types two illustrations of Africans. One is fig. 5 of a man from south of the Sahara characterized, he wrote, by "the bowed aspect in the outline of the entire face, the breadth of the eyes; the flatness of the nose; especially the great swollen expansive, tough lips; removed from all fineness and grace. . . ."[36] The other is of a North African on which he commented: "What a well-proportioned, long, almost too long figure! The position itself is not clumsy. Heat and softness, sharp sensuality without reflection, fullness, limitedness, ease, constancy. Exactly the element of earthly passion."[37] Was he, perhaps, thinking of Othello, the Moor of Venice? A few years later questions were raised, apparently for the first time, as to whether Othello should be played on the stage and envisaged by readers as a black. From discussions of this point a horror of sexual relations between black men and white women emerged, at the moment when the anthropological status of blacks was being widely discussed and, paradoxically, abolitionists were campaigning to free them from slavery.[38] "If we are to think that this bright, this fairfaced Venetian lady was wedded to a black, we should almost be tempted to think that the monstrous alliance was fitly blotted out in its fearful catastrophe," an editor of Shakespeare wrote in 1803.[39] Even the gentle and usually humane Charles Lamb asked if anyone who had seen

a blackface actor in the part "did not find something extremely revolting in the courtship and wedding caresses of Othello and Desdemona."[40] The conjunction had come to seem almost a form of bestiality. Painters illustrating scenes from the play thus departed from eighteenth-century traditions and usually gave Othello a tawny rather than a black complexion and a European profile to indicate the nobility of his tragi-heroic character.[41]

According to Lavater a prominent nose indicated exceptional intelligence, a flat one stupidity, and in this connection he referred approvingly to Immanuel Kant's view that "the black is appropriate to his climate, that is, strong, fleshy, supple but because of the rich provisions of his motherland lazy, inactive and slow."[42] Could Newton, Lavater asked, "have weighed the planets or split a ray of light in the head of a black, whose race is so impressed on his face, whose eyes bulge, whose lips, as swollen as they are, hardly cover his teeth, who is generally fleshy and round?"[43] "And why not?" answered Georg Christoph Lichtenberg whose own physical deformity may have led him to question the premises of Lavater's system.[44] But this was a minority view. The urge to categorize and explain the diversity of human character and appearance was seldom resisted. Hence the success of Franz Josef Gall's somewhat different theory of phrenology, based on the notion that protuberances on the skull indicate faculties and propensities of the brain, which was still more generally accepted as scientific by the general public.[45]

Ostensibly, the theories of Lavater and Gall cut across racial lines, the shapes of noses and chins, the sizes of bumps on the skull, having the same significance for blacks as for whites. Features believed to reveal the maximum of sensuality and the minimum of intellect were, nevertheless, combined in what was termed "Negroid" physiognomy—in fact found only among some ethnic groups in Central and West Africa, significantly those who had been most extensively enslaved. For these early anthropologists drew their sweeping generalizations from a limited supply of skulls and a still smaller number of living heads.

In 1798 the French zoologist Georges Cuvier definitively split the Linnean class of primates to distinguish human beings (*Bimana*) from the rest. He was followed by Johann Friedrich Blumenbach, the virtual founder of physical anthropology in Germany, who recognized that the varieties of the human race were not distinct but ran into one another "through imperceptible passages." But this did not prevent him from identifying five main types distinguished by geographical location and exclusively physical features. "Personal observation, combined with the accounts of trustworthy and unprejudiced witnesses" had convinced him that Africans were not "specifically different in their bodily structure from other men," nor should they be placed "considerably in the rear, from the condition of their mental capacities."[46] The qualifications are significant. Although he owned a collection of books by black writers, he clearly thought that Africans were only potentially as intelligent as Europeans. And although he tried to escape from the notion of qualitative degeneration by introducing in 1795 the term *Varietas Caucasia*, in place of his earlier and more obviously hierarchical *Varietas Primigenia*, he used it to categorize "the inhabitants nearly of the world known to the ancient Greeks and Romans . . . and, according to the European conception of beauty in the countenance and shape of the skull, the most handsome of men."[47]

The heads of an antique statue of Zeus, an Ibo African with pronounced fig. 6
prognathism, and an orang-outang were illustrated in Julien Joseph Virey's
popularizing and unfortunately popular *Histoire naturelle du genre humain*
first published in Paris in 1801 and reprinted in 1824, 1826, and 1834.[48] The
comparison he wished to make was cultural as well as aesthetic: Virey
believed physical beauty to be the prerogative of the most civilized nations
and ugliness the mark of savagery. His aim was ostensibly to explicate the
significance of African features by means of Lavater's theories, but in fact
to rationalize his Negrophobia by reference to physiognomy. He wrote:

> Very important reflections arise from these remarks on the propor-
> tions between the skull and face of the negro, and the comparative
> volume of his brain and nerves. Indeed, the more an organ extends,
> the more powerful and active it becomes; in like manner, the more
> it contracts, the more it loses its activity and power. Hence it follows,
> that if the brain contracts, and the nerves emerging from it expand,
> the negro will be less inclined to think, than to abandon himself to
> sensual pleasures, whilst the reverse will be remarked in the white.
> The senses of taste and smelling of the negro, having more extension
> than those of the white, they will have more influence upon his moral
> qualities, than they have upon ours. The negro will be more inclined
> to the pleasures of the body, we, to those of the mind. In our white
> species, the forehead is projecting, and the mouth retreating, as if
> we were rather designed to think than to eat; in the negro species,
> the forehead is retreating, and the mouth projecting, as if he were
> made rather to eat than to think. Such a particularity is much more
> remarkable in inferior animals; their snout is protruding, as if about
> to reach the food; their mouth becomes wider, as if they were born for
> gluttony alone; the size of their brain becomes smaller, and is placed
> backwards; the faculty of thinking is but secondary.[49]

Virey's book was based on an assumption of the superiority in intellect
and physical beauty of whites, about whom his remarks were hardly less
absurd than those about blacks. The part devoted to blacks was translated
into English by J. H. Guenebault and published in Charleston, South
Carolina, in 1837 as *Natural History of the Negro Race*. But there were many
other publications with the same burden. Where, but among Europeans
shall we find "that nobly arched head, containing such a quantity of
brain?" the surgeon and student of comparative anatomy Charles White
asked rhetorically in 1799. "Where that variety of features, and fulness
of expression; those long, flowing, graceful ringlets; that majestic beard,
those rosy cheeks and coral lips? . . . Where, except on the bosom of the
European woman, two such plump and snowy white hemispheres, tipt with
vermillion?"[50] White had measured the anatomical features of fifty blacks—
the number seemed large to him—and claimed that in "bodily structure
and economy" they were closer to apes than to Europeans, the product of
a separate creation, although endowed with souls which distinguished them
from brutes. But serious anthropologists also took European superiority for
granted, and the notion of black inferiority was lent authority by men who

18

made enduring contributions to science–Camper in optics and obstetrics, Blumenbach in embryology, Cuvier in vertebrate paleontology.

The separation of human beings from other primates had an almost immediate effect on zoological illustrations of apes which tended to soften what a writer of the time called the feeling of humiliation aroused by their resemblance to men.[51] With the development of theories of evolution, initiated mainly by Jean-Baptiste Lamarck in 1809, the notion that apes were the immediate neighbors of humankind in a static order of nature gradually gave way to that of their being cousins, or colateral descendants from the same stock, in a dynamically changing universe. The juxtaposition of the heads of an ape and a black, rather than a white with the same distant ancestry, remained none the less perniciously memorable.

Camper's method of recording facial angles was subsequently revised, and other factors were taken into account for the measurement and comparison of skulls which survived as a system of ethnological classification until well into the twentieth century. The notion summed up by Cuvier that there was "a cruel law which seems to have condemned to an eternal inferiority the races of depressed and compressed skulls" was given new significance and specious validation by the colonization of Africa.[52] And Lavater's interpretation of prognathism lived on long after his theories of physiognomy had been discredited—people still talk of highbrow and lowbrow—underlying innumerable caricatures of whites as well as blacks.

The facial angle could of course be regarded simply as an aid for artists. In 1822 Henry Fuseli, a friend and illustrator of Lavater, told students at the Royal Academy in London that the more a profile

> recedes and inclines to the horizontal, so much the nearer a head approaches the form of a brute; the more it inclines to the perpendicular, the more it gains of man. This observation has been demonstrated in the least fallible manner by Camper, the anatomist, who, by a contrivance equally ingenious and unequivocal, appears to have ascertained, not only the difference of the *faceal* of animals, but that which discriminates nations.[53]

Yet Fuseli was a zealous supporter of the campaign to abolish slavery. So too was Pierre-Jean David d'Angers who believed nevertheless that low powers of reflection, indicated by receding foreheads, accounted for the "mobility in action that is characteristic of Negroes."[54] Fuseli, as we have seen,[55] did not give a sharp facial angle to his images of heroic blacks, whereas David d'Angers three decades later emphasized prognathism as well as bodily elasticity,[56] for these, he said, were the signs the artist must record.

In the 1820s the Prussian sculptor Johann Gottfried Schadow began to make measured drawings of men, women, and children in order to discover a system of bodily proportions derived from individuals as an alternative to the classical canon based on antique statues. The results of his studies were published in two large folios intended for international circulation (texts in German and French) as manuals for artists: *Polyclet* (Berlin, 1834) with lithographs of Europeans, and *National-Physionomieen* (Berlin, 1835) devoted to other ethnic types. But his choice of models for the latter was severely limited. He was able to illustrate only three heads of blacks drawn from

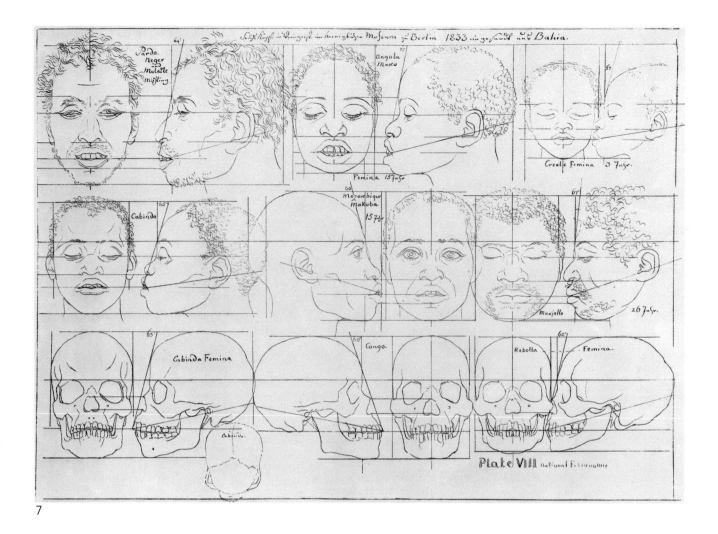

life: a thirteen-year-old boy and a man brought to Berlin as a domestic servant, both from Darfur, and a man whose father was African and mother "Hindustani."[57] But in 1833 the Royal Museum in Berlin acquired thirteen heads, preserved in spirits, of blacks who had been massacred in the suppression of a slave uprising in Brazil. There were those of women and children as well as men, all apparently labeled—a three-year-old girl; a young woman of fifteen named Maku, said to have been a native of Angola; a youth, Makuba, from Mozambique, and so on.[58] They arrived just in time for Schadow to add drawings of them to his collection, with measurements and a grid to indicate facial angles. But they hardly modified his preconceptions. For although the material available to him was a haphazard assortment of skulls and heads, he was not inhibited from making generalizations about national physiognomy, with due reference to the works of Camper, Gall, Blumenbach, and Cuvier. When the shape or size of a skull did not conform with racial theories, he regarded it simply as an exception that proved the rule, remarking that one black with a facial angle of 82 degrees differed little from the norm for Europeans. Another was, he wrote, *grand pour un nègre*; it never occurred to him that any might be small *pour un nègre*.[59]

fig. 7

The significance ascribed to acute facial angles was not always taken seriously. A drawing of two Englishmen with contrasting profiles was reproduced in *Punch* with the caption: "The Hydrocephalous Jones chooses

7. Johann Gottfried Schadow. Illustration for *National-Physionomieen . . .*, 1835, pl. VIII. Lithograph. 590 × 450 mm.

8. John Boyne. *A Meeting of Connoisseurs.* Ca. 1807. Watercolor on paper. 413 × 555 mm. London, Victoria and Albert Museum.

to believe in Phrenology. The Prognathous Robinson chooses not to. They will *never* agree."[60] Prognathism was, nevertheless, often emphasized in images intended to illustrate savagery, of Australian aborigines as well as Africans.[61] For painters and sculptors intent on recording the appearance of blacks without reference to racial theories, anthropological and physiognomical diagrams no doubt served if at all merely as schemata against which they checked off their own visual impressions. An artist's manual published in 1968 still illustrated the head of a black with the facial angle clearly marked.[62] The revival of colorism in the early nineteenth century had deflected attention from strongly drawn profiles as well as giving new pictorial value to dark skins. Loss of faith in absolute classical criteria opened the way to aesthetic relativism. But Europeans seem very rarely to have doubted their claims to superior beauty and intellect in a period of increasing materialism, expanding colonialism, and rampant racism. This is, however, more obvious in images which juxtapose and insidiously contrast blacks with whites than in studies and portraits of individuals.

ACADEMIC MODELS

Blacks were increasingly employed by artists as models from the early nineteenth century despite the common association of their color and physiognomy with ugliness. Men with well-developed, muscular physiques

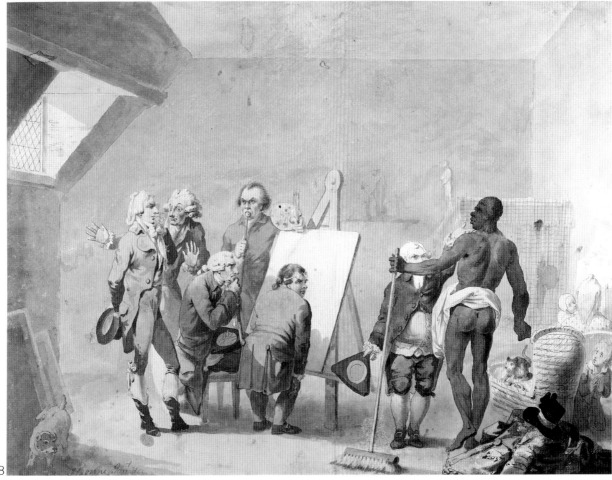

8

I arose this morning disgusted with
my Macbeth and every about me
after contemplating that exquisite &
form of the black — he is a perfect
model of beauty and activity
small body & large limbs, with
small joints — his contour was
undulating and nature suffered
nothing to interrupt this beauty in
any position — even when the
arm was bent — the declension instead
of making a disagreeable angle, as
of the middle forms thus

was curved as 2
beautifully within the
line — this seemed to
be the principle
every they were packed in

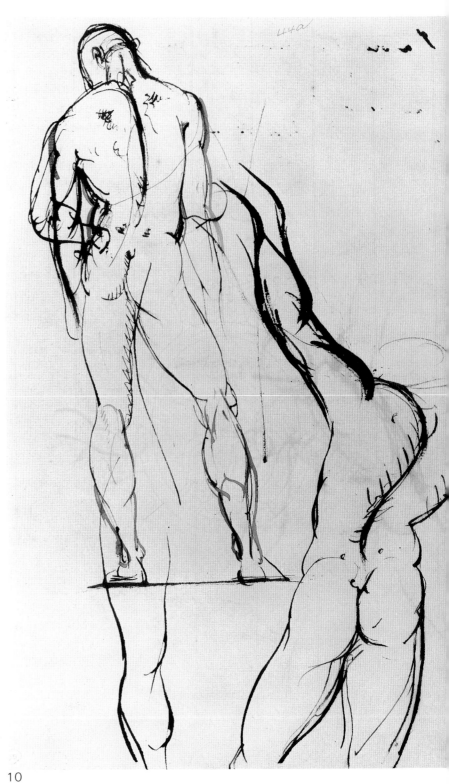

were regarded by painters and sculptors as "fine specimens" of virility whose bodily strength and agility compensated for supposed deficiency in intellectual and emotional capacity. A caricature by John Boyne, published in 1807, satirized the admiration of English artists and connoisseurs for one of heroic proportions whom they scrutinize as if he were an ancient Greek or Roman statue.[63] Whether or not it records a specific incident is unknown. But three years later, in the summer of 1810, the "extraordinary fine figure" of a man named Wilson, who had been born in Boston and came to England as a sailor, caused quite a stir in the artistic circles of London.[64] He was spotted and brought to the attention of artists by the surgeon Anthony Carlisle, professor of anatomy at the Royal Academy, who had treated him for a minor injury. Thomas Lawrence "thought Him the finest figure He had ever seen, combining the character & perfection of many of the Antique Statues" and promptly made a large drawing of him. "When His arm was suspended it appeared like that of Antinous, when contracted for exertion it was like the Farnese Hercules," Lawrence enthused to Joseph Farington, the garrulous chronicler of artistic life.[65] Benjamin West and the collector William Lock were no less favorably impressed. A younger artist, George Dawe, "paid Him 2 guineas a week for standing to Him." Benjamin Robert Haydon took him on for a whole month to study his "exquisite form" and made a series of drawings. He also wrote an extensive account of his physical appearance, and this combination of visual images and verbal descriptions provides a uniquely revealing account of a painter's response to a black model.

fig. 8

In his diary Haydon described the man as:

> . . . a perfect model of beauty and activity—small body & large limbs, with small joints—his contour was undulating and nature suffered nothing to interrupt this beauty in any position. Even when the arm was bent, the olecranon instead of making disagreeable angles, as in other meagre forms . . . was buried . . . beautifully within the line— this seemed to be the principle; every thing was packed in.
>
> Wilson was 3 noses to the top of his head, like the antique, but to his chin from the end of his nose is 1 nose and half—his was therefore shorter. Every part depends on its form from its action—the great beauty of the Antique and fine nature is the flexibility of the loins— that is the body in its motions to bend them instead of rolling on the thigh bones. . . . Wilson has all the markings of the antique. . . .
>
> Such was his beauty & power that whether in action or relaxation, his forms expressed either more perfectly than I ever before saw them in Nature—the moment he moved, his intentions were evident— . . . he had that perfect suppleness that one felt but never before saw—his joints were exquisitely clear—every head of bone, having insertion of tendon—but marked by delicacy & feeling—in repose they became undulating beauties & in action vehicles of energy and refined activity—his body bent at his loins like whale bone; he sat upon his heel & put his foot over his neck—

and so on for several pages of diary.[66] Some years later, in his autobiography, Haydon recalled how "pushed to enthusiasm by the beauty of this man's

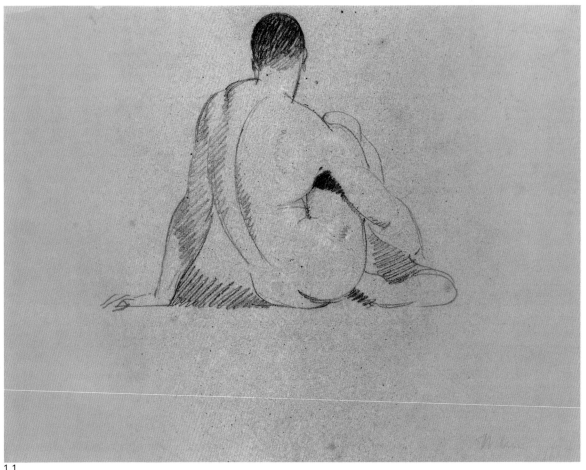

11

form, I cast him, drew him and painted him till I had mastered every part." The taking of life casts almost proved fatal for Wilson, for not content with those of separate limbs, Haydon had a kind of wall built round Wilson's naked body and poured in seven bushels of plaster which began to suffocate him as it set. He was released only in the nick of time, but the "hinder part" of the mold had "taken the impression of his figure with all the purity of a shell," and looking into it Haydon saw "the most beautiful sight on earth."[67] Haydon's admiration for Wilson's superb physique is conveyed with no less brio in the sketches he made on pages of his diary[68] and by a series of black chalk studies.[69] Perhaps significantly, however, he paid much less attention to the head than the body. Features which, together with his color, were thought to distinguish a black model from an antique statue were minimized, and only one drawing shows the head in profile. Skin color is not so much as hinted at in the drawings and would, of course, have been completely transformed in the dead white of the plaster cast.

figs. 9, 10
fig. 11

Haydon measured the proportions of Wilson's body—"he was 7 heads & ¾; his half below his pubis—the third head ends at his navel. . . ." He scrutinized his movements and "*was now convinced from Nature that one great cause of action & strength as I had before observed in the antique was the parts to be moved always to be smaller and depending on the parts moving.*"[70] In the process of this almost clinical examination, however, doubts arose in Haydon's mind. There were, he noted, some "defective parts" in Wilson's body: "his Deltoid, his fore arm, his vastus internus, his calves, his ankles—

11. Benjamin Robert Haydon. Chalk study of Wilson, the black model. Dated 1810. Approx. 394 × 520 mm. London, British Museum.

12. George Dawe. *A Negro Overpowering a Buffalo.* British Institution, 1811. 203.8 × 204.4 cm. Houston, Menil Foundation Collection.

24

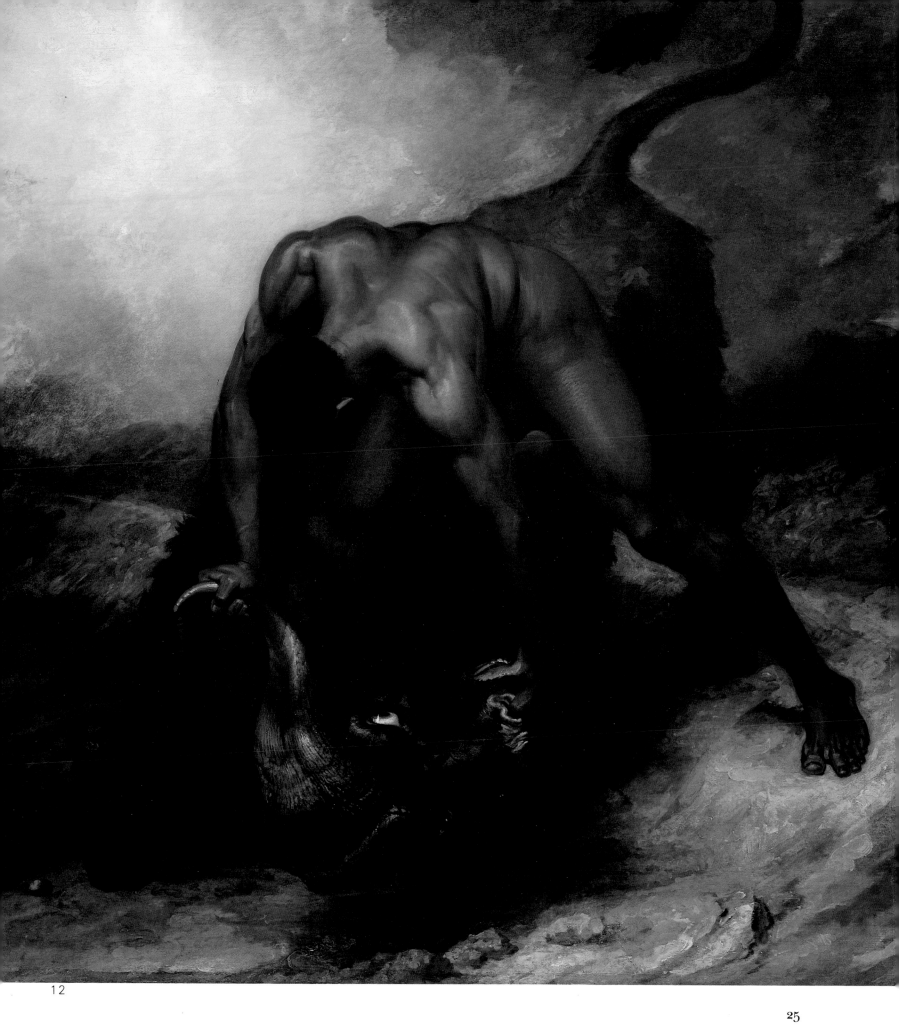

and his feet—answering exactly to the defects of animals in comparison with a human form." Thereupon his empirical observations were subjected to pragmatic theories and in due course various generalizations followed, of a familiar type. Blacks, he now wrote, "in their form approach that of those who are deficient in intellect—their lobes of ear small, their teeth frequent, lower jaw retreats, the scull [sic] is diminished—they have longer bodies, longer fore arms" and so on.[71] However, having made this ritual gesture, as it were, to current and omnipresent anthropological theories, Haydon went on to qualify it so radically as almost to retract, denying in fact that intellectual abilities were always and necessarily reflected in physical features as was commonly believed and had recently been elaborated into "scientific" theories of physiognomy by Lavater and others.[72] But unfounded though such ideas might be, they were held so widely and unquestioningly as to pose an awkward problem for artists. Physical features were part of an artist's means of expression—"form being his language," as Haydon put it. And intellectual qualities and classical ideals of beauty were so interconnected in the common mind that they could hardly be dissociated. Figures of other types—usually other racial types—connoted unintellectual, sensual, and instinctive qualities. There was therefore no place for blacks in "high" art. Not until many years later did Haydon include one in a painting—his large picture of the World's Anti-Slavery Convention of 1840.[73]

Another of the artists who employed Wilson as a model, George Dawe, painted a "study larger than life" which he worked up into a picture celebrating just those unintellectual qualities of "brute strength" that Haydon spurned. This large canvas, more than six feet square, was exhibited at the British Institution in London in 1811 and entitled *A Negro Overpowering a Buffalo—A Fact Which Occurred in America, 1809.*[74] The subtitle recalls that of *Brook Watson and the Shark* with which John Singleton Copley had established his reputation in England in 1778. And there can be no doubt that Dawe was making a bold bid for fame. Although only recently elected as an Associate of the Royal Academy, he was ambitious to become a full member, and as soon as he had finished the picture, he invited several senior academicians to see it in the hope of securing their votes (without success).[75] In its modernity and unliterary character, it marked a departure from his previous paintings of traditional classical and biblical subjects. The source of the "fact" he illustrated remains to be identified and was perhaps no more than a newspaper story.

fig. 12

While he was at the academy schools, Dawe had been noted as a diligent student of anatomy—he went beyond drawing to dissection—presumably under the tuition of Anthony Carlisle. With Wilson as model he no doubt aimed at displaying his ability to depict the nude in energetic action with every muscle extended. Yet he may have been predisposed to paint the image of a black for other reasons. As the lifelong companion and biographer of George Morland (to whose father he had been apprenticed) he was familiar with *Execrable Human Traffick*, the first explicitly abolitionist painting.[76] Frequenting the London literary world, he became a close friend of the playwright Thomas Holcroft, formerly Granville Sharp's secretary, and was acquainted with several men of strong abolitionist sympathies including Samuel Taylor Coleridge and the radical politician John Thelwall. Much later, shortly before his death in 1829, he was to make sketches

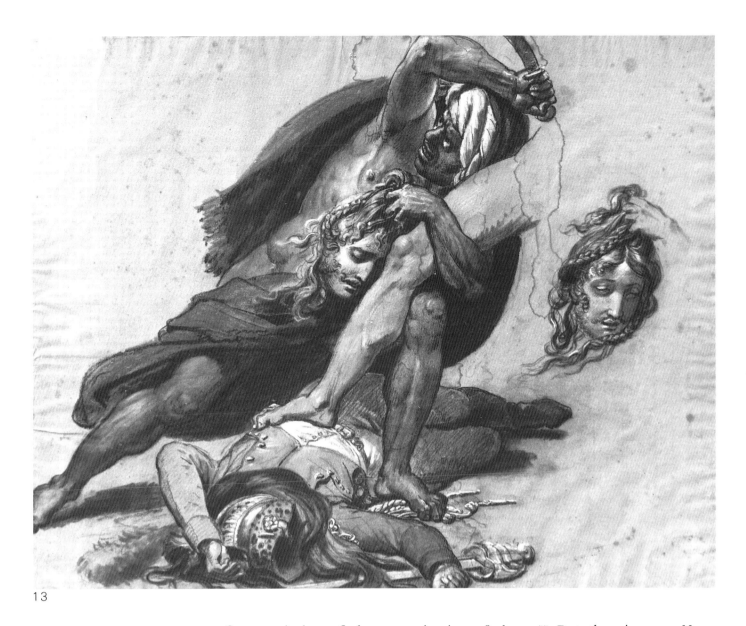

13

13. Anne-Louis Girodet. Study for the painting exhibited in 1810: *La révolte du Caire*. Pastel and pencil on paper. 455 × 585 mm. Avallon, Musée de l'Avallonnais.

for a painting of the emancipation of slaves.[77] But the vigorous *Negro Overpowering a Buffalo*, painted during a lull in abolitionist activity which followed the British prohibition of the slave trade, has nothing in common with conventional images of victimized blacks. It may, nevertheless, reflect the views of Charles White who went beyond the majority of philanthropists of the time to advocate the abolition of slavery throughout the world (not simply the suppression of the trade) and yet, in his influential treatise, *An Account of the Regular Gradation in Man* (London, 1799), presented a new division of humanity into four separately created species arranged in descending order—European, Asian, American, and African.[78]

For self-educative studies, like those by Lawrence and Haydon, black models may sometimes have been employed because they were more readily available and also charged less than Europeans with equally well-developed physiques.[79] Artists otherwise resorted to them when working on the relatively few predetermined subjects which demanded the inclusion of blacks. Reversing the normal practice of the time, Dawe seems to have been prompted by Wilson's "extraordinary fine figure" to seek the subject for a picture in which it could be displayed to best advantage. (His next model

was a boy of precocious muscularity, or possibly a dwarf, publicly exhibited as a freak of nature, whom he depicted as the infant Hercules strangling serpents.) Much of the objectivity of the study from life was however lost in an image conditioned by preconceived notions of the African's place in the natural world.

A drawing of the same period by the French painter Anne-Louis Girodet fig. 13 explicitly emphasizes the physical violence ascribed to Africans.[80] It is a preliminary sketch for the huge painting of *La révolte du Caire* exhibited in the Paris Salon in 1810.[81] The black clutching the severed head of a white represents one of the Nubian slaves of the Mamelukes who had revolted against the French army occupying Cairo in 1798. Much had happened to transform French mental and visual images of blacks in the decade since Girodet had portrayed J.-B. Belley with allusions to liberty and the rights of man.[82] Napoleon had, as we have seen,[83] revoked the Revolutionary decree emancipating slaves in French territory and prohibited the entry of colored people into France. But he had also lost, or was very soon to lose, the French colonies in which slave labor was employed—Saint-Domingue to the Haitians who had wreaked vengeance on the French army and French Guiana, Martinique, Guadeloupe, Mauritius, and Senegal to the British. Louisiana had been sold to the United States. His interests lay in the opposite direction, with continuing ambition for expansion toward the East.

In the *Harangue du général Bonaparte avant la bataille des Pyramides, 21* fig. 14 *juillet 1798* by Antoine-Jean Gros, a prodigiously tall, nearly naked black is slumped dead in the center of the foreground.[84] There was of course historical justification for this figure. Nubian slaves were owned by the Mamelukes, and many of both sexes were taken prisoner by the French after the Battle of the Pyramids.[85] He also answers the description of Nubians given by Vivant Denon who took part in the Egyptian campaign and drew up the program for paintings recording it:

> . . . stingy nature has denied them any superfluity; they have neither fat nor flesh, only nerves, muscles, and tendons. . . . Their shiny skin is a transparent, warm black, absolutely similar to the patina of last century's bronzes. They are not at all like the Negroes of West Africa: their eyes are deep-set and sparkling, under drooping eyebrows; their nostrils are broad, the nose sharp-pointed. . . .[86]

The main subject of the picture is of course the young general Bonaparte, whom Denon likened to Alexander the Great, shown addressing his troops as he points to the Pyramids: "Go forward, and remember that from the top of these monuments forty centuries are watching us."[87]

The dead black and wounded Arabs signify the outcome of the Battle of the Pyramids rather than its beginning. They also seem to symbolize the vanquished forces of savagery and barbarism—the two levels of culture being indicated by nudity and exotic costume. Similarly in Girodet's *La révolte du Caire*, the conflict is not simply that of French soldiers against Arabs but also that of civilization and Enlightenment against what Denon called "fanatisme."[88] Both pictures form part of the series of *grandes machines* officially commissioned to glorify Napoleon and celebrate the benefits of his regime. They were destined to have a lasting influence. For

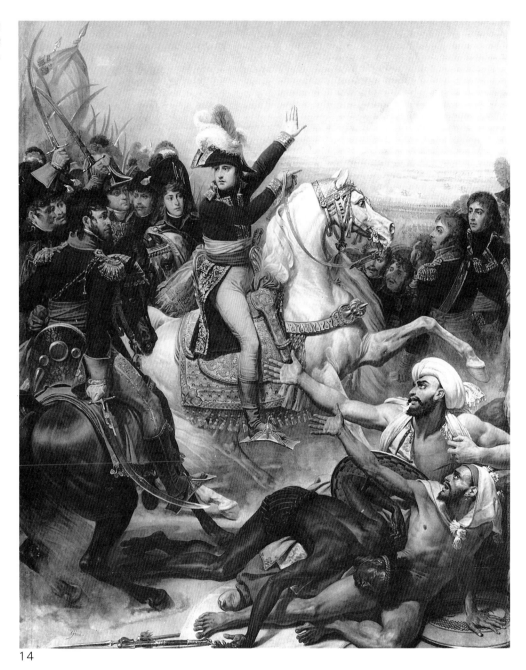

14. Antoine-Jean Gros. *Harangue du général Bonaparte avant la bataille des Pyramides, 21 juillet 1798* (detail). Salon, 1810. 389 × 511 cm. Versailles, Musée national du Château de Versailles.

14

although the French occupation of Egypt was brief, the paintings it inspired mark the beginning of the annexation of the Orient as a French artistic domain which included blacks among its colorful denizens. Those by Gros, who became the major official painter in France after the Restoration, gave a kind of academic sanction for images of the black in France.[89]

FRENCH DEVELOPMENTS

The first of the several images of blacks in the work of Théodore Gericault is a boxer in a lithograph drawn in 1818.[90] Although it may seem to be no more fig. 15 than the straightforward record of a prizefight, this print has somewhat complex origins in English rather than French art and life, and ambiguous significance. Black slaves boxed against one another in the United States

in matches on which bets were laid. Of those who settled in England two became well known, Bill Richmond as a trainer and his protégé Tom Molineaux (or Molineux) whose contests with the English champion Tom Cribb were very popular events.[91] Only in England did blacks box with whites. Here, at the beginning of the nineteenth century, boxing was a fashionable sport practiced as well as patronized by such notabilities as Lord Byron and even the Prince Regent. There were demonstrations of boxing in London theaters, and although prizefights were illegal, they aroused great enthusiasm, vividly evoked in a famous essay by William Hazlitt, himself an amateur boxer.[92] Addiction to "the fancy," as pugilism was called, transcended social barriers.

"A plan of making the public exercises of the Pugilists, a school of study for Artists who study the Human figure" was put forward in 1807 by Anthony Carlisle, the professor of anatomy at the Royal Academy who, as we have seen, "discovered" the black model named Wilson. "In a school for study such as He wd. propose," Joseph Farington recorded, "the figures shd. of course exercise *naked*; and to *Pugilists*, he wd. add *Tumblers* &c, to obtain as great a variety as possible."[93] It was an unorthodox idea in the context of academic education, for although based on the belief that the ancient Greeks had mastered the representation of the male nude by watching youths exercise in gymnasia, it was at odds with the current practice of drawing static life models in the poses of antique statues. How far artists responded to his suggestion is unknown. English images of boxers of the period are limited to artistically unambitious drawings and prints, including several of Molineaux on his own and boxing with Cribb.[94] They are a form of popular art to which Henry Raeburn referred when complaining of the poor sale of engravings after his portrait of Walter Scott:

> The thing is damned, sir—gone—sunk: nothing could be more unfortunate: when I put up my Scott for sale, another man put up his Molyneux. You know the taste of our London beer-suckers: one black bruiser is worth one thousand bright poets; the African sells in thousands, and the Caledonian won't move;—a dead loss, sir—gone, damned; won't do.[95]

La boxe was introduced into France in the Restoration period when sporting society in Paris was Anglophile. Gericault frequented these circles and in 1818 made a number of drawings of youths sparring, probably two young artists who were pupils of his neighbor in Paris, Horace Vernet.[96] These he gradually developed into the composition used in his lithograph. Even in the most advanced of the compositional sketches, however, both the boxers are white. Not until he drew the lithograph on the stone did he transform one of them into a black. His motives for making the change were probably mixed. Although he had not, as yet, visited England, he may well have seen one of the several images of the fight between Molineaux and Cribb and recognized that their contrasting colors would give his print a dramatic and also obviously unclassical effect. When drawing the figures on the stone he experimented with two contrasting techniques, using a pen for the strongly modeled torso and a crayon for the trousered legs of the black, the reverse for his antagonist.[97] But Gericault's other lithographs of

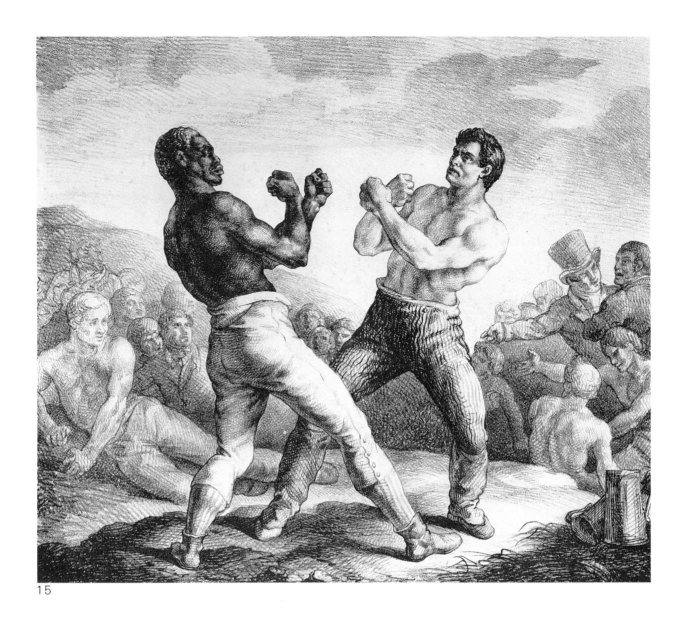

15

the period have social if not political implications, and it is possible that his views about human equality and the rights of man had some bearing on his decision to substitute a black for one of the white boxers. The ring was the only place where blacks and whites encountered one another on equal terms.[98] Even if his motive for the substitution was primarily pictorial and artistic, the lithograph is significant in the history of the image of the black. For it dates from the moment when the symbiotic relationship between ethnic and aesthetic theories—the notion of a racial hierarchy corresponding to an aesthetic value system derived from the idealization of classical antiquity—was falling apart.[99] Exploiting the potentiality of the relatively novel medium to reproduce the personal touch which reveals the artist's unique vision and sensibility—a prerequisite for romantic art— it suggests the possibility of detaching individual visual perceptions from widely held mental preconceptions even in an image that maintains the traditional association of blacks with purely physical strength.

Shortly after drawing the lithograph of the boxers, Gericault began work on his masterpiece *The Raft of the Medusa* in which, as we have seen,[100] he included three blacks, giving great prominence to the signaling figure at the

15. Théodore Gericault. *Boxers*. 1818. Lithograph. 352 × 416 mm.

31

16. Théodore Gericault. *Negro Soldier Holding a Lance*. 1822–23. Ink and wash over graphite on paper. 335 × 249 mm. Cambridge, Fogg Art Museum, Harvard University.

17. Théodore Gericault. *Portrait of a Black Man (Joseph)*. Ca. 1818–19. 46.5 × 38 cm. Malibu, J. Paul Getty Museum.

16

apex of the composition. The model was a man from Haiti named Joseph who had come to Paris in a troupe of acrobats. Joseph may also have been the subject of a striking pen and wash drawing of a man in oriental costume who stands clasping a lance in an attitude of bold defiance.[101] This is probably somewhat later, dating from about 1822–23 when Gericault made a number of oriental costume studies with his Turkish servant Mustapha as model. A more straightforward sketch in oils of a man with a somewhat melancholy expression is similarly said, on good authority, to portray Joseph.[102] He was, as contemporaries recorded, not only "wonderfully handsome," with broad shoulders and torso tapering to a slender waist, but also an engaging personality, and Gericault seems to have favored him as a model not so much because he had a physique that could be assimilated to antique statues (like Haydon's Wilson) but for himself as an individual. This painting places so little emphasis on skin-deep ethnic diversity that it has been mistaken for a portrait of one of the European survivors from the *Méduse*.

fig. 16

fig. 17

Images of blacks by Gericault may have been included in the posthumous sale of his studio effects: a single lot was catalogued simply as "forty academic figures, studies of heads, and portraits."[103] The arresting portrait of a man in a scarlet coat with trimmings of gold braid is among several that have been attributed to him.[104] It is focused on the subject's proud bearing and strong individuality. His rich costume seems to have been selected to provide a color contrast for his dark skin rather than to emphasize exoticism. Although differing markedly in handling and in palette from Gericault's documented

fig. 19

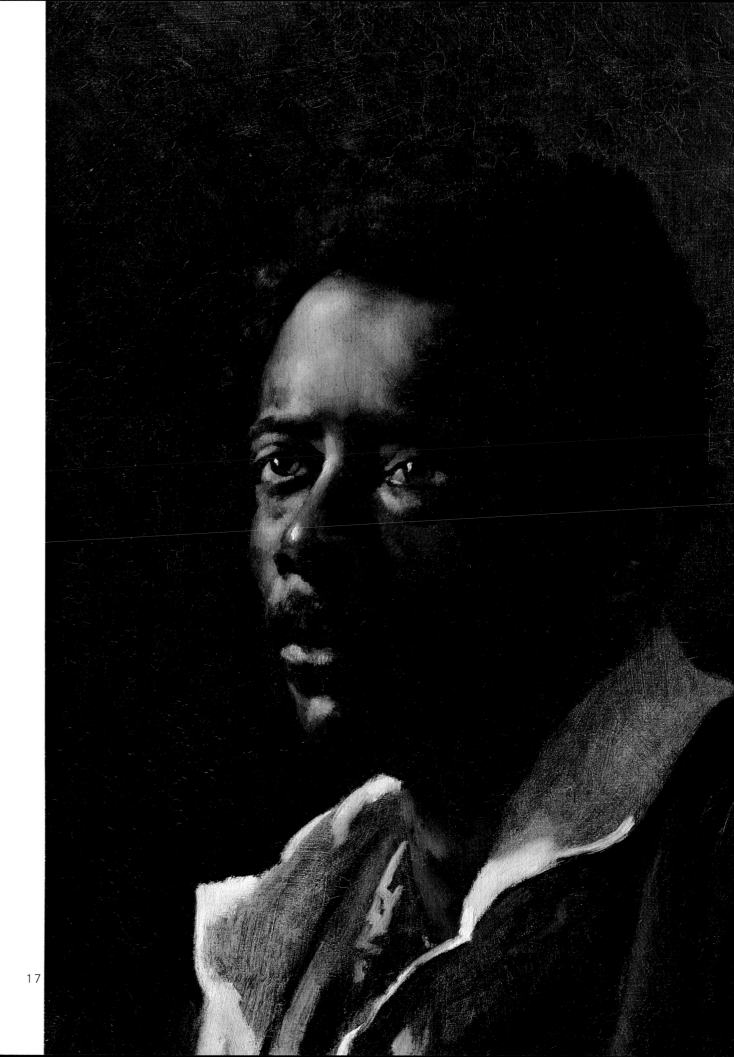

18. Eugène Delacroix. *Head of a Black Wearing a Turban*. Pastel on paper. 470 × 380 mm. Paris, Musée Eugène Delacroix.

19. French/19th century. *Portrait Study of a Negro*. Oil on paper mounted on canvas. 54.6 × 46.2 cm. Buffalo, Albright-Knox Art Gallery.

19

works, it suggests an objective pictorial response to a black sitter akin to his. No one of his generation was more highly respected by slightly younger artists, and the example he set may partly account for the sharp increase in the number of images of blacks painted in France during the Restoration period, though other factors were involved.

Ten or more paintings of blacks have at various times been ascribed to Gericault.[105] There are also records of a number of (at present untraced) paintings exhibited in the early nineteenth-century Salons: in 1819 *Une Négresse, étude* by Charles-Porphyre-Alexandre Desains; in 1824 *Un jeune nègre joue avec une perruche; scène des Antilles* by Jean-Pierre Léonard; in 1827 *Une jeune mulâtre tenant un enfant* by Henri de Caisne; in 1830 *Africain, assis sur le bord d'un lac, se préparant à fumer une pipe* by Léonard, *Un Nègre et une mulâtre* by Julien Vallou de Villeneuve, and *Un jeune nègre. (Etude)* by Pierre Asthasie Théodore Senties.[106] It is noteworthy that of these five obscure artists, three were teachers of painting: Léonard, Senties, and Desains, of whom Charles Gabet wrote in 1831, "entirely engaged in private lessons, he was able to produce only a small number of works."[107] The painting of *études* of figures from life, as of landscapes *sur le motif*, had become an

important part of artistic education. "Certain attempts in painting have been called studies [*études*], to distinguish them from works that are whole and complete," wrote the arch-academic theorist J. N. Paillot de Montabert. But, he went on to remark: "Several painters who were incapable of completing a figure or a simple composition have given these unfinished works the name of *étude*, and often enough the public has been taken in, especially when the artist carefully left some parts incomplete, like the background, and even certain accessories of the principal parts. This abuse should be pointed out. . . ."[108] The spontaneity and lack of finish of such paintings could, nevertheless, be seen as merits, with notable consequences for subsequent developments in European art.

Painted *études* came to constitute in this period a kind of genre defined not so much by subject as technique and admired mainly for their painterly qualities. Thus, an art critic remarked of Eugène Delacroix's *Tête d'étude d'une Indienne* exhibited in the Salon of 1827: "Rather remarkable portrait, especially with regard to the colors and the likeness, prime merits in a composition of this kind."[109] Blacks figured among the subjects chosen for *têtes d'étude* which, as distinct from commissioned portraits which were usually of famous or well-to-do sitters, comprised old people, beggars, peasants, and a wide variety of ethnic types (Desains exhibited one of a *Jeune Ecossais*) who were literally and metaphorically colorful rather than conventionally beautiful. Many were of Jews who seem to have excited artistic interest as much as, if not more than, blacks. It is not unusual to find an artist painting both these types of social outcasts.[110]

There appear to have been several black models in Paris during the Restoration period. One posed in about 1818 for the young Eugène Delacroix, then under the spell of Gericault. Delacroix's painting of him and a series of drawings in a sketchbook are quite simply studies of a male nude in a variety of attitudes.[111] He seems to have regarded the man's color as of little or no account, concentrating his attention on the articulation of limbs and the play of muscles in an attempt to master figurative representation. In the pastel head of a man wearing a red turban the darkness of the skin and the reflection of light on it acquired paramount importance.[112] It is an essay in portraiture and in coloring—also in a medium he rarely adopted. There is a suggestion of detachment in the dignified bearing of this man who gazes straight at us without betraying his feelings. But Delacroix's relationship with his female models was more intimate.

fig. 18

In a sketchbook he was using in 1821 he named "Steline négresse," with her address, in a list of available female models.[113] In May 1824 he referred in his diary to a model, *la nera* with whom he had sexual intercourse.[114] She may well have been a mulatto woman named Aspasie whose sensual attractions he recorded in three portrait studies, one in muted, almost grisaille colors, another with a sultry crimson background,[115] and the third and largest showing her more than half-length with her thick hair falling down, wearing a necklace, a striped skirt, and white blouse open to reveal her shoulders and full breasts.[116] An image of *luxe, calme, et volupté*, it was to catch the attention of the young Paul Gauguin who painted a copy of it half a century later.[117] Delacroix clearly painted these studies for himself: he never exhibited them but kept them in his studio until his death. Shortly after painting them he wrote some notes on his (not unrelated) aesthetic

fig. 20

20. Eugène Delacroix. *Portrait of Aspasie, the Mulatto Woman.* Ca. 1824. 80 × 65 cm. Montpellier, Musée Fabre.

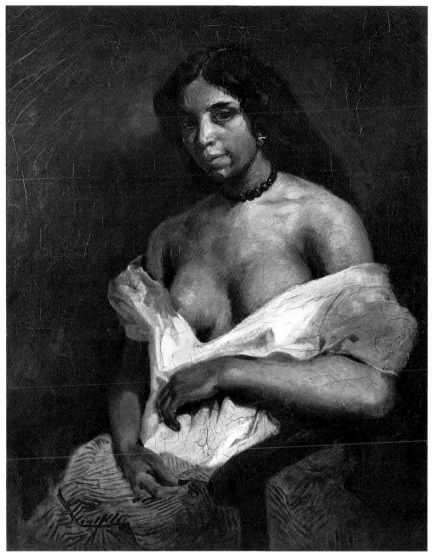

20

ideas. With reference to a friend who had said "that nature seems to give more intelligence to the races that have more of what we regard as beauty," he remarked, "but the arts are not like that." Criticizing the neoclassical conventions from which he had freed himself, he wrote:

> Our painters are delighted to have an ideal of beauty ready-made and nicely in hand which they can communicate to their kin and their friends. To lend a touch of the ideal to an Egyptian head, they give it the profile of the Antinous. They say, "We have done what we could, but if it is not still more beautiful thanks to our correction, you must blame that baroque nature, that flat nose, those thick lips, things intolerable to look upon." Girodet's heads are an amusing example of this principle: those awful hook noses and snub noses, etc., which nature shapes, drive him to despair.[118]

The physical attraction of women of color had been less often illustrated in visual images than expressed in European literature before the nineteenth century.[119] In painting Aspasie and another darkskinned (probably Indian)

37

model, Delacroix broke away from current, accepted ideals of female beauty and introduced if not a new ideal at any rate a new and more wholly carnal, ravening response to femininity in which a languorous, heavy-lidded sensuality becomes almost wistful in its voluptuous abandon. His paintings of Aspasie have the melancholy quality that Charles Baudelaire, his most perceptive critic, so greatly admired in all his work. He did not paint "pretty women, at least from the point of view of high society," Baudelaire wrote. "It is not simply that he knows how best to express suffering, but beyond that—the prodigious mystery of his painting—moral suffering!" [120] And this "suffering" is deepened in the case of his black model, perhaps by his sense of her alienation in European society. Aspasie was probably a prostitute, like many of the women of whatever color who served as artists' models at this period in France. But Delacroix's paintings seem to invest her with the loneliness and frustrated passion of the virtuous Ourika, the tragic heroine of the novel by the duchesse de Duras. [121]

Essentially essays in objective representation, *études* are less distorted by mental preconceptions than most other images of blacks. The meaning they take from the context of the artist's studio is modified though not essentially changed when they are framed and hung in a museum or exhibition where they are outnumbered by paintings of whites. Even those created in the process of work on subject pictures in which the figures are given predetermined roles often make an impression of transparent directness. The complete disjunction between the painting of a slender athletic man by Théodore Chassériau and its intended purpose is, nevertheless, exceptional. [122] fig. 21

This work was commissioned in 1836 by Jean-Auguste-Dominique Ingres, then in Rome, who wrote to a friend in Paris saying that he needed a painting of a model in a pose of which he enclosed a sketch—"a simple figure of a Negro in this attitude." His former pupil Chassériau was chosen for the task and sent a drawing with very precise instructions:

> First square the figure exactly for transfer to the canvas—Have this figure painted after the model Joseph the Negro—His size: studio figure—The white, or gray, canvas will serve as background—The light coming from left to right—Request the most exact likeness of the model, with the most correct rendering of the forms and his color—Repeat and paint separately a clinched fist and, without moving the arm, the hand in a relaxed position. [123]

Joseph, after posing for Gericault, had become a professional model employed by several artists in Paris. [124] Whether Chassériau portrayed him or a younger black model he complied with the brief despite difficulties—"the pose being very tiring." The result was an outstandingly beautiful and vital image which to modern eyes has a kind of surrealist appeal. Ingres had carefully concealed from Chassériau that he needed the figure to represent Satan in a picture he was planning to paint of "the Lord chasing the Demon from the mountain top." [125] Although it had become very unusual to represent Satan as a black at this time, he was probably inspired by the description of a destroyed, early altarpiece by Raphael in which the figure of Satan was said to have been "free from the singular deformity with which

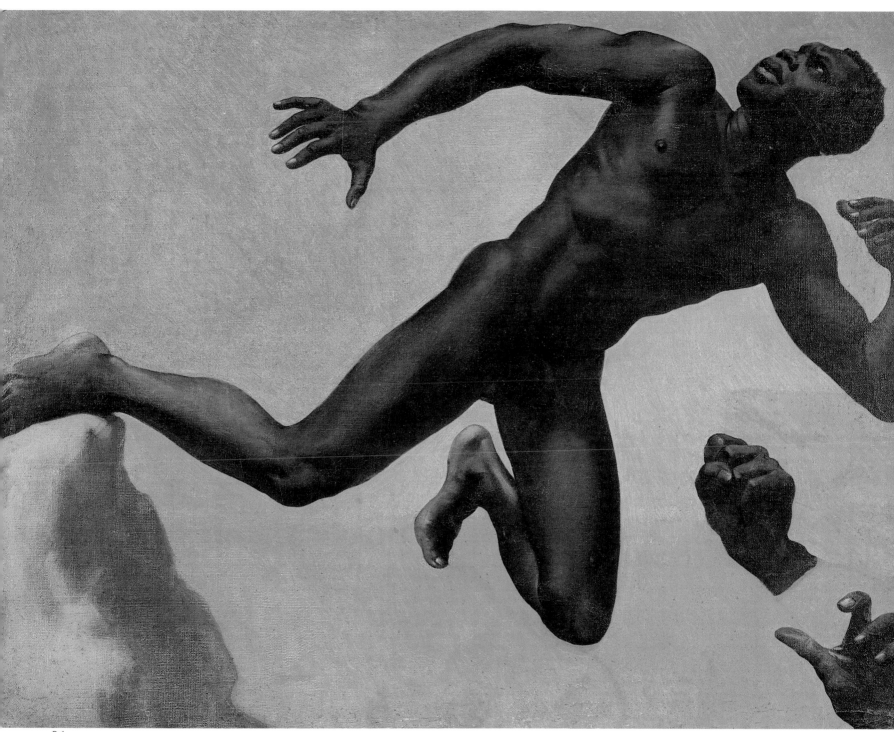

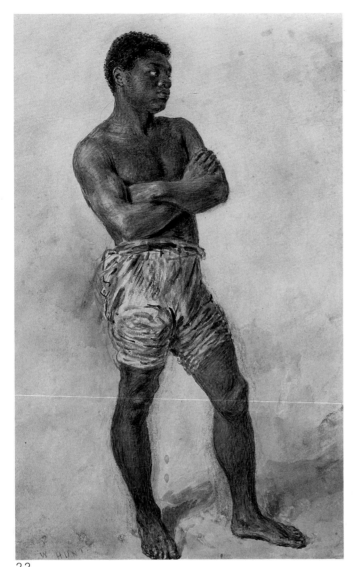

22

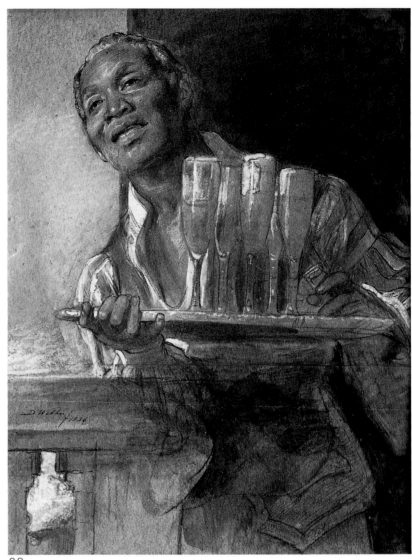

23

the ancient painters represented him; and has the genuine features of an Ethiopian."[126] By concealing his purpose, Ingres probably hoped to obtain an *étude* similarly uninfluenced by conventional images. But had Ingres executed his project, Chassériau's objectively naturalistic figure would have been transformed into a personification of the powers of darkness.

OTHER EUROPEAN COUNTRIES

A watercolor by William Henry Hunt of a young man naked to the waist with his trousers rolled up above his knees has been said to represent a boxer.[127] The subject is, nevertheless, more obviously a model posing in a studio—a sturdy, broad-shouldered youth with well-developed biceps who stands in an attitude that is pensively resistant rather than aggressive. It is somewhat exceptional in the œuvre of Hunt who was best known for his meticulous paintings of fruits, vegetables, and birds' nests, highly and sometimes extravagantly praised by John Ruskin. His paintings and drawings of the human figure were usually of children with a sentimentally humorous

fig. 22

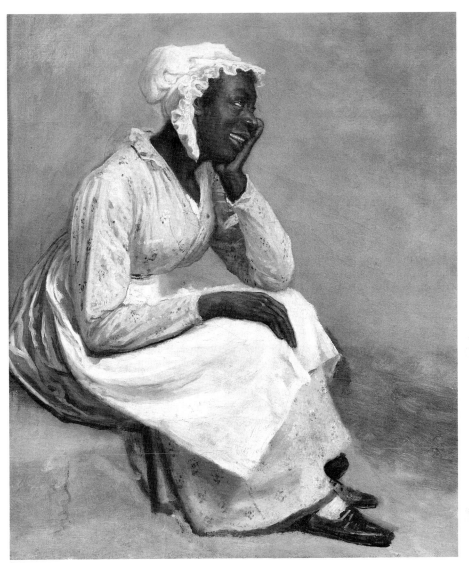

24

appeal.[128] Like other English watercolor painters of the time, however, he made his living partly as a teacher of upper-class amateurs, providing exemplars for them to copy. This highly finished study may well have been made for such a purpose, as an aid in figure drawing for those who did not have access to a life-class. The model—like Haydon's Wilson—seems to have been employed on account of his fine physique rather than ethnic characteristics. But the mere fact that he was black sharpened Hunt's focus, obliging him to concentrate on visual appearances with less reliance on schemata derived from classical art than was usual in life drawings of nude or seminude models.

Another watercolor, of about the same period, also appears to have been painted from life although the subject is cast in the black's traditional role of an attendant.[129] It is a study for the servant carrying a tray of champagne glasses in the background of *The Empress Josephine and the Fortune-Teller* which also includes a naked black child.[130] Wilkie had placed a black with somewhat similar features, partly for pictorial effect, in the center of his earlier anecdotal *Chelsea Pensioners Reading the Waterloo Despatch*.[131] But this figure was also symbolic, recording the presence of a man who had been

fig. 23

25

a witness to the execution of Louis XVI and was subsequently a bandsman and body servant in the British army—as was stated in the catalogue of the Royal Academy exhibition in 1822 when the picture was first shown. In the painting of Josephine, the servant and the child similarly have a double function, locating the scene on Martinique and contributing to a bold coloristic composition. "After seeing all the fine pictures in France, Italy, and Germany, one must come to this conclusion— that *colour*, if not the first, is at least an essential quality in painting," Wilkie wrote; "in oil painting it is richness and depth alone that can do justice to the material."[132] This is one of the large-scale history pictures in which he strove to emulate the work of old masters; the black servant recalls those in paintings by Paolo Veronese and Rubens, especially the latter's *Feast of Herod*.[133] Whether or not he was aware that the creole Josephine may have influenced Napoleon's reestablishment of slavery, his picture makes no allusion to the issue. The blacks have a purely, if only subsidiary, pictorial significance.

Images of blacks were very often drawn as studies for figures in narrative pictures where the subjects required their presence. As their initial purpose was simply to record visual appearances, such studies give an impression of unprejudiced objectivity which is rarely retained when they are worked into finished compositions, especially those in which whites have the leading roles. Western artists were rarely able to avoid a suggestion of invidious comparison when they juxtaposed blacks with whites. The Swiss artist Jacques-Laurent Agasse, however, painted a lively study of a black fig. 24

42

26

27

flowerseller nicknamed "Albino" who had caught his eye in Hungerford Market, London.[134] He used it with little change in a painting entitled *The Contrast*, dominated by a standing white woman in tattered clothes balancing fig. 25 a basket of flowers on her head.[135] The two figures exchange friendly smiles, but Albino is placed in an inferior position in the lower corner of the canvas. It is a glimpse of London street life—an image of contented poverty—painted with the sharply focused verisimilitude for which Agasse was admired, and the suggestion of a story. Albino who sits on her empty basket has apparently sold her flowers whereas the white woman still has hers on offer, and this may explain the title. But there cannot be much doubt that visitors to the Royal Academy, where the picture was exhibited in 1829, would have seen the contrast also as that between the physical beauty of the black and the white, in favor of the latter.

To European artists blacks were picturesque, in the simplest meaning of the word. That the attraction and interest they exerted was essentially pictorial is indicated by the way in which studies painted in the studio merge into open-air sketches. The German landscape painter Carl Blechen, fig. 26 for example, made a watercolor of a black in military uniform whom he somewhat surprisingly spotted among the ruins of Pompeii in 1828–29 and added it to his collection of sketches of the more conventionally picturesque Italian peasants, shepherd boys, fishermen, and monks.[136] A decade later another northern artist, the Danish Martinus Rørbye, on a visit to Rome saw a Nubian of whom he immediately resolved to paint a "lille Studie" fig. 27

25. Jacques-Laurent Agasse. *The Contrast*. Royal Academy, 1829. 92 × 70.5 cm. Bern, Kunstmuseum Bern.

26. Carl Blechen. *Der Negerkorporal*. 1828–29. Watercolor and graphite on paper. 293 × 203 mm. Berlin (GDR), Staatliche Museen zu Berlin, Nationalgalerie.

27. Martinus Rørbye. *Seated Nubian*. Dated 1839. 75 × 61 cm. Charlottenlund, Collection of Niels Arne Ravn-Nielsen.

28

(as he noted in his diary). Rørbye persuaded him to pose stripped to the waist, smoking a cigarette, by a potted orange tree, for a full-length portrait in which the *étude* and picturesque sketch painted *sur le motif* are fused and united.[137] His other Italian figure studies were of subjects similar to those depicted by Blechen and so many other northern artists. A few years later he was to travel through Greece and Turkey in search of more exotic picturesque material.

Opportunity makes the thief—and also accounts for the depiction of several studies of blacks. The picture of a boy with a soulful expression and dressed in rags appears to have been prompted by a casual encounter.[138] fig. 28
The child is said to have crossed the Atlantic as a stowaway and to have been noticed, sitting on the doorstep of a hotel in Liverpool, by William Windus, a young painter then studying at the local art school. A black child was a relatively uncommon sight in England, one that might well catch the eye of an artist in search of original material. Windus portrayed him with careful, almost loving, attention to his several layers of tattered clothing, as an exercise in chiaroscuro and also an image of picturesque poverty of the type that exerted a strong and ambivalent appeal in Victorian England, arousing in the art-buying public mixed feelings of pity and self-satisfaction.

For although the waifs and strays depicted in genre scenes and described in novels—notably by Charles Dickens—may have encouraged charity, they also suggested to members of the middle class that their own prosperity was providential. As an indigent black child, isolated from family and friends in an alien environment, the subject of Windus's painting was doubly pathetic. His finished picture assimilated a study from life to the well-established and popular tradition of genre painting.

II

THE ART OF OBSERVATION

SOUTH AFRICA'S "SAVAGE TRIBES"

Etudes and portraits were conceived as works of art, the former especially as works of artists whose individual perceptions and abilities they expressed. Images of blacks drawn and painted as ethnographic illustrations, on the other hand, were intended to be so sharply focused that the role of the artist was reduced to that of a reporter whose intervention was limited to the selection of subject and physical viewpoint—like that later to be given to a photographer. Their aim was the visual equivalent to the transparent objectivity modestly claimed by Mungo Park for his *Travels in the Interior Districts of Africa*: "a plain, unvarnished tale; without pretensions of any kind, except that it claims to enlarge, in some degree, the circle of African geography."[1] Park's book, which had a formative influence on nineteenth-century attitudes to Africa—not least on account of its very favorable comparison of black Africans with Arabs—was poorly illustrated with prints three times removed from reality, "improved" and engraved after his sketches which must have been drawn from memory.[2] Professional artists may well have been deterred from following his tracks in the Niger Valley by the climate and the other hazards he had run. From the early nineteenth century, however, a succession visited southern Africa and recorded its indigenous inhabitants.

British interests in sub-Saharan Africa had been stimulated by the abolitionist movement, the development of "legitimate trade" with Africans, missionary endeavor, and colonial expansion—all of which were closely connected and interrelated. Special attention was directed to the south as a result of the occupation of the Cape Colony, temporally from 1795 to 1802 and definitely from 1806. It was the major territorial acquisition made by Great Britain in the Napoleonic wars. Although founded by the Dutch as no more than a victualling station on the route to the East Indies, this colony had

gradually expanded into the agriculturally rich terrain of the hinterland. Settlers were thus brought into conflict with the three indigenous groups known at the time as Bushmen, Hottentots, and Kafirs (nowadays San, Khoikhoi, and Xhosa).

Before the arrival of the British little was known to Europeans of the Xhosa—well-organized clans of cattle breeders and farmers who were also formidable warriors that blocked the path to expansion. But travelers' tales of Bushmen and Hottentots, rarely distinguished from one another, had aroused much curiosity. Physical peculiarities were supposed to dissociate them from other human beings: the males were said to have only one testicle, the females a large vaginal flap called a *tablier* and a fatty enlargement of the buttocks known as *steatopygia*. The language of Bushmen, composed mainly of strange clicks, sounded to Europeans more like animal noises than human speech. Their consumption of raw meat seemed bestial. If they were not categorized as a distinct species, a link between animals and men in the great chain of being, they were relegated to the lowest place in the scale of human life. Pitiless fun was made of their supposed way of life in a story, printed in 1754 in the English periodical *The Connoisseur*, that caught the eye of Gotthold Ephraim Lessing who gave it lasting international circulation by citing it in *Laokoon* as an example of the close relationship between the disgusting and the comic.[3] Accessible visual images of these people were similarly fantastic. The most widely diffused were the illustrations drawn by a European artist from verbal descriptions (and not from observation) in Peter Kolb's account of the Cape of Good Hope, first published in 1719 and reprinted in later editions and translations.[4]

In the last decades of the eighteenth century, the second major period of European geographical discovery, a sharpened sense of scientific accuracy led to the inclusion of trained draftsmen among the personnel of maritime explorers. Captain James Cook, whose voyages initiated this practice, called twice at Cape Town. On the second occasion William Hodges, the most accomplished of his artists, painted a view of the harbor from the sea without, however, depicting the local inhabitants.[5] Only on the islands of the Pacific did he portray the people, setting a new standard for ethnographic illustration. But draftsmen, who could easily be accommodated on a ship, rarely took part as yet in overland expeditions. Samuel Daniell was an exception, accompanying an official mission sent in 1801–2 by the British governor of the Cape Colony to obtain information about the tribes living beyond its frontiers. He was virtually the first trained artist to depict these people in their own environment.[6] He came from a family of artists, his uncle and elder brother specializing in topographical views of India drawn with the aid of the camera obscura to ensure accuracy.[7] While a boy at the East India College, Hertford, he had learned landscape painting—an accomplishment expected of colonial officials as of officers in some military regiments. And he probably acquired the art of figure drawing from his uncle or elder brother, both of whom had studied in the Royal Academy schools. In 1800 he went to Cape Town as secretary to the governor and commander in chief of the military forces stationed there. From the beginning the British were more anxious than the Dutch had ever been to protect the indigenous population from the farmers—or Boers—who were encroaching on the territory of those they had not already enslaved. The triangular struggle that was to

30

29

31

29. Samuel Daniell. *Korah Man with a Spear in a Landscape.* Dated 1802. Pencil and sepia wash on paper. 262 × 183 mm. Present whereabouts unknown.

30. Samuel Daniell. *Bushmen Hottentots Armed for an Expedition.* Ca. 1802. Watercolor and pencil on paper. 127 × 177 mm. Johannesburg, Africana Museum.

31. Samuel Daniell. *Booshuana Women Manufacturing Earthen Ware.* Ca. 1802. Watercolor and pencil on paper. 159 × 216 mm. Johannesburg, Africana Museum.

determine the tragic subsequent history of South Africa had begun. The mission which Daniell accompanied as secretary and draftsman was intended to establish peaceful trading relations between the Xhosa and the settlers.

On the expedition Daniell made drawings of the landscape and its inhabitants. His portrait heads have the appearance of faithful likenesses though whole-length figures, standing or seated in attitudes which could be held without muscular strain, suggest the poses of the life class.[8] From these sketches he composed finished watercolors, almost certainly painted after his return, in Cape Town or London. One shows Hottentots armed for an expedition.[9] Another is of the "Boosuana" (i.e., Tswana, a Bantu-speaking Xhosa group) and depicts women making pottery vessels by hand modeling without a wheel—evidence of their level of material culture.[10] Further refinements were introduced in the set of delicately colored aquatints he published in London in 1804–5, entitled *African Scenery and Animals.*[11] The

fig. 29

fig. 30

fig. 31

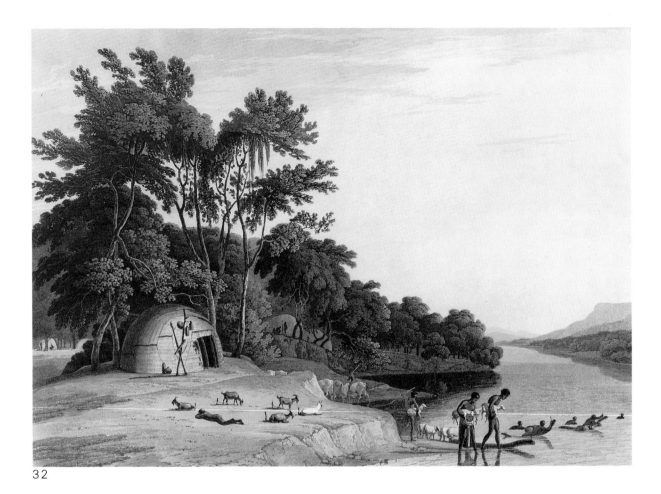

32

view of *A Korah Hottentot Village on the Left Bank of the Orange River* is fig. 32
so closely assimilated to British notions of the picturesque that it might
at first sight be mistaken for an exotic sector of a gentleman's park.[12]
But the hemispherical hut, the scanty costumes of the people, and the
logs on which men are swimming across the river are represented with
ethnographical fidelity. Cattle and goats indicate a pastoral way of life. The
print incorporates as much information as possible in a single image drawn
according to the conventions of topographical illustration.

 Daniell's images, especially the aquatints, tend to present their subjects
in the context of current notions of "noble savages" inhabiting a natural
paradise, though it is impossible to determine how far this was due to his
following artistic prototypes (evolved mainly for the depiction of American
Indians) and how far he subscribed to the views of John Barrow who took
part in the same mission. Barrow extolled the "Booshuanas" for "their state
of moral refinement," "the uninterrupted harmony that seemed to prevail
in this society," and the "almost perfect equality of their condition," while
regarding Bushmen and Hottentots simply as "savages"—and the Boers as
brutes.[13] But Daniell endowed all his figures, apart from Boers, with natural
grace and dignity.

 As more information became available about the inhabitants of the
interior of southern Africa, the focus of ethnographic illustration narrowed.
Paintings by Henry Clifford De Meillon concentrate on the physiognomy
and especially the details of costume of two individuals.[14] De Meillon, a naval figs. 33, 34
captain who settled in Cape Town and found employment in the civil service,

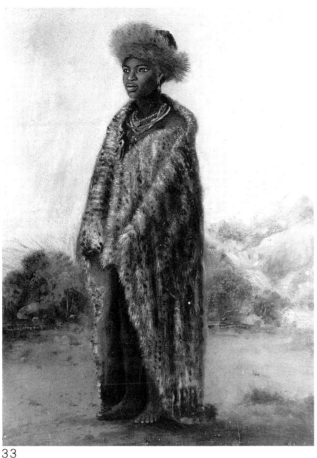

33

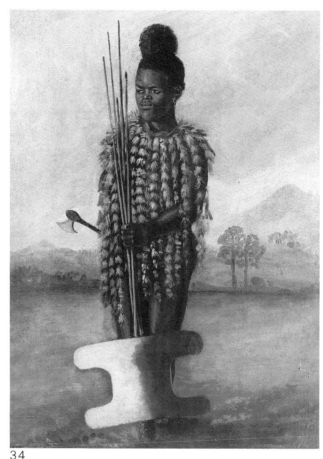

34

was an amateur without Daniell's accomplishment, hence the awkwardness of his stiffly posed figures. He painted them to illustrate a book by George Thompson entitled *Travels and Adventures in Southern Africa* (London, 1827). In his preface Thompson remarked:

> The majority of the travellers who penetrated into the interior of the country in former times, were men enthusiastically and almost exclusively devoted to scientific pursuits. Discoveries in Natural History were their paramount objects. Man himself, whether social or savage, was secondary, in their researches, to a new plant or animal. . . .[15]

His own education was, as he noted, mercantile "not literary or scientific," and he seems to have had as few illusions about noble savagery as preconceptions derived from anthropological theories. He simply described his own experiences. And De Meillon was similarly little influenced by artistic conventions.

One of De Meillon's paintings is of Peclu, the eldest son of the chief of the Tlhaping clan—a Xhosa group in Bechuanaland (modern Botswana). He was a "fine looking lad of about seventeen years of age" according to Thompson who detailed the items of his costume:

> The cloak in which the young chief is dressed, is that worn by the higher class of Bechuanas. It is composed of the skins of a very

32. Samuel Daniell. Illustration for *African Scenery and Animals: A Korah Hottentot Village on the Left Bank of the Orange River*. Dated 1804. Colored aquatint. 325 × 455 mm.

33. Henry Clifford De Meillon. *Portrait of Peclu.* Dated 1824. Oil on wood. 30.5 × 22.2 cm. Johannesburg, Africana Museum.

34. Henry Clifford De Meillon. *Portrait of Hanacom.* Dated 1824. Oil on wood. 30.5 × 22.2 cm. Johannesburg, Africana Museum.

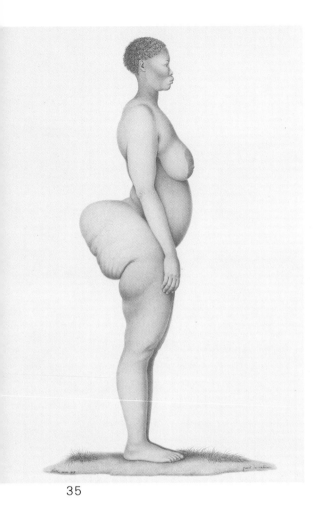

35

beautiful species of wild cat, which are joined together with much taste, and neatly and firmly sewed with thread from the dorsal sinews of the springbok. . . . The cap worn by Peclu is of jackal skin.[16]

The other painting is of Peclu's attendant, Hanacom:

. . . arrayed in his war habiliments, ready for the field. The plume upon his head is of ostrich feathers. Stripes of leopard-skin hang dangling from his shoulders. His right hand wields the battle-axe; his left grasps his sheaf of assagais. His bow and quiver of poisoned arrows are slung on his back. The target at his feet is of ox or buffalo hide, sufficient to ward off an arrow or a half-spent spear.[17]

By chance, Thompson visited the Tlhaping at a vital moment in their history, when they were threatened in 1823 by the "Mantatee Horde" from the north, saved from extinction by the neighboring Griquas (descendants from mixed marriages between Dutch settlers and Hottentots) with firearms provided by the British, but behaved ignobly in the conflict and its aftermath. Some months later Peclu, an aged counselor of his father, and their attendants were taken by the missionary Robert Moffat[18] to Cape Town in order to impress them with the benefits of European civilization. (The sage counselor remarked that he preferred the customs and manner of life of his own country although he saw the British were wiser).[19] De Meillon portrayed the two men on this occasion with the different aim of displaying their "savagery" to the British public. (Thompson's book included a long section of advice for prospective emigrants to South Africa.)

People from South Africa had already been taken to England to be viewed as living ethnographic specimens. In 1803 a Hottentot man and two women were to be seen at the house of the great naturalist Sir Joseph Banks. "They were dressed in the English manner," Joseph Farington recorded. "One of the woemen spoke loud in Her own language. I remarked a *Click* of the tongue as a particular singularity. Their manner was as decent and well regulated as well ordered Country people of our own could be."[20] Preconceptions about the life and physical appearance of these people were more amply satisfied by a woman with pronounced steatopygia, Saartjie Baartman—the "Hottentot Venus"—who was brought to London and publicly exhibited as having "the kind of shape which is most admired by her countrymen."

The deplorable way in which Saartjie was put on show, as if she were a wild animal to be gaped at, and prodded and teased, aroused protest from a few humane Londoners.[21] From the general public that flocked to see her she provoked more mirth than pity, as several caricatures testify.[22] When she was taken to Paris in 1814, she was regarded in much the same way. But she attracted more than idle curiosity from the great comparative anatomist Georges Léopold Cuvier, who examined her scientifically and commissioned three artists attached to the Jardin du Roi to portray her. After her death Cuvier dissected her. The result of his investigations was to show that Hottentots differed in no generic way from other members of the human species. Her buttocks were a fatty accumulation, her *tablier* was no more than the enlargement of a part of the vulva common to all women. She confirmed

35. Nicolas Huet le Jeune. Profile view of Saartjie Baartman, the "Hottentot Venus." Dated 1815. Watercolor on vellum. 440 × 307 mm. Paris, Muséum national d'Histoire naturelle, Bibliothèque centrale.

36. Léon de Wailly. Frontal view of Saartjie Baartman, the "Hottentot Venus." Dated 1815. Watercolor on vellum. 483 × 335 mm. Paris, Muséum national d'Histoire naturelle, Bibliothèque centrale.

37

his belief in the anatomical integrity of the human race without, however, disturbing his hierarchical classification of its varieties. Thus, he went on to say that he had "never seen a human head more resembling a monkey's than hers," and that her movements also "recalled those of a monkey."[23] Such was his eminence that the detailed report he wrote on her came to be regarded in scientific circles as the description of a "typical" African woman—standing on the lowest rung of the ladder which led up to the European! Her genitalia, which he preserved and presented to the Académie Royale de Médecine, later transferred for all to see in the Musée de l'Homme, also served to focus attention on the lasciviousness commonly ascribed to blacks at a time when sexuality was still termed a base or animal passion.[24] In England, however, she seems to have been remembered mainly as "an intensely ugly figure, distorted beyond all European notions of beauty," and the phrase *Hottentot Venus* passed into the language in this sense.[25]

The French portrayals of Saartjie answered demands for accurate visual records, unlike the English caricatures that exaggerated the size of her buttocks. Jean-Baptiste Berré depicted her from four viewpoints in diminishing scale.[26] But he disposed these figures in a barren landscape with such tact and sensibility that the painting has the effect—at any rate to modern eyes—of slightly veiling and diminishing her physical abnormalities and lends a certain poignancy to her lonely predicament. This work is unfortunately in a poor state of preservation. The other two portrayals are in delicate watercolor but more sharply defined and explicitly scientific. They were painted to form part of the incomparable collection of *vélins*— illustrations of flora and fauna on sheets of vellum—in the library of the Muséum national d'Histoire naturelle.[27] One, by Nicolas Huet le Jeune, fig. 35 is a clinically observant profile of her figure. The other, by Léon de fig. 36 Wailly, presents her frontally and also in a three-quarters view, standing

in a landscape of low hills with palm trees on the horizon to locate her geographically. But an expression of profound sadness on her face suggests a sympathetic response from the artist at variance with Cuvier's assertions.

Several viewpoints are also juxtaposed in the portrait of a Madagascan painted by James Ward in England in 1815.[28] Eleven years earlier Ward had, as we have seen, completed a very large picture of a black on a horse attacked by a boa constrictor—a work in which he sought to demonstrate his ability to depict a striking subject on a grand scale.[29] He continued to be known and admired nevertheless mainly for his paintings of domestic animals, notably thoroughbred horses whose "points" he recorded for their proud owners. His portrait of a Madagascan has a similarly cool objectivity, especially the profile and full-face which seems to be have been added, perhaps at the request of a patron, after the more artistically sensitive three-quarters study had been finished. This work seems indeed to be the pictorial equivalent of the models and casts of heads of "racial types" which

fig. 37

38

became in the nineteenth century an essential part of the equipment of physical anthropologists bent on measuring angles of prognathism, height and breadth of forehead, and so on.[30]

A similar device might seem to have been adopted by the landscape and genre painter Auguste-Xavier Leprince in his *Lion Hunt*.[31] But it was no doubt *faute de mieux* that he depicted the same athletic black model in four different poses—that on the left displaying *contrapposto* as in an academic life class. Here *études* have been combined with a weather-beaten banana tree from the Jardin du Roi and a lion borrowed from a taxidermist to compose a subject picture which Leprince exhibited at the Galerie Lebrun in Paris.[32] Although the elements are genuinely African and depicted with precision, the result is an exotic fantasy which instead of presenting new information reflects current preconceptions of the unexplored continent, its naked human population, wild life, and luxuriant vegetation.

fig. 38

JIM CROW

Blacks continued to be regarded by Europeans as Africans despite knowledge of the vast population on the other side of the Atlantic which was seen to be anomalous. They could be depicted in their own exotic environment

39

40

without reference to Western civilization, except by way of implicit contrast. The black presence in America was necessarily recorded in relation to white society. In watercolors by Pavel Petrovich Svinin blacks figure as part of the street life of Philadelphia. He was secretary to the Russian Consul General for nearly two years, 1811–13, and took advantage of his posting to gather material for a travel book, *A Picturesque Voyage in North America,* published in St. Petersburg in 1815.[33] His aim was to inform his compatriots about the development of the United States since the Declaration of Independence which had aroused hopeful interest in the intellectual circles of Russia. "The incredibly rapid headway made by this country" seemed to him "more like a dream than a reality."[34] In more than fifty watercolors (only six of which were reproduced in his book) he made a unique visual record of the United States in the Federal period. Like other painter-travelers in other parts of the world, he concentrated on the subjects which seemed most revealingly characteristic—Niagara Falls for the natural landscape; the spruce, new buildings of Philadelphia for evidence of progress; rich whites, poor blacks, and solitary Indians (copied from another artist) to indicate the ethnic mixture of the population. Anticipating Alexis de Tocqueville by two decades, he saw that the Indians belonged to America's past and that the future lay with the blacks and whites. Slavery had already been abolished in Pennsylvania, where he spent most of his time, and he predicted that it would gradually be abandoned in the other states of the Union. Coming from a country with many million serfs he was, however, less disturbed than visitors from western Europe by the persistence of slavery.

In one of Svinin's watercolors two ragged, black chimney sweeps and their master are juxtaposed with a fashionably dressed white couple in front of Christ Church.[35] In another a team of black carpenters is at work outside Benjamin Latrobe's Greek Revival Bank of Pennsylvania. He also depicted a meeting of black Methodists in a Philadelphia alley.[36] The variety of Christian sects in America was notorious, and Svinin was impressed by their

fig. 39

fig. 40

mutual tolerance. A man of the Enlightenment himself, he applauded the religious liberty guaranteed by the American Constitution while viewing religious enthusiasm with somewhat lofty detachment. There is a hint of mockery in his image of white Anabaptists taking part in the rite of baptism by total immersion during a thunderstorm, and very much more than a hint in that of the Methodist meeting. Whereas he depicted other urban figures in the style evolved for representing vendors in the European streets—Francis Wheatley's *Cries of London*, for example—and landscapes according to the picturesque tradition, for the Methodists he seems to have resorted to prototypes in satirical prints of alien religious practices and antiabolitionist images of happy-go-lucky slaves.[37] These figures with exaggerated gestures and expressions, prancing, kneeling, and rolling on the ground, make an impression far removed from the contemporary portraits of the dignified leaders of the black churches in America.[38]

Svinin's vision of America was that of an outsider who checked what he saw against his preconceptions. Slightly later images by Edward Williams Clay project the views of a native Philadelphian.[39] In 1821 he illustrated a pamphlet by Mason L. Weems, *God's Revenge Against Duelling*, with etchings of blacks, one of which is entitled *Like Master Like Man*. His point was to emphasize the absurdity of so-called affairs of honor by showing blacks engaged in them. *Life in Philadelphia*, a set of fourteen etchings issued between 1828 and 1830, satirized the modish clothes of the time by showing blacks parading in them.[40] The vagaries of fashion were a perennial butt of caricaturists, and Clay satirized the dressy blacks of Philadelphia in much the same way that the *macaronis* of eighteenth-century England and the *incroyables* of the Directory period in France had been ridiculed. He published these etchings upon returning from a tour of Europe, and their immediate source of inspiration was probably, as its title suggests, Pierce Egan's *Life in London* of 1820–21, illustrated by George and Robert Cruikshank. Also in England, in 1827–28, Thomas Landseer (brother of the more famous Edwin) had published a volume of etchings entitled *Monkey-ana*, a series of *singeries* which included images of apes dressed in high fashion.[41] Frivolity in dress was of course repugnant to the Quakers of Philadelphia, and dueling still more so. But there is also a strong social element in Clay's images of blacks adopting the finery, the airs, and graces of affluent whites. The barbs of his satire passed through the fancy clothes to hit the bodies inside.

fig. 41

Attempts to break through class barriers were very frequently ridiculed in European literature and graphic art: servants aping their employers, shopkeepers putting on the airs of the aristocracy. The situation was somewhat different in the United States where, at this time, less clearly marked divisions of class and the racial issue often heightened anxiety about social mobility. In Philadelphia and a few other northern cities a generation of free blacks had grown up and begun to acquire a measure of prosperity manifested in their clothing. A "dandy Negro waiter, leader of the Broadway fashions" made his debut on the New York stage in 1829 immediately after the first appearance of such other "characters" as the Irish immigrant and the Yankee.[42] At first the aspirations of free blacks were regarded with amusement or mildly paternalistic disapproval. "In the olden time dressy blacks and dandy *colour'd* beaux and belles, as we now see them issuing

41. Edward Williams Clay. *Life in Philadelphia*, no. 13: *How you like de Waltz, Mr. Lorenzo?* Dated 1829. Hand-colored etching. 164 × 147 mm. (image).

LIFE IN PHILADELPHIA
Plate 13.
How you like de Waltz, Mr. Lorenzo?

'Pon de honour ob a gentle...
I tink it vastly indelicate.
Only fit for de common
people!!

Clay fecit 1829

Published by S. Hart & Son No. 65. South Third St. Philad.ª
Copy right secured.

41

from their proper churches, were quite unknown," John F. Watson wrote in *Annals of Philadelphia* in 1830.

> Their aspirings and little vanities have been rapidly growing since they got those separate churches, and have received their entire exemption from slavery. Once they submitted to the appellation of servants, blacks, or negroes, but now they require to be called coloured people, and among themselves, their common call of salutation is—gentlemen and ladies. Twenty to thirty years ago, they were much humbler, more esteemed in their place, and more useful to themselves and others. As a whole they show an overweening fondness for display and vainglory—fondly imitating the whites in processions and banners, and in the pomp and pageantry of Masonic and Washington Societies, &c. With the kindest feelings for their race, judicious men wish them wiser conduct, and a better use of the benevolent feelings which induced their emancipation among us.[43]

This preposterous demand that blacks should always remember that they had been emancipated (rather than, in the first place, enslaved) by whites was made shortly after the first serious antiblack riot had broken out in Philadelphia in late 1829—stirred up by poor whites who regarded the increasing black population as a threat to their chances of employment. It was from this moment that the abolitionist movement was hampered by

opposition not only from plantation owners in the South but also from members of the working class in the North (including recent immigrants from Europe) who feared that emancipation would create a surplus of cheap labor.

After 1830 Clay made no additions to his series of prints of *Life in Philadelphia*. But it had already been imitated in New York [44] and in 1831 crossed the Atlantic to England. Vignettes derived from Clay's prints were used in the *New Comic Annual*, published in London, as illustrations to a story poking fun at manners adopted by emancipated slaves. Its appearance coincided with the rearguard action fought by antiabolitionists which prompted the publication of a number of satirical prints in England. [45] But the series seems to have become still more popular after the House of Commons passed the emancipation bill in 1833. A new subject was immediately added with the title *Grand Celebration ob de Bobalition ob African Slavery*. [46] Next year Gabriel Shire Tregear, an engraver and publisher who specialized in cheap prints for the mass market, reissued the series with six new subjects as *Tregear's Black Jokes, Being a Series of Laughable Caricatures on the March of Manners amongst Blacks*. The "jokes" in question were childish puns—of a type peculiarly popular in early nineteenth-century England—on the word *black* as in *blackball* or *black tea*, illustrated respectively as a dance and a tea party attended by blacks. As there were virtually no black aspirants to middle-class fashion and manners at this date in England, the popularity of the series can have been due only to the notion that blacks were figures of fun. Incongruity provokes mirth; to the English a modishly dressed black may well have seemed incongruous. The prints that had begun as satires on

42

42. Robert William Buss. *The Art of Love.* Dated 1831. 76.2 × 63.5 cm. Present whereabouts unknown.

43. Colored lithograph by Thomas Fairland after William Henry Hunt. *Hunt's Comic Sketches,* pl. VIII: *Master James Crow.* 1844. 546 × 372 mm.

44. Colored lithograph by Thomas Fairland after William Henry Hunt. *Hunt's Comic Sketches,* pl. IX: *Miss Jim-ima Crow.* Dated 1844. 546 × 372 mm.

43

44

fashionable affectations but acquired more serious, if fortuitous, implications as a result of mounting racial tension in Philadelphia, had been transformed into a series of coarse jokes at the expense of blacks, and perhaps also Americans. (A persistent current of anti-American feeling was soon to be exploited by Charles Dickens.)

An English painting of the same period by Robert William Buss was no doubt intended to appeal to a slightly less crude sense of humor and a much more refined aesthetic faculty. It depicts the astonishment of a man in elaborate mid-eighteenth-century costume courteously taking the white-gloved hand of a woman who lifts her veil to reveal a black face.[47] The tragedy of *Ourika* as illustrated by Gérard[48] has been turned into comedy. Like many other scenes of eighteenth-century life painted in a neorococo style at about this date, notably illustrations to Sterne's *Tristram Shandy*, the picture also belongs to a somewhat vaguely defined category of humorous or comic genre scenes. Buss painted it when, as Samuel Redgrave was later to record, "escaping from portraiture, his art took a humorous character."[49] There was as great a demand for pictures which could raise a smile as for those intended to jerk a tear.

Winsome children depicted from a viewpoint of indulgent superiority were among the most frequent performers in humorous genre scenes. William Henry Hunt, author of the study of a black man already discussed, was responsible for a whole series. Two were of black children, exhibited at the Old Water-Colour Society in London with the titles *Jim Crow* (1837) and *Miss Jem-ima Crow* (1839).[50] Lithographs after them were subsequently published in a volume of *Hunt's Comic Sketches* mainly composed of images of white children aping their elders (there is a connection with *singeries*) and given such punning titles as *A Poser—an Embryo Chancellor of the Exchequer* and *A Young Shaver—Giving Himself (H)Airs*.[51] In this collection the two

fig. 42

cf. fig. 22

61

watercolors of black children were given obviously comic titles: *Master James Crow—Out of His Element* and *Miss Jim-ima Crow—a West Indian Cinderella*.[52] figs. 43, 44 Both must have been painted from living models posed and surrounded with studio "props" to suggest a story.[53] The boy, out of his element (the sun), warms himself in front of a stove. The West Indian Cinderella kneels by the hearth, unable to go to the ball suggested by the print of a dancing black labeled *James Crow*.

Jim Crow, whose name was unhappily to survive long after its origin had been forgotten, was the invention of a white actor, but the character had antecedents in earlier stage history. From the beginning of the seventeenth century blacks had been represented in the theater either as tragic heroes (Othello, followed by Oroonoko) or as villains (Aaron in *Titus Andronicus*)— just as they had been painted in the contrasting roles of proud Magus and cruel tormentor. The comic black made his debut in leading parts in the mid-eighteenth century—just when the slave trade was reaching its height. The most celebrated was Mungo, the slave of a West Indian planter, in Isaac Bickerstaffe's comic opera *The Padlock* which was first performed in London in 1768 and remained in the repertory for more than a hundred years. This character is said to have been based on information about slaves on Barbados whose manner of speech Bickerstaffe attempted to reproduce for the amusement of the English public, but it owes as much to the long tradition of cheeky servants in comedy. In 1822, however, the English actor Charles Mathews on tour in the United States was struck by the dialect, songs, and dances of the blacks he encountered and, blacking his face, he began to mimic them in his very successful one-man entertainment entitled *A Trip to America*. One of his most popular turns was derived from an incident he claimed to have witnessed in the African Theater in New York when an actor playing Hamlet was interrupted in the "to be or not to be" soliloquy by calls for the slave song "Opossum up a Gum Tree."[54] Within a few years his lead was followed by several American actors—immediately after the African Theater had been closed down by the civic authorities. The most successful was Thomas Dartmouth Rice who evolved a blackface act purportedly based on the antics of an old black dressed in rags with a deformed right shoulder and crooked left leg whom he saw dancing and singing the words:

> Weel about and turn about and do jus' so,
> Eb'ry time I weel about, I jump Jim Crow.

A catchy tune and a novel dance step, as well as physical deformity that provoked unfeeling and unsophisticated mirth, made an immediate appeal to the white public.[55] Prints of Jim Crow were published.[56] And after fig. 45 performing the turn in the main American cities, Rice introduced it to London audiences in 1836.

The parts of blacks in the theater were normally taken by whites. Ira Aldridge was the first black actor to play them successfully.[57] Often in a single evening he appeared in the roles of Othello and Mungo revealing his versatility as tragedian and comedian as well as contrasting aspects of the human condition. He somewhat transformed both parts, bowdlerizing Shakespeare to reduce Othello's sexuality and developing the

45. *Jim Crow*. Late 1820s–1830s. Copper engraving. 209 × 171 mm.

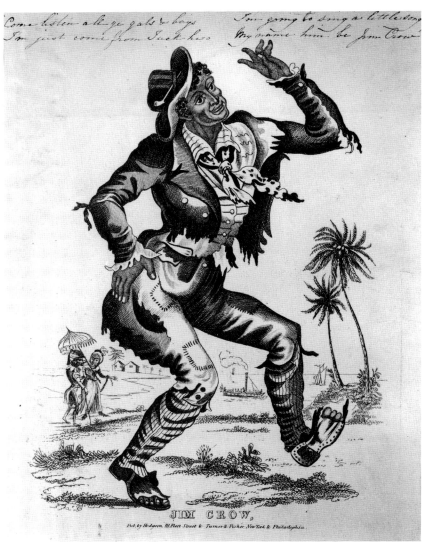

45

character of Mungo into a rebel against slavery, gleefully subverting the social order. A painting of him in the latter part suggests how little he resembled the conventional blacks.[58] He also delighted British audiences by singing "Opossum up a Gum Tree" and sometimes "Jump Jim Crow," which he is said to have rendered with great pathos, before ending a long evening's entertainment with an earnest plea for the abolition of slavery. Aldridge's success was, nevertheless, exceptional. No other black actor received comparable recognition in the role of Othello until Paul Robeson played it in 1930.[59] In defiance of Shakespeare's text, but with craven deference to prejudice, the character was usually represented on the stage as a tawny-skinned Arab.[60] But blackface comedians—that is to say whites parodying blacks imitating whites—had already begun to proliferate.

Following up the success of Rice's turn, four men who specialized in impersonating blacks joined together in New York in 1843 to perform what they called the "oddities, eccentricities, and comicalities of that Sable Genus of Humanity." It was the first blackface minstrel show and, taken to London before the year was out, set a pattern that was to be followed for more than a century.[61] This enduring popularity on both sides of the Atlantic is more than a little difficult to explain. In the United States

the minstrel show won acceptance as an essentially national product—a "theatrical entertainment . . . absolutely native to these States," as its first American historian claimed.[62] It appealed to a very wide public which included several presidents who had "command performances" at the White House. Whether or not it initially assuaged guilty feelings about slavery and later defused the threatening image of the freedman, it travestied the appearance of blacks and especially their use of the English language in ways that bolstered a white audience's notion of its own superiority. But the lively dances, the clowning, the sentimental songs, and the time-honored jokes of the cross talk between Brudder Tambo, Brudder Bones, and the pompous Mister Interlocutor, in a conventionalized dialect, appealed just as much in England as in America.

In England the minstrel show had the charm of exoticism supposedly providing a glimpse of life not simply "down there" but also "over there"— on the other side of the ocean. But the travesty which, in itself, amused American audiences (rather like a transvestite performance) lost much of its point in Europe. An impresario who took a troupe of "Negro Minstrels" to Germany was threatened with prosecution for fraud because its members were white-skinned.[63] Even in England the caricatured exaggerations of the performers tended to be accepted as representative of black American manners and speech. From the mid-century Afro-Americans were far less familiar to the English than blackface minstrels who were to be found in the streets and on the beaches of holiday resorts as well as in the theater.[64] By the beginning of the 1860s there were some fifty "Street Negro Serenaders" in London, playing the banjo and the bones, dancing and singing such songs as "Old Mr. Coon," "Going over de Mountain," and "O, Susannah" in imitation of white American imitations of blacks. One of them told Henry Mayhew, "Some niggers are Irish. There's Scotch niggers, too. I don't know a Welsh one, but one of the street nigger-singers *is* a real black—an African."[65] The prevalence of these minstrels gave support to the common notion of American blacks as comic figures with a strong strain of sentimentality—like European clowns—which coexisted with and gradually overshadowed that of pathetic slaves.

The relationship between the minstrel show and visual images of Afro-Americans is complex even though both reflected the views of whites. Images of the minstrels themselves seem to have been confined to crude prints, usually on the covers of sheet music. Blacks had been depicted as entertainers, usually musicians, before the invention of the minstrel show, and they continued to be given these roles in paintings throughout the century.[66] In works of art intended for prosperous homes (as distinct from satirical prints) they were rarely guyed, even though the less competent artists tended to fall back on a stereotyped image of a large-eyed, grinning man strumming a banjo.[67] The American art buying public demanded verisimilitude in genre paintings which represented the world they knew as they wished to see it. To this public, which ranged from intransigent supporters to passionate opponents of slavery and the color bar, with a large intermediate section, neither the image of the suffering slave nor that of the jaunty buffoon was generally acceptable. Yet paintings of blacks by white artists often seem to be based on the assumptions crudely embodied in the blackface act.

46. Lithograph by Childs and Lehman after John Lewis Krimmel's painting. *Dance in a Country Tavern*. 1835–36. 200 × 276 mm.

46

TRANSCRIPTS FROM NATURE, OR "NEGRO SUBJECTS"

A black fiddler plays the tune to which young whites dance in a genre scene by John Lewis Krimmel.[68] It was painted in 1819 shortly before the artist's early death in 1821 and was lithographed in 1835–36; the gap between these dates is significant. Although blacks formed an important part of the American population, outnumbering whites in some southern states, they figure inconspicuously if at all in paintings by American artists between the late eighteenth century and the 1830s. This was a period of vital importance for the development of a specifically American culture, from roots deep in the colonial past, by the first generation born after the Declaration of Independence. These years were marked in literature by the virtual creation of the American novel and in the visual arts by the emergence of distinctive styles of portrait, landscape, and still-life painting. It was also a period of industrial revolution in the northern states, a change from artisan to factory production, provoking the emergence of a labor movement. From these developments, however, blacks were excluded.

Krimmel was a German immigrant who settled in Philadelphia in 1809. In his picture of the *View of Centre Square, on the 4th of July* painted soon after his arrival, the black presence is suggested by two children in the foreground and a fashionably dressed couple in the background.[69] Although no more than a token representation of a large population, these figures give some idea of Philadelphia's social structure. Svinin, in search of characteristic American scenes, made a watercolor copy of the picture.[70] For his *Dance in a Country Tavern*, however, Krimmel appears to have lifted several figures, including that of the black fiddler, out of a sketch by Svinin.[71] From a strictly American point of view, both artists were outsiders. Svinin's purpose was to inform his Russian compatriots about the United States. (While in

fig. 46

Philadelphia he exhibited paintings of Russian life for the information of Americans.[72]) But Krimmel's aim was to fashion out of the raw material of American life works of art acceptable to the American public for which he worked and of which he had become a member—as the anglicization of his Christian names is alone enough to reveal.

For the artistic means of depicting the *Dance in a Country Tavern*, Krimmel seems to have turned to the immensely popular scenes of simple life in Scotland by David Wilkie, notably *Blind Man's Buff*, *The Penny Wedding*, and *The Blind Fiddler*, of which he painted a copy exhibited in Philadelphia in 1813.[73] Wilkie's paintings appealed at several levels: as touching anecdotes, as studies of character, and as glimpses of the life of the rustic poor with Wordsworthian overtones. They are British Romantic equivalents—with less symbolism and more sentiment—to the Dutch and Flemish genre scenes of the seventeenth century which had always been popular with collectors despite academic disapproval. Krimmel shifted the scene to the United States. The location of his tavern is made explicit by its furnishings, a gun hung over the door, a portrait of George Washington above the fireplace, and, most prominently, the grinning black fiddler who was destined to have a long progeny in American genre paintings.

Genre paintings were, almost by definition, "vulgar." The term was used in the eighteenth century to categorize all the genres which were ranked below history painting. When, in the nineteenth century, it came to be reserved for depictions of everyday life, it retained academically opprobrious overtones. Partly for this reason, genre occasionally attracted artists in revolt against academic theory. But the vast majority of genre painters were unadventurous practitioners who appealed to the large public for works of art with pathetic or comic anecdotal content—those who demanded that every picture should tell a story. These paintings tended to depict the everyday life not of their prospective purchasers but of people removed from them by social class or age: the poor and children (very often poor children) figure prominently in them. In America they began to gain increasing popularity from the 1830s with the growth of prosperity in the cities, especially those of the northern states. American genre paintings were focused on rural life, and it was in this context that American blacks figured most frequently throughout the nineteenth century, as the equivalent of the lowest social class of farm laborers and fishermen in European art. They were intended to be hung in private houses, and their authors rarely broached subjects which might seriously disturb prospective buyers. The more revolutionary thinkers of the time on both sides of the Atlantic equated wage slavery with chattel slavery.[74] And there are as few—perhaps even fewer—images of the victims of the factory system in British art as of oppressed slaves in American art. Blacks, usually outnumbered by whites, figure in American genre pictures as part of the harmonious rural scene.[75] Whether these images were intended to justify the social system of the time (wage slavery as well as chattel slavery) or expressed a hope that blacks might be happily and fully integrated into American life, their effect was reassuring, not to say anodyne. The status of blacks, as freemen or slaves, is rarely stressed.

The tensions in mixed white and free black communities were brought to the surface only in images intended to appeal at the social level where they

were most commonly experienced—in caricatures of life in Philadelphia, for instance. They are also expressed in a series of large naïve paintings illustrating the story of a black murderer named Bill Freeman.[76] It is perhaps fig. 47 fortuitous that these are the only surviving examples of a type of work which, before the development of illustrated newspapers, was a prime source of visual information for the general public and also reached country districts where self-consciously artistic pictures were rarely to be seen. They were put on show in villages of upper New York State in 1846–47 as part of an *Unparallelled Exhibition of Oil Paintings* which included also five biblical scenes, three illustrations of incidents in the American Revolution (including the murder of Jane McCrea by an Indian), and the *Burning of an American Captive at the Stake* (another scene of Indian violence).[77] The proprietor and impresario, George J. Mastin, expounded the meaning of the pictures in an evening's entertainment which concluded with sentimental and comic singing, and a double clog dance. As a whole it seems to reflect the mental structure of a white American subculture which was brought into conflict with the culture of the elite by the case of Freeman, the crazed murderer.

Freeman was a native of the village of Auburn, the son of a freed slave. In 1840 he was charged, unjustly so he claimed, with stealing a horse and sentenced to five years in prison where he was brutally flogged. After his release he had difficulty in obtaining employment and took his revenge on the white community by breaking into a farmhouse and murdering two women, a man, and a child in March 1846. When he was taken prisoner, the villagers of Auburn demanded that he should be lynched, and one observer was as deeply shocked by their behavior as by his crime. "I trust in the mercy of God I shall never again be a witness to such an outburst of the spirit of vengeance as I saw while they were carrying the murderer past our door," wrote the wife of the ex-Governor William Henry Seward.[78] It soon became evident that Freeman was mad, and Seward himself—later to be Lincoln's secretary of state—elected to conduct his defense before the court on a plea of insanity. At the same time, however, the white population of Auburn was metaphorically put on trial. The minister of the Universalist Church asked: "Is not society in some degree accountable for this sad catastrophe?" Blacks in Auburn were, he said, "victims of unworthy prejudices which compel them to exist under circumstances where they are exposed to imbibe all the vices, without being able to become imbued with the virtues of those around them." Freeman's brother-in-law giving evidence made the same point more bluntly, declaring that white men had brutalized the murderer: "They don't make any thing else of any of our People but brute beasts; but when we violate their laws, then they want to punish us as if we were men."[79] Such arguments were of no avail. The jury found Freeman guilty. He was sentenced to be hanged and although the Supreme Court ordered a new trial, he died in prison before it could be held.

The paintings in Mastin's exhibition show Freeman's attack on the sleeping child (with its father lying dead in the foreground), his fight with a female member of the family after leaving the house, his return to peer through a window at his victims and their survivors, and his execution which did not in fact take place. This final scene is strangely equivocal. Its composition is strongly reminiscent of a medieval retable in which the central place was given to Christ crucified or to a martyred saint. And the

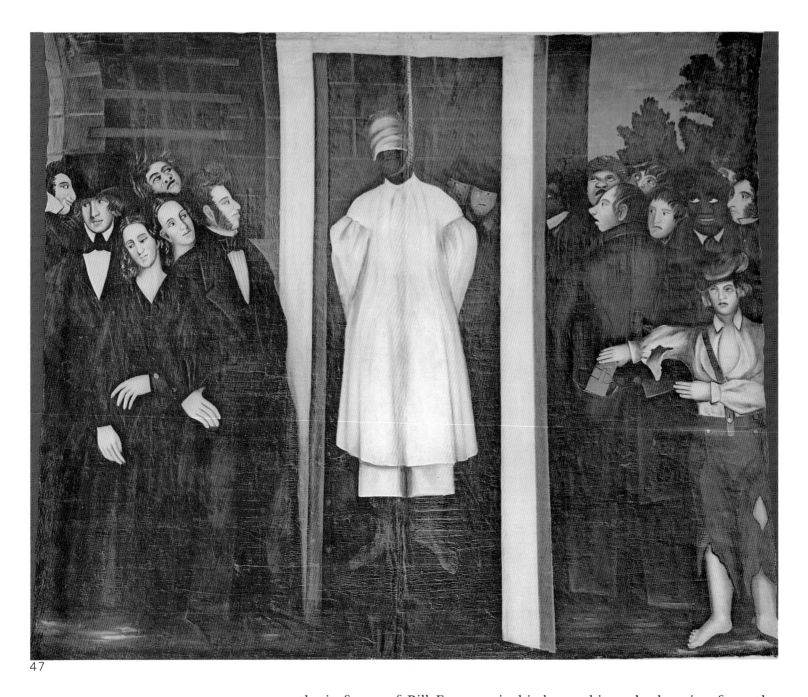

47

47. Unidentified American artist. *Hanging of Freeman*. 1846. Oil on ticking. Approx. 265 × 330 cm. Cooperstown, New York State Historical Association.

pathetic figure of Bill Freeman in his long white robe hanging from the gallows seems to have a religious aura. On either side the figures have expressions ranging from sadness to self-righteousness, gloating satisfaction, and idiotic stupefaction. Those on the left are well dressed and perhaps intended to represent notabilities of Auburn (the man in a top hat with eyes averted from the hanging and the sorrowful woman beside him have similarities with later portraits of the Sewards). The people on the right are lower class, including a barefoot boy picking a pocket and two blacks, one with an enigmatic grin and the other half-hidden by the gallows. As Mastin, who commissioned the painting, claimed to be a phrenologist, the similarity of the faces with diagrams of heads supposed to indicate varying degrees of intellect, kindness, cruelty, and so on, may be significant. One is bound to ask whether the naïve artist (and his patron) intended to display the inhumanity of the people of Auburn or merely to indicate to the best of

his ability, making use of such schemata as were available, how they would have reacted to the hanging of Freeman. The public for Mastin's exhibition was composed not of the Sewards and their like but of simple country folk, the majority of whom clamored for Freeman's execution. It was a public that regarded blacks and—as other paintings in the exhibition suggest—Indians with equal distaste and some fear.

Murderers have always excited the popular imagination, and in the nineteenth century there was a widespread demand for portrayals of them (most notoriously answered by the "Chamber of Horrors" in Madame Tussaud's waxwork exhibition in London). Yet it may be doubted whether a painting of the punishment, as well as the crime, of a white murderer would have been exhibited like that of Freeman. His declaration that he was wreaking vengeance on the society that had wronged him gave to his story the deeper significance that accounts for the passions it aroused and the publicity it received.

For some time hostility against free blacks had been growing in the northern United States, polarizing opinion on the situation in the South. While the abolitionist movement gained supporters, it also met with increasing opposition, especially at a low social level. Advocates of emancipation were mobbed and their meetings broken up in northern towns. William Lloyd Garrison was paraded in Boston with a rope round his neck. Elijah Lovejoy, the editor of an abolitionist paper in Alton, Illinois, was murdered in 1837. A school built for black children by a philanthropist in a Maine village was bodily removed to a swamp by white inhabitants.[80] (Such instances mark the difference between the abolitionist campaigns on either side of the Atlantic).

A black farm hand appears, nevertheless, as the fellow worker of a white in a small picture by James Goodwyn Clonney, painted in 1844 at about the time he settled at New Rochelle in New York State where slavery had been abolished.[81] The wide, open landscape, neatly spaced corn plants, and the two youthful figures of different color emphasize the American location. It is indeed a vision of natural harmony on the fresh green breast of the New World, but an exceptional one. For the black, though more poorly dressed and shod than his companion, is given the superior position, mounted on the horse and seemingly in command. Pictorial factors may have determined this reversal of the social relationship between blacks and whites as recorded in other genre scenes, including several by Clonney himself.[82] Painted with a miniaturist's attention to detail, the picture seems to record a scene Clonney had witnessed. His preparatory drawing of the youth on the horse was clearly done from life. It is a scene of cultivation, "hilling up" the soil to encourage the growth of the corn and bury weeds. Yet one may wonder whether Clonney did not also intend to make some symbolic reference—to the community of labor at the beginning of a new era. The picture is permeated with the spirit of youth and springtime.

In a painting of 1845 by William Sidney Mount, *Eel Spearing at Setauket*, a black woman is given a similarly dominating position.[83] Mount, unlike Clonney (an immigrant from England), was born and bred on Long Island, self-consciously an American painter and one of the first who rose to distinction without visiting Europe. He described this work as: "Recollection of early days. Fishing along Shore, with a view of the Hon. Selah B. Strong's

fig. 48

fig. 49

48. James Goodwyn Clonney. *In the Cornfield.* Dated 1844. 35.5 × 43.2 cm. Boston, Museum of Fine Arts.

49. William Sidney Mount. *Eel Spearing at Setauket.* Dated 1845. 73.7 × 91.4 cm. Cooperstown, New York State Historical Association.

residence in the distance during a drought at Setauket, Long Island."[84] This suggests the fusion of a duality of visions: what he saw in 1845 superimposed on his memories of childhood days—some quarter of a century earlier—when he had sat like the boy who paddles the boat and been taught to fish by "an old Negro by the name of Hector." In the painting Mount transformed Hector into a black woman—one of the most striking and memorable in American art—perhaps because a man in this attitude might seem threatening. But he also eliminated the undertone of mockery in his written description.[85] The eel spearer seems still to be seen through the innocent eye of a child unprejudiced by notions of race. Hence, perhaps, the picture's strongly moving dreamlike quality, its combination of unclouded precision of observation with a mysterious atmosphere of perfect harmony. It did not, however, enjoy a critical success when exhibited, nor were engravings diffused of it as of so many of Mount's other works.

48

49

In most American genre paintings of the 1830s and 1840s, blacks were typecast and usually marginalized. The sketch of a young man dancing by Clonney was probably drawn from life but nevertheless recalls Jim Crow.[86] And this figure, more smartly dressed in what is perhaps a servant's livery, reappears jigging with a companion to the strains of a violin as one of numerous incidents in a picture which presents a cross section of American society—exhibited in 1841 as *Fourth of July* and later retitled *Militia Training*.[87] "The negroes are painted with great truth," a contemporary critic remarked of this work, but went on to complain: "There is something too much of the vulgar, however, in the subject, as here portrayed. We hope to see a pencil so capable, employed upon details more interesting to a pure and refined mind."[88] The words are a reminder of the limitations set on American genre painting.

fig. 50

Mount was the most successful of the genre painters who included blacks in their pictures during these years. He made his name with *Rustic Dance after a Sleigh Ride* which won first prize when exhibited at the American Institute of the City of New York in 1830.[89] As in Krimmel's earlier *Dance in a Country Tavern*, which was probably Mount's direct source of inspiration, a black fiddler plays the tune but is given much less prominence in the composition. Mount described the work as his first "Comick picture," presumably to distinguish it from his earlier biblical and mythological subjects painted in an academically approved classical manner.[90] "Low life," especially rustic low life, was traditionally the province of comedy and demanded truth to the common face of nature rather than idealization. Such past masters of low life genre as Adriaen van Ostade and Jan Steen were praised at the time for "truth, nature, life" and figures with countenances "full of humour."[91] And in 1834 Washington Allston, though himself a painter with different aspirations, wrote of Mount, "If he would study Ostade and Jan Steen, especially the latter, and master their color and *chiaroscuro* there is

cf. fig. 46

50

51

nothing, as I see, to prevent his becoming a great artist in the line he has chosen."[92] Although, or perhaps because, he may never have seen original works by either painter, Mount, who was well informed about the history of European art, provided updated and specifically American equivalents to them in his several pictures of the everyday life of farm hands on his native Long Island.[93] Blacks formed part of this community, as freemen after the emancipation of slaves throughout New York State in 1827. They thus appear in Mount's genre scenes no less objectively depicted than the other figures. To one he gave a central position, lying asleep on a fresh stack of hay and being teased by a white boy, in *Farmers Nooning*—a picture which soon became famous throughout the United States as "a perfect transcript from life."[94] Several other blacks are set apart. One is the sober background observer of tipsy whites reveling in a tavern.[95] In *The Power of Music* of 1847 another wearing patched and tattered clothes, hat in hand, leans against the door of a barn listening to a white fiddler playing inside.[96] This picture is similar to Mount's *The Dance of the Haymakers* (also known as *Music is Contagious*) painted two years before, with a small black boy beating time with bones outside the barn where the main scene is set as on a stage.[97] Both compositions have a clearly articulated geometrical structure that brings to mind theories of the golden section and the relationship between musical, visual, and social harmony.[98] And in the later work the black listener, responding to the "power" of the title, is no mere adjunct but the most clearly lit and fully realized figure. To the modern spectator

fig. 51

50. James Goodwyn Clonney. Study for *Militia Training: Negro Boy Dancing*. Dated 1839. Wash and graphite on paper. 210 × 155 mm. Boston, Museum of Fine Arts.

51. William Sidney Mount. *The Power of Music*. Dated 1847. 43.5 × 53.3 cm. New York, Century Association.

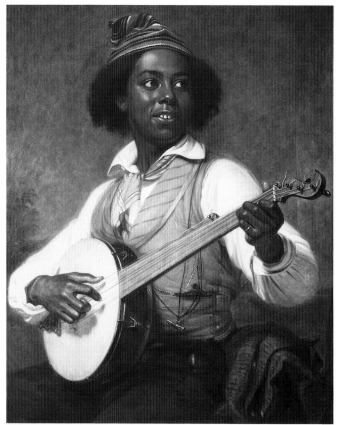

52. William Sidney Mount. *The Banjo Player.* Dated 1856. 91.4 × 73.7 cm. Stony Brook, Museums at Stony Brook.

52

these figures have the touching poignancy of "outsiders," yet Mount seems to have been recording, rather than protesting against, the substitution of a color bar for the distinction between the slave and the free.

Colored lithographs after paintings by Mount were issued in Paris by the print publishers and art dealers Goupil, Vibert & Company.[99] The first was *The Power of Music* published, perhaps significantly, in 1848, the year of revolution which brought about the emancipation of slaves in French colonies. It was immediately followed by three more, selected from Mount's exhibited work by Goupil's American agent, William Schaus, with evident commercial success. In 1850 Schaus began to commission new paintings from him by asking for a companion piece to a half-length of a white musician tuning his violin. "Do you wish a negro man or a white man . . . ?" Mount asked. "I think a Negro would be a good companion," Schaus replied, and a black violinist was promptly portrayed for reproduction in a lithograph.[100] Before the year was out Mount had agreed to paint, as an entry in his diary reveals, three more half-lengths of blacks of which prints were to be published: a banjo player, a bones player, and "a Negro—African—head life size—laughing, showing his white teeth and holding something funny in his hand—*Goose, a Duck, or a squirrel* etc."[101] fig. 52

When working for the firm of Goupil, which had establishments in Paris, London, Berlin, and New York, Mount must have been aware that he was addressing an international audience and not only his countrymen.[102] This may partly account for the notable difference between the blacks in his earlier genre scenes and these musicians with their somewhat fancy dress, forced smiles, and jaunty air. Although they have the appearance of portraits—albeit shallowly perceived ones—they come much closer to

the image of the American black as presented in the minstrel show. Mount protested, nevertheless, when he found that the figure in the first of Goupil's lithographs was "coloured blue black"—perhaps because this assimilated him to the blackface performer with his face colored in greasepaint. "Figures should be colored true to the picture, liberties taken in other parts of the painting is [sic] not of so much consequence," he wrote.[103] Mount's art was inspired, as he constantly reiterated, by an ambition to imitate nature as he saw it. The images of blacks in his genre scenes owe their distinction to the fidelity with which they were represented—that is to say to the figures themselves. But there is reason to believe that he began to see blacks rather differently in the early 1850s, when his vision of rural harmony in America was shattered by dissension between slaveholders in the South and abolitionists (on whom he put the blame). The author of a brief biographical account of Mount remarked in 1851 that he "would find open-handed patrons among the cultivated and opulent planters."[104] He had been able to paint the Long Island scene without reference to the issue of slavery which, after the turn of the century, was almost automatically raised by any image of a black. In 1852, excusing himself for a delay in painting the last two of his musicians, he told Schaus, "I will undertake those large heads for you, although I have been urged not to paint any more such subjects. I had as leave paint the characters of some negroes as to paint the characters of some whites, as far as the morality is concerned. 'A Negro is as good as a White man—as long as he behaves himself.'"[105] The pictures in question were finally completed in 1856, and Mount, apart from several pencil sketches, is not known to have depicted a black again until some years after the end of the Civil War (in which he emerged as a "copperhead," a Northern sympathizer with the South) and then only in an anti-Republican political allegory of a "rooster standing upon a dead Negro."[106]

In genre paintings by Richard Caton Woodville—a generation younger than Mount to whose example he was probably indebted at the outset of his career—blacks figure again as essential visual elements in American scenes which they help to locate. These pictures were in fact painted not in the United States but in Europe, where he studied and worked from 1845 until his early death ten years later, and reflect memories of life in his native Maryland (a slave state). In one the black is a conventionally rendered servant, in two others background onlookers.[107] But in *War News from Mexico* figs. 53, 54 painted in 1848 while he was studying at Dusseldorf, the man and child in the foreground seem to have rather greater significance.[108] The Mexican war of 1846–48, which began with the annexation of Texas and ended with the acquisition of New Mexico and Upper California by the United States, was regarded from different political and moral viewpoints: by some as a triumphant achievement for the Republic, by others as a conspiracy to obtain more slave territory, tilt the balance of power within the Union against the free states above the Mason-Dixon Line, and thus preserve the "peculiar institution" in the South. It was strongly opposed by abolitionists, notably Henry David Thoreau who manifested his feeling in the earliest act of civil disobedience on record, justified in his seminal essay on this form of political protest.[109] News from the front was consequently of vital interest to blacks even though they had no say in the conduct of the war which occasioned heart-searching among the more thoughtful white electorate.

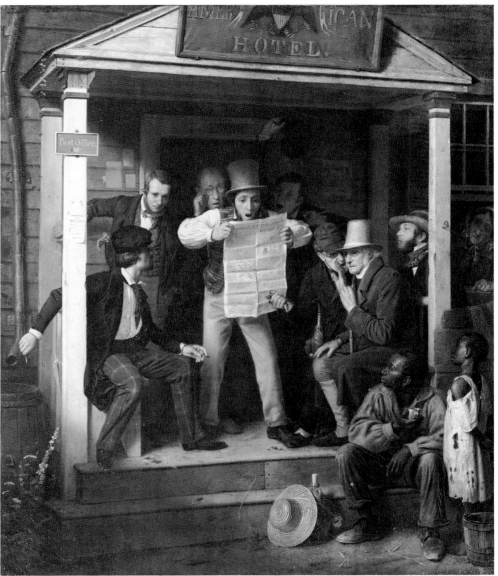

53

Woodville's painting is essentially a study in character, revealed in reactions to the news and expressed on the faces of the man reading the paper and those listening to him—ranging from exultance to pensive dismay. It is also a picture of American society with blacks on its fringe—placed outside the porch which serves as a kind of stage. As such it enjoyed great success in the United States and was acquired by the American Art-Union which distributed some 14,000 engraved reproductions. The technical facility of the painting, the precise rendering of telling details, and the somewhat theatrical method of composition and lighting which Woodville had learned in Dusseldorf were much appreciated in America.[110] One may, however, wonder if he had not imbibed other influences there. The emphasis on abject poverty in the figures of the two blacks, especially the lean child in her ragged shift, is unusual at this date. The poor, in genre scenes painted on both sides of the Atlantic, were almost invariably made to look picturesque, generally well scrubbed and dressed in their Sunday best to appear, as the Germans say, *salonfähig*. At Dusseldorf, however, more than

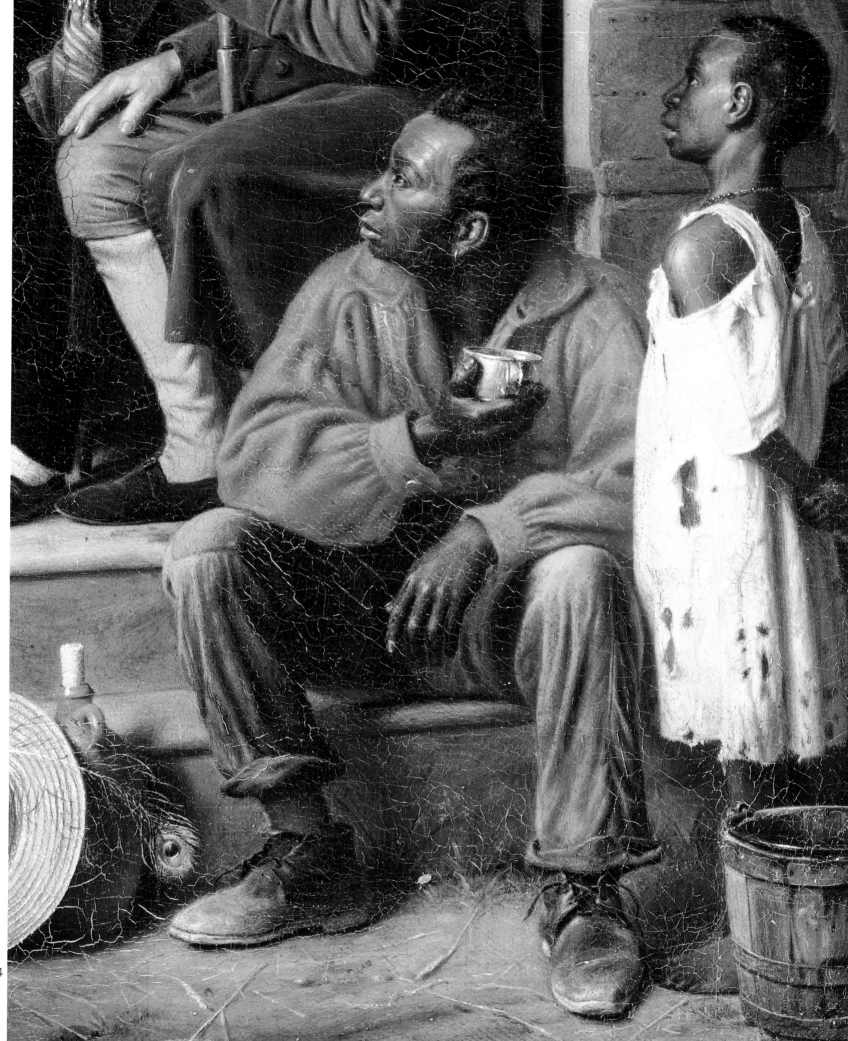

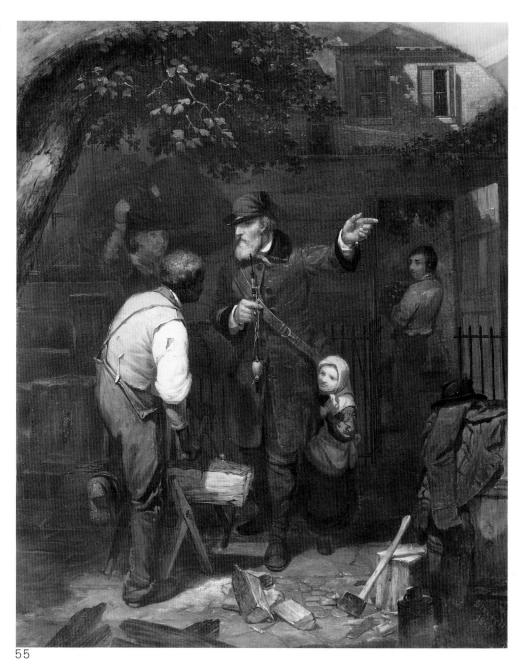

55

one artist had made genre a vehicle for social criticism, winning praise from Karl Marx and Friedrich Engels. Peter Hasenclever in the 1830s led a protest against the teaching at the academy of an art out of touch with the harsh realities of life. His works include two semisatiric pictures of men with newspapers in reading rooms—believed to be revolutionary hotbeds—as well as a far more explicit record of a confrontation between workers and magistrates at Dusseldorf during the 1848 revolution (in which he emerged as a Communist). Carl Wilhelm Hübner, celebrated in the local press as the "painter of the proletariat," exposed the plight of peasants prevented by game laws from killing the animals that destroyed their crops, of grossly underpaid piecework weavers, and of emigrants driven by hunger to seek

. . . über'm großen Meer
Ein neues freies Vaterland

in the United States, of course.[111] Woodville can hardly have been unaware of these works in 1848, though their subjects would have had only minor interest to his public at home. His depiction of the blacks in *War News from Mexico* suggests, nevertheless, concern for one conspicuous instance of social injustice in his otherwise "free fatherland." This is the first nineteenth-century painting by an American artist to touch, albeit rather gingerly, on the sensitive issue of slavery.

An unusual, not to say unique, glimpse of race relations in the United States in the mid-century is presented in the painting by Charles Felix Blauvelt entitled *The German Immigrant Inquiring his Way*.[112] It shows a fig. 55
European who has just crossed the Atlantic in search of a new life. As yet unemployed he is asking for directions from an elderly working black carpenter who was part of the established scene and whose ancestors must have been brought forcibly to America some generations before. The picture was exhibited at the National Academy of Design in New York in 1855 when it had a topical significance. During the previous decade the first great wave of immigrants from Europe, mainly Ireland and Germany, had broken over the United States, shaking its social structure. They were not entirely welcome. In 1835 Samuel F. B. Morse had cautioned his compatriots: "Shut the open gates. . . . Your enemies, in the guise of friends, by thousands, are at this moment rushing in to your ruin through the open portals of *naturalization*."[113] In the 1840s about 1.5 million arrived, and the total for the 1850s was more than 2.8 million—in a country which had a population of only just over 23 million at the beginning of the decade. New York was the main port of entry; by 1855 less than half of its nearly 630,000 inhabitants were of American birth.

This influx was concentrated on the northern states, and the people most seriously affected were free blacks obliged to compete for work with the newcomers, especially the aggressive Irish (though many employers preferred blacks). Mainly, it seems, to protect themselves from an increase in black labor, "immigrants" (the word was an American neologism of the period) who were naturalized tended to vote for the proslavery Democratic party. There cannot be much doubt that immigrants who, at the lowest level of the social scale, differed from blacks only in skin color played a large part in exacerbating racial discrimination. The Irish were certainly the instigators of race riots. It was not however to protect the blacks that attempts to restrict immigration and naturalization were made by the so-called Know-Nothings who formed the short-lived American party in 1854 and won control of local government in all but one of the New England states and also Maryland, Delaware, Kentucky, New Jersey, Pennsylvania, and California by 1855—the year of Blauvelt's picture. There were, of course, many enlightened Americans who favored immigration and deplored slavery—Abraham Lincoln among them. Where Blauvelt stood it is impossible to say. He was a "native American" born in New York, but his picture gives no inkling of his attitude to the problem of immigration: it reports without comment.[114] Perhaps significantly, the immigrant is not Irish but one of the Germans who were less generally disliked and usually left the city to farm the undeveloped lands of the West where there was no surplus of labor. Germans were also far less antagonistic than the Irish to blacks. Like so many other genre scenes of the period, Blauvelt's picture

56

57

referred to a serious problem in a manner that was not too disturbing to the
public for works of art. It could be accepted simply as a touching anecdote.

By the middle of the century blacks had been given a well-defined place
in American genre painting, apart from the main subject but nonetheless
part of the scene. The German is the protagonist in Blauvelt's picture, as
its title indicates. Blacks are spectators in Woodville's paintings and most
of those by Mount. In Europe by this date, however, they had become
a spectacle, seldom seen outside the major trading ports, and thus could
rarely play a part in images of daily life. The curiosity they could excite
is illustrated by William Parrott's picture entitled *The Nigger Boat Builder* fig. 57
exhibited at the Royal Academy in 1851.[115] With somewhat timorous wonder,
and standing at a safe distance, a group of children gape at an old peg-
legged black carving the model of a ship. It is probably the record of a
scene observed by the artist on the beach at Brighton. In *The Toy Seller* by
the Irish artist William Mulready a white child is frightened at the sight of
a black peddler. There are two versions of this strange work—painted in
1835 and between 1857 and 1863—in the second of which a moral purpose is fig. 56
more clearly suggested by the child turning away from the toys of the world

to gaze at the sunflowers that follow the course of the sun through the heavens, and also from darkness to light.[116] Another picture by Mulready, *Train Up a Child. . .*, shows a boy encouraged by his elders to overcome fear of three darkskinned lascars and give them alms (the title presumably refers to the lessons of charity).[117] Like the toy seller, the lascars terrify the young by their unwonted appearance. A black might be identified with the "bogeyman" (a euphemism for the Devil) of old wives' tales—but only on one side of the Atlantic. Although blackface minstrels were regarded as comic figures, blacks themselves were disquieting in Europe.

THE ORIENT AND ITS LOCAL COLORS

Southern Africa, South America, and the United States attracted relatively few Europeans artists whose works have more than documentary interest. North Africa was the great pictorial discovery of the nineteenth century. "The Orient, whether as image or as thought, has become a kind of general preoccupation for minds as well as for the imagination," Victor Hugo wrote in 1829 in the preface to the volume of poems he entitled *Les Orientales*. He declared that

> the colors of the Orient have succeeded, by themselves as it were, in stamping themselves on all [the poet's] thoughts and all his reveries; and his reveries and his thoughts have become in turn, and almost involuntarily, Hebrew, Turkish, Greek, Persian, Arab, even Spanish, for Spain is still the Orient. Spain is half-African, Africa is half-Asiatic.[118]

This appears to be the earliest definition of *l'Orient* as seen from France: an area only just the other side of the frontier of the "Occident" from which it differed in nearly every way. But he was not simply attempting to satisfy a fashionable taste for piquant exoticism. His preface begins almost defiantly with the words: "The author of this collection is not among those who grant critics the right to quiz the poet about his fantasy and to ask him why he chose a particular subject, mixed a particular color, plucked from a particular tree, drew from a particular source."[119] Eugène Delacroix might well have said the same. In the previous year he had exhibited in the Salon his vast *Death of Sardanapalus* which dramatically evoked the opulence, the fatalism, the eroticism, and the cruelty which had for so many centuries been associated with the East in European minds.[120] And in 1831 he seized the opportunity to visit Morocco with the comte de Mornay, French ambassador to the sultan. This confrontation with a reality, still more visually exciting than the imaginary vision of the Orient, proved to be a turning point in his artistic development.

"We landed in the strangest crowd of people," he wrote to a friend on the day of his arrival in Tangier, 25 January 1832. "At the moment I am like a man in a dream, seeing things he is afraid will vanish from him."[121] During the following five months in Morocco, Andalusia, and Algeria, he filled seven albums with sketches drawn and annotated with feverish excitement, planning to publish a series of etchings and woodcuts.[122] There were

58. Eugène Delacroix. Pen and ink drawing of a black man washing a horse from the *Album du Maroc*, fol. 24ᵛ (detail). 1832. 165 × 98 mm. Paris, Musée national du Louvre.

58

"subjects for pictures at every street corner," he immediately perceived.[123] "Economists and Saint-Simonians might find much to criticize as regards human rights and equality before the law," he admitted, but "this place is made for painters."[124] After four months he still believed "how peacefully men live here under the scimitar of tyrants; . . . nothing suggests that this is not the most desirable state in the world."[125] Blacks, many of them slaves, were conspicuous in this "unspoiled, sublime natural scene."[126] At Meknes he remarked on a "fine sight on looking behind us at a mass of swarthy and black faces."[127] He sketched a "distinguished black" seated in his shop, and another washing his horse, noting "the Negro just as black and glistening."[128] The statuesque carriage and graceful movement of the people, dressed in predominantly white garments which set off dark skins, enchanted his eye. His attitude was quintessentially pictorial. In North Africa he developed a new understanding of the way in which local colors are modified by bright clear sunlight, and this was to affect all his later work—and also that of several younger painters. fig. 58

Although Delacroix was never to issue his projected series of North African prints, he returned frequently to his sketches for subject matter for paintings, most notably the large *Women of Algiers in Their Apartment*[129] and still larger *Sultan of Morocco and His Entourage*.[130] The meeting with the sultan, Mouley-abd-er-Rahman, at Meknes was the objective of comte de fig. 59

83

Mornay's embassy, and Delacroix described it in detail as well as making many sketches, one of which records the presentation of the French delegation.[131] While waiting for the appearance of the sultan he noted how the square in front of the palace was gradually lined with "black soldiers." In the sultan himself he saw a

> strong resemblance to Louis-Philippe, younger, thick beard, fairly dark complexion. Fine burnous almost closed in front. Haik underneath, high over the chest and almost completely covering thighs and legs. White chaplet with blue silks around his right arm, of which one saw little.[132]

However, when after the lapse of thirteen years he painted his great canvas, he described the sultan as "remarkably mulatto." His dark bearded face and forearm set off by pale drapery are at the focal point of the composition, fixing its darkest and lightest tones. The black soldiers were withdrawn into an indistinct background crowd, but prominence was given to a black page standing at the horse's head "whose job it was to wave a cloth now and then to drive away the insects."[133] Although Delacroix was at pains to stress the authenticity of the picture in his unusually long catalogue note, he was surely less concerned with reportage than the artistic problems of color and composition presented by a painting on this grandiose scale. Baudelaire's enthusiastic account, making no reference whatever to the subject matter, concentrated on its pictorial harmony.

> Indeed, has a grander musical coquetry ever been displayed at any time? Was Veronese ever more entrancing? Has anyone ever made a canvas sing more fanciful melodies? Has a more prodigious harmony of new, unknown, delicate, charming tones ever been created? . . . This picture is so harmonious despite the splendor of the tones, that it is gray, gray like nature, gray like the atmosphere in summer when the sun spreads a twilight of shimmering dust over every object.[134]

The time lag between Delacroix's visit to Morocco and his completion of the painting of the sultan may be explained partly by political events. The comte de Mornay's diplomatic mission—to extract from the sultan a treaty acknowledging French possession of Algeria and to establish friendly relations—was a failure, and so was that of a subsequent envoy. In August 1844 the French forced the issue, defeated the Moroccan army at Isly, bombarded Mogador (today Essaouira), and after little more than a month obliged the sultan to capitulate. Delacroix was asked to provide drawings of the sultan for the periodical *L'Illustration*, and this commission probably spurred him to paint his large canvas. He resorted to the sketches he had drawn in Meknes without, however, making any allusion to the diplomatic mission he had accompanied—excluding the comte de Mornay from the painting and thus, whether intentionally or not, eliminating any suggestion of equality between the sultan of Morocco and the king of the French. The scene is presented as Oriental pageantry. Knowledge that the proud central figure, monarch of all he surveys, had been humbled may have added a note of poignancy. But the defeat of the sultan also opened the picture to

59 ▷

60

60. Horace Vernet. *The Arab Tale-Teller*. Dated 1833. 99 × 136.5 cm. London, Wallace Collection.

61. Horace Vernet. *The Arab Tale-Teller* (detail of figure 60).

a colonialist interpretation which made it acceptable for purchase by the French state.[135]

Horace Vernet who visited Algeria in 1833—a year after Delacroix—was more consciously inspired by French colonialist ideas. He was director of the French Academy in Rome, applied to Louis-Philippe for facilities to go to Algeria, and had a brig put at his service by the Ministry of the Marine. Algiers, completely taken over by the French, disappointed him, but in the country he was no less enthralled than Delacroix had been. "At the sight of so many new and picturesque things, I thought my head would burst. And there was more to come," he wrote.[136] But he also declared: ". . . One could not find a colony that offers more opportunities for prosperity. Without entering into governments' secrets, I believe that if one wanted to or if one could take advantage of the situation, Africa would be a gold mine for France. . . . The country is beautiful and rich; the natives ask nothing better than to be on friendly terms and trade with us. . . ."[137]

Immediately after returning to Rome Vernet painted a *Scène d'Arabes dans leur camp, écoutant une histoire* as it was titled when exhibited in

62

the Salon the next year (nowadays known as *The Arab Tale-Teller*).[138] It evokes the atmosphere of nomadic life as he saw it when on an excursion from Algiers he found himself "up to my ears in the pastoral." He had encountered a group of nomads, and, he wrote, "Nothing could give a clearer notion of our fathers in the Land of Canaan. It was Jacob and all of Genesis."[139] The picture was almost certainly worked up from sketches made in Algeria but, like so many later essays in Orientalism, reflects contemporary preconceptions about life on the margin of the desert as much as it provides information with its abundance of telling details. "No modern painter has seized the peculiar character of the Arabians in so masterly a manner," Gustav Waagen wrote. "The animation and variety of the heads, preserving at the same time the national type of character, are truly admirable."[140] Among the heads of the figures seated in their white burnouses one is black with strongly characterized features. But this man is in no way set apart from the others: he is simply one of the ethnically mixed population of Algeria which the French were attempting to "pacify."

A black has a far more prominent position in Vernet's painting of a lion hunt.[141] When this picture was exhibited in Paris in the Salon of 1836, it was entitled *Chasse dans le désert de Sahara le 28 mai 1833*, the precise date suggesting that it records an incident witnessed by the artist. The authenticity of the representation was stressed by the characteristically careful rendering of the costumes of the Arabs, their weapons, and the accouterments of their horses—despite the almost too neat integration of the composition. This pyramid of men and animals recalls Gericault's *Raft of the Medusa*. But the black at its apex—perhaps painted from the model Joseph who had posed for Gericault in 1819 and was to pose for Chassériau in 1836–39—has a different pictorial role. Detached by his nakedness as well as his color from the Arabs in their ample burnouses, and holding the cubs in his bare hands while the other men attack the lion and lioness with weapons, he is shown as a kind of link between them and the domestic animals in conflict with the noblest of wild beasts. The picture evokes the savagery of Africa, presenting a counterpart to the timeless tranquility of *The Arab Tale-Teller*. Both were acquired by private collectors. The official commission given to Vernet after his visit to Algeria in 1833 was for a specifically colonialist painting of the assault on the casbah in Bône (modern 'Annaba)—the first of his several North African battle pieces.[142]

Vernet's major painting of the conquest of Algeria was the panoramic *Prise de la smalah d'Abd-el-Kader* (of which Alfred-Charles Decaen later made a smaller copy).[143] Commissioned by Louis-Philippe to record the attack led by his son, the duc d'Aumale, on the camp of a leader of Algerian resistance (16 May 1843), it had a clear political purpose in the campaign to invest the bourgeois July Monarchy with an air of military glory and thus steal the fire of Bonapartist opponents. Hence the vast size of the canvas, some twenty-five yards long, and the six pages of commentary on it in the Salon catalogue when it was exhibited in 1845. Vernet must have borne in mind the battle scenes painted by Gros under the Empire and once again put on public exhibition after the July Revolution. But whereas Gros had celebrated the glory of Napoleon and his marshals in rigidly ordered compositions, Vernet's several battle scenes have no conspicuous heroes standing above the melee. Baudelaire complained that there was no unity

fig. 60

fig. 61

fig. 62

fig. 63

63

63. Alfred Decaen after Horace Vernet. *Prise de la smalah d'Abd-el-Kader* (detail). Dated 1856.130 × 440 cm. Chantilly, Musée Condé.

64. Alexandre-Gabriel Decamps. *The Punishment of the Hooks.* Dated 1837. 90 × 135.5 cm. London, Wallace Collection.

in *La prise de la smalah*, "rather a lot of interesting little anecdotes—the sort of vast panorama seen in taverns."[144] This might almost have been deliberate: Vernet depicted a conflict between the French *en masse* and the Arabs, between Europe and the Orient. Of all the many incidents in this picture the one that immediately catches the eye is that of blacks—presumably eunuchs—bundling the women of the harem into palanquins mounted on camels. Attention is thus drawn to the disruption by the French of one of the most notorious institutions of Islamic life, though one that aroused in Europe perhaps more secret longings than public remonstrances.

Although the victories of the French in North Africa were celebrated in official art, pictures of an undisturbed Islamic world had greater appeal for painters and the art-buying public. Alexandre-Gabriel Decamps was the first of the many nineteenth-century artists who specialized in scenes of daily life in the Orient. After making his debut at the Salon of 1827 with the picture of a *Soldat de la garde d'un visir*—a topical subject while

64

French attention was fixed on the Greek struggle [145]—he set out for the East, accompanying an artist commissioned to record the Battle of Navarino with "all the local authenticity possible." [146] When they reached Smyrna (modern Izmir), he stayed on in Asia Minor and may have visited Algeria on his way back to France. [147] Although he was out of France for less than a year, the impressions he gathered lasted him for some three decades.

Blacks appear as part of the Oriental population in several paintings by Decamps. One stares out with unblinking gaze from the foreground of *The Punishment of the Hooks*. [148] He forms part of a group of mounted janissaries, fig. 64 one of whom raises his cane to strike an importunate beggar, while the richly dressed commander, as impassive as the horse he rides, surveys over the heads of a jostling crowd the execution of criminals hurled from the citadel to perish on great hooks sticking out of its walls. It is not known whether Decamps witnessed any such gruesome scene. But both the black and the commander of the janissaries may well have been painted from sketches which he made in Turkey and reused for similar figures in later works. [149] The whole picture is built up from revealing details—Baudelaire noted "the birds of prey soaring in the background" [150]—to evoke the violent backdrop of the Ottoman Empire, and also the brilliant color of the eminently picturesque East. Decamps's aim was, as Charles Clément remarked, "to awake violent emotions," [151] but he was clearly making no moral protest. He seems almost to have accepted the execution as a fact of Oriental life and death, concentrating on the spectators' reactions, ranging from pity and horror to fatalistic acceptance and, on the part of the black, complete indifference. The work was praised mainly for the handling of paint. Amaury-Duval, a devout disciple of Ingres, who visited Decamps while it was being painted later recorded: "I was struck by the brilliance and strength that he succeeded in putting into his painting, and he may have seen my astonishment when I looked closely at the impasto, which had no relation to our way of painting. . . ." [152] Some years later Julius Meyer remarked that "the picture would be intolerable if the dazzling play of light on the sunlit wall did not distract the eye from the incident itself." [153] But subject matter and purely pictorial qualities were surely of equal importance to Decamps, and the black contributes to both—as a member of the posse of janissaries whose cruelty was notorious and as a figure of contrasting color in a composition of sultry richness.

THE ORIENT OF THE ORIENTALISTS

Trails blazed by Delacroix, Horace Vernet, and Decamps were soon followed by other Europeans and a few Americans. The annexation of the Orient as an artistic province enlarged the range of subject matter for painters of landscape, architecture, and genre. They passed easily from depicting the mountains of Switzerland to the deserts and oases of North Africa, from ancient Roman ruins and Gothic churches to pyramids, temples, and mosques, from French and Italian peasants to Algerian nomads and Egyptian fellahin. The Orient offered subjects for narrative pictures as colorful as any scene from ancient or medieval European history, yet purporting to record contemporary life in a world where time had stood still for hundreds

65. William James Müller. *Eastern Letter Writer*. Dated 1841. Oil on wood. 31.8 × 24.1 cm. Glasgow, Glasgow Art Gallery and Museum.

65

if not thousands of years. Few travelers failed to be reminded of biblical incidents. "A Holy Family is found in every Arab village," one remarked.[154] The Orient also invited artists to use a more brilliant palette and more varied poses for human figures, and to indulge in virtuoso displays of technique, *l'art pour l'art*. Subject matter, rather than style, was nevertheless the distinguishing mark of Orientalist paintings, almost invariably depicted from the viewpoint of an outsider as spectacles staged for the delight, amusement, horror, or quite simply information of the Western public.

Europeans are almost conspicuously excluded from such works. As a recent writer has remarked, one of their defining features is their dependence on "a presence that is an absence."[155] The Westerner is only implicitly present as the recorder or, one might say, the showman. And this conditioned the depiction of blacks who were included in the scene sometimes as protagonists though far more frequently in minor parts. They were part of a mixed population, all of whom were regarded as equally

inferior by Europeans of the time. Although they often figured in the conventional roles of servants or attendants, they also appeared as the equals of Arabs—in Horace Vernet's *The Arab Tale-Teller*, for instance. Some may cf. fig. 60 have been slaves, but their status is rarely stressed. In the Islamic lands the slaves who attracted the attention of Western artists were fair-skinned women.[156] And even their predicament seems rarely to have aroused much sympathy, let alone moral indignation. Exclusion from Islamic life and ignorance of its social structure permitted a dispassionate view of its customs, however deplorable they might seem.

Delacroix's remark about "subjects for pictures at every street corner" is brought to mind by many later Orientalist pictures. Only outdoor life was in fact readily visible to Westerners, and, initially, this sufficed for most of them. The crowds of figures in the streets seemed "like humanity put into a kaleidoscope" to an English artist, William James Müller, who visited Egypt in the winter of 1838–39.

> You get into some one of the many curious carved and painted doorways, and watch the scene with an interest which none can understand but those who have found themselves in a similar place. And now, for a moment, let us imagine the poor artist, with his feelings of enthusiasm properly kindled, in such a crowd, and anxious to sketch. Poor devil! I pity him. He longs for some photogenic process to fix the scene before him, could he but sketch it.[157]

Among the pictures he painted after his return to England, one is of two turbaned Arabs with a squatting black scribe.[158] Although so very carefully fig. 65 composed, it may well have been derived from a group of people he had seen and sketched in Cairo. Professional letter writers were a feature of North African towns, at once picturesque and an indication of widespread illiteracy which bolstered the Europeans' belief in their own superiority. What is unusual, in art if not in life, is that the black in Müller's picture figures as the literate man taking dictation from one of the better-dressed Arabs— a reversal of the received idea of the intellectual relationship between the two races. Yet one may doubt whether he intended to do more than present a richly colored glimpse of daily life.

"The markets and bazaars of the Egyptian towns form the most perfect pictures for Rembrandt," Müller wrote in his diary.[159] He was no doubt thinking of exotic costumes and rich effects of light and shade. But a canvas on which he painted five heads, as a set of variations on a theme, brings to fig. 66 mind the oil sketches by Rubens.[160] It is similarly a study of physiognomy without theoretical overtones. The man is shown both turbaned and bareheaded with different expressions which suggest a range of thoughts and emotions. Müller's painting differs from the majority of *études* by his contemporaries in that there is no sense of rapport between the artist and his subject, who seems to be watching some occurrence in his own world, unaware that he is observed.

A Nubian woman portrayed by the Swiss painter Charles Gleyre is fig. 67 absorbed in her own thoughts, with a suggestion of melancholy—the sadness of the tropics—in her mouth and eyes.[161] Her physiognomy and hairstyle are recorded with ethnographic precision but also a kind of tenderness.

66

66. William James Müller. *A Study of Five Negro Heads*. Ca. 1840. 50.2 × 68.6 cm. London, Spink & Son Ltd.

Gleyre spent rather longer in the Orient than most of his contemporaries, accompanying a rich American who wished to have visual records of the places he visited in the Levant and Egypt, traveling as far south as Sennar in the Sudan and then settling on his own near Khartoum where he spent more than a year with the local population whose way of life he adopted.[162] After his return to France, however, his vision seems to have been almost immediately clouded by European notions of the Orient. (In fact, he almost lost his sight in the Sudan and did not regain it until he crossed the Mediterranean.) *La Nubienne*, painted as a dining room decoration for a Parisian restaurateur in 1838 is a life-size figure of fantasy. Balancing a water jar on her head, she stands against a backdrop view of the Nile, with palm trees and a crocodile, in a state of almost complete nudity, abhorrent to Muslims, wearing only a flimsy bead skirt, bracelets, and an amulet. Her facial features are European rather than Nubian, and her flesh tones are

68

olive brown below the waist and pink above, rather than black.[163] At about the same time he painted a genre scene, *La pudeur égyptienne*, in which a small girl handing a jar of water to a Nubian horseman lifts her dress to hide her face—and reveal her naked brown body.[164] But he soon abandoned Oriental subjects. "We are Aryans," he remarked to a pupil who wished to travel to Egypt. "There is nothing for us to do out there. There is nothing but anecdote, genre, costume. For us, beauty is a must."[165]

The charm of a young black woman is delicately evoked by Prosper Marilhat's drawing somewhat fancifully entitled *La sultane noire*.[166] Marilhat spent two years in Greece, the Levant, and Egypt, from April 1831 to May 1833, returning to France with ten albums of sketches which served him as the basis for Orientalist paintings during the rest of his short career. In spirit "to tell the truth, he had not left the Orient," his most enthusiastic admirer, Théophile Gautier, remarked.

fig. 68

For him the mottled crowds of Fellahs, Nubians, Copts, Negroes, Turks, and Arabs wandered forever in Cairo's picturesque labyrinth with their weapons and their bizarre dress. In his imagination

there was a perpetual mirage of tin domes, ivory minarets, mosques with white and pink courses, squat carob trees, slender date palms, flamingos taking cover in the reeds, flights of doves strung out in the air like pearl necklaces. . . .[167]

But *La sultane noire* owes as much to Rococo art, then enjoying a revival, as to the Orient: she belongs to the world of eighteenth-century *turqueries* rather than the Egypt of Mohammed Ali.

Visions of the Orient conjured up in eighteenth-century paintings and prints, novels, plays, and operas—most beautifully in Mozart's *Die Entführung aus dem Serail* first performed in 1782—lingered in Western minds. Only the ways in which they were represented visually underwent a conspicuous change to answer new demands for verisimilitude. As Europeans were still barred from penetrating the women's quarters of Muslim houses (Delacroix was an exception), pictures of life in the harem, exhibited in increasing numbers from the 1830s, remained imaginative fantasies given an appearance of fidelity by a profusion of carefully depicted circumstantial details.[168] John Frederick Lewis who lived in Cairo from 1842 to 1851 painted a number with backgrounds that may well have been derived from his own house (similar rooms are preserved in that of a later English resident in Cairo, Major Gayer-Anderson). The "wives" he depicted are so fair-skinned that they might easily be mistaken for Europeans: they are truly "Caucasian." But the scenes are localized, often by the presence of a black servant girl as well as the decor of textiles, ceramic tiles, intricate moucharaby work, and bric-a-brac, including Chinese porcelain and Islamic brass, rendered with meticulous care. They evoke an atmosphere of luxurious languor that seems to have been peculiarly appealing to his English patrons. One represented, according to his own account, a bey seated with his wives and a "laughing slave, an Abyssinian" inspecting a newcomer to the household. "The girl who is being unveiled by the black guardian is also an Abyssinian, but lately arrived from the upper country," he explained.[169] But this picture has a curious and perhaps revealing later history. When it was exhibited at the Society of Painters in Water Colours in London in 1850—the first harem scene to be shown there—a reviewer declared that it gave "no offence to Western feelings of decorum" even though it was "voluptuous—or it would not be true to its theme."[170] Another writer called it "a marvellous picture; such as men love to linger around, but such as women, we observed, pass rapidly by. There is nothing in the picture, indeed, to offend the finest female delicacy; it is all purity of appearance; but at the same time it exhibits woman, to a woman's mind, in her least attractive qualities."[171] At some later date, however, the right-hand part of the sheet was cut off, removing the focal point of the composition: the unveiling of the black girl. Whether or not this was done accidentally can only be conjectured. Although descriptions suggest that the girl's attitude was modestly restrained, it was popularly believed that black women were peculiarly lascivious, appealing to depraved sexual tastes. In pictures of harem life they normally figure as attendants or slaves of the almost invariably fair-skinned wives.[172] One on her knees, in a delicate oil painting by Lewis, holds a looking glass so that a reclining odalisque can admire herself.[173]

fig. 69

69

69. John Frederick Lewis. *The Harem*. Oil on wood. 89 × 112 cm. Birmingham, City Museum and Art Gallery.

Blacks had been much less frequently the subject of modeled than of painted *études*. The *têtes d'expression* that young sculptors were required to model in the course of their academic training were invariably of Europeans.[174] Whereas painting was regarded as "Romantic art," sculpture was still believed to be essentially "classical" and thus devoted mainly to realizing European ideals of moral nobility and physical beauty. Sculptured blacks had figured mainly as symbols on public monuments, like those by David d'Angers,[175] or as part of the world of nature in small-scale works by animaliers, notably Antoine-Louis Barye.[176] The bust of an African named

70. Jean-Pierre Dantan. *Gala*. Dated 1848. Plaster. H (without base): 26.3 cm. Paris, Musée Carnavalet.

71. Charles Cordier. *Nègre du Darfour*, also entitled *Nègre de Tombouctou*. Dated 1848. Bronze. H: 83 cm. Paris, Musée de l'Homme.

72. Charles Cordier. *Vénus africaine*, later entitled *Négresse des côtes d'Afrique*. Dated 1851. Bronze. H: 82 cm. Paris, Musée de l'Homme.

70

Gala was, however, modeled by Jean-Pierre Dantan in 1848, apparently from fig. 70 life.[177] Dantan divided his work between formal portraits and more widely known caricature statuettes of contemporary celebrities, including one of Alexandre Dumas exaggerating the ethnic features inherited from a black grandmother.[178] He went to North Africa twice to execute portrait busts, of Thomas Robert Bugeaud de la Piconnerie, the French governor general of Algeria, in 1844, of Mohammed Ali and his French physician Dr. Clot, founder of the first European-style hospital in Cairo, in 1848.[179] But he also modeled and exhibited in the Salon, from time to time, *têtes d'étude*, and there can be little doubt that he conceived the bust of Gala as such, the direct representation neither formalized nor caricatured, of a face that caught his attention. It is indeed the sculptural equivalent of studies of individuals by W. J. Müller and other Orientalist painters. cf. fig. 66

Only two sculptured images of blacks had been shown in the Salons in Paris since 1781 when Houdon's *Négresse* was first exhibited—a *Tête de Nègre* by Antoine-Laurent Dantan (elder brother of Jean-Pierre) in 1837 and a statuette of Marie, the slave in *Paul et Virginie*, by Charles Cumberworth in 1846.[180] The Salon of 1848, however, included a plaster group of a *Cavalier africain attaqué par une lionne* by Isidore Bonheur (brother of Rosa Bonheur), an unspecified *Sujet d'Afrique* by Théodore Hébert, and, most notably, a plaster bust by Charles Cordier described in the catalogue as *Saïd Abdalla de la tribu de Mayac, royaume du Darfour*. The sudden appearance of these works—and many more were soon to follow—may have been prompted

71 72

partly by the abolition of slavery in the French colonies which gave topicality to images of blacks. But there can be little doubt that they also appealed to the current taste for Orientalism. In the same exhibition there was a portrait bust said to represent the sixteenth-century pirate and Ottoman admiral *Khair-ed-Din, surnommé Barberousse* by Emile-François Chatrousse.[181]

In a brief autobiographical memoir Cordier recorded how he came to model the bust of the man from Darfur which determined his subsequent career. He was then, aged twenty-one, studying under François Rude whose pupils were notorious for their unorthodox attitudes to sculpture (all had been excluded from the Salon of 1846). One day "a superb Sudanese came into the studio," Cordier wrote. "I did this bust in two weeks. A comrade and I carried it to my room, near my bed. I brooded the work. Once it hatched I had it cast and sent to the Salon, convinced that it would be accepted. But the revolution of 1848 broke out. The jury was elected. All atremble, I took a chance and sent the bust representing the Sudanese. It was a revelation for the whole artistic world."[182] He had the bust cast in bronze and exhibited it in the Salon of 1850 with a different title: *Nègre de Tombouctou*.[183] Tombouctou—or Timbuctoo as it used to be called in English—was a far more evocative place name than Darfur though some three thousand kilometers away. But the change of title also transformed the portrait of an individual into the image of a racial type.

In 1851 Cordier provided a female companion which he entitled *Vénus africaine* and promptly received from the state a commission for bronze casts

fig. 71

fig. 72

101

of both busts to be placed among a collection of skulls in the ethnographic gallery of the Muséum d'Histoire naturelle in Paris.[184] The busts were also shown in the Great Exhibition in London in 1851 and bronzes purchased by the English royal family.[185] At least eight bronzes were cast of the pair. "My kind of work had the news value of a new subject, the revolt against slavery, anthropology coming to birth: there was something sensational in my works," he declared. Two years later he began to carve the polychromatic busts of non-Europeans with which, he remarked, "I was putting a new value into sculpture and creating the study of races, widening the scope of beauty by finding it everywhere." This high claim was made long after the event and, indeed, after the type of work in which he had specialized had gone out of fashion.[186] But it was not entirely unwarranted. Cordier's busts of Africans are at the point of intersection, as it were, of mid-nineteenth-century ideas about aesthetics, race, and colonization.

Cordier appears to have modeled his busts of the man from Darfur and the *Vénus africaine* as *têtes d'étude*, that is to say, works of art. But his career took a new turn after he received the commission for bronze casts of them for the Muséum where his wife's former guardian, Constant Dumeril, had succeeded Cuvier as professor of natural history. At the suggestion of Serres, the professor of anthropology at the Muséum, he then modeled busts of a Chinese man and wife who happened to be in Paris, exhibited them at the Salon of 1852, and solicited a state commission for bronze casts of them. Writing to the Directeur des Beaux-Arts he remarked: "I did this work without a commission, having confidence, as did these gentlemen [Dumeril and Serre], in your feeling for art and the usefulness of the work for science, for France to have worthwhile types which are worked up everywhere. But I have done this conscientiously as an artist, in such a way as to make it possible to grasp the physiognomy of the country."[187] The commission was given to him. With the support of the two professors he applied to the Ministère des Beaux-Arts in 1854 for funds to visit Algeria "in order to reproduce different types which are about to blend together into that of one and the same people."[188] He received the grant in 1856, spent six months in Algeria, and returned with twelve busts of Arabs, Kabyles, Jews, Moors, and blacks. They were executed either in bronze or colored marbles and exhibited in the next year's Salon. Ten were acquired by the state for the Muséum, including those of a black Sudanese, a *Mauresque noire*, and a woman of mixed black and Moorish parentage.[189] Two, perhaps the most colorful, of an Arab and a Sudanese black wearing Algerian costume, in bronze and onyx were bought by Napoleon III for his own apartments at Saint-Cloud.[190] In 1858 Cordier visited Greece, again financed by the state, "to execute reproductions of the human types of that country"[191] and returned with twenty-three plaster models. But in 1860 when he submitted a representative collection of his works for the Salon, it was refused by the jury. He showed a still larger collection, instead, in an "Anthropological and Ethnographical Gallery for the History of the Races" at the Palais de l'Industrie within the general framework of an exhibition of Algerian products.

fig. 73

The catalogue of this collection was written by a somewhat obscure philosopher, Marc Trapadoux, who declared: "M. Cordier's works are intended not only for artists but also for anthropologists, ethnographers, anatomists, philosophers, and historians."[192] At this moment the *histoire*

73

des races was being more widely discussed than ever before. Seven years earlier Arthur de Gobineau had published his notorious *Essai sur l'inégalité des races humaines* in which he argued that mankind had degenerated as a result of miscegenation. Theodor Waitz in 1858 had begun to publish at Leipzig his *Anthropologie der Naturvölker*—a six-volume inventory of "primitive" peoples, describing their customs as well as their appearance with unprecedented objectivity. In 1859 Paul Broca outlined a new program for ethnographical studies in his inaugural lecture at the Ecole d'Anthropologie in Paris. That same year Charles Darwin published *On the Origin of Species* which aroused a storm throughout the West, though the theory of evolution it put forward only suggested the process of the "descent of man" which he was not to confront directly until 1871.

Cordier did not so much attempt to illustrate these theories as to exploit the popular interest they aroused. One of his avowed aims was to demonstrate the "ubiquity of the beautiful." *Le Nègre du Soudan* had, in the words of the catalogue, "an inborn nobility that gives him this bearing of a Roman emperor. . . . The sculptor declares him king in the world of forms." *Le Nègre nubien,* "with pride suffusing his every feature, looks to me like a Spartacus, like a Toussaint Louverture. The sense of human dignity, revolt against injustice, hatred of slavery, carve deep grooves in this noble face; the reflection of an ardent soul, the gleam of intelligence light up this stormy visage which commands respect. . . ." The Nubian had been a slave, and so too had the *Négresse des côtes d'Afrique,* the subject of the bust previously entitled *Vénus africaine,* which inspired the cataloguer to write: "A somber beauty; our great Th. Gautier has said: fateful beauty. I might add, a diabolical beauty which must ravage the senses and the heart . . ." and so on. The "singular beauty" of the *Mauresque noire* was, he declared, "the felicitous outcome of the mixing of Moorish blood with black blood."[193] Yet Cordier seems to have had no more doubt than most of his European contemporaries of the superior beauty of the white race. When applying for funds to visit Greece he had written:

> From the viewpoint of ethnography, as from that of art, Algeria has provided me with clearly defined types. The Berber Kabyle, the Arab from Laghouat, the Moorish, etc., have shown me unexpected characteristics of strength, nobility, and grace.
>
> The Algerian races, however, do not possess the perfection of form which Greek artists found in a privileged race. Therefore, it is in Greece, Monsieur le Ministre, or rather in the center of the cradle of the human race in Georgia, that I should like to follow up the conscientious imitation of human beauty by doing whole "nudes."[194]

In his Anthropological Gallery, blacks were outnumbered by Arabs and Europeans.

Models of the heads of people of different races had been made for scientific purposes more than half a century earlier. Johann Friedrich Blumenbach, the German anthropologist and inventor of the term *Caucasian,* had two of them at Göttingen.[195] It is likely that they were also made for other anthropologists and comparative anatomists similarly obsessed by the size and shape of skulls, though casts of skulls were more widely diffused.

Unfortunately none can now be traced: they were probably discarded as soon as photographs began to provide more extensive and accurate documentation. But some impression of their probable appearance may perhaps be obtained from the later nineteenth-century "reconstructions" of the heads of the supposed ancestors of *Homo sapiens sapiens*—ape, Neanderthal man, etc.—displayed until recently in many museums of natural history. Cordier's works were, however, self-consciously artistic.

In an address to the Société d'anthropologie in Paris in 1862, Cordier revealed how he modeled his busts. "I sculpted these busts from nature, availing myself of a geometrical process which assures the exactness of the reproduction, the dimensions, and the shapes," he claimed. But his selection of models was less scientific.

> First I examine and compare a large number of individuals. I study the shape of their heads, the facial features, the expression of their physiognomy. I strive to seize the common characteristics of the race I want to represent, evaluate them overall and in detail, retain the range of individual variations in each, and in the end form a concept of the ideal, or rather the type, of each of these characters. Then, assembling all these partial types, I form in my mind a general type in which all the beauties of the race I am studying are combined.[196]

In other words, he worked according to the time-honored process of selection by which Zeuxis was traditionally supposed to have painted Helen. And the busts themselves suggest that his choice was determined largely by current European notions of what might be regarded as aesthetically the highest common factor. Hence, perhaps, their widespread popularity.

Although many of Cordier's busts were executed for the Muséum d'Histoire naturelle as ethnographical illustrations, the majority were acquired by private patrons. They could be admired simply as decorative objects and, especially those in polychromatic mixed media, as virtuoso feats of craftmanship. They have a generic similarity with seventeenth- and early eighteenth-century, mainly Italian, busts of so-called Moors with black marble for flesh and colored marbles for drapery. (Some of the most notable early seventeenth-century polychromatic statuettes of blacks had been the work of Charles Cordier's namesake Nicolas). Such works were despised by neoclassicists but seem to have returned to favor in the climate of mid-nineteenth-century historicism. Cordier may have been more directly inspired by the antiquities from which they derived—busts of Roman emperors in colored marbles and such mixed-media statues as the marble and bronze *Zingara* in the Louvre. The polychromatic statues of antiquity and also medieval Europe attracted increasing interest in the nineteenth century, and many attempts were made to emulate them.[197] For this type of work, darkskinned people in richly colored clothes provided obviously appropriate subjects. In England in about 1856, Carlo Marochetti carved a bust of an Indian princess with patterned sari round her shoulders tinted in strong colors.[198]

Cordier's first bust had been a named African. He subsequently portrayed ethnic "types," rather than individuals, in busts acquired by the state for the Muséum and also by private patrons. But after 1860 his

sculptures seem to have been conceived simply as works of art, without scientific pretensions. In 1862 he received the commission for atlantes and caryatids, one representing a black woman, in bronze, gilded bronze, marble, and onyx for the entrance hall of Baron James de Rothschild's château de Ferrières.[199] He subsequently made use of the same combination of materials for *lampadaires*, one representing an Egyptian fellah which Cordier showed in the Salon of 1870.[200] "These luxurious sculptures require luxurious surroundings," one of his several admirers wrote.[201] But bronze versions of his works seem also to have been produced for a wider market by the firm of Lerolle Frères, manufacturers of *bronzes d'ameublement*, which showed some of them in the International Exhibition in London in 1862.

Busts of Africans in a combination of bronze and marble, like that used by Cordier, were shown by the Milanese sculptor Pietro Calvi in exhibitions throughout Europe from the late 1860s.[202] The same materials were used for the bust of a *Chef abyssin* by the duchess of Castiglione-Colonna in the Salon of 1870,[203] for a *Femme mauresque* by Emile Guillemin in that of 1877, and a *Tête de nègre* by Nicolas Mayer, a pupil of Cordier, in that of 1885.[204] Such works might easily be incorporated among the heavy draperies, abundantly upholstered "ottomans," tables inlaid with mother-of-pearl, beaten copper trays, and various North African weapons in the "Moorish" smoking rooms for which there was a vogue throughout Europe in the late nineteenth century, evoking as they did the atmosphere of harems depicted in so many Orientalist pictures. That they represented members of subject races—most of the non-Europeans portrayed by Cordier were inhabitants of French colonies[205]—may also have been a reminder of European superiority, adding a further dimension to their decorative appeal.

Paintings of multi-ethnic, multi-colored people of North Africa are of course far more numerous than busts wrought out of costly materials. One is by the Spanish artist Mariano Fortuny y Marsal who was in his own time one of the most highly praised and widely known of all the Orientalists. In 1860 he was sent to Morocco by the Diputación Provincial of Barcelona to record the war against tribes who were threatening the Spanish coastal possessions.[206] After his return he began to compose a huge (3 × 9.7 meter) painting of the Battle of Tetuan on which he worked intermittently during the rest of his short life without finishing it.[207] The portrait reproduced here may perhaps represent a man named Farragi, one of the *Moros del rey* loyal to the Spaniards whom he is known to have painted.[208] On two subsequent visits to Morocco he gathered material for paintings of street scenes and other picturesque subjects which had no explicitly Spanish colonialist significance and were, indeed, acquired by collectors throughout the West, from Russia to the United States. They seem to have been admired for their richness of color and bravura of handling as much as their Orientalist subjects.

fig. 75

Profile portraits, in addition to displaying Camper's facial angle, always distance a sitter from the artist and his public. That of a black *Bashi-Bazouk* by Jean-Léon Gérôme suggests indifference if not disdain for other men.[209] These unpaid irregular soldiers in the Turkish army, who lived by plunder and were notorious for their cruelty, especially after the Bulgarian massacres of 1876, were recruited from Africa and Asia. But this portrait was probably painted in Paris from a professional model wearing the silk

fig. 74

75

jacket and elaborate headdress in which Bashi-Bazouks were attired in several of Gérôme's other pictures.[210] An illusion of reality is given by the artist's technical precision. His astonishing skill and apparent abnegation of artistic individuality—with the effective concealment of brushwork—led one contemporary to call him "a scientific picture maker."[211] Théophile Gautier praised him for "ethnographic veracity," remarking that his pictures would be of value to anthropologists while also satisfying "one of the most demanding instincts of the age; the desire people have to know more about each other than that which is revealed in imaginary portraits."[212]

Alfred Dehodencq, according to a contemporary, "is most accomplished in the art of delineating types. One would think he had always lived among uncivilized peoples and studied at leisure the various manifestations of their animal passions."[213] The writer was referring to the painting of *L'exécution de*

75. Mariano Fortuny y Marsal. *Portrait of a Moroccan Black, perhaps Farragi*. After 1861. 46.1 × 36.8 cm. Houston, Menil Foundation Collection.

76. Alfred Dehodencq. Study for the painting exhibited in 1861: *L'exécution de la Juive*. 62 × 44.5 cm. Paris, Musée des Arts africains et océaniens.

la Juive in which a muscular black wielding a sword figures in the traditional role of executioner.[214] It was inspired by a scene Dehodencq had witnessed in Tangier: the beheading of a young Jewish woman who had undergone conversion to Islam in order to marry a Muslim but then declared her reversion to the religion of her family. This gruesome "drama of two fanaticisms locked in conflict"—both equally remote from the religious experience of the artist and most of his public—provided the subject for a picture at once oriental, historical, and contemporary.[215] Like other Orientalists, Dehodencq painted several scenes of Jewish life in Morocco partly, no doubt, because it was more accessible than that of the Muslims. No connection seems to have been made between the persecution of Jews in North Africa and expressions of anti-Semitism in Europe. The Jewish woman on the scaffold is simply a victim who appeals for sympathy as blacks had so often done in earlier images. But the picture is also a record

fig. 76

76

109

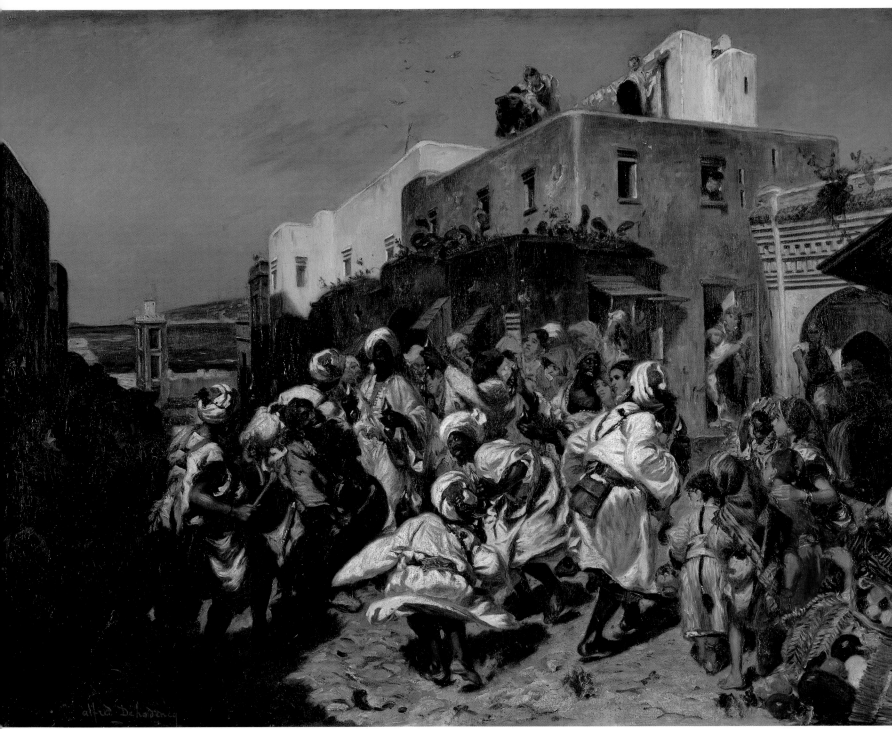

77

77. Alfred Dehodencq. *Danse des nègres à Tanger*. Salon, 1874. 152 × 202 cm. Paris, Musée d'Orsay.

78. Alfred Dehodencq. *Black Musician*. 1854–63. Charcoal on paper. 333 × 210 mm. Paris, Musée national du Louvre.

of the violence that, it was supposed, could be pacified only by European colonization.

Dehodencq who settled in Spain in 1849 and from 1854 to 1863 spent part of each year in Morocco, was more familiar with the country than any other French painter of the time. He prided himself on being an "exact observer." When his pictures were termed "romantic," he remarked: "Romanticism, dear Sir, for which I have the highest regard (it is my father), has no part in the composition of these canvases. It is a hymn to the sun which I shall never stop singing; it is the rapture of movement and life, quaffed at the true springs."[216] He may well have had in mind such a work as his *Danse des Nègres à Tanger* painted a decade after his last visit to Morocco.[217] Although strongly reminiscent of Delacroix's *Fanatics of Tangier*,[218] it differs in the greater detail with which costumes and architecture are depicted, the outcome of closer and longer study and of an interest in ethnology much stronger in the 1870s than thirty years earlier. It also differs from the vast majority of Oriental scenes, including Dehodencq's other works, in that it is exclusively devoted to blacks. The description of the picture by the artist's biographer and personal friend reveals a contemporary reaction to the subject:

fig. 77

> How they dance, these simple Negroes, under the wide, blue sky, oblivious of the sun and gracefulness! . . . The white shirts pulled in at the waist with a thick, green cord and the broad, white turbans that crown their heads give an odd gleam to whatever one sees of the bodies, shining black like ebony. Their contented laughter, like that of a mindless creature, cleaves their black faces with the flashing whiteness of their teeth. They pound the tambourine with a crescent-shaped piece of wood. They jump, bound, twist, and grimace; they go through a thousand contorsions; they whirl to the point of dizziness. You hear the screeches coming out of their thick, drooping lips.[219]

Even if Dehodencq's own vision was less clouded by racialist stereotypes, his picture did nothing to dispel them. Although he made numerous sketches from life in Morocco, his choice of subjects—like that of a photographer—was determined by notions of typicality. One of his drawings is of an aged black musician, so strongly characterized that it must surely have been done from life in Morocco though not until many years later did he use it as the model for a figure in a painting.[220]

fig. 78

Painters who had traveled in North Africa and the Levant concentrated on what they had seen and, of course, on what they and their public expected to see. From slightly different viewpoints and in slightly different lights, the same subjects were depicted again and again. Blacks who figure in them were given a limited range of roles. Léon Belly who was in Egypt in 1851, 1855–56, and 1857–58 painted one as a study for his picture of *Fellahs halant une dahbiek, Egypte* exhibited in Paris in the Salon of 1864.[221] Arabs and blacks haul a boat up the Nile in a picture of the same timeless subject by Frederick Arthur Bridgman, an American who had settled in Paris in 1866 and visited Egypt and Algeria in 1872 gathering visual material that lasted him for the rest of his career.[222]

fig. 79

"Above all others the Orient has become the land of painter-travelers," the art critic Léon Lagrange wrote in 1864. "Everything Italian nature has

78

111

79

lost, Oriental nature has gained. From Algiers to Constantinople art has laid claim to the shores, the countryside, the rivers, the cities, the deserts, all seen in the light of an unclouded sun."[223] Delacroix had suggested in 1832 that young painters would profit more from being shipped to North Africa than "wearing out the classical soil of Rome."[224] Mature artists also took advantage of any opportunity that was offered for visiting the Orient, however little they had previously been attracted by non-European subject matter. Léon Bonnat, painter of Italian genre scenes, solemn religious and mythological subjects, and still more solemn portraits (nowadays better remembered as an inspired collector) made an Eastern tour with Gérôme and other friends in 1868–69, witnessing the opening of the Suez Canal. Although he can hardly be termed an Orientalist, Bonnat painted in the following years a few pictures of people he had seen. That of a black barber shaving a client transformed two figures glimpsed in a street into a classically fig. 80 statuesque image of muscularity and languor.[225] When exhibited in the Salon of 1876 Charles Yriarte praised it simply as a *tour de force* of figure painting and a "prodigious exercise" in foreshortening.[226] It is indeed an *étude* from which all trace of spontaneity has been eliminated, so smoothly rendered that it seems no less veracious than a photograph—almost an anticipation of Cartier-Bresson's street scenes. These two motionless figures completely absorbed in one another, sealed off in their own world, observed

79. Léon Belly. Study for the painting exhibited in 1864: *Fellahs halant une dahbiek (Egypte)*. 55 × 40 cm. Saint-Omer, Musée de l'Hôtel Sandelin.

80. Léon-Joseph-Florentin Bonnat. *Barbier nègre, à Suez*. Salon, 1876. 80 × 58.5 cm. New York, *Forbes* Magazine Collection.

but unobserving, are subject people in an artistic sense. The painting is an instance of the way in which blacks could, by the later nineteenth century, be assimilated into academic art as members of the cast of performers on the Orientalist stage.

There was evidently a demand for blacks willing to pose for artists in Paris. One had a visiting card inscribed: "Said of Timbuctoo, first-classs model for Algerian and Oriental scenes."[227] His name was in fact Toukou, he was a Hausa enslaved in childhood who escaped to Algeria, joined the French army when he was eighteen, fought in the Crimean War, then settled and married in Paris where he earned his living as a concierge and artist's model. The anthropologist Ernest Hamy, who published a study of his physique with measurements, reveals that he was depicted by Jean-Joseph Benjamin-Constant in the huge painting of the entry of Sultan Mohammed II into Constantinople shown in the Salon of 1876.[228] Scimitar in hand, he stands beside the victor, about to trample over the corpses of the Byzantine defenders in the foreground. But he must surely have figured in many other pictures of the time.

80

81. Eugène Fromentin. *Bateleurs nègres dans les tribus.* Salon, 1859; Salon, 1867. 96 × 137.5 cm. Private Collection.

"The Orient is very distinctive," wrote Eugène Fromentin in 1857. ". . . All its traits are impressive: the novelty of its sights, the singularity of its costumes, the originality of its types, the sharpness of its effects, the particular rhythm of its lines, the unusual range of its colors." But a painter who concentrated on the peculiarities of the scene produced, to his eye, no more than "documents," that is to say

> the description of a country—what sets it apart, what makes it itself, what makes it live again for those who know it or makes it known to those who do not. I am speaking of the exact type of a country's denizens, exaggerated though it may be by Negro blood or interesting only because of its extravagance, their foreign and quaint costumes, their attitudes, their manners, their customs, their bearing, which is not our own. [229]

Such pictures—the majority of Orientalist works—appealed to many people who, according to Fromentin, "will then require of painting what only a travel account can supply. They will want pictures drawn up like an inventory, and the taste for ethnography will end up by being confused with the sense of the beautiful." His own aims were different.

The author of two North African travel books, a novel which is a masterpiece of psychological analysis, and a sensitive account of Dutch seventeenth-century art, Fromentin was equally distinguished as a writer and a painter. "A great painter in literature, a remarkable writer in painting," a contemporary called him. [230] No writer provided a more vivid account of Algeria in the mid-nineteenth century, before it had been fully colonized and extensively Europeanized. No artist apart from Delacroix, whom he both admired and understood, made better pictorial use of impressions gained in North Africa. On his first visit to Algeria in 1846 Fromentin wrote, "the more I study this land, the more I believe that, Marilhat and Decamps notwithstanding, the Orient remains to be done." [231] He came to recognize that the former had "turned the Orient into landscape" the latter "landscape and genre" and only Delacroix "genre and grand painting." Delacroix "went up a step on the almost endless staircase of great art, and in the Orient he saw the human drama." [232] Without attempting to work on the same grand scale Fromentin found in the Orient a means of escape not only from Europe but from the fixed categories of landscape and of genre which he believed "destroyed grand painting and distorted the very landscape." [233] His aim was "to turn the Orient into" paintings at once individual and general, a purely pictorial art. There is thus a striking disparity between his precisely itemized written descriptions and his generalized, strongly atmospheric paintings.

In *Une année dans le Sahel* Fromentin gave a vivid account of a *fête nègre* at which he had been present in Algiers, describing the brilliant colors of the costumes, a "vast display of flamboyant fabrics," the sparkle of jewelry with "gilding, glass beads, pearls, *sultanins*, corals, shell necklaces from Guinea" and the beauty of the young women "with gleaming eyes, cheeks as firm and polished as basalt, . . . their forms so vigorous that, despite the veils and *fouta,* the vitality of their muscles under their garments was as distinct as

81

though under wet drapery."[234] He repeatedly termed the scene "a picture," but one "lacking discipline and having almost nothing in common with art." He did not attempt to depict it.

His painting of *Bateleurs nègres dans les tribus*, exhibited in the Salon of 1859, was however inspired by a scene he had witnessed a decade earlier.[235] In 1848 at the *smalah* of a sheikh near Biskra he noted in his journal: "Arrival of wandering musicians, two Negroes and three donkeys . . . Stuffed bird, guitars with hair bows. Clothing of white calico with blue stripes. White turbans."[236] When he wrote *Un été dans le Sahara*, begun in 1853 and completed four years later, he greatly elaborated the description:

fig. 81

> We saw coming toward us two travelers on foot, leading three small asses. The men were Negroes, but true Negroes, pure blood, jet black, with rough spots on their legs and furrows in their faces grayed by the desert sun and wind: one might have said tree bark. Each wore a turban, a vest, and baggy trousers, and they were dressed all in white, pink, and pale yellow with strange ankle boots resembling old acrobats' laced slippers. They were almost old men, and the cheerfulness of their costumes, the effect of the soft colors against those mummies' bodies took me completely by surprise. One had a string of reed flutes around his neck, like the madman of Djelfa; he was holding a musette made of carved wood inlaid with mother-of-pearl and much embellished with shells. Slung around the other's chest was a guitar fashioned out of a turtle's shell joined to a rough stick.[237]

He went on to describe their strange animal marionettes, concluding: "Just imagine, my dear friend, what can come out of a Negro's fantasy when he whiles away his time remaking birds of sewn skins with legs and heads attached." Few of these details are apparent in the picture, however, where the *bateleurs* seem to provide no more than a pretext for assembling a group of variously posed figures in draperies of contrasting color in a limitless desert landscape beneath a sunset sky. Fromentin, who was acutely aware of the difference between verbal and visual images, rendered the strange incident that had caught his eye and imagination within the limits of what he regarded as pictorial possibility seeking, as he was later to put it, "truth beyond exactitude and resemblance beyond an exact copy."[238] But one of his most enthusiastic admirers, Théophile Gautier, translated the picture back into literature emphasizing the blackness of the *bateleurs*—"the blacks specters splashed in gaudy rags . . . gesticulating like drunk monkeys . . . The sweat streams down their bronze masks, and their fleshy lips open wide in laughter to reveal glistening, pearly teeth."[239] Nor did he fail to convert the mounted figure on the right of the composition into a stereotypical Arab—"the chief of the tribe, silent and dejected like a sphinx."

Black and Arab women figure in a painting by Fromentin dated 1873 but probably inspired by a scene he had witnessed at least two decades earlier (his last visit to Algeria was in 1853).[240] He had noted the black women in Algiers and written in *Une année dans le Sahel*:

figs. 82, 83

> As for the Negro women, like the men, they are people apart. They stride along the streets briskly, at a man's pace, never wavering under

82

83

their burdens, going forward with the self-assurance of people who take things easily, move freely, and keep their hearts free of sadness. They have large bosoms, long torsos, and very broad hips: nature destined them to their dual function of wet nurses and beasts of burden. *She-ass by day, woman by night*, says a local proverb that fits the black women as well as the Arab women. The way they carry themselves—a sort of rolling gait difficult to describe—helps to show off the robust opulence of their shape, and their white-checked haiks float like a nuptial veil around those large, immodest bodies.[241]

His painting is however a more generalized and at the same time more powerfully expressed image of female labor and endurance. Still more obviously than the *Bateleurs nègres*, it is a travel document transformed into a work of art, but with wider human significance. In 1853 he had written with reference to sketches recently made *sur le motif* at Laghouat: "You will see that my memories are worth more and that, when all is said and done, I have always produced much more from my memories than from my notes."[242]

83. Eugène Fromentin. *Femmes arabes en voyage.* Dated [18]73. Oil on wood. 49.5 × 61.6 cm. Houston, Menil Foundation Collection.

That blacks should be shown in these two paintings by Fromentin as entertainers and victims of social oppression—filling the conventional roles of minstrel and slave—may be no more than a coincidence. Although he saw the blacks in Algiers as "people apart," his extensive writings suggest no particular interest in their status. Nor was he concerned, like Gérôme, with distinguishing between the various peoples of the Orient. His art was almost deliberately antiethnographic. In his painting of women carrying water vessels, differences in skin color appear to be registered only for pictorial effect, and no emphasis is placed on those of physiognomy. Nor are these figures simply items in the colorfully picturesque North African scene. They are part of humanity observed and depicted from the viewpoint not only of a traveler but also that of the author of *Les maîtres d'autrefois* who was soon to praise Dutch painting for "the total absence of what we today call a *subject*."[243]

The Orient presented artists with an abundance of subject matter and also, paradoxically, the opportunity—which relatively few took—to evade the current demand for pictures with narrative content and concentrate on the manipulation of pigment, *l'Orient pour l'Orient* as *l'art pour l'art*. Gustave Guillaumet quite literally escaped from the academic tradition in which he had been trained when, having won the second *prix de Rome* for *paysage historique*, he set off for Italy in 1862 but changed course and went instead to Algeria. The subject pictures he had exhibited in 1861—*Destruction de Sodome*, *Enterrement d'Atala*, and *Macbeth et les sorcières*—were followed by *Prière du soir dans le Saharah* and *Souvenir des environs de Biskra (Saharah)* in 1863, and *Marché arabe dans la plaine de Tocria* and *Un soir dans le Sahara; au sud de Bouçada* (both of 1865).[244] He made at least ten visits to Algeria, despite the ill health he suffered there. Far from the coastal towns that were becoming increasingly Europeanized, he found the nomads and dwellers in the oases maintaining a way of life that seemed to remain in harmony with nature. He developed a kind of transcendental idea of the oneness of man and nature in the strange harmony created by the violent oppositions of color that he saw and strove to record on his canvases. In his paintings, as also in his writings, he concentrated on giving general impressions rather than precise details.[245] Ethnic differences between the figures, except in so far as all differed from Europeans, could therefore have little importance. There are blacks among the crowd of people swathed in white burnouses in *Marché arabe dans la plaine de Tocria*, but they have no extrapictorial significance.

figs. 84, 85

When Eugène Fromentin wrote a preface for a new edition of his travel books in 1874, he remarked: "The places have changed a great deal. Some of those I mention used to pass for being rather mysterious, but now they have all lost the charm of uncertainty, and long since."[246] The European presence had become pervasive. Numerous French *colons* had settled in Algeria which was already a French *département d'outre mer* sending deputies to Paris (and Tunisia was to become a French protectorate seven years later). The French and the British were present in Egypt, to be brought under their double control in 1876. And here Thomas Cook and Son had already begun to organize tourism, leading ever larger troops of sightseers to the markets, mosques, and ancient ruins. Only the harems of Muslim houses remained inviolate and mysterious.

84

85

There is, however, no suggestion that any change had taken place in the work of Leopold Carl Müller, a German-born, Austrian-trained artist who had studied in Paris where he was first much impressed by the work of Fromentin. In 1873 he made the first of nine visits to Egypt and promptly turned from historical subjects and rustic genre scenes to the Orient. Next year he painted and made his name with the picture of an Arab encampment in the desert, *Rast in der Wüste bei Gizeh*,[247] and in 1878 its urban counterpart *Markt in Kairo*.[248] Some figures in the two works are so similar as to suggest fig. 86 that they were sketched from the same models in Cairo and merely arranged in different settings when the canvases were painted in Vienna. Both allude to the continuity of life over the millennia in Egypt. The Pyramids loom up in the background of the desert scene; a man plays a harp of ancient Egyptian form in the foreground of the market in Cairo. That time stands still is also suggested by the precision of every detail: there are no fleeting movements of light or mysterious obscurities. Order is imposed on the confusion of a crowd by composition and careful selection. In the market a representative of every type of person to be observed in the streets of Cairo—with the exception of the Europeanized Egyptians and, of course, observing European tourists—is assigned a place, ranging in color from sallow to dark black, in ethnic origin from Levantine to Nubian, and of every age. Camel drivers, vendors of fruit and vegetables, a naked child, a woman carrying a huge water jar, an old blind beggar led by a black boy are all present—and, one might say, correct.

Müller was the most notable of the few Austrian Orientalist painters and enjoyed international success. He was however little patronized by Austrians who perhaps continued to see Islam as a threatening rather than a picturesque neighbor. Many of his works were acquired by the British who were far more actively engaged in exploiting the commercial opportunities offered by the Egyptian market.[249] Orientalism was, nevertheless, taken up by artists of all European nationalities and also Americans. The regular appearance of Orientalist paintings in the increasing number of international art exhibitions and their success with the art-buying public encouraged innumerable artists to jump on the same bandwagon, or perhaps one should say join the caravan. There was an extensive display of them in the Centennial Exhibition of 1876 in Philadelphia which also included reconstructions of their most familiar subjects—Near Eastern and North African bazaars and cafes. Their appeal was by no means limited to collectors and connoisseurs with politically or even economically colonialist ambitions. But whether they were imaginative[250] or purported to present a realistic view, all tended to express the whites' belief in their superiority over peoples of other color. It might be said that the presence of blacks as the equals of other figures suggested that all were equally inferior. In popular English terminology the contemptuous word *nigger* was applied indiscriminately to all darkskinned people.

Some artists had, of course, found and continued to find more than a source of picturesque subject matter in North Africa. Claude Monet, recalling his military service in Algeria in 1860–62, remarked: "It did me the greatest good in every way. . . . I could think of nothing but painting, intoxicated as I was by that wonderful country."[251] Yet he is not known to have painted a single Oriental subject. Auguste Renoir, lured by his

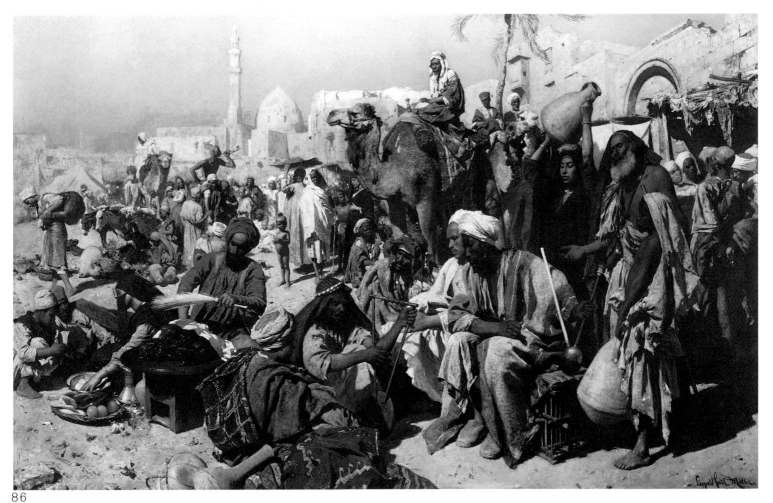

86

86. Leopold Carl Müller. *Markt in Kairo*. Dated 1878. 136 × 216.5 cm. Vienna, Österreichische Galerie.

admiration for Delacroix and a desire to see *le pays de soleil*, made two visits to Algeria in 1881 and 1882, recording his impressions on several canvases. He was struck by the light, the luxuriance of the coastal landscape, and, like so many earlier visitors, the statuesque bearing and biblical character of the people. But in his paintings, rendered in optical rather than local colors to record what the eye sees without reference to what the mind knows, black faces and brown are no more than dark spots in luminous mists.[252]

Jules Antoine Castagnary, a champion of the Realists, remarked in 1876 that "in a few years we shall be able to erect a stone and engrave on it these conforting words: 'Orientalism has lived in French painting'."[253] In the 1830s and 1840s Orientalist paintings had won the approval of several of the most conservative critics as well as devotees of the Romantics— Decamps was admired by both Etienne Delécluze and Baudelaire. But as the rift between the work of innovative artists and academic or Salon painters widened, the subject matter that had been an escape route for the former became increasingly a resort for the latter. In French reviews of the Salon and other art exhibitions *tableaux d'Orient* were discussed on their own, as a genre apart, from the 1850s. By the 1880s the *Orientmaler* was recognized in Germany as belonging to a professional category, on a par

with the *Tiermaler*.[254] A French Société des peintres orientalistes founded in Paris in 1893 began to hold annual exhibitions the following year, and a similar society was established in Algiers in 1897. Some of the artists adopted new pictorial techniques, but all helped to keep alive the myth of an unchanging Orient as the antithesis of the dynamically progressive Occident. This traditional opposition set pictures of the brilliantly lit, richly colored North African scene, its deserts, verdant oases, and cities teeming with an ethnically mixed, brown-skinned and black population, apart from those of other European colonies.

SENEGAL

French colonies in Africa south of the Sahara provided the subject for one, and only one, relatively small painting commissioned for Louis-Philippe's fig. 87 Musée historique at Versailles where the conquest of Algeria was celebrated on several large canvases, including Horace Vernet's vast *Prise de la smalah d'Abd-el-Kader*.[255] It records the eminently peaceful visit of the prince de Joinville, one of the king's sons, to the island of Gorée in December 1842 en route for Rio de Janeiro where he was to marry the sister of the emperor of Brazil. In the following year the prince, who had a position in the navy equivalent to that of his brother the duc d'Aumale in the army, made a tour of all the French establishments on the African coast and was regally entertained by the local rulers.[256] But the visit to Gorée seems to have been chosen as the subject for the picture in order to combine reference to the presence of a member of the House of Orléans with the House of Braganza, duly mentioned in the catalogue when the work was exhibited in the Salon of 1846. The artist, Edouard-Auguste Nousveaux, had been in Senegal between 1842 and 1845 and appears to have used sketches made on the spot to condense the essential data about Gorée in a single frame— in much the same way that Rugendas and other artists of the time depicted Brazilian scenes. He may indeed have composed the picture before receiving the official commission and merely added the figures of the prince and his entourage to the crowd of Africans, some of whom are clearly mulattoes, watching a traditional dance, with shipping, the harbor, and spruce colonial buildings, one flying the tricolor, in the background.

Gorée, an island only two kilometers from mainland Senegal in a bay that provided an excellent harbor, was among the earliest French trading posts on the African coast, first garrisoned in 1677. It was subsequently developed as a convenient point of departure for the Middle Passage, taken by the British in 1751 but returned to France by treaty in 1763. During the Napoleonic wars the island and other French establishments at the mouth of the Senegal River were again occupied by the British and not handed back to France until 1817. (*La Méduse* of Gericault's painting was the flagship of a convoy carrying troops and settlers to take possession while the British were leaving.) Subsequently, Gorée became a naval base and attempts were made to transform the settlements on the mainland into an agriculturally productive colony, without much success. They for long remained trading posts struggling to compensate for the declining traffic in slaves (abolition of the slave trade had been one of the conditions for the restitution of

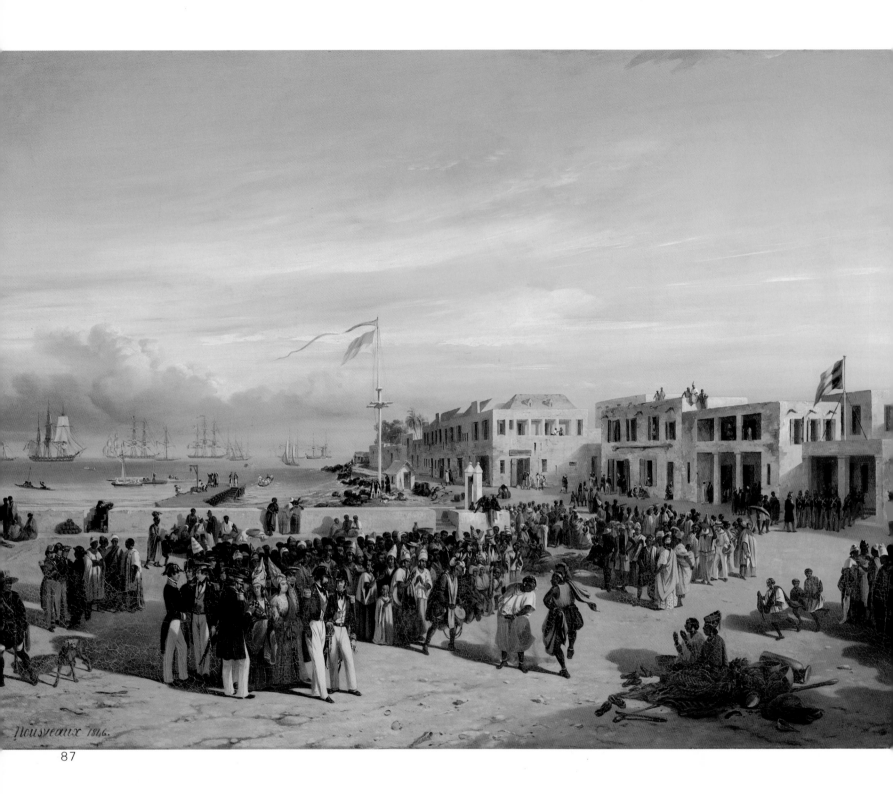

Nousveaux 1846.

87

87. Edouard-Auguste Nousveaux. *Le prince de Joinville assistant à une danse nègre à l'Ile de Gorée (Sénégal), décembre 1842*. Dated 1846. 131 × 178 cm. Versailles, Musée national du Château de Versailles.

Senegal to France) and to compete with the British who were extending their hegemony along the West African coast.[257]

Senegal, unlike Algeria, thus provided no background for celebrations of martial glory. That it was of interest in other ways was stressed by the Senegalese priest David Boilat who claimed: "Few regions on our globe offer so many varieties of the human species, so many topics for study, so much material for scientific research."[258] During his education in France he seems to have adopted the viewpoint of an outsider and regarded his native land as if through European spectacles. He asked:

> Do you want to visit the countryside, wend your way through our rivers' many branches? . . . You will see on display before you ravishing green mangroves soaring into the air; twittering and flitting in and out of their foliage are birds with plumage so splendid that our most colorful bouquets can conjure up only a pale image of them. Cast your gaze upon these sites, these groves planted by nature, these vast grasslands where herds of humpbacked cattle, sheep with long, silky wool, and young goats graze. Unavoidably you will expect to find in the distance an antique castle reminiscent of the perfection of the fine arts. At the very most you may encounter a few straw huts with an old Negress grinding millet to be used in her couscous.[259]

With this appreciation of the picturesque landscape he combined an anthropologist's curiosity in its ethnically mixed population:

> You will find material for studies and research of the most curious and interesting sort, from a scientific viewpoint. In a single area, what a variety of people, manners, beliefs, and languages! Some are as black as ebony, others somewhat lighter, some are the color of dark copper, others reddish, while still others are merely swarthy.[260]

To distinguish "one black people from another," however, written descriptions were inadequate.

> That certain something which characterizes the physiognomy of a race is reserved for the painter's art. It is to be found not in copies of other works of art nor in drawings taken from the imagination, rather from portraits of individuals. It is up to the painter to capture nature on the spot, in all parts of the world, and to report it in signs that anyone with eyes can read and comprehend.[261]

Although these remarks suggest that Senegal might be for artists as fruitful a field as the Orient, it was less easily accessible and its climate was believed to be insupportable for Europeans. There was no established artistic tradition for depicting the way of life of its inhabitants, except in the context of the Atlantic slave trade. Nor did it attract any painter of the caliber of Decamps or Vernet, let alone Delacroix, to blaze a trail through its pictorially virgin territory. The first French artist known to have depicted Senegal was Stanislas-Henri-Benoît Darondeau. Previously a somewhat unsuccessful painter of historical subjects, he accompanied a French naval captain Louis-

Edouard Bouët (later to style himself Bouët-Willaumez) who was charting the coastline while also persuading local rulers to make treaties ceding land to France. After a short time, however, Darondeau succumbed to a tropical fever and died in 1842.[262] His place was taken by Nousveaux who had been painting French landscapes for a decade without attracting much critical attention. Between 1845, when he returned to France, and 1848 he exhibited the first views of Senegal to be seen in the Salon—eighteen watercolors and four oil paintings including that of the prince de Joinville visiting Gorée. cf. fig. 87

One of the two oil paintings exhibited by Nousveaux in 1845 was described as representing a *"Moorish Camp on the Outskirts of the Sahara Desert, Bank of the Senegal River.* The Moors, having pitched their tents, eat their meal." The subject was as close to the Orient as was possible in West Africa. The other depicted the corpses of slaves exposed to be eaten by birds of prey, "an established custom on the Gold Coast." A quotation from Bouët's account of his travels was printed in the Salon catalogue to explain that the slaves in question were owned by Africans and had not been bound for the Americas.[263] The painting evoked, nonetheless, the idea most commonly associated with the West African coast. Bouët was presumably responsible for the choice of scenes painted by Nousveaux whose watercolors became the property of the Ministère de la Marine. In 1842 he was appointed governor of Senegal where one of his duties was to suppress the Atlantic slave trade. He thus became involved in the vexed question of the *droit de visite*, the humiliating right of the British to inspect French ships suspected of carrying slaves, and in 1845 he went to London to protest that this task was adequately performed by the French squadron. The Brazilians were at the same time trying to extricate themselves from a similar agreement with the British, and one may wonder whether there was not some collusion. In the previous year the prince de Joinville had raised the question while extolling the power of the French navy in a pamphlet described by Queen Victoria with characteristic underlinings as "a *most unfortunate* and *most imprudent* brochure."[264] His presence in the picture commissioned for the Musée historique may therefore have had another level of allusive significance.

In emulation of British Sierra Leone and American Liberia, the town of Libreville on the Gabon estuary was founded by Bouët. Here, for a few years, Africans liberated from ships illegally taking them across the Atlantic were given a home and set to work in a regularly planned environment very different from their native villages. By this time the slave trade north of the equator had been greatly reduced if not entirely suppressed. But the development of legitimate trade necessitated fuller exploitation of natural resources. Apart from a few images of *palabres* between local rulers and the French, most of the watercolors exhibited by Nousveaux were views of rivers, the only means of access to the potential riches of the interior.[265] He also depicted in oils the riverside village Diodoumé with a vast prospect of fig. 88
fertile but as yet uncultivated land.[266]

Attempts to increase the productivity of Senegal were however hindered by a way of life and work based on a traditional form of slavery. The French were obliged to deal with traditional Muslim landowners whose plantations for rubber and palm oil were worked by slaves, and their attention was directed as much to the abolition of the power of the former as to the emancipation of the latter. Nousveaux made several drawings of slaves or

88

88. Edouard-Auguste Nousveaux. *Village de Dio-doumé. (Fleuve du Sénégal)*. Ca. 1845. 47 × 72 cm. Paris, Musée des Arts africains et océaniens.

89. Edouard-Auguste Nousveaux. *Maison d'es-claves à Gorée*. Dated 1848. Watercolor on paper. 330 × 405 mm. (sight). Paris, Musée des Arts africains et océaniens.

89

90. George French Angas. *A Zulu in Visiting Dress*. Dated 1847. Preliminary drawing for *The Kafirs Illustrated*, 1849. Watercolor on paper. 327 × 237 mm. London, British Museum.

captifs one of which, dated 1848 after his return to France, showed them preparing manioc in a *Maison d'esclaves* on Gorée.[267] In the same year he exhibited in the Salon a picture entitled: "*Ile de Saint-Louis in Senegal*: View taken from Guetidar beach facing the government palace and two barracks. Governor Edouard Bouët reviewing the troops of Senegal upon their return from an expedition against rebel tribes on the upper river, 7 August 1843."[268] With the benefit of hindsight the incident can be seen as marking the beginning of the spiral of territorial acquisition widening into the interior of the continent as one tribe after another was subdued to protect, as much as to increase, the colonized area. This was the last view of Senegal to be exhibited by Nousveaux—followed by very few by other artists later in the century. In 1890 some of his drawings were, nevertheless, reproduced in a book by Colonel Frey, a governor of Senegal. They include a portrait of King Denis, who ceded the left bank of the Gabon to France and was given the title of Chevalier de la Légion d'Honneur (he is shown in French costume with a huge plumed hat beside him), and a few images of slaves as illustrations of a practice eradicated under colonial rule which established Europeans as the only masters.[269]

fig. 89

SOUTH AFRICA

The inhabitants of the territory adjacent to the British colony in South Africa were far more frequently depicted than those on the borders of Senegal. George French Angas went there in 1846–47 in search of subject matter similar to that he had just found among the aborigines in South Australia and the Maoris of New Zealand. Trained as a natural history illustrator and topographical draftsman, he described himself as "a disinterested observer, who went to the Antipodes actuated by an ardent admiration of the grandeur and loveliness of Nature in her wildest aspect."[270] Conscious that tribal life was liable to be swept away by colonization, he set out to represent the people of southern Africa, as well as Australasia "with unexaggerated truth and fidelity." His quest led him into the land of the Zulu who were temporarily at peace with their African neighbors and also the Europeans. The Zulu nation emerged in the early years of the century as the most powerful and bellicose in the whole continent. Since that time it had excited the fear of the colonists and also much interest, especially on account of its large army of resolutely fearless warriors obliged to lead a celibate life dedicated exclusively to military exercises when they were not fighting. Angas depicted some of these warriors, the boys and girls in dancing dress, and also men and women leading an apparently peaceful life in the kraals.[271] The drawings he made on the spot provided the basis for thirty colored lithographs and eleven wood engravings published in a handsome folio entitled *The Kafirs Illustrated in a Series of Drawings Taken among the Amazulu, Amaponda, and Amakosa Tribes* (London, 1849).[272] They are much more closely observant than the aquatints after Samuel Daniell's drawings published four decades earlier[273] and mark a sharpening of focus from the generally picturesque and exotic to the ethnographically informative. Skills developed by natural history painters to record the distinguishing features of a species—the

fig. 90
fig. 91

UYEDWANA. at Issekobosa Kraal.
G. F. Angas. 1847.

91. George French Angas. *Zulu Woman Making Pottery*. Dated 1847. Preliminary drawing for *The Kafirs Illustrated*, 1849. Watercolor on paper. 245 × 348 mm. London, British Museum.

92. Frederick Timpson I'Ons. *Portrait of Maqoma*. 1852. 33 × 26.7 cm. Johannesburg, Africana Museum.

93. Frederick Timpson I'Ons. *Portrait of Sandilla*. 1852. 33 × 26.7 cm. Johannesburg, Africana Museum.

94. Frederick Timpson I'Ons. *Witch Doctor with Woman and Children*. Ca. 1846. 25.4 × 35.5 cm. Johannesburg, Africana Museum.

91

feathers of a bird or the petals of a flower—were adapted by Angas to the meticulous representation of human physique, physiognomy, clothing, and accouterments. His illustrations are objective in the German sense of the word: they record the visual appearance of the Zulu uncolored by personal feelings or opinions, quite simply as specimens for study.

These images by Angas suggest nevertheless a lingering belief in noble savagery. A painting by Frederick Timpson I'Ons of a witch doctor, a woman, and children, presents another side of African life.[274] The activities of witch doctors, especially their "smelling out" of evil spirits, had been made notorious by missionaries and were among the pretexts for "liberating" Africans from their traditional religious beliefs and practices—by force if necessary. There is more than a hint of caricature in the picture although it may have been done from life. Whereas Angas addressed the public in Britain where the Aborigines Protection Society (founded in 1839) was strongly influencing public opinion and colonial policy against the territorially ambitious Boers, I'Ons worked for a clientele in South Africa itself. In 1834 he settled at Grahamstown on the eastern frontier of the colony and made his living by portraying Europeans and also painting scenes of Xhosa life; it appears that he sold the latter to officers of the British army stationed in the region as a peace-keeping force between the Boers and the indigenous population. Thus it was for a "General Maclean" that he painted in 1852 half-length portraits of Maqoma and Sandilla.[275] Maqoma was the leader of a Xhosa group who had been dispossessed of their lands on the Kat river, returned in 1834 with 12,000 warriors and ravaged the country, was taken by the British and imprisoned for a while but in 1846 directed a raid that captured nearly half a train of Boer trekkers' wagons and a large number of oxen. Sandilla, his nephew, became paramount chief of the Xhosa and his deposition by the British for insubordination in 1850 provoked the Eighth Xhosa War as a result of which his people were driven over the

fig. 94

figs. 92, 93

92

93

94

95

Great Kei river and their former lands made over to whites. Both men were enemies from a British viewpoint, but enemies who commanded respect. The portraits by I'Ons, despite—or perhaps because of—their naïveté, carry conviction as documentary records of two formidable African rulers who aroused mixed feelings on the frontier.

In addition to portraying the Xhosa leaders I'Ons depicted the land for which they bravely if vainly fought. His view of a reach on the Kowie river fig. 95 evokes the well-watered terrain coveted by white farmers.[276] Another, more talented, British artist in South Africa, Thomas Baines, painted the ford at the junction of the Kat and Brak rivers, worked up from a sketch made on fig. 96 an excursion from Grahamstown with an official in the colonial service.[277] In both pictures Africans stand somewhat idly in the potentially productive landscape. Baines noted in his journal "the fine figures, unconstrained and easy motions, and graceful drapery" of the people in this region who "forcibly reminded" him of "the statues of antiquity."[278] At this fairly early stage in his career his view of Africa seems still to have been colored by the classical myth of the Golden Age, and his means of representing the country conditioned by the picturesque tradition of topographical painting.

132

95. Frederick Timpson I'Ons. *Reach on the Kowie River*. Dated 1851. 206.5 × 296 cm. Port Elizabeth, City Hall.

96. Thomas Baines. *Ford at Junction of Kat and Brak Rivers*. Ca. 1848. 62.9 × 45.7 cm. Johannesburg, Africana Museum.

96

Thomas Baines spent most of his life in Africa from 1842, when at the age of twenty-two he sailed from England to Cape Town, until 1875 when he died in Durban.[279] He traveled far beyond the colonial frontiers in the south and center of the continent, both on his own account, and as an artist accompanying explorers, David Livingstone on his ill-starred Zambezi expedition of 1858–59 (until they quarreled) and James Chapman on that of 1861–62 to the Victoria Falls which he was the first to depict. In drawings, watercolors, and oil paintings, to a total of some four thousand, he made a uniquely extensive visual survey of African life and landscape in the mid-nineteenth century. He portrayed individuals and families of the San, Khoikhoi, and the several Bantu-speaking groups, including of course the Zulu, painting whenever possible from life in the open air. He recorded the daily activities of the kraals and their ceremonies—Tambookie youths who had just undergone initiatory circumcision and several war dances. With an apparently detached curiosity rare at the time he painted a group of fetishes.[280] As a traveler and an artist he seems to have been impelled by a spirit of adventurous curiosity. His aim was quite simply to record what he had seen in areas as yet little visited by Europeans. As a writer in the

97. Thomas Baines. *Village near Tete (Mozambique)*. Dated 1859. 45.8 × 65.8 cm. London, Museum of Mankind.

98. Thomas Baines. *Working a Coal Seam near Tete (Mozambique) on the Lower Zambezi*. Dated 1859. 45.5 × 66 cm. London, Royal Geographical Society.

Anthropological Review remarked in words that sum up the prevailing attitude of British ethnologists:

> The author, while he has no sympathy with that class of philanthropists who injure the cause they strive to serve by representing the native as living in a state of primæval innocence till he learns wickedness by contact with the white man, is equally removed from those who, on the other hand, would degrade the Negro to the level of the gorilla—his object has been fairly to record the impression produced on his own mind by events of which he became cognisant, neither shutting his eyes to the degrading vices of the savage, nor seeking to deny him such virtues as are occasionally displayed even by the most barbarous.[281]

On the Zambezi expedition Baines painted a view of a village near Tete far in the interior of Mozambique.[282] It is a carefully composed fig. 97 picture which itemizes the buildings, artifacts, costumes, domestic animals, and activities of the people as well as giving an impression of the wide landscape, with a huge baobab tree—almost a symbol of tropical Africa—in the distance. Another painting of the same region shows scantily dressed fig. 98 Africans working a coal seam under the supervision of two blacks in European dress—a rare equivalent to scenes of slave labor on the other side of the Atlantic.[283] As in so many Orientalist pictures, the presence of the European observer (who would in fact have aroused embarrassing curiosity in such a place) is ignored. There can be little doubt that this was intentional.

97

98

99

Baines made use of photographs and in "almost every one" taken on his travels found "some little bit of effective representation that I, as an artist, would give almost my right hand to be able to reproduce." But, he remarked:

> As for the difficulties in the way of a photographer, their name is Legion: the restlessness of the sitters, who naturally shrink when the mysterious-looking double-barrelled lenses are levelled full at them, and cannot imagine what "the shadow-catcher" is doing under the black curtain. . . . the different conditions of atmosphere and intensity of the sun—the constant dust raised either by our people or the wind—the whirlwinds upsetting the camera, and no end of other causes—combine to frustrate the efforts of the operator.[284]

He recognized that the photographic fidelity for which he strove could, paradoxically, be achieved only in a painting which gave the illusion of a scene observed as if by a disembodied spectator from another world.

Conflicts between settlers and the indigenous population, however, provided subjects for a number of his drawings and paintings. One of them

136

99. Thomas Baines. *The Battle of Blauwkrantz, 1838*. Dated 185[4?]. 62.9 × 66.8 cm. Johannesburg, Africana Museum.

100. Thomas Baines. *A Zulu War Dance*. Dated 1860. 44.8 × 60 cm. South Africa, Private Collection.

commemorates the Battle of Blauwkrantz, showing Boer men, women, and children and a Khoikhoi servant with guns warding off magnificently athletic Zulu warriors armed only with assegais. As a label on the back declares, it depicts the "attack on the waggons of the Dutch emigrant Boers after the murder of their Commandant, Pieter Retief, by the Zulus under Dingaan at Natal, 1838."[285] Retief had attempted to trick Dingane into signing a treaty which ceded a large part of his kingdom to Boer emigrants from the British colony. But he and seventy companions were trapped by Dingane who saw through their ruse, had them all impaled and sent his warriors to massacre men, women, and children in the Voortrekker encampments. It was an incident that the Boers were never to forget or forgive, the pretext for terrible reprisals in a series which soon involved the British and led to the crushing of the Zulu nation.[286] Baines painted this picture sixteen years after the event (which he had not witnessed) during one of his visits to England, not in Africa. The canvas is rather larger than those he normally used, and he was perhaps attempting to establish his reputation as a painter of history rather than a mere reporter.[287] If so, he failed. No paintings by him were shown in any British art exhibition though some of his portraits of Africans were displayed at meetings of the Royal Society and the Anthropological Society.[288] They seem to have been regarded less as works of art than as geographical documents. As such they are comparable with paintings of other parts of the world remote from Europe by artists of the same generation, constituting a subgenre of informative (rather than expressive) works to which neither art critics nor collectors paid much attention.[289]

fig. 99

The painting by Baines of a Zulu war dance has, however, a different significance.[290] For it records no prelude to a combat but a spectacle

fig. 100

100

101. Thomas Baines. Pencil drawing of a *Dance of the Matabele (Ndebele) Warriors*. 1869–70. 240 × 240 mm. London, British Museum (Natural History).

102. Adolph von Menzel. *Die Zulus*. Ca. 1850–52. Watercolor and gouache on paper. 275 × 303 mm. Hamburg, Hamburger Kunsthalle.

101

staged for the entertainment of Prince Alfred, Queen Victoria's second son who can be seen with his escort in the background. The prince and his elder brother (who went to Canada) had been sent off on the first of the innumerable tours of empire made by members of the British royal family. In South Africa the prince visited Kaffraria, Natal, the Orange Free State, and Cape Town where he laid the foundation stone of a breakwater in Table Bay. "What a cheering picture is here," his father wrote, "of the progress and expansion of the British race, and of the useful co-operation of the Royal Family in the civilisation which England has developed and advanced."[291] A decade later Baines made a drawing of dancing Matabele or Ndebele warriors who seem still more docile and theatrical than the Zulus executing their command performance.[292] But Africans could not be transformed into innocuous performers dancing for the pleasure of whites as easily as these images suggest: the Zulus were to administer a violent shock to the British at Isandhlwana in 1879, the Ndebele in 1893 and 1895.

fig. 101

SAVAGERY AS A SPECTACLE

In Europe Africans aroused popular interest for their savagery rather than their docility. The "Hottentot Venus" exhibited as an isolated curiosity[293] was followed by whole groups taken to Europe to give demonstrations of their ways of life. One of them, in the throes of a frantic dance on a rough stage before a crudely painted backdrop jungle, was depicted in Berlin by Adolph von Menzel with all his ability to catch—one might almost say to "snap"—momentary visual appearances.[294] The troupe was similar to,

fig. 102

102

and may even have been the same as, that of Zulus or "Kaffirs" which was brought to London from Port Natal in 1853 and thrilled audiences by enacting a witch finder's search "to discover the culprit whose magic has brought sickness into the tribe," a military expedition, a hunt, and a wedding "all with characteristic dances."[295] A writer in the *Spectator* declared that

> the exhibition transcends all others we have witnessed of the kind. The charm-song and the proceedings of the witch-finder or "smeller out" were especially expressive and forcible in their pantomime. As for the noises—the howls, yells, hoots, and whoops, the snuffling, wheezing, bubbling, grovelling, and stamping—they form a concert to whose savagery we cannot attempt to do justice.[296]

Charles Dickens dissented from the general enthusiasm and sharply attacked the notion of the "noble savage" in an essay prompted by the exhibition of the "Kaffirs." "I have not the least belief in the Noble Savage, I consider him a prodigious nuisance and an enormous superstition," he wrote. ". . . I call a savage a something highly desirable to be civilised off the face of the earth."[297] In the previous year he had satirized philanthropic concern for Africans in *Bleak House*. Basically, however, his attitude to savagery differed little from that of philanthropists and missionaries who sought to civilize Africa. They all assumed African culture to be inferior. (And not until much later was African dancing to win Western admiration.) The exhibition in London had a topical interest, for it coincided with the last stage of the Eighth Xhosa War when, as a writer in *The Athenæum* remarked, the "Kaffirs" were "giving us more trouble and thought" than any other nation.[298] If only indirectly, it might seem to justify the "pacification" of southern Africa— no custom aroused greater horror in colonial officials as well as missionaries than that of "smelling out" witches, and Dickens gave prominence to it in his essay.

In Germany, which had as yet no African colonies, the performance of the Zulus may have been regarded rather differently. It seems to have aroused much less attention. Menzel's watercolor was one of several he painted in the 1850s for his *Kinderalbum* which was devoted mainly to scenes in the Berlin zoo. This juxtaposition of Africans as entertainers with children and animals was, no doubt, fortuitous. But blacks were beginning to be associated with the circus. Georg Cornicelius, in a painting exhibited in Munich in 1858 entitled *Musizierende Kunstreiterbuben* ("Circus Boys"), gave fig. 103 the central position to a nearly naked black child flourishing cymbals in his outstretched hands while one of his white companions blows a trumpet, the other beats a drum, and a dog howls at the cacophony.[299] Paul Meyerheim's *Die Wilden* of 1873 depicts a fairground booth in which well-behaved white fig. 104 children and a few old people gape at the antics of African dancers while an impresario seems to provide a commentary.[300] It was painted the year before Carl Hagenbeck in Hamburg founded his enormously successful traveling show in which human beings and animals from all parts of the non-European world were displayed in tableaux vivants.[301] A later picture by Meyerheim, who was mainly a *Tiermaler*, is of a menagerie with an African holding a fig. 105 live crocodile on his shoulders as the focus of attention.[302] Earlier in the century exotic animals had often been attended by people from their native

103

habitat. But now collectors in Africa sought human beings as well as animals for the European zoos. In Meyerheim's painting man and beast seem almost inseparably part of the world of wild nature—and a European keeper is in charge of both. Once again there are children among the spectators, for such displays were supposed to be educational and surely made on the young an indelible impression of African savagery.

"Africa is always producing something new," Pliny's quotation of an earlier Greek adage, was given new meaning in the nineteenth century.[303] Africa was explored by Europeans for the first time. Major discoveries of rivers and lakes and mountain ranges were made and publicized in the enormously popular geographical magazines—*Über Land und Meer* from 1858 in Germany, for instance, and *Le Tour du Monde* from 1860 in France. Specimens of the people and their artifacts, of animals and plants were brought to Europe in ever increasing numbers, one novelty soon followed by another. In the second half of the century exhibitions of African life became more frequent as colonization made the material for them more readily available. They formed in fact an essential part of the colonial exhibitions that were inspired by pride of conquest and a self-justifying urge to demonstrate the contrast between savagery and civilization. This was made particularly obvious in the "Savage South Africa" display in the Greater Britain Exhibition of 1899 where 174 Africans in a so-called Kaffir Kraal gave "A Vivid Representation of Life in the Wilds of the Dark Continent."[304] Incidents from the Matabele War of 1893 and the Matabele uprising of 1896–97—in which British colonists were massacred—were dramatically reenacted. The outcome of such "savage wars of peace"—Rudyard Kipling's

104

104. Paul Friedrich Meyerheim. *Die Wilden.* Dated 1873. 80 × 112 cm. Aachen, Suermondt-Ludwig-Museum.

105. Paul Friedrich Meyerheim. *In der Tierbude.* Dated 1894. 88 × 129 cm. Dresden, Staatliche Kunstsammlungen, Gemäldegalerie Neue Meister.

phrase—was later displayed in a Dahomey village assembled by the French and put on show in a number of exhibitions from 1908: it included a shop with European merchandise "tempting the native . . . by their brightness and cheapness." "The days of savagery are passing away," the cataloguers remarked: "one day the European tourist will go to far Dahomey as he now does to Egypt in search of sunshine and merriment in the winter months."[305]

So far as the visual arts are concerned, however, very little that was new came out of Africa until the beginning of the twentieth century. Africans who had figured for a relatively short time as objects of compassion while abolitionists campaigned on their behalf, were put back in the ancient role of savages to whom nobility was now seldom ascribed. Evolutionary theories traced the "descent of man," strengthened the earlier association of blacks with apes even while admitting that Europeans had the same remote ancestry. "If this book be true," the professor of geology at Oxford wrote of the pre-Darwinian *Vestiges of the Natural History of Creation* published by Robert Chambers in 1844, "religion is a lie; human law is a mass of folly, and a base injustice; morality is moonshine; our labours for the black people of Africa were works of madness; and man and woman are only better beasts."[306] The idea of the evolution of man out of the animal world had, nevertheless, a strong appeal in the historicist climate of the time. Africans

105

were regarded as representatives of the childhood of the human being, culturally if not also biologically. The social application of Darwin's theory of "the preservation of favoured races in the struggle for life" only served to support white arrogation of superiority and provide a paradigm for colonial expansion in natural history. It is more than a coincidence that Orientalists evoked a timeless world where material progress had halted many centuries before, that their pictures were so often close to historical compositions, and that painters in sub-Saharan Africa focused on its most obviously "primitive" characteristics.

III

THE SEDUCTIONS OF SLAVERY

THE CURTAINS OF THE HAREM

A black man, large as life, holding the reins of a white horse in one hand while he plunges a dagger into its throat with the other, is given great prominence in Eugène Delacroix's *The Death of Sardanapalus*.[1] The scene fig. 106 is set in ancient Assyria but, from the beginning, Delacroix determined that it should include one or more blacks. On a sheet of rough pencilings of heads drawn when he was first contemplating the subject he wrote among several other inscriptions: "the fierce Ethiopians, heads of Marabouts, of Africans, of Nubians" and, more cryptically, "exaggerated sketches after the Negro."[2] A supremely accomplished pastel study of a black model—sketches fig. 107 of his head with a gently pensive expression as well as the full length of his muscularly supple body in energetic movement—dates from a somewhat later stage of work on the composition.[3] Neither here, nor in the finished picture, were the man's features in any way exaggerated although he was given a savage role in this powerful vision of the opulence, the violence, and the voluptuousness associated with the Orient.

The *Death of Sardanapalus* exhibited in the Salon of 1827–28, to the horror of classicists and the consternation of most of Delacroix's admirers, was a defiant, one might say an outrageous, declaration of allegiance with the Romantics. It was inspired by, although significantly not directly based on, Byron's tragedy. Delacroix's erotically imaginative choice of subject was a kind of manifesto for the autonomy of the artist as creator and destroyer, his rendering of it a demonstration of the supremacy of color over line, dynamic movement over stability and order. In this uninhibited display of orgiastic sexuality and violence, of sensual indulgence in rich colors and contrasting textures—flesh and silk, sparkling gold and polished steel—of exuberantly vital brushwork, the black slave has a place of great importance for the darkness of his body and the vigor of his pose among the pale-skinned,

145

106

soft-bodied women in attitudes of frenzied exhaustion or of pain which is also rapture. He is an instrument of the passion and self-destructiveness of the king of Nineveh who ordered the massacre of his concubines, slaves, and horses before he too was burned to death in his palace.

No painting could make a greater contrast with this dramatic scene than Delacroix's *Women of Algiers in Their Apartment* in which sensuality is low- fig. 108 keyed, movement suspended, and time arrested.[4] It was exhibited in 1834, the first major product of his North African travels[5] and at the same time the first of his large Salon pictures (nearly two meters high) which had no literary or historic subject matter. The painting was indeed based on a scene of a type which very few other nineteenth-century artists had the opportunity to observe. When he was in Algiers, an acquaintance succeeded in having him admitted to the female quarters of a Muslim household and recorded how Delacroix was "intoxicated by the sight he beheld," remarking: "It was as in the time of Homer! The woman in the gynaeceum taking care of her children, spinning wool or embroidering marvelous fabrics. It was woman as I understand her!"[6] In a series of pencil and watercolor drawings, presumably made shortly after leaving the house, he sketched the poses of

106. Eugène Delacroix. *The Death of Sardana-palus.* Salon, 1827-28. 392 × 496 cm. Paris, Musée national du Louvre.

107. Eugène Delacroix. Sheet of sketches for *The Death of Sardanapalus.* Pastel over pencil, sanguine, and white chalk on paper. 440×580 mm. Paris, Musée national du Louvre.

107

108

the three seated women as they were to appear in the picture, carefully noting their names. But the black servant standing on the right in the finished composition seems to have been an afterthought. His only known drawing for her was made in Paris from a studio model.[7] Although such a figure was as much a constituent part of an Oriental interior as a nargileh, one may doubt whether that was the only or even the main reason for her inclusion. She provides a necessary upright to counterbalance the pose of the Algerian woman on the left, as well as adding a very gentle rustle of movement to the otherwise static scene. The darkness of her skin and the rough simplicity of her servant's dress also make a telling contrast with the seated figures. Such a black woman in an Algerian household would probably have been a slave, but in the painting she carries no burden of symbolism.

When the *Women of Algiers* was first exhibited, Gustave Planche remarked that it "is only concerned with painting and has nothing to do with the literary nonsense of dabblers or the sentimentality of frivolous women." He called it "the most brilliant triumph that M. Delacroix has ever achieved . . . It is painting and nothing more—fresh, vigorous, vividly defined, possessing a Venetian boldness yet owing nothing to the old masters it brings to mind."[8] More perceptively perhaps, if also more subjectively, Baudelaire wrote: "This poem on an interior, filled with repose and silence, laden with costly fabrics and toilet articles, exhales that certain heady perfume of houses of ill fame that soon leads us to the unfathomable regions of sadness."[9] For the painting of a harem in which women patiently wait to serve the pleasure of their master could hardly fail to arouse thoughts of the brothel.

A few years later, in 1840, Jean-Auguste-Dominique Ingres completed the painting known as *Odalisque with a Slave*, a harem scene which differs as much from the *Women of Algiers* as from the *Death of Sardanapalus*.[10] He might almost be credited with inventing the image of the white odalisque who all but supplanted classical goddesses and nymphs in nineteenth-century art. He began with two paintings of female nudes, the seated *Bather of Valpinçon* of 1808 (Musée du Louvre) and the recumbent *Sleeper of Naples* of 1809 (lost). As a pendant for the latter he painted in 1813 a wakefully expectant female nude in an Oriental setting—Turkish textiles and jewelry, a peacock-feather fan, and a nargileh—which he exhibited at the Salon of 1819 as *An Odalisque* (later to be called *The Great Odalisque*, Louvre).[11] The seated nude reappears in the so-called *Small Bather* of 1828 (also in the Louvre) as a member of a harem, with background figures derived from eighteenth-century prints of Turkish life, including a black servant dressing the hair of a white woman.[12] For the *Odalisque with a Slave*, he reverted to the pose of the *Sleeper of Naples* adding a female musician of Indian complexion playing a tamboura—the slave of the title—and setting them in a room with rich Islamic decorations, cushions and draperies and metalwork. He painted the picture for his friend of many years, Charles Marcotte d'Argenteuil, to whom he wrote in 1836: "I must forewarn you that this will perhaps not be Madame Marcotte's painting, for it is gallant, but honest it is true. In short, I put all these considerations on your conscience. We may be beaten, let's be on the lookout!"[13]

Ingres determined the theme of the picture—a languorous, all but nude woman lulled by music—and even its general composition before deciding on a specific subject, let alone a title. On an early drawing for it he wrote: ". . . The sultana's repose/a sultana reposing in the midst of her women /a Sultana and her women/Sleep/Italian woman/Italian having a siesta /the Siesta a guitar. . . ."[14] Characteristically he drew a series of exquisite nude studies for each of the two women. No preparatory drawing for the black standing in the background is recorded. This figure in turban and fine brocaded robe is, however, more than a mere part of the Oriental decor. To the public familiar with accounts of harem life he was of course recognizable as a eunuch, the sexually impotent guardian and observer of the beautiful, sensual creature who is made to seem all the more desirable for being unattainable. In a second version of the picture, painted in 1842, fig. 109 Ingres removed the rear wall of the room, opening a view onto a Persian or Mogul garden with women disporting themselves beside a canal.[15] Here the black, instead of closing the scene, is given a transitional position between

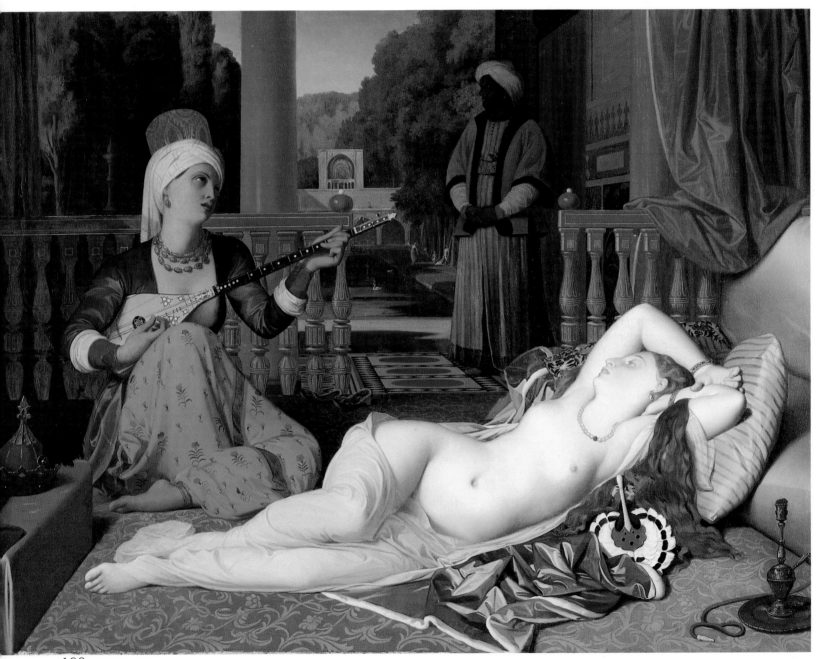

109

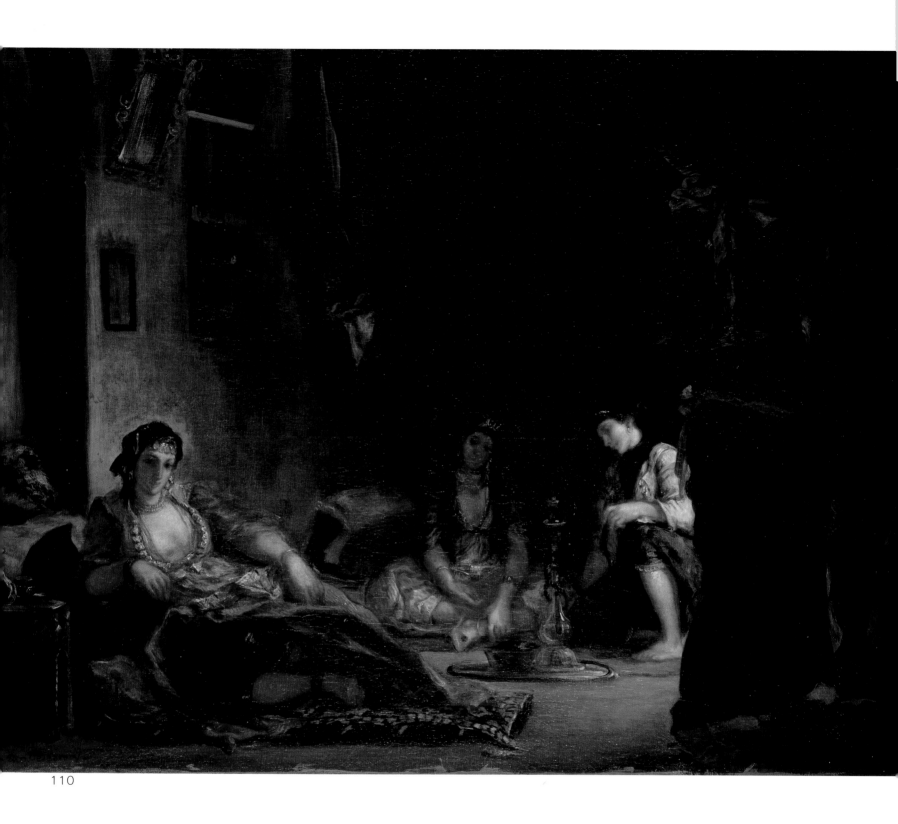

110

foreground and background. Half-silhouetted against the distant trees, he is made far more conspicuous, and at the same time his role as eunuch within the harem is emphasized. And the recumbent figure also undergoes a change in role from the sultana to an odalisque—one of the many slaves of sensual pleasure who haunted the erotic daydreams of European men. This second version is more obviously *galant* than the first, and perhaps a shade less *honnête*.

Delacroix's *Women of Algiers* was also subtly transformed in a second and, in this instance, smaller version, painted in 1847–49.[16] But he reduced still further the erotically exciting aspect of the subject. The first version, though based on direct observation in the Algerian house, was composed as a theatrical tableau with the figures posed "front stage." In the second, the space is somewhat deeper but still more rigidly walled in (without a door), and the suggestion of theater is emphasized by the black servant who, instead of tiptoeing out of the picture, lifts a curtain to reveal the forbidden place to the spectator. Delacroix could hardly have removed his evocation of life in the harem further from that conjured up by Ingres, in content as well as pictorial technique. And although his black woman is, like the eunuch depicted by Ingres, subservient, she has a revelatory role.

When Eugène Fromentin described his visit to a house in Blida—a partly fictitious incident in his otherwise factual travel book—he remarked that, on reaching the room of its mistress, "the black servingwoman turned her head halfway toward me and made the same gesture that you see in Delacroix's painting to draw aside the curtain of flowered chiffon." The room was, he said, "in every way similar" to that of the *Women of Algiers*.

> It is just as charming. It is not more beautiful. In nature, life is multifarious, details more unpredictable; nuances are unlimited. There are sounds, odors, silence, gestures strung together in time. In a painting, the nature of the scene is defined, the moment predetermined, the choice perfect, the stage set forever and absolutely. It is the formulating of reality—what should be seen rather than what is, the verisimilitude of truth rather than the truth.[17]

But few Europeans were able to check the authenticity of Delacroix's paintings. They exerted some influence on younger painters, but less on Orientalists than on those seeking new means of recording visual impressions (with ideas diametrically opposed to those of Fromentin). The two pictures by Ingres, on the other hand, gave form to mental images of the denizens of harems—not least perhaps because the recumbent woman conformed with European ideas of female beauty (she was in fact painted from an Italian model). There is a direct reference to "Ingres's odalisque" in Théophile Gautier's "Poème de la femme," and she seems also to recline in "the warm air redolent with the scent of jasmine" of Leconte de Lisle's "La vérandah"—a poem with an intricacy of construction analogous with *Odalisque with a Slave*.

The Orient provided a setting for erotic fantasy in paintings by Jules-Robert Auguste. He was a collector of North African costumes and accouterments, though it is not known for certain whether he ever crossed the Mediterranean.[18] His paintings make no pretense of recording scenes

fig. 110

111. Théodore Chassériau. Othello beside Desdemona's corpse. Dated 1847. Oil on wood. 27 × 21 cm. Metz, Musée d'Art et d'Histoire de Metz.

111

observed in North Africa or the Levant. A man of independent means, he painted for his own pleasure neither exhibiting nor selling his works and was thus able to give free rein to his excited imagination, fed by memories of earlier, especially eighteenth-century, and contemporary art. And in some works he celebrated the allure of black women with a frankness unique in the visual arts of his time and rare in literature apart from such a passing reference as that by Victor Hugo to

> Les vierges aux seins d'ébène,
> Belles comme les beaux soirs,
> Riaient de se voir à peine
> Dans le cuivre des miroirs. [19]

Auguste depicted one from behind, completely nude, mounting a horse—the familiar symbol of virility.[20] Another he showed in love play with an almost startlingly white-skinned woman in a watercolor and a pastel.[21] In this image of caressing sensuality there is—most unusually—no invidious comparison between black and white, nor any suggestion of difference in status. Auguste, a friend of Delacroix, was a colorist who delighted in combinations and contrasts of hue, whether of textile, animal pelts, or

fig. 112

112

human flesh, for pictorial effect. And *Les Amies* is an essay in the use of color rather than line to suggest rather than to define form. But it is also a delicately erotic image from which all grossness is eliminated by the transposition of difference in gender into that of skin color, without any diminution of voluptuousness.

In Western art virile blacks rarely appear in the company of white women until late in the nineteenth century. A small painting by Théodore Chassériau is exceptional.[22] It shows Othello lifting the pillow with which he has just smothered Desdemona who lies in what might be mistaken for an attitude of postorgasmic exhaustion. *Othello*, illustrated only in engravings for complete editions of the works of Shakespeare before the very end of the eighteenth century, had subsequently begun to provide subject matter for painters throughout Europe. It became indeed one of the most frequently illustrated of all Shakespeare's plays. But in England doubts had been expressed as to whether Shakespeare had envisaged Othello as a black rather than an Arab.[23] English artists tended to give him a dark skin but European features (like those of actors who played the part) and also to avoid the tragic climax of the play. Similarly Delacroix, inspired by Rossini's opera rather than Shakespeare's text, gave him a bearded, tawny countenance and showed him stealing into Desdemona's bedroom.[24] In a series of etchings published in 1844 Chassériau depicted him as an Arab.[25] Only in his oil painting, which may not have been intended for public exhibition, did he stress the contrast between the blackness of Othello and the whiteness of Desdemona.

fig. 111

The importance of the blackness of Othello—"the old black ram," "thick lips"—for a full understanding of the play was appreciated by Heinrich Heine who wrote that Desdemona "was so bound in chains of magic that the timid, tender child felt herself drawn to the Moor and had no fear of the hideous, black mask which the multitude regarded as the face of Othello:" she saw "the beautiful, white face of the soul." The choice of adjectives, reducing Shakespeare's subtle psychological drama to the level of "Beauty and the Beast," reveals how conventional attitudes to blacks could be accepted unquestioningly even by a poet of Heine's humane sensibility. He went on to describe Desdemona as "tender, sensitive, patient, like those slender, great-eyed lights of women who beam so lovingly, so softly and dreamily, from the Sanskrit poems"[26]—and one may wonder whether he did not have in mind contemporary paintings of odalisques as much as Indian literature. Chassériau's painting seems also to place her in an Orientalist harem. But it suggests, at the same time, the mixture of disgust and pruriency with which the coupling of Othello and Desdemona could be regarded. For while she exemplifies the ideal of soft, yielding femininity, he is the dominant male. White and black, good and evil, soul and body, passivity and activity: these opposites compose a metaphor for the sexual act as understood at the time.

In a painting of the biblical Esther, exhibited in the Salon of 1842, Chassériau included an androgynous black attendant with muscular, male arms, feminine headdress and jewelry—presumably the eunuch keeper of the women, Hegai—to set off the preternaturally slender, white, golden-haired central figure raising long braceleted arms to display her nubility.[27] Such an entirely secular and sensual rendering of a scriptural subject was

fig. 113

113

made possible by a new nineteenth-century tendency to read the Bible, especially the Old Testament, as literature although there was, of course, a precedent in Racine's play. A very brief passage, hardly more than an aside, in the Book of Esther provided the text and pretext for the celebration of the beauty of a svelte, blonde woman (with none of the anxious melancholy of Racine's heroine).[28] Chassériau seems also to have been influenced by the equally novel tendency to see in the contemporary Orient the people as well as the landscape of the Bible. (Several painters explored the Near East in search of local color for biblical scenes and a way out of baroque iconography.) The black attendant is included in the picture as part of the Oriental scene as well as a pictorial foil to Esther. Some years later, in 1849, Chassériau again depicted a nude white woman with one black and one Arab attendant, but now as a bathing scene in a harem![29] Another artist of the time, the short-lived Léon Benouville, exhibited in the Salon of 1844 a picture of a soulful, fully clad Esther with a strikingly beautiful

113. Théodore Chassériau. *Esther Adorning Herself for Presentation to King Ahasuerus*. Dated 1841. 45.5 × 35.5 cm. Paris, Musée national du Louvre.

114. Dante Gabriel Rossetti. *The Bride* or *The Beloved*. Dated 1865–66. 82.5 × 76 cm. London, Tate Gallery.

114

black "handmaiden" in a décolleté dress.[30] Although observant of "period" details of decoration (Egyptian rather than Persian), he projected back into the ancient Near East figures conjured up by artists to inhabit nineteenth-century harems. A contemporary critic remarked that Esther "looks more like a courtesan than the chaste heroine of the Jewish captivity."[31] And it was for some time incorrectly titled *Odalisque*. As in Chassériau's picture, the black attendant looks admiringly at Esther who stares out of the canvas to meet the admiring gaze of the white observer.

The clear indication of amorous liaison between the black and the white woman in Auguste's *Les Amies* is reduced to no more than a hint in Chassériau's *Esther*. In a painting by Dante Gabriel Rossetti of a group of women of the languorously sensual type he so often depicted, the insertion of a black child holding a vase of roses was manifestly for pictorial effect alone.[32] In 1863 he was given the commission for a picture of Dante's Beatrice. While working on it, however, Rosetti's eye was caught by a black

fig. 114

115

boy whom he persuaded to pose as a model; he then decided to substitute the image of the child for that of a mulatto girl originally intended for the foreground, giving him an androgynous appearance. "I mean the colour of my picture to be like jewels and the *jet* would be invaluable," he wrote at the time.[33] His brother, William Michael Rossetti, recorded that although the boy was usually cheerful, "whilst sitting the tears would run down his cheeks: the skin, as if it absorbed them as blotting-paper, would look darker"— creating the desired effect of jet blackness.[34] As a result of this change of model and also of the fair complexion of the woman who posed for the central figure, Rossetti realized that he would, as he put it, have to "find another subject to suit the figure," decided that the picture must be "turned without remedy into Solomon's Bride," and provided it with a text from Psalm (45:14): "She shall be brought unto the king in raiment of needlework; the virgins her companions that follow her shall be brought unto thee."[35] The reference to Solomon suggests that he may also have had in mind the famous line from the Song of Songs—"I am black but comely"—but merely to justify the black presence that had been determined pictorially rather than symbolically in this sultry image of chaste sensuality.

The presence of a black woman in a picture of the same years but an entirely different character, Edouard Manet's *Olympia*, was explained in formalist terms as no more than a pictorial device.[36] Addressing the artist with whom he had discussed the work, Emile Zola wrote: fig. 115

> To you a picture is simply a pretext for analysis. You wanted a nude, and you chose Olympia, the first to come along. You wanted bright, luminous patches, and you put in a bouquet. You wanted black patches, and you placed a Negress and a cat in a corner. What does all that mean? You hardly know, and neither do I. But I do know that you have succeeded admirably at doing a painter's painting, the work of a great painter.[37]

Manet was indeed experimenting with tone, making strong contrasts between related shades at either end of the scale and eliminating the softening tones of intermediate range. The pictorial effect of *Olympia* depends on the juxtaposition of the dark face of the black woman, the deeper black of the cat, and the somber green of the curtain behind them with the ivory skin of the main figure and the yellow shawl and white bed linen on which she reclines. In two etchings he made of the picture, and his depiction of a "photograph" of it, pinned to the wall in his portrait of Zola, Manet further simplified the tonal structure of the work in a way that emphasizes the pictorial significance of the black woman.[38] Yet there can be no doubt that the subject of the picture had as much importance for him as the way in which he rendered it: the two are interdependent.

There is no more famous image of a black in mid-nineteenth-century art than that in *Olympia*, the picture which aroused a storm of protest when first exhibited in the Salon of 1865 and soon came to be regarded as a kind of manifesto of avant garde art—praised by Zola and Huysmans, copied by Fantin-Latour and Gauguin, affectionately parodied by Cézanne and Picasso.[39] She is an integral part of this scene of modern life which shocked the conservative French public on account of its subject—a prostitute—

159

and perhaps still more the way in which it was painted. And yet, from an iconographical point of view, this black woman could hardly be more traditionally conventional, cast in the "narrative" role of a servant and the pictorial role of a figure whose dark complexion sets off the pallor of a white woman. There is also a striking contrast between the way in which Manet depicted Olympia herself with chilly realism suggesting portraiture, and the black woman with generalized features carrying a bouquet of flowers painted in delicately fresh, one might almost say rococo, colors.

Manet painted *Olympia* for exhibition in the Salon hoping, no doubt, that it would help to establish his place in and also mark his development of the great tradition of figure painting. Hence its very obvious debts to artists he admired—to Courbet, Delacroix, Ingres, Goya, and especially Titian. It presented a contrast with and also a kind of critical comment on the innumerable images of odalisques provocatively flexing their ample thighs, displayed in practically every European art exhibition of the time. By depicting sincerely his own vision of the contemporary world, comparing and contrasting what he saw before him with reminiscences of artistic images of similar subjects, Manet was attempting to return to what he considered essential principles. The scene is set in France in the 1860s. Olympia is, Zola wrote,

> a girl of sixteen, doubtless some model whom Edouard Manet has quietly copied just as she was. Everyone exclaimed that this nude body was indecent. That is as it should be since here in the flesh is a girl whom the artist has put on canvas in her youthful, slightly tarnished nakedness. When other artists correct nature by painting Venus, they lie. Manet asked himself why he should lie. Why not tell the truth? He has introduced us to Olympia, a girl of our own times, whom we have met in the streets pulling a thin shawl over her narrow shoulders. [40]

Representing Olympia as a common prostitute, he stripped away the subterfuges by which images of the naked female body, as an object of male desire and possible purchase, had been given respectability. It was well known that there were black women in Parisian brothels. At the same time the Goncourt brothers, gathering material for a realist novel, jotted in a notebook a reminder to "make the prostitute's friend a Negress, study the type, and incorporate it in the story." [41] But it was in Orientalist paintings that white women were most often accompanied by blacks. And Olympia's attendant might seem to intrude from this fantasy world to present a contrast between falsity and truth as well as skin color.

FLESH FOR SALE

The Scottish painter David Roberts found the slave market in Alexandria "peculiarly disquieting" when he inspected it shortly after arriving in Egypt in 1838. "The slaves were mostly girls; some from Circassia were well dressed; others, negroes, squatted on the ground with scanty bits of matting thrown round them, and in a sun that would have killed a European" he told his daughter. "It was altogether a sickening sight, and I left it proud that I

116

belonged to a nation who had abolished slavery."[42] Later he met the Greek
owner of a slave boat and regretted that he "had too few words of Arabic
or Greek to tell the old rascal how much his occupation was abhorred
in England."[43] His feelings did not however prevent him from depicting
the slave market in Cairo and a slave boat. These scenes were part of the
European vision of the Orient and as such they were included among the
delicately lithographed illustrations of his three-volume *Egypt and Nubia*.[44]

Another British painter, William James Müller, in Cairo in 1838 remarked
that the slave market was one of his "most favourite haunts" and when
describing it made no more than a conventional gesture of repugnance.

> One enters this building, which is situated in a quarter the most
> dark, dirty, and obscure of any at Cairo, by a sort of lane; then one
> arrives at some large gates. The market is held in an open court,
> surrounded with arches of the Roman character. In the centre of this
> court the slaves are exposed for sale, and in general to the number
> of from thirty to forty, nearly all young, many quite infants. The
> scene is of a revolting nature; yet I did not see, as I expected, the
> dejection and sorrow I was led to imagine. The more beautiful of the
> females I found were confined in a chamber over the court. They
> are in general Abyssinians and Circassians. When any one desires
> to purchase, I not unfrequently saw the master remove the entire
> covering of the female—a thick woollen cloth—and expose her to the

gaze of the bystander. Many of these girls are exceedingly beautiful—small features, well formed, with an eye that bespeaks the warmth of passion they possess. The negresses, on the contrary, have little to please; they disgust, for their hair is loaded with two or three pounds of a sort of tallow fat, literally in thick masses, and as this is influenced by the heat of the sun, it gradually melts over the body, and the smell from it is disagreeable in the extreme; yet in this place did I feel more delight than in any other part of Cairo: the groups and the extraordinary costume can but please the artist. You meet in this place all nations. When I was sketching—which I did on many occasions—the masters of the slaves could in no manner understand my occupation, but were continually giving the servant the price of the different slaves, to desire me to write the same down, thinking I was about to become a large buyer.[45]

There is no better account of the allurement exerted on a European by an Oriental slave market which, as Müller implies, differed from abolitionist images of the sale of slaves in America. An Oriental setting permitted indulgence in eroticism that was inhibited by some sense of moral responsibility, if not of guilt, when a similar scene was located in the West. The French abolitionist Victor Schœlcher was one of the few Europeans who visited Egypt with the express purpose of comparing slavery in Muslim and Christian countries.[46]

The painting of an Egyptian slave market by Müller is simply pictur- fig. 116
esque.[47] A turbaned Arab and a black trader in the right foreground appear to be discussing the price of the black man stripped to the waist. The kneeling black child and woman nursing her infant in the center are presumably waiting to be sold. But the "revolting nature" of the scene was not made explicit—it might represent the hiring of a free laborer or some other market transaction—unless, as seems likely, it was one of a series of paintings with the title *Slave Market, Cairo* which conditioned the spectator's response.[48] In 1840, shortly after returning to England, Müller exhibited at the British Institution in London a large oil painting *Offering a Greek Slave for Sale in a Street Leading to the Slave Market, Grand Cairo*, its authenticity as an image guaranteed by the declaration that it had been "painted from sketches made on the spot."[49] This was the major product of his visit to Egypt, and the title suggests that it had the narrative content beloved by the general public. But in the following two years he showed at the Royal Academy and the British Institution scenes of the slave market in Cairo, and he is said to have painted "three or four copies" of a picture entitled *Selling a Slave at Alexandria.*[50] There was clearly a demand for images of the subject in early Victorian England despite, or perhaps because of, the strict code of monogamous sexual morality and prevalent views of slavery. By a curious coincidence *Offering a Greek Slave for Sale* was put on show while preparations were under way for the international antislavery convention that met in London in June 1840 when Biard's *The Slave Trade* and Turner's *The Slave Ship* were also exhibited.[51]

At the end of his description of the slave market in Cairo, Müller somewhat surprisingly remarked: "I only wish some artist would make this the spot of his studies, and paint the figures and groups."[52] Concerned

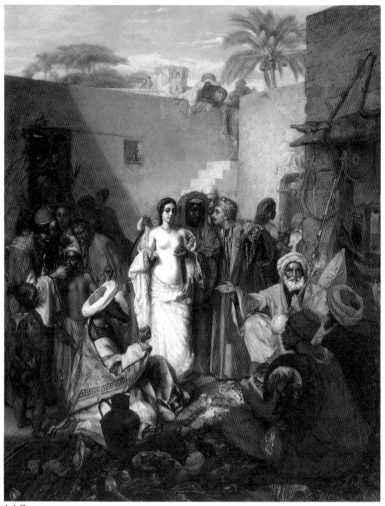

117

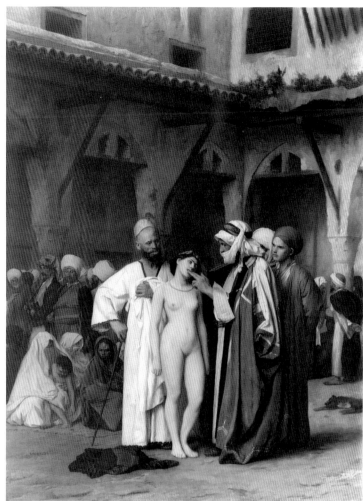

118

mainly with picturesque effects of light and color, he did not regard himself as a "figure painter," but those who specialized in depicting the nude were soon to fulfill his wish. In Germany Karl Wilhelm Gentz made his debut as an Orientalist with a large picture of the Cairene slave market fig. 117 in which a white-skinned "Circassian" woman is exposed to the "gaze of the bystander," very much as described by Müller.[53] Her clothing is being removed by a black man, and there are other blacks in the foreground and background. A white-bearded Arab seated nearby indicates her with an outstretched hand, looking straight out of the canvas—across the frontiers of the Orient it might seem at the European spectator who can possess her only in imagination. Her whiteness amongst so many darkskinned figures may have invested her with pathos in the eyes of some of the visitors to the Berlin Academy where the picture was exhibited in 1852. But one may wonder whether it did not also stimulate erotic daydreams akin to those expressed with astonishing frankness in a poem about a Greek slave—a fantasy of female submissiveness including complete submission to violent sexual assault—by the Prussian educationalist, diplomat, and statesman Wilhelm von Humboldt.[54]

A young, white-skinned woman is the central figure in a painting by Jean-Léon Gérôme where her complete, frontally displayed nudity as well as her fig. 118 color is in contrast with the surrounding figures.[55] She is an academically

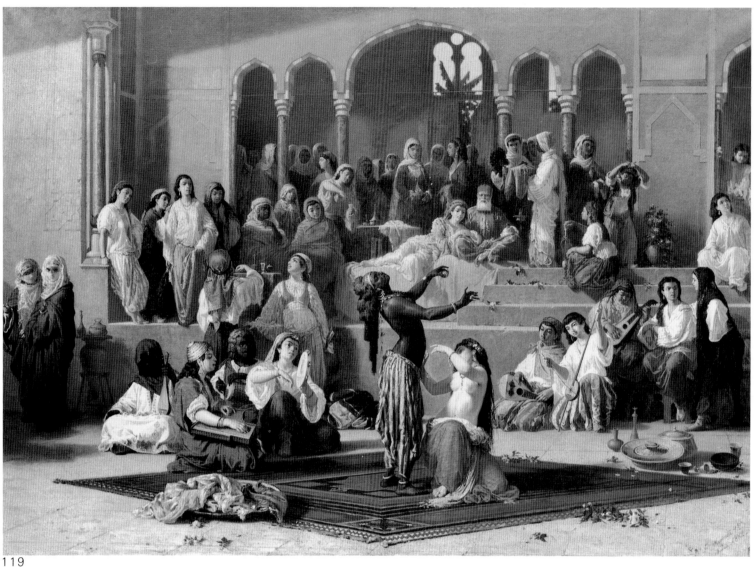

119

ideal figure, but an Arab heavily swathed in his haik and burnous pushes preternaturally long fingers into her mouth, as if she were an animal. His gesture recalls that of an English slave buyer ascertaining the age and health of an African in an eighteenth-century print.[56] The dealer with a villainous expression on his face holding a long cane might also be paralleled with figures in earlier scenes of slavery. But the relegation of two blacks—a seated woman and a naked man—to the dimly lit background effectively dissociates the subject from abolitionist images. The picture was surely intended to titillate rather than to arouse protest, even though it recorded with disingenuous objectivity a way of life that was supposed to justify the imposition of European culture on the Near East.

The slave market provided a setting for images of nude, subdued female bodies available for purchase. Active feminine sexuality was personified by dancers, the almahs, who were of course prostitutes. In *Il Ballo dell'Ape* by fig. 119 the Neapolitan painter Vincenzo Marinelli, a black woman naked from the waist up undulates her slender torso with head thrown back in an attitude of sensual abandon.[57] Marinelli had lived for a while in Egypt (as a political exile after the revolution of 1848) and may well have made sketches of the

individual figures, costumes, musical instruments, pieces of metalwork, and so on which he assembled in the picture. He painted it in 1862 shortly after his return to Naples where—so he wrote—artists were fired by an ambition to break free from the old academic rules and devote themselves to the "imitazione del vero."[58] In Egypt he had found himself "in a new world, far from every classical exemplar," and he saw in Oriental subject matter a means of escape from the conventions governing his earlier depictions of mythology. His picture is, however, an imaginative evocation of Oriental life in which he concentrated less on "truth" than illusionism and the exactitude of ethnographic detail. To the European public the audience ranged round the pasha and the pale-complexioned woman reclining beside him are just as much a spectacle as the performance they watch. The painting might easily be supposed to represent the ballet interlude in some opera of the period, with the principal singers and chorus temporarily withdrawn to the back of the stage.

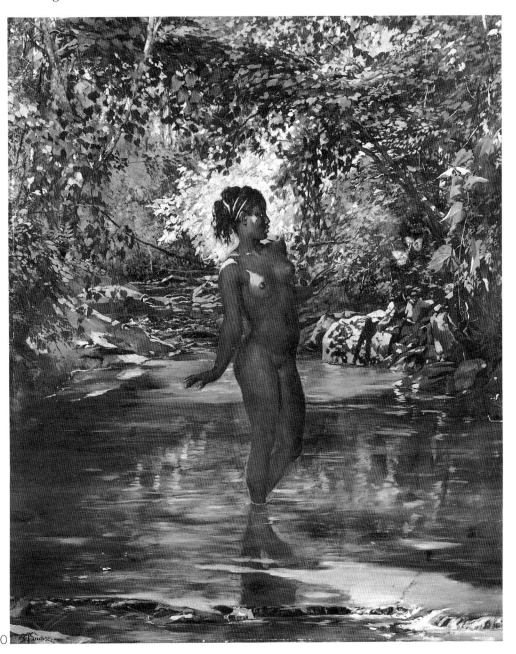

120

121. Jean-Baptiste Carpeaux. *Pourquoi naître esclave*. Dated 1868. Terracotta. H: 56 cm. Douai, Musée de la Chartreuse.

The dance of the bee was Marinelli's pretext for bringing together a large cast of exotic figures. It was, however, a traditional striptease act often described by European travelers as one of the "sights" of the Orient—like the slave market. The art critic Léon Lagrange remarked that the dancing of the almahs was the "last word in lubricity," and he had not denied himself the "exotic pleasure" of witnessing it. He described a performance of the dance of the bee by two women, "one the florid white of antique marble, the other golden brown like a Florentine bronze," shedding one garment after another in feigned search for the bees that had stung them until, completely naked, they hid their heads for shame—"they were women, and the disgracefulness of their trade could not snuff out their modesty."[59] In Marinelli's painting the dancers are also of contrasting skin color, but the lubricity of their movements is offset by the open-air setting and the crowd of spectators. They are presented as the central item in an ethnographic document stressing, nonetheless, the sensuality commonly ascribed to African women.

This sensuality is more delicately suggested in the picture of a young black woman painted by Frank Buchser while he was in America in 1867. She is shown bathing in a stream running through a forest glade which he called "a sacred nook in Virginia."[60] This is essentially a European's vision of an idyllic American landscape with sunshine filtered through fresh green leaves to glitter on dark flesh and limpid water. But it is also a vision colored by the experience of Orientalist art: Buchser had been to Morocco before he went to the United States. His model had, no doubt, been born a slave, and he assimilated her to the slave girls of the Orient. The picture is said to have been exhibited in New York, but it was not sold. Such an image would hardly have been acceptable in the United States where there was a strong current of objection to depictions of the nude and apparently little demand for any paintings of physically attractive black women. From a European viewpoint on the other hand the subject was doubly distanced, by her setting and her color. fig. 120

A remarkable increase in images of female slaves in European art exhibitions after emancipation in the United States—when abolitionism ceased to be a popular cause despite the persistence of slavery elsewhere—suggests that they appealed, and may always have appealed, to libidinous as much as philanthropic instincts. They are very often equivocal in their moral condemnation of chattel slavery and reflect male desires for the absolute possession of women. Jean-Baptiste Carpeaux's strongly emotive bust of a black woman, bound by a rope twisted round her arms and cutting across her full breasts, is a case in point.[61] When exhibited in the Salon in Paris in 1869 it was described in the catalogue simply as *Négresse: buste, marbre*. It seems to have been categorized as the representation of an ethnic type, like Cordier's *Vénus africaine* which is said to have portrayed the same model, a former slave from the French colonies.[62] Carpeaux modeled it while working on the statues of the four continents or points of the compass for the Fontaine de l'Observatoire which he had been commissioned to execute two years earlier.[63] But whereas the African on the fountain was to be shown free, with a broken chain attached to one ankle, the subject of the bust is enslaved. Her tormented expression and twisted pose, straining against the bonds, suggest a painful struggle to escape, recalling one of the most famous fig. 121 cf. fig. 72

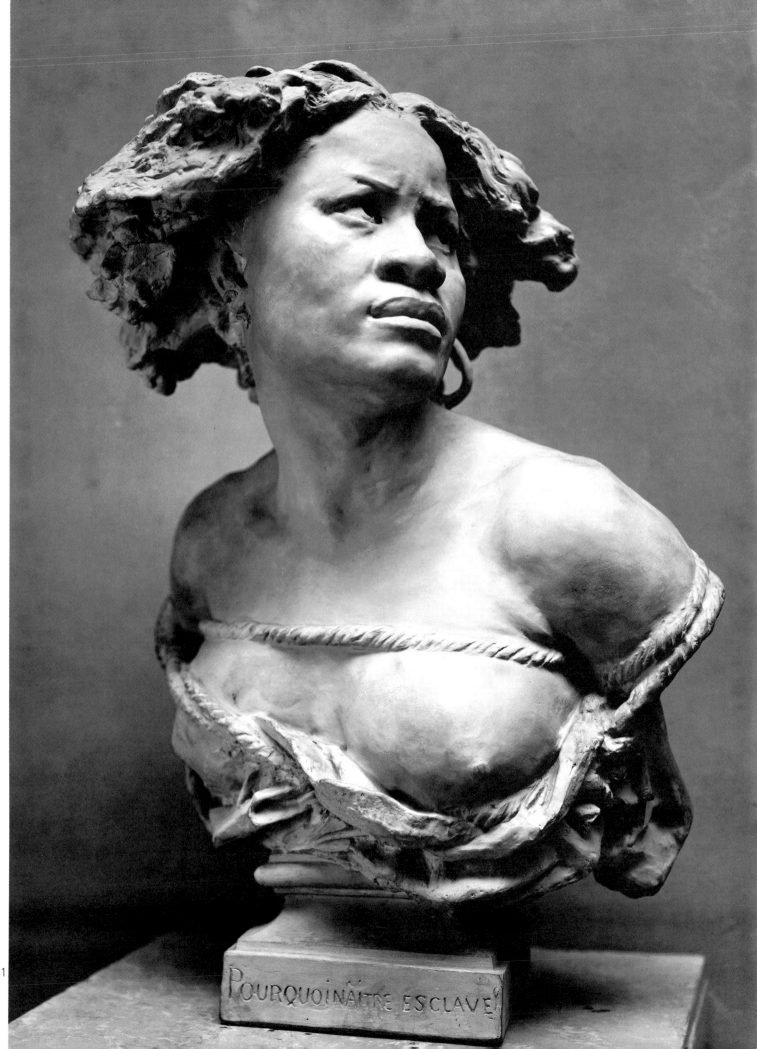

POURQUOI NAITRE ESCLAVE

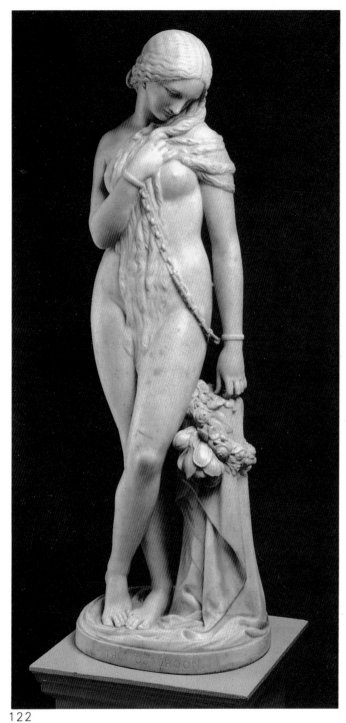

122

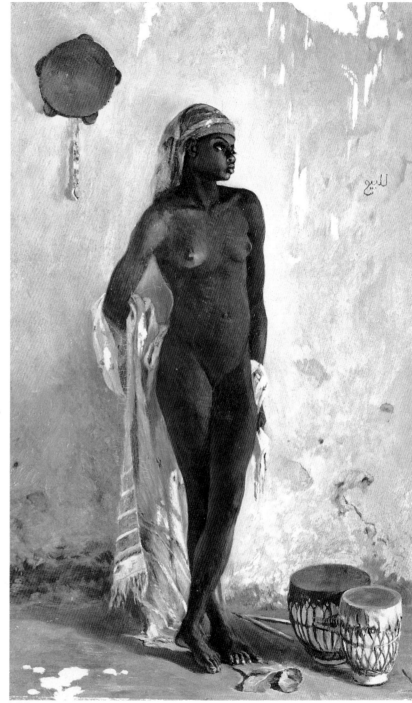

123

122. John Bell. *The Octoroon*. Royal Academy, 1868. Marble. H: 159.6 cm. Blackburn, Town Hall.

123. Frank Buchser. *Nackte Sklavin*. 1880. 54 × 33.5 cm. Solothurn, Museum der Stadt Solothurn.

Renaissance statues, Michelangelo's so-called *Rebellious Slave* in the Louvre. The base of each of the surviving early examples of the bust, except the one in Valenciennes, bears the inscription *Pourquoi naître esclave* ("Why Born a Slave"), though it is not known whether it was also on that exhibited in the Salon of 1869.[64]

Many years earlier, as we have seen,[65] Houdon gave significance to his bust of a black woman by adding an inscription referring to the

Revolutionary decree of emancipation. She was "rendue à la liberté et à l'égalité." Carpeaux's inscription, which may also have been an afterthought, has the opposite effect and takes its ambivalent meaning from the vigorous sensuality of the bust. It is susceptible to a range of interpretations, as a deeply felt symbolic protest no longer against chattel slavery but the subjugation of women, or perhaps colonialism in Africa, or even political oppression in France during the last years of the Second Empire. Yet one may doubt whether any such ideas were in Carpeaux's mind. They can hardly have occurred to his patron, Napoleon III, who bought the bust exhibited in the Salon for his own apartments at Saint-Cloud. It could be admired from a purely aesthetic point of view as a masterpiece of sculptural form. But it also retains to the present day a strongly emotive power as an image of slavery, in the widest meaning of the word, personified by a black woman.

In Western sculpture female slaves usually had classically European features. The *Jeune esclave* by Jean Debay carved in Rome in 1835 is simply the life-size statue of a young, nude white woman with a chain hanging from her right wrist: a critic suggested that the sculptor had not decided on the subject until he had nearly completed it.[66] *The Greek Slave* by the American sculptor Hiram Powers—who carved no fewer than six versions of it between 1843 and 1869—was sometimes given an abolitionist interpretation, though it was only in a satiric vein that John Tenniel drew the statue of a black "Virginian slave intended as a Companion."[67] It surely won its great popularity as a crystallization of the mid-nineteenth-century ideal of femininity. The pathos of the subject made it acceptable in the United States where the Rev. Mr. Dewey, in a pamphlet published when the statue was exhibited in New York in 1847, claimed that it was "clothed all over with sentiment, sheltered, protected by it, from every profane eye. Brocade, cloth of gold, could not be a more complete protection than the vesture of holiness in which she stands."[68]

Not until after emancipation in the United States was the theme of the darkskinned slave girl exploited by sculptors, and then exclusively in Europe.[69] In 1868 John Bell exhibited at the Royal Academy in London the statue of a young woman in a demure pose with a coy expression on her face entitled *The Octoroon*.[70] He had no doubt been inspired by one of the several stories of "tragic octoroons" published by American abolitionists in the previous decades.[71] It was widely believed that nearly white slave girls were sent to the brothels of the southern states, and Bell's title thus alludes distantly to the social problem of prostitution that troubled the Victorian conscience. Unlike Manet's brazen *Olympia*, she is veiled in the sentiment of Thomas Hood's poem "The Bridge of Sighs"—"One more Unfortunate, . . . Fashion'd so slenderly, / Young, and so fair! . . ." But chained wrists also indicated her plight as a "damsel in distress"—like Andromeda of whom Bell had previously modeled a statue—a theme that appealed to nineteenth-century chivalry or sadism, or a confusion between the two. A somewhat similar statue by Michele Boninsegna, *La schiava denudata*, was exhibited in Milan in 1874, at the Philadelphia Centennial exhibition in 1876, and again in Milan in 1881.[72] It cannot now be traced but is known from a print and a revealing commentary which might serve equally well for Bell's *Octoroon*. The writer described the subject as the daughter of a slave mother who was

fig. 122

cf. fig. 115

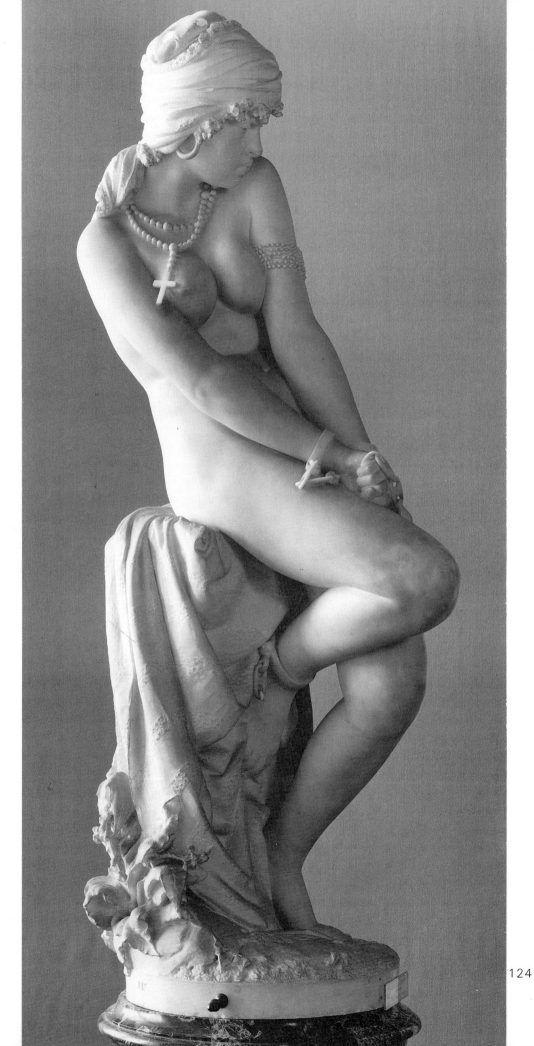

sent to be sold in the market, stripped of her clothes to the last shred before jeering men, and pleaded vainly for her modesty to be respected although "rough hands will deflower that perfect flesh and no humiliation of the horrible transaction will be spared her."[73] Such words echo the rhetoric of the abolitionists but, like the statue itself, seem to have been calculated to excite prurience rather than pity—a decade after the last sale of slaves in the United States.

Boninsegna's slave, like Bell's *Octoroon*, had regular, Caucasian features. Frank Buchser's *Nackte Sklavin*, painted on a visit to Morocco in 1880, fig. 123 is black.[74] By this date chattel slavery had come to be associated almost exclusively with the Islamic countries. Yet one may doubt whether Buchser was concerned with his subject's status except in so far as it enabled him to employ her as a model. The painting has the appearance of a life study converted into a "picture" by the addition of a few carefully placed African artifacts and an explanatory title. The *Nackte Sklavin* differs from his earlier American *Negermädchen im Bach* in her more obvious availability. By this date the physical allure of black women for white men was more readily admitted than before, as in Pierre Loti's immensely popular *Roman d'un spahi* published in 1881, frequently reprinted, and dramatized as a comic opera in 1897. Of Fatou-Gaye the Senegalese heroine, Loti wrote:

> Her slender, regular figure now and then took on something of the mysterious beauty of an idol in polished ebony: her large, enamel-blue, half-closed eyes, her dark smile slowly disclosing her white teeth—all this had a Negro grace, a sensual charm, a physical power of seduction, something undefinable that seemed to stem at one and the same time from the monkey, the young virgin, and the tigress, and sent unknown spasms of delight racing through the spahi's veins.[75]

The statue by the Italian Giacomo Ginotti of a buxom woman wearing fig. 124 only heavy jewelry, twisting her ample body into a voluptuous attitude as she struggles with the chain joining her wrists,[76] differs as much from Buchser's slave girl as from the demure figures by Bell and Boninsegna. She was presumably intended to represent an African though the cross hanging from her neck suggests that she was Christian. When first exhibited in Naples in 1877 the statue was entitled *L'emancipazione dalla schiavitù*. One critic was reminded of Eliza in *Uncle Tom's Cabin* and of other books which had, he wrote, elicited compassionate tears by their "anecdotes of tyranny and outrage, and stories of the pains and injustices suffered by the poor blacks under a fatally cruel and unjust system." But such thoughts were surely prompted more by the title than the statue which he described in words which would have horrified Mrs. Stowe. With uninhibited delight this writer dwelt on the physical beauty of the woman, her "soft and rounded figure" and the "proud expression showing that the blood rebels in her veins." She is of "a beauty that charms you, that makes you wish that the marble was a live woman."[77] There is no more provocative image of a black female slave. Ginotti seems to have envisaged slavery in America through a haze of Orientalist exoticism. The emancipation of the title might seem to refer less to the subject than the imagination of the sculptor, free to locate her in a never-never land of male desire.

125. Edward John Poynter. *Israel in Egypt*. Dated 1867. 137.1 × 316.8 cm. London, Guildhall Art Gallery.

126, 127. Edward John Poynter. *Israel in Egypt* (details of figure 125).

DEAD MEN

A painting by Edward John Poynter illustrates a passage in the first chapter fig. 125 of the Book of Exodus: "And the Egyptians made the children of Israel to serve with rigour: And they made their lives bitter with hard bondage, in mortar and in brick, and in all manner of service in the field: all their service, wherein they made them serve, was with rigour."[78] It had no known artistic precedent and thus answered current demands for novelty of subject matter as well as those for reconstructions of the past in pictures with narrative content and pathos. It also followed a tendency, developed especially by Protestants, to visualize biblical incidents with the benefit of archaeological knowledge, evoking their temporal appearance at the expense of their eternal significance. Poynter, a pupil of Gleyre, paid obsessive attention to local color, painting the granite lion from a smaller example in the British Museum and taking details of architecture and decoration from books illustrating ancient Egyptian monuments—Luxor, Philae, Edfu, and so on. The taskmasters wielding long whips seem to have been derived from fig. 126 outline engravings of relief carvings; they are, however, depicted as Nubians. Blacks thus figure in the context of slavery, recalling overseers in abolitionist imagery, to emphasize the degradation of the Israelites. And in the lower right-hand corner there is a black man dancing and clapping his hands—an fig. 127 avatar of Jim Crow in the thirteenth century B.C.

When the picture was first exhibited to an admiring Victorian public in the Royal Academy, London, in 1867, a critic commented on "that hot sunlight which, while it expresses the nature of the climate of Egypt, enhances the toil of the miserable."[79] He might as easily have been referring to the lot of the fellahin in his own time. The words also echo descriptions of the slave labor in the West Indies and the southern United States—where the slaves so often likened themselves to the Israelites in Egyptian captivity.

125

126

127

173

128. Jules-Jean-Antoine Lecomte du Nouy. *Les porteurs de mauvaises nouvelles*. Dated 1871. 74 × 121 cm. Tunis, Ministère des Affaires Culturelles.

129. Jules-Jean-Antoine Lecomte du Nouy. *La porte du sérail: Souvenir du Caire*. Dated 1876. 74 × 130 cm. Paris, Collection of Pierre Bergé.

Yet it is hardly to be supposed that Poynter intended to make a social protest. The picture was, perhaps significantly, acquired by Sir John Hawkshaw, the civil engineer who had in 1863 written the decisive report on the feasability of cutting the Suez Canal which was then being dug by teams of fellahin. With his practical knowledge he remarked that there were too few Israelites to haul the massive carving of a lion, and Poynter complaisantly added some more, extending the line to the edge of the canvas to suggest that others were out of sight.[80]

In another painting of an ancient Egyptian subject, *Les porteurs de mauvaises nouvelles* by Jules-Jean-Antoine Lecomte du Nouy, blacks lie dead fig. 128 in the foreground.[81] It illustrates a passage in Théophile Gautier's *Roman de la momie* (1858): "Surveying in his mind's eye this immense city of which he was the absolute master, Pharaoh sadly pondered the limits of human power. . . . A second messenger rolled beside the first. A third met the same fate."[82] Sentiments so often inspired by ancient Egyptian ruins were thus projected back onto one of the pharaohs, together with Gautier's notion of "Oriental fatalism."[83] The painter, a pupil of Gleyre and Gérôme, established his reputation with this work (bought by the state for the Luxembourg) which demonstrated both his archaeological erudition and his technical ability. "The pharaoh's apparel is flawless," wrote Paul Mantz. "The perspectives of the Egyptian city are scrupulously drawn, but, oh, how cold this art is!"[84]

128

174

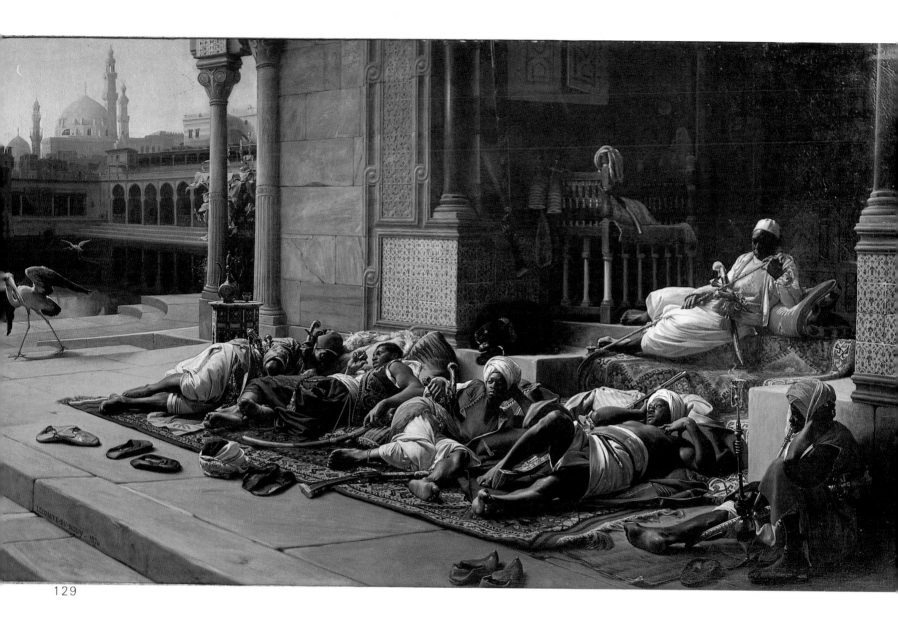

129

Despite very obvious differences of style and handling, *Les porteurs de mauvaises nouvelles* recalls Delacroix's *Death of Sardanapalus*. In both, blacks figure in the context of the contempt for human life associated with the Orient. But in Delacroix's scene of dynamic violence the black man plays one of the most active parts. In Lecomte du Nouy's sepulchrally static painting, the stagnant atmosphere of death, associated with ancient Egypt, emanates from the corpses of the hapless messengers. They are victims of tyranny—slaves in the widest sense of the word—and partly for this reason, no doubt, represented as blacks (although Gautier did not specify their color, it was known that many slaves in Egypt had been Nubians). Whereas black slaves had previously provided subject matter for pictures, here the subject called for their inclusion.

Somnolent, rather than dead, blacks lie on a carpet outside the entrance to a palatial building in another picture by Lecomte de Nouy after he had visited Egypt.[85] As the title of the work indicates, *La porte du sérail: Souvenir du Caire*, they are the guardians of the khedive's harem with the double duty of preventing strangers from entering and inmates from escaping. All have scimitars ready to hand, but their poses are languid and the most wakeful puffs at a stupefying nargileh. This is indeed an evocation of Oriental torpor, the end of a day, and perhaps also a historical epoch, with the last rays of the sunset flaming on the cupola and minarets of a distant mosque. The *Nubian*

cf. fig. 106

fig. 129

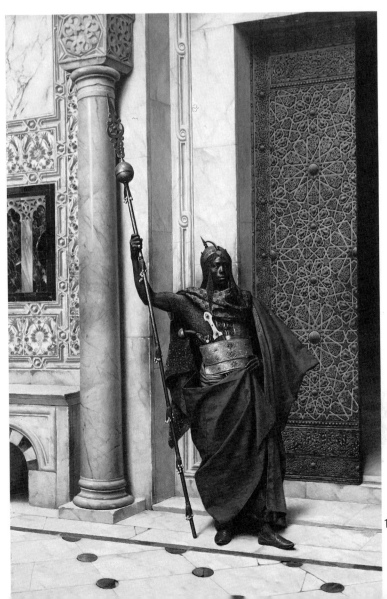

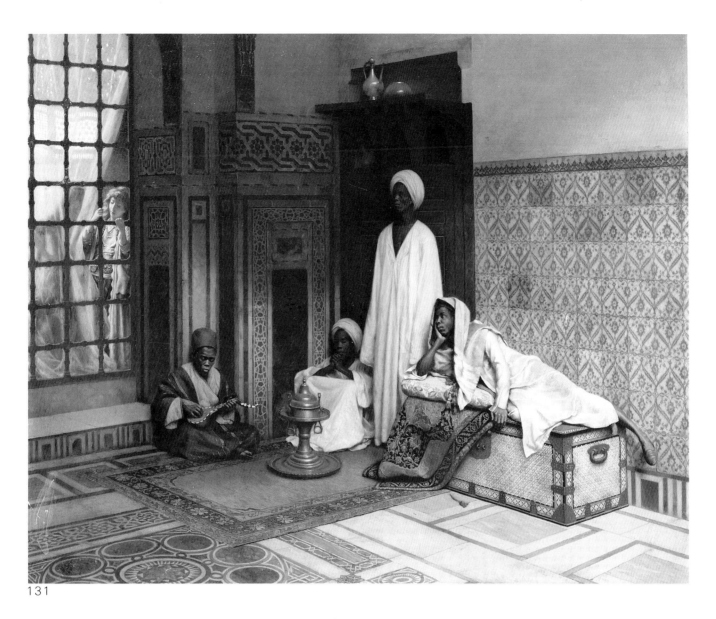

131

Guard by Ludwig Deutsch, an Austrian painter who was trained and worked in Paris, is alert, heavily armed with the sinister aspect of an executioner, the depersonalized agent of his master's will.[86] Depicted with meticulous attention to every detail of costume that gives an illusion of realism, he stands between the European spectators and the fair-skinned odalisques of their imagination, his black opacity emphasizing the separation.

 It was generally known that the blacks inside a harem were either women or eunuchs. In art they are almost invariably women, attendants on the odalisques whose white skins they set off—slaves of the slaves of passion. The depiction of eunuchs presented difficult problems which seem to have been solved satisfactorily only by Ingres. Sexually they are dead men, but their emasculated condition can be no more than deduced from the contexts of the paintings in which they figure. In another painting by Deutsch four impassive blacks are separated by iron bars from the women of the harem whom they guard.[87] Such segregation was in accord with European feelings of repulsion and lubricious attraction stimulated by black and white sexual relations. The denial suggests the desire. But it is also a picture of death in life from which there is no possibility of release.

fig. 130

cf. fig. 109

fig. 131

130. Ludwig Deutsch. *Nubian Guard.* Dated 1895. Oil on wood. 50.5 × 33 cm. Malibu, J. Paul Getty Museum.

131. Ludwig Deustch. *The Guards of the Harem.* 78.7 × 96.5 cm. Jeddah, Collection of Mr. and Mrs. Waleed Y. Zahid.

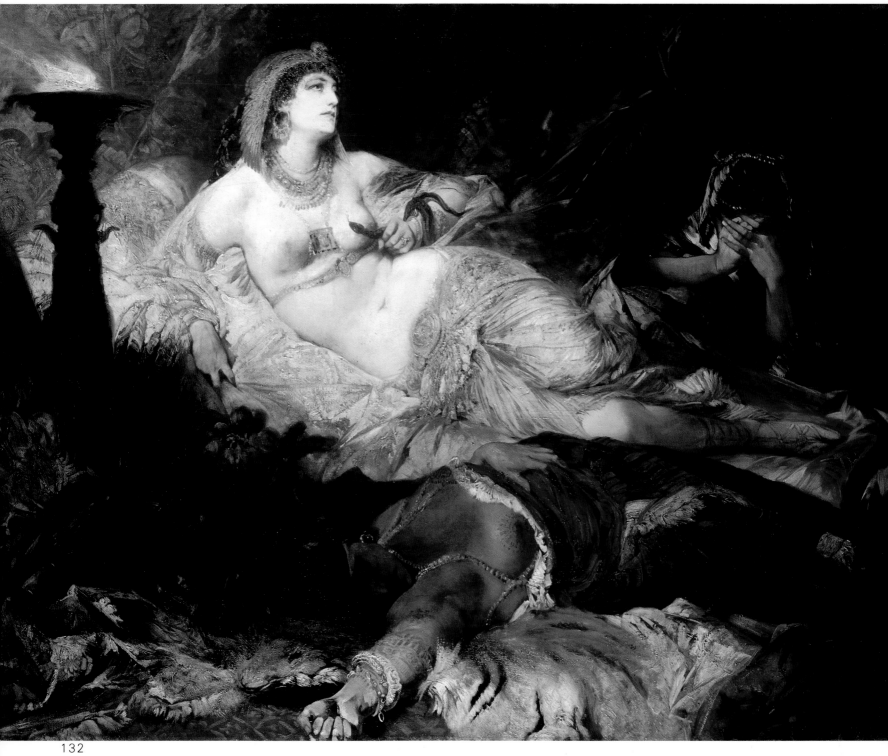

132

132. Hans Makart. *Death of Cleopatra*. 1875. 191 × 255 cm. Kassel, Staatliche und Städtische Kunstsammlungen, Neue Galerie.

133. Benjamin-Constant. Reduced replica of the painting exhibited in 1884: *Les Chérifas* (detail). 114 × 195 cm. Pau, Musée des Beaux-Arts.

A large picture of the death of Cleopatra by the Austrian painter Hans Makart illustrates the closing scene of Shakespeare's tragedy, with Iras lying dead in the foreground and Charmian weeping in the shadows.[88] Emphasis is on the drama of the situation rather than ancient Egyptian local color. The lighting is theatrical with a "spot" on Cleopatra who has the features of the Viennese actress Charlotte Wolter (depicted by Makart also in the role of Messalina), though she can hardly have appeared as scantily dressed on the stage of the Burgtheater. Her two attendants are represented as black women.[89] The picture thus presents a kind of feminine counterpart to the all-male *Porteurs de mauvaises nouvelles* by Lecomte du Nouy with the blackness of a prominent corpse intensifying the heavy atmosphere of mortality. But in Makart's picture the preoccupation with death, so long ascribed to the civilization of ancient Egypt, is combined with the eroticism associated with the contemporary Orient. Cleopatra, asp in hand, voluptuously displays her bejeweled but otherwise almost naked body like an odalisque, its milky whiteness set off by the dark skins of her women. The contrast is made greater by the tattooing or body painting—a mark of supposedly primitive culture—on Iras's breast and forearm. Decadence is emphasized by the juxtaposition of luxury and "savagery."

Eroticism is overt in a painting by Jean-Joseph Benjamin-Constant, *Les Chérifas*, exhibited in the Salon of 1884, of which he made a smaller version, apparently the same year.[90] And a contemporary description of it, at once

fig. 132

cf. fig. 128

fig. 133

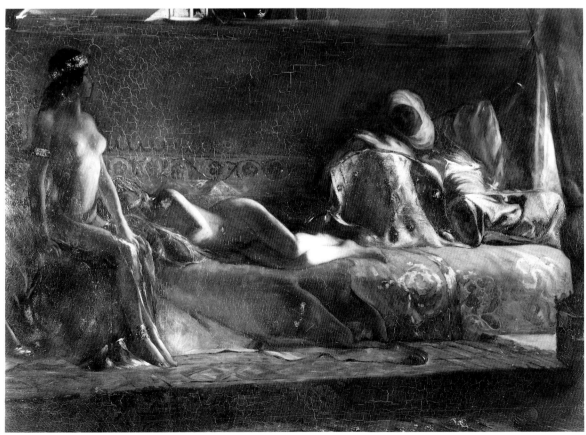

133

179

salacious and moralistic, expresses current attitudes to such a scene, and the Orient as well.

> Mr. Benjamin leads us into a harem with elegant architecture and lavish furnishings. Everywhere rich hangings, costly furniture, ornaments on which the Orient has squandered the resources of its fanciful art. Several figures lounging in various attitudes. At the far right end of a divan sits the master, blacker than Othello, his face marked with the lethargy brought on by an excess of sexual pleasures. Beside him a female slave has rolled over, completely enervated. At the other end of the sofa another victim of Oriental ways is withdrawn into herself. Finally, a third woman sits bolt upright on cushions and arches her torso, accentuating her breasts which look as though they were cast in bronze. With a suggestive and willful eye she gazes at the master in a state of dazed satiety. . . . [91]

Benjamin-Constant had begun his career with, as he wrote, "no other dream than to be a painter of Oriental scenes, to lead the life pointed out by Marilhat, Delacroix, and Henri Regnault." [92] Although he spent a couple of years in Morocco, the notes he made and the artifacts he collected there merely served to give an appearance of authenticity to imaginative fantasies, inspired by what he had read and what had previously been painted. When he exhibited his monumental *Entrée des turcs de Mahomet II à Constantinople le 29 mai 1453* in 1876, [93] Zola called him "a good pupil of Cabanel tormented by the shadow of Delacroix." [94] *Les Chérifas* seems a far cry from the *Femmes d'Alger*, but a description of its companion piece, *La justice du Chérif* in which the same nude women were depicted "their throats cut, lying in the midst of rumpled carpets and overturned furniture," with a silhouette of an executioner in the shadows, brings to mind *The Death of Sardanapalus*. [95] *Les Chérifas* is nevertheless strongly marked as a product of the fin-de-siècle, not least by the depiction of the master of the harem as a black.

Léonce Bénédite, who was to found the Société des Peintres Orientalistes Français, remarked that the sumptuous decor of *Les Chérifas* was a pretext for studies of female nudes. [96] The same could be said of innumerable nineteenth-century paintings of solitary odalisques distinguished only by their titles and an occasional artifact from other idealized paintings of nude women, all of which were made acceptable to the bourgeois public by being distanced from contemporary Europe in time or place. But these two pictures by Benjamin-Constant could be regarded also as products of the French school of large-scale history painting—perhaps even as "improvements" on Delacroix with more regular brushwork and closer attention to detail. Both were bought by the state and hung in the Musée du Luxembourg from which the works of artists who deviated from academic conventions were rigorously excluded.

Two harem scenes by Rudolph Ernst and Maurice Bompard are somewhat different: small-scale pictures of blatant eroticism that are not known to have been publicly exhibited and were presumably intended for private patrons. The Austrian-born Ernst who settled in Paris (like his compatriot Deutsch) devoted himself to the usual repertory of Orientalist subjects from 1887. [97] Bompard exhibited in the Salon pictures with such titles

134. Rudolph Ernst. *The Master's Favorite*. Oil on wood. 46.5 × 33.5 cm. London, MacConnal-Mason Gallery.

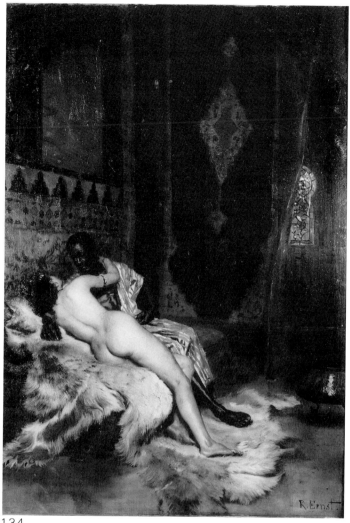

134

as *Boucher tunisien*, *La prière à la mosquée*, and *Les musiciens nègres: Scène de vie arabe*.[98] Ernst's painting of a completely nude odalisque embracing a black man—on a couch covered with furs to add a final touch of sensuality— has been entitled *The Master's Favorite*.[99] It was usually believed that blacks in the harem were women or eunuchs.[100] But there can be little doubt that this man is the master in his own luxurious room, like Benjamin-Constant's sharif, though here shown in physical contact with the odalisque. As the image of white slave and black owner it reverses the traditional color roles, without any anxiety about the problem of prostitution politely termed "white slavery." The man's body is, nevertheless, completely hidden by his striped garment and by the woman whose ample buttocks are displayed to the spectator, or voyeur.

fig. 134

In the picture by Bompard the odalisque is in a still more provocative pose, reclining on the lap of a richly dressed black man, with a female musician sitting beside them.[101] The dramatis personae are those of Ingres's "galant, mais honnête" *Odalisque with a Slave*. But the differences, not only in artistic quality, are far greater than the similarities. Bompard's space is more darkly, almost suffocatingly enclosed. His musician, naked to the waist with heavy jewelry hanging between her breasts, seems to play no lulling melody. The odalisque is neither somnolent nor physically unobtainable,

fig. 135

cf. fig. 109

135. Maurice Bompard. *Harem Scene*. 40 × 56 cm.
Marseilles, Musée des Beaux-Arts.

136. St. George Hare. *The Victory of Faith*. Royal
Academy, 1891. 123.3 × 200 cm. Melbourne,
National Gallery of Victoria.

and whether or not the black to whose caresses she responds with ecstatic movements is a eunuch is left to the spectator's imagination. As in the picture by Ernst, the body of the black is hidden: his main pictorial role is to display the spotlit object of male desire—rather as a dancer assists and shows off the movements of a prima ballerina. But he also heightens the temperature of torrid eroticism. The Oriental setting, further emphasized by the frame with a pseudo-Islamic inscription, is far from a mere pretext for a display of nudity. The harem is evoked as the forbidden place where forbidden pleasures are indulged.

Black men were, however, seldom shown in physical contact with white women in nineteenth-century art. (Othello when depicted as a black was usually placed somewhat apart from Desdemona, and his hands did not touch her body even in the murder scene.) Censors allowed no "equivocal situations between white girls and men of other races" to be shown in cinemas anywhere in the British Empire until the 1950s—a ruling that reflects attitudes to gender as well as race.[102] On the other hand, black and white women were depicted together, sometimes without social distinction.

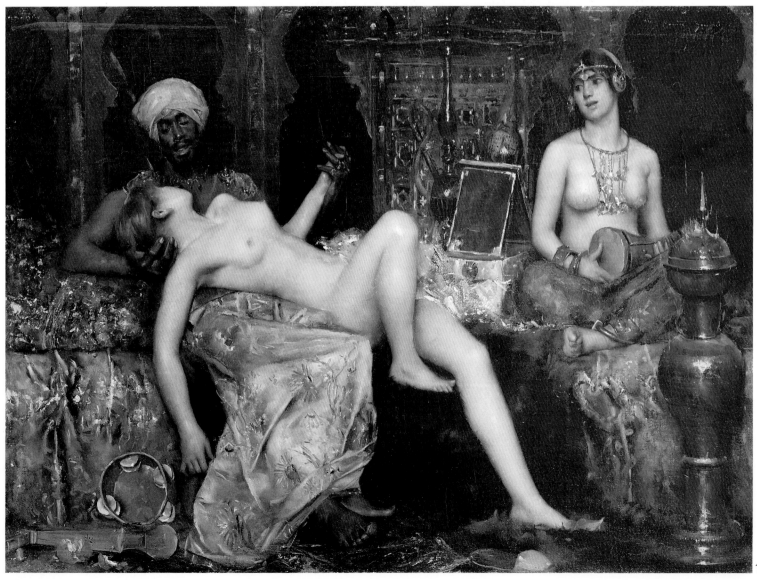

135

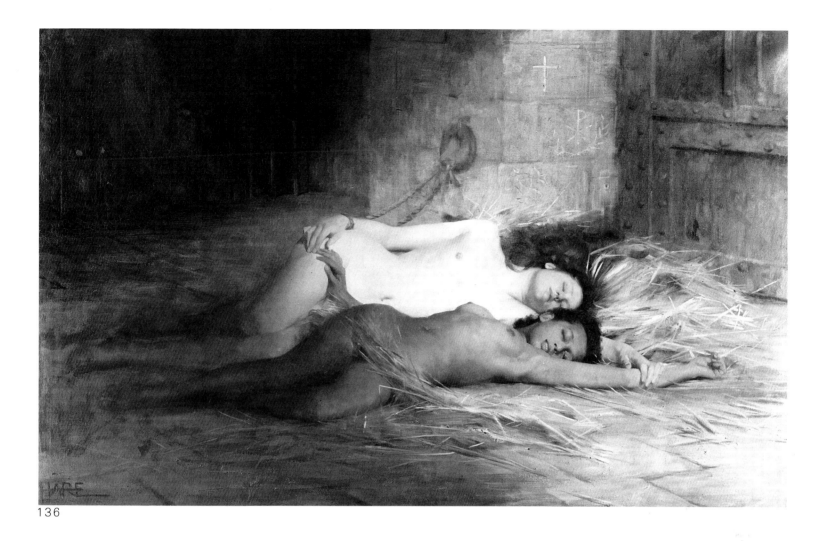

136

To a public as yet unenlightened by Krafft-Ebing, Freud, and Havelock Ellis, a picture by St. George Hare of a nude black woman sleeping beside a white companion may well have seemed innocently sentimental.[103] Entitled *The Victory of Faith*, it purported to represent two early Christians in a prison beneath the Colosseum fearlessly awaiting their martyrdom. No more farfetched solution to the problem of clothing the female nude with an aura of sanctity was ever devised. But the narrative content, emphasized by a quotation from Foxe's Book of Martyrs printed in the catalogue of the Royal Academy exhibition in which it was shown in London in 1891, must surely have aroused visions of how these perfect bodies would be displayed and mutilated in the arena.

fig. 136

For *Les deux perles* by Fernand Le Quesne, exhibited in Paris in the Salon of 1889, there is no historical, literary, or even Orientalist pretext.[104] Nor does it have any complex psychological undercurrent. It is quite simply a "soft-core" erotic image, the picture of two life-size, completely nude young women, one seen from the front the other from the back, one white the other black. The color contrast seems to be no more than a pictorial device, though one that reflects acknowledgment of the physical charm of a black woman. Depictions of the female nude aroused fewer objections in France than in England, let alone the United States, in the nineteenth century. They were nevertheless restrained by conventions which only the more daring artists (notably Manet and Degas) defied. The subjects were invariably young

fig. 137

183

137

and still to be enjoyed, and even when shown frontally in provocative poses deprived of the pubic hair which men recognized as the first symptom of their own sexuality. This denial of female sexuality is paralleled by the denial of virility in images of blacks as slaves, eunuchs, or literally dead men.

Eroticism is combined with symbolism in a vast diptych by the Italian Aristide Sartorio. One panel is entitled *Diana d'Efeso e gli schiavi*, the other *La Gorgone e gli eroi*.[105] When these pictures were exhibited in the Biennale in Venice in 1899, Sartorio was presumably the writer of the catalogue note declaring that

figs. 138, 139

> . . . the artist intended to express mythically two aspects of the profound vanity of human existence. On one side stands the Gorgon who has the enthralling form of beauty and is at once life and death, arousing and casting down heroes. Diana of Ephesus of the hundred breasts which nourish men and their illusions stands on the other side. "Men," says the poet, "are of the same substance as their dreams," and they are here represented asleep, clutching in their hands the symbols of their ambitions.[106]

Diana of Ephesus has a black head and hands—as in some antique statues—although most of the slaves are white.[107] Two blacks are barely visible in the heap of bodies. The white Gorgon is painted according to late nineteenth-century academic precepts with the abundant head of hair so beloved by the

138

139

English pre-Raphaelites (whom Sartorio greatly admired). One of the black heroes clutches a snake, the other has a crowned head on which the Gorgon rests her foot. They are similar to recumbent figures in a Bacchanalian scene sketched by Sartorio a few years earlier and appear to have been painted from the same life model (or, according to his usual practice, the photographs he took of one).[108] And this similarity is perhaps significant. He painted the diptych while teaching at the Akademie in Weimar where he may well have absorbed the Nietzschean concept of the Dionysian as opposed to the Apollonian. Depicted with great sensuality, the two black heroes might therefore seem to symbolize the physical senses—the soma—and their white companion the psyche: he is in the pose of Michelangelo's *Dying Slave*, which had recently been interpreted by a German art historian as symbolizing the Platonic idea of the soul imprisoned on earth. As "heroes" they are far removed from abolitionist, colonialist, and Orientalist images of blacks, and yet owe something to each in a picture dominated by a white *femme fatale*.

IV

THE NEW NEGRO

CABINS FOR JIM CROW

Despite the increasing internationalism of Western art in the last quarter of the nineteenth century—encouraged by the great international exhibitions—the differences between European and American images of blacks became still more strongly marked. Erotic Orientalist fantasies of the type in which they were incorporated by European painters found little if any favor in America. A large proportion of the lowest level of society in America was black, but there seems to have been no demand for paintings which realistically recorded its condition—nothing to compare with Luke Fildes's harrowing picture of poverty in England, *Applicants for Admission to a Casual Ward*, which astonished the public when it was shown in the Centennial Exhibition in Philadelphia in 1876.[1] Among thoughtful Americans there was, of course, no lack of serious concern about the social problems of their time and country—the gravest of all being that presented by the conflict between whites and blacks, especially in the southern states. The savagery of whites toward freedmen was condemned in one bitterly satirical drawing after another by Thomas Nast,[2] and more coolly realistic scenes of lynching were also illustrated in the press. But the notion that paintings of human misery could be a source of aesthetic pleasure was alien to American artists and their public.

Before abolition American artists had rarely depicted the degradation of slaves, which was so strongly emphasized on the other side of the Atlantic. The most notable had expressed the hopes and rights of blacks to be free. After the Civil War the vast majority of American images of blacks suggest that they were enjoying their freedom but keeping the place assigned to them by whites. A minority claimed, nevertheless, the right of blacks to equality. There are thus strong lines of continuity. For while the superficial picturesqueness of Eastman Johnson's famous *Negro Life at*

140

the South—now retitled *Old Kentucky Home*—was unconscionably exploited by numerous painters of "Negro subjects," its underlying seriousness was also developed, most notably by Thomas Eakins and Winslow Homer—the greatest American artists in the eyes of posterity if not of their contemporaries. Eakins and Homer both dedicated themselves to depicting specifically American subjects from American viewpoints. But both were gradually driven into introspective isolation by the rampant materialism of the Gilded Age.

A painting by Eakins of a woman with a gentle, sadly resigned expression suggests sensitivity to the predicament of blacks in the United States.[3] It dates, however, from the period when he was studying in Paris between 1866 and 1869, initially under Jean-Léon Gérôme whose influence is apparent in the meticulous treatment of the head scarf.[4] He was intent on becoming a portrait painter at the time, and this painting is an accomplished exercise in the direct representation of a living model (who is more likely to have been

fig. 140

an African than an Afro-American), like the *études* executed by European artists as part of their training during the previous half century.[5] As the image of a nude and physically attractive young black woman, it is an unusual—perhaps unique—work by an American nineteenth-century artist.

In a watercolor painted by Eakins a decade later, the three figures are fig. 141 explicitly Afro-American.[6] Representing a young man playing a banjo and a barefoot boy dancing under the eye of an elderly man, it is quite literally the re-vision of a subject long popular in American genre scenes. Eakins had already emerged as a master of realism with *The Gross Clinic*, which shocked the American public in 1876.[7] And in this small watercolor he seems to have been testing his vision and ability to record what he saw with an innocent eye against all too well-established schemata, in much the same way as he compared his visual perceptions with photographs. He gave great care to the figures, painting oil studies, obviously from life, of the banjo player and the dancing child (a reversal of the normal procedure of working from paper to canvas).[8] But apart from the technical skill with which the movement and weight of the figures and the texture of their clothes are rendered, what most distinguishes this watercolor from conventional images of black musicians is the mood of deeply serious concentration it creates. They are wholly preoccupied with one another, not performing for the amusement of a white audience. The banjo player is no less absorbed, body and mind, in making music than the white pianists Eakins also portrayed (in fact his own sisters). A large section of Eakins's work was devoted to musicians—as another was to sportsmen.[9] In this context, his watercolor suggests that the

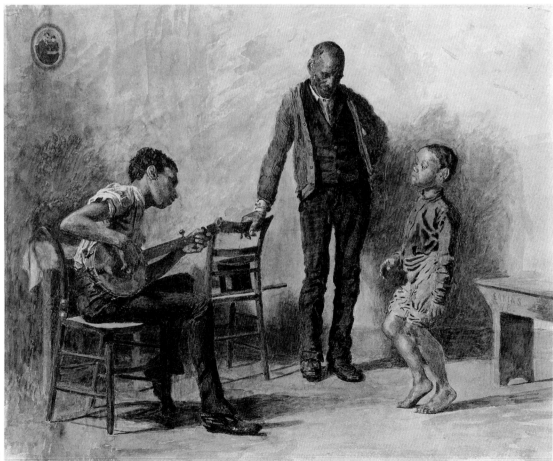

141

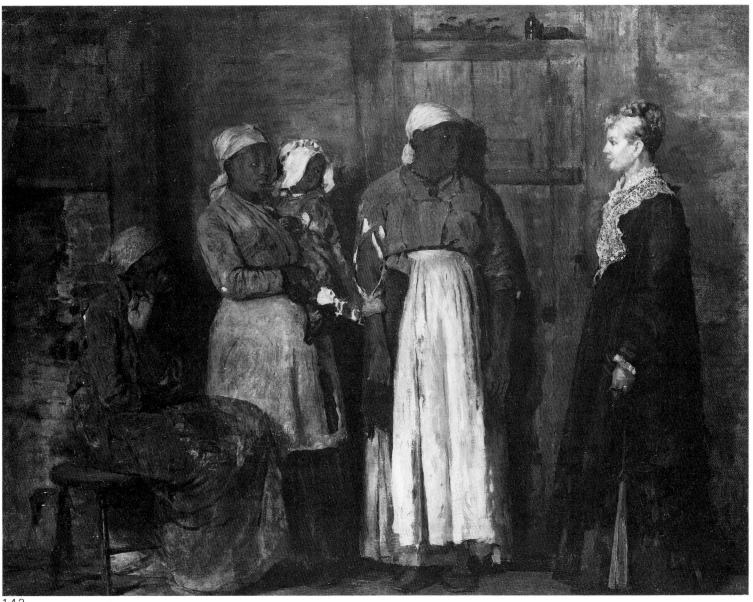

142

banjo, so intimately associated with Afro-Americans, is an alternative rather than an inferior instrument for artistic expression to the piano of white bourgeois homes—with implications for the relationship between black and white cultures.

In *A Visit from the Old Mistress* Winslow Homer referred directly to the fig. 142
postbellum situation in the South. It is not a polemical work. The black women are neither obsequious nor rebellious, though obviously free— self-confident in their stance.[10] The old mistress, just as sure of herself, neither ingratiating nor commanding, eyes her former slaves across a gulf of incomprehension. Perhaps significantly, Homer ranged the frieze of figures according to the composition he had adopted a decade earlier for *Prisoners from the Front* with the mistress in the place of the young Union army officer and the blacks in that of the disheveled Confederate troops—another confrontation across a similar spatial gap, with the effect of an eloquent pause. Homer went back to Virginia, where he had previously worked as a war artist,[11] on a series of visits in the mid-1870s, no doubt simply in search

142. Winslow Homer. *A Visit from the Old Mistress.* Dated 1876. 45.7 × 61.3 cm. Washington, D. C., National Museum of American Art, Smithsonian Institution.

143. Winslow Homer. *Dressing for the Carnival.* Dated 1877. 50.8 × 76.2 cm. New York, Metropolitan Museum of Art.

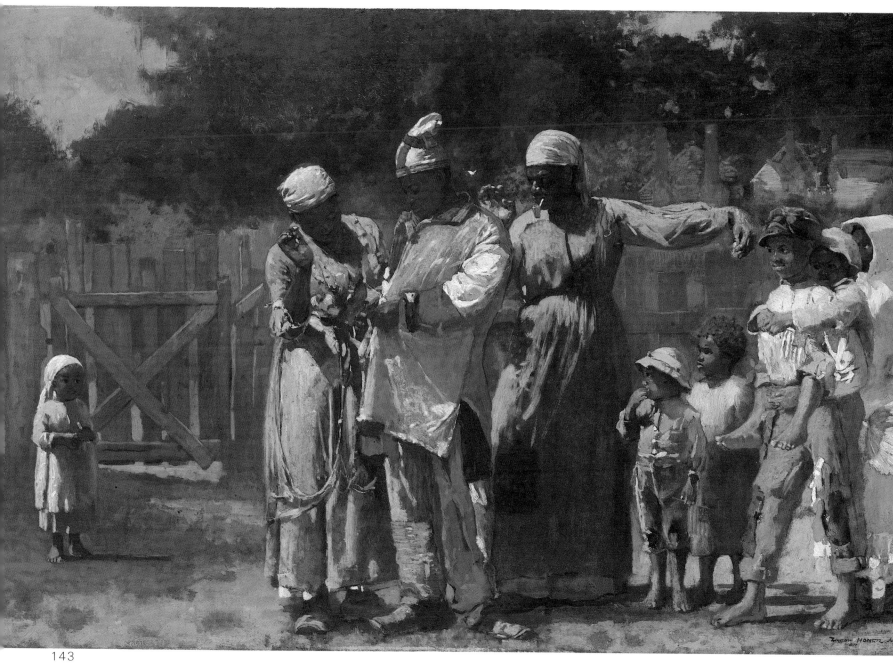

143

of new pictorial material.[12] The warm and colorful agricultural South had begun to assert an allure for the dwellers in the busy, expanding cities of the North, who were the main patrons for works of art. Although wide publicity had been given to the conflicts that had broken out, comforting accounts of life in the "new South" had also been published, stating that blacks and whites were harmoniously adapting themselves to the new relationship. What Homer saw with an artist's eye was far more subtly complex.

Dressing for the Carnival, painted in bright, vibrant pigments, might at first sight appear to record nothing more than a picturesque, sun-drenched, southern scene.[13] It is a masterly rendering of light striking colored forms of great solidity. But closer inspection reveals sorrow in the sunshine. The man in the center is being dressed in a clown's costume by two women whose expressions are anything but festive. There are no smiles of happy anticipation. Even the children seem unnaturally subdued. That two of them hold miniature American flags suggests that the man is getting ready to take part in the Centennial Fourth of July celebrations, and Homer may well have witnessed some such scene on that very day in Virginia. Before he finished the picture in the following year, however, the situation of blacks in the southern states had undergone a violent change for the worse.[14] In one southern town those who had taken part wearing militia uniforms in a Centennial parade had been harassed, and several were killed a few days later. The contested election in the fall of 1876 led to the compromise whereby the southern Democrats accepted a Republican president, Rutherford B. Hayes, on the tacit understanding that federal troops would be withdrawn from the South and no further effort made to implement the Fifteenth Amendment which enfranchised all men whatever their "race, color or previous condition of servitude." The hopeful period of Recontruction had ended, and blacks were forced back into the status of second-class citizens, to be increasingly segregated from the rest of the population. It has been suggested that the closed gate and the clown's costume in *Dressing for the Carnival* have symbolic significance.[15]

In Virginia Homer exposed himself to the hostility of whites. While painting a black model he was threatened with physical violence. When a Virginian lady looking at some of his pictures asked why he did not paint "our lovely girls instead of these dreadful creatures," he is said to have replied, "Because these are the purtiest."[16] But there can be little doubt that he was moved to paint naturally graceful, statuesque women—the least free of all Afro-Americans—by an understanding of their predicament as well as an appreciation of their pictorial value. In *The Cotton Pickers*, the most impressive of his Virginian pictures, the two figures, boldly silhouetted against a vast expanse of field and lightly clouded sky, dominate their environment as blacks had never done in earlier American paintings.[17] They take possession of the land. Burdened though they are by unwieldy loads of cotton bolls, they appear to be not working but thinking. One looks somewhat sadly down while the other stares ahead—though not at the artist or spectator—with an expression of troubled hope for the future. This was one of the group of Homer's works which prompted George W. Sheldon to write in 1879: "His negro studies, recently brought from Virginia, are in several respects—in their total freedom from conventionalism and mannerism, in their strong look of life, and in their sensitive feeling for

fig. 143

fig. 144

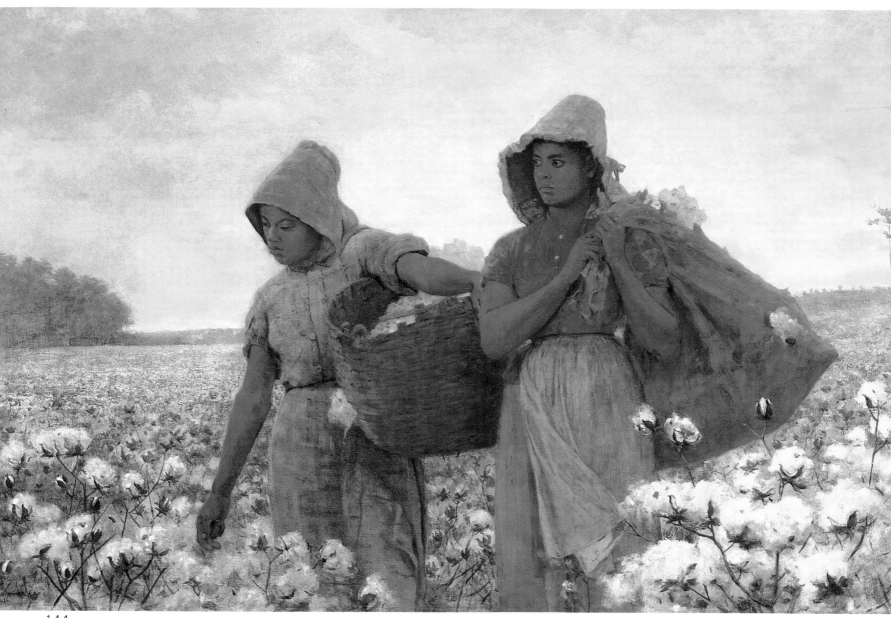

144

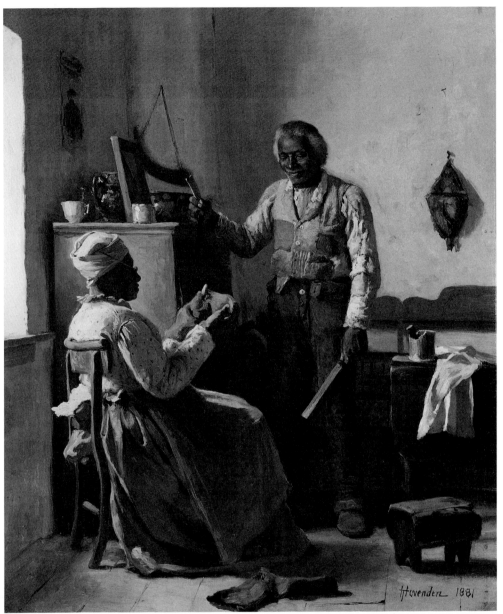

145

character—the most successful things of the kind that this country has yet produced."[18] These qualities were, however, imperceptible to an English art critic who saw *The Cotton Pickers* when it was exhibited at the Royal Academy in London in 1878. It was a "curious picture," he remarked. "The effect produced is scarcely an agreeable one; but the work is full of character nevertheless."[19] For him, perhaps, it was insufficiently colorful to be exotic yet too remote in subject for its realism to be recognized.

By portraying them directly, Eakins and Homer recorded the isolation of blacks in American society while also making the most eloquent claims for their recognition as the equals of whites. They were more often depicted in the roles of obsequious servants or living apart, as in Thomas Hovenden's *Sunday Morning*.[20] Hovenden, who was Irish by birth, had been trained fig. 145 first in New York then in Paris (under the academic painter Alexandre Cabanel) and spent some years in France specializing in scenes of Breton peasant life before returning to America and settling in Philadelphia in

145. Thomas Hovenden. *Sunday Morning*. Dated 1881. 46.3 × 39.4 cm. San Francisco, Fine Arts Museums of San Francisco.

146. Joseph Decker. *Our Gang*. Dated 1886. 60.9 × 77.8 cm. Private Collection.

1880. *Sunday Morning* was one of his first American genre scenes, envisaged with the sentiment and depicted with the attention to local color beloved by the general public on both sides of the Atlantic. The two elderly figures seem to be portraits of individuals, neither caricatured nor idealized, with a sharp focus on the man's patched garments but without any suggestion of discontent or higher aspiration.[21] As in Orientalist paintings, an illusion of realism is given by the tangible fidelity with which objects in the room are rendered. The picture no doubt records how some members of the black community in Philadelphia lived and at the same time the way in which whites liked to think they all lived, complaisantly apart. Such images of picturesque poverty, calculated to tranquilize rather than to disturb social consciences, continued to be painted until well into the twentieth century.

Few works of art so much as alluded to the hostility toward blacks that was increasing in these years, exacerbated by the ever growing number of immigrants from various parts of Europe with different languages, religious beliefs, and customs, and only the color of their skin in common. A painting of children by Joseph Decker evokes the atmosphere of tension at street level.[22] With an anxious, sidelong glance a black child looks at a group of fig. 146 tough, little white ragamuffins, one precociously smoking a cigarette. He seems to call for the spectator's sympathy, though whether this was the artist's intention is not entirely clear. Decker was a German immigrant who failed to achieve popular success, and in the general context of American art the painting is unusual as an image of direct confrontation between whites

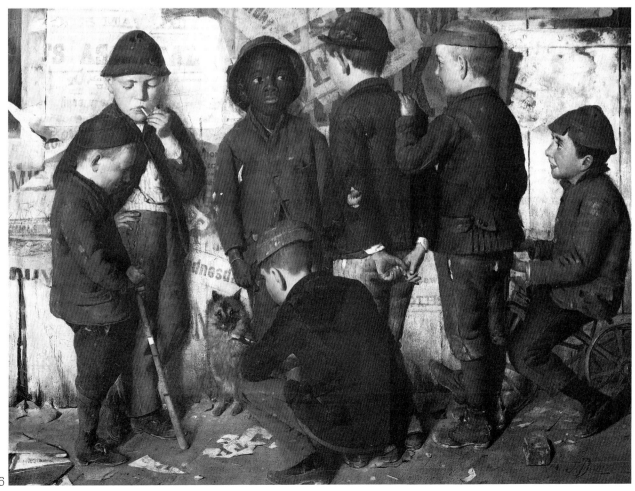

146

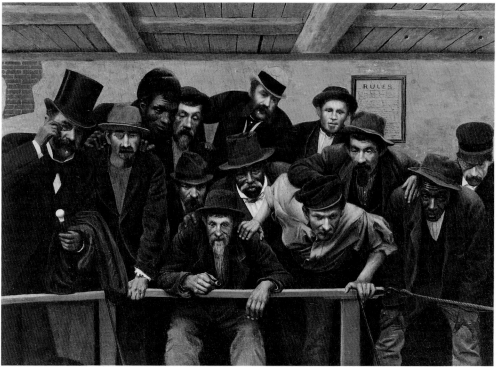

147

and a black, looking at each other with mutual distrust.[23] Many years had passed, and much had happened since James Goodwyn Clonney had depicted a white boy and a black exchanging similarly oblique glances *In the Cornfield*. cf. fig. 48

Black men and white, rich and poor, jostle one another as spectators of a popular but illegal "sport" in Horace Bonham's *Nearing the Issue at the Cockpit*.[24] Conflict is not only transferred from the human to the animal fig. 147 world but, conspicuously, omitted from the picture. The painting seems to have been conceived mainly as a depiction of American "types" of different social classes and ethnic origins, said to portray inhabitants of the artist's hometown, York, Pennsylvania: the moustached black man in the center has been identified as the coachman of a leading citizen.[25] Little more than a decade earlier Thomas Waterman Wood had included a black man in his optimistic picture of American citizens going to the polls with equal voting rights.[26] The electorate, as defined by the Fifteenth Amendment in 1870, may also have been in Bonham's mind. At this time the political arena was not infrequently described as a cockpit, and on the wall behind the excited crowd of individuals there is a notice headed "RULES"—presumably for a cockfight but perhaps referring also to those intended to regulate combats between Democrats and Republicans. There is, however, no suggestion in the picture of the tragic consequences of the presidential election of 1876 to which Homer seems to have alluded in *Dressing for the Carnival*.[27] The blacks cf. fig. 143 and whites depicted by Bonham are all equally thrilled by the spectacle, whether of gamecocks or politicians.

Blacks and whites rarely mingled on terms of equality except in the realm of sports. In boxing rings on both sides of the Atlantic they fought one another, but apparently without attracting the attention of painters from the time of Gericault to that of George Bellows nearly a century later. Although white pugilists were depicted by Eakins, the earliest known painting of a

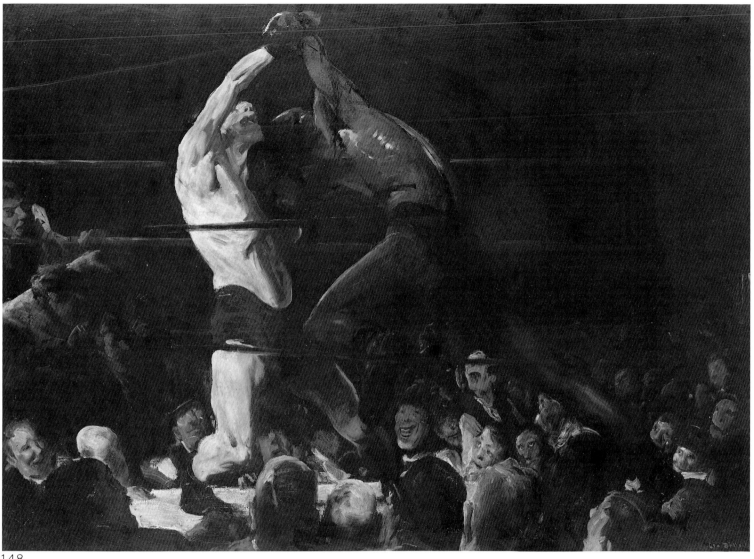

148

match between men of different color is that by Bellows of a black boxer apparently getting the better of his opponent with bloodied face and neck. When executed in October 1909 this powerful image was first entitled *A Nigger and a White Man*, but only three months later the artist retitled it *Both Members of This Club*.[28] A law permitted boxing matches in New York fig. 148 only among members of athletic clubs. But many were in fact staged in the back rooms of bars—notably that run by an ex-boxer named Tom Sharkey opposite Bellows's lodgings—whose habitués were designated members of a club in which boxers were formally enrolled for the occasion. The first of Bellows's several boxing pictures, which established his reputation as an artist, were entitled *Club Night* (1907) and *Stag at Sharkey's* (1909), both showing white boxers in the ring.[29] There may thus be an undertone of irony in the revised title of the picture illustrated here: the black boxer (probably Joe Gans) would have been admitted to "this club" only to fight before the spectator-members who appear to be exclusively white. The irony seems stronger in the title Bellows gave to a later drawing of a white boxer resting in his corner between rounds, *Savior of His Race*, probably alluding to the victory of Jess Willard over the famous, black heavyweight

champion, Jack Johnson, in 1915.[30] Bellows was associated with the painters of the so-called Ash Can School who introduced into American art scenes of squalid, modern urban life depicted with almost aggressive realism.[31] In *Both Members of This Club* the brutality of the subject matter is matched by the brushwork and color. Whether or not it was conceived mainly as reportage and a display of pictorial virtuosity, it could hardly fail to raise thoughts of the racial tensions of the time (more explicitly, perhaps, with its first title). In the previous year at least eighty blacks had been lynched, and the boxer lunging forward to punish his white antagonist might almost seem to be their vindicator—reminding one less of Gericault's lithograph than of Fuseli's *The Negro Revenged*.[32]

Although many white Americans deplored the prevalence of lynch law, and some also the color bar, few if any wished to have paintings referring explicitly to either on the walls of their homes or even the museums they frequented. The "Negro Subjects" that were acceptable to the large art-buying public had, on the other hand, little attraction for the more sensitive and less commercially minded artists. Winslow Homer, who had so poignantly evoked the predicament of blacks in Virginia, turned to other subject matter after 1877. But he began to depict blacks in an entirely different setting when he spent two months in the Caribbean during the winter of 1884–85. This was the first of the several visits he was to make to the tropics, nearly every year until his death.[33] One of his watercolors, painted on the island of Key West off the coast of Florida in 1886, is of a sadly pensive woman standing under a palm tree.[34] The painting brings to mind the figure anxiously waiting in *Captured Liberators*[35] but includes

fig. 149

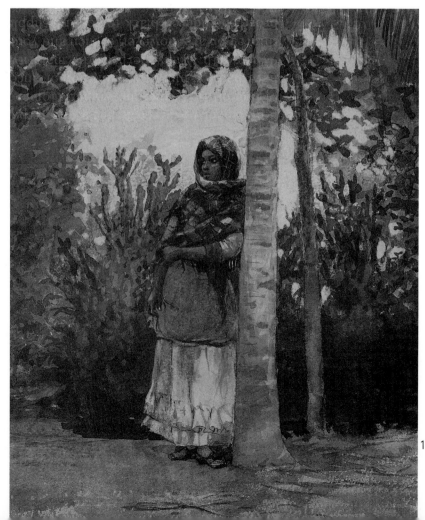

149

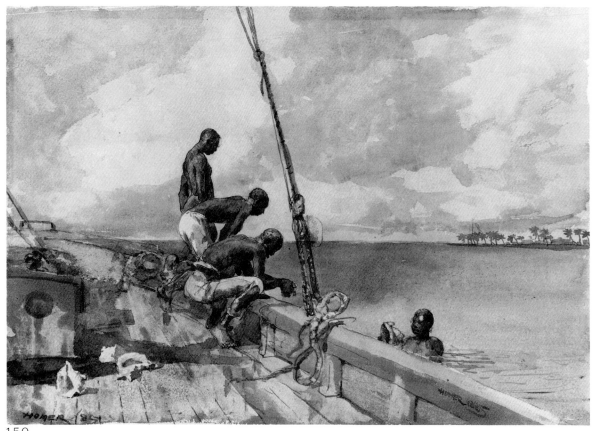

150

no element to direct a spectator's response. It is essentially the portrayal of one of the statuesque women Homer loved to paint, and her color may have had for him little more importance than that of fishermen's wives at Tynemouth. Many, perhaps the majority, of the watercolors he painted in this region are, however, of men and youths with sunlight gleaming on their broad-shouldered black torsos and supple limbs, or partly immersed in the warm blue sea. They convey a sense of joyful release and appear to have been painted with a spontaneity to match the graceful but unselfconscious poses and movements of people living in harmony with nature. *The Conch Divers*, dating from his first visit to the Bahamas and Cuba, suggests carefree surrender to the enchantment of the exotic scene.[36] In fact, the life of these fishermen was no easier than that of workers on the land, and the social position of blacks in the islands (apart from Haiti) was as much subject to discrimination as in the United States. (Slavery was not abolished in Cuba until 1888.) Only for tourists was this economically depressed region an earthly paradise.

fig. 150

The watercolors Homer painted in the tropics are among his most immediately attractive works. Delicately composed, exquisitely painted with translucent washes, and usually sunny in theme, they have a lyrical quality. They are not so much views of the tropics as personal expressions of delight in the beauty of nature. But the masterpiece that emerged from these winter visits, *The Gulf Stream* completed in 1899 after several years of preparation, is an oil painting intended for public exhibition and a far more complex image.[37] A black sailor lies exhausted on the deck of his small boat from which masts and sails have been torn away: there is a waterspout

fig. 151

149. Winslow Homer. *Under a Palm Tree*. Dated 1886. Watercolor on paper. 382 × 308 mm. Washington, D. C., National Gallery of Art.

150. Winslow Homer. *The Conch Divers*. Dated 1885. Watercolor on paper. 356 × 508 mm. Minneapolis, Minneapolis Institute of Arts.

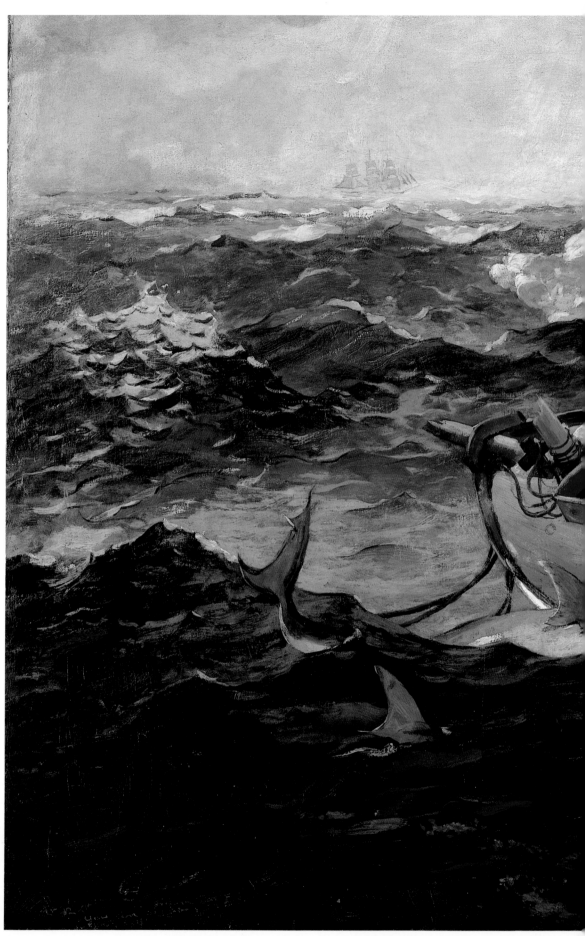

151. Winslow Homer. *The Gulf Stream*. Dated 1899. 71.4 × 124.8 cm. New York, Metropolitan Museum of Art.

151

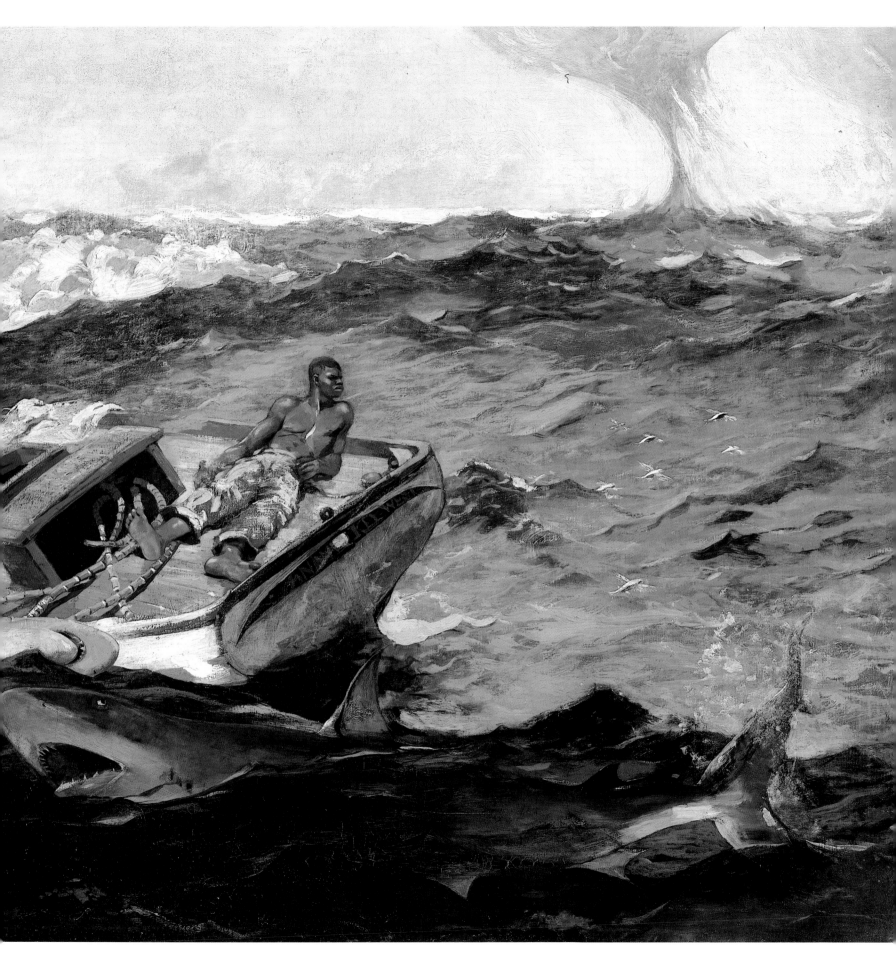

on the horizon, a distant ship sails by unheeding, and sharks splash around expectantly in the foreground. Words painted on the rudderless stern of the boat, *Anne – Key West*, reveal that the man tied to the deck, drifting on the storm-tossed sea, is an American citizen. The picture is in fact charged with unobtrusive symbolism which gives it more than one level of meaning—like T. W. Wood's *A Southern Cornfield* or Carlton's *Watch Meeting*.[38] Boatmen living on Key West may have enjoyed the benefit of a tropical climate but were also in peril of the violent storms that swept across the area, and *The Gulf Stream* records the effect of such a far from infrequent natural calamity. Tornadoes had, however, been described in literature, notably William Cowper's famous poem,[39] as acts of divine judgment on slave owners. And there are other elements in the picture that bring slavery to mind. Sugar canes emerging from the hold of the boat recall the plantations for which Africans were first enslaved and transported across the Atlantic. The sharks remind one of those to whom so many dead and dying slaves had been thrown in the course of the Middle Passage.[40] The Gulf Stream is, of course, the strongest of the ocean currents between Africa and America.

In the art historical perspective the painting comes at the end of a succession of three of the most notable works including images of blacks: Copley's *Watson and the Shark* (set in Havana harbor) which Homer would have known from a print or one of the several copies; Gericault's *Raft of the Medusa* which he must surely have seen in Paris; and Turner's *Slave Ship* which had been in the United States for two decades before it was bought by the Boston Museum of Fine Arts, in the year *The Gulf Stream* was finished.[41] Whether or not Homer consciously alluded to these paintings— all of which date from the years of struggle for the abolition of slavery—*The Gulf Stream* presents a kind of commentary on them. He was always more interested in the present than the past, and his subject was contemporary. His deeply pondered image is of an individual in conflict with the forces of history as well as nature, summing up the tragedy of slavery and its aftermath. Yet it may also have had a personal meaning for Homer who painted it shortly after his father's death. It conveys a mood of pessimistic, introspective isolation. The artist who had painted blacks with deepening understanding since the Civil War seems here to have identified himself with the figure on the boat, alone on the cruel sea that had been the means of his livelihood.

There is more obvious empathy in the portrait of Henry Ossawa Tanner by Eakins.[42] A light-complexioned octoroon, Tanner was the son of a fig. 152 bishop of the African Methodist Episcopal Church, brought up in relatively prosperous circumstances, and well educated. With the ambition to be an artist he attended the Pennsylvania Academy of the Fine Arts where he was taught and befriended by Eakins but cruelly persecuted for his presumption by a gang of white students.[43] In 1891 he went to study in Paris and soon began to exhibit in the Salon. When he returned briefly to the United States he painted, as he stated in an autobiographical letter, some "Negro subjects" wishing to represent the "serious and pathetic side" of their life.[44] They were closer in feeling to European images of poverty, including those by Vincent van Gogh, than to most American images of blacks—poor people who were colored rather than colored people who were poor.[45] Critical comment in the press was however condescending. Tanner painted no more

152. Thomas Eakins. *Portrait of Henry Ossawa Tanner*. 1902. 60.9 × 51.4 cm. Glens Falls, Hyde Collection.

152

such subjects after 1894. He went back to Paris and spent the rest of his life in Europe, apart from a visit to the United States in 1902–4, when his portrait was painted by Eakins. In Europe he could be regarded as a painter whose ancestry was of minimal significance. He was in fact the first Afro-American artist to win an international reputation. His portrait is one of a number which Eakins, on his own initiative, painted of intellectually distinguished American (mainly Philadelphian) contemporaries. Showing him as a thoughtful, perhaps rather introspective, middle-aged man seated at his ease, it might almost be a pendant to that Eakins painted of himself in the same year—similarly lit, posed, and dressed—for presentation to the National Academy of Design. But it is also a kind of meditation on the physiognomy of a friend and former pupil who had been virtually driven into exile by the virulence of racial prejudice extended to so-called white Negroes whose true appearance could be recorded only in such a clearly focused painting.

153

THE AVATARS OF THE ACADEMIC MODEL

In Europe black men and women could be regarded by artists quite simply as academic models without the burden of extrapictorial significance—moral, social, and political—they bore on the other side of the Atlantic. They also had a kind of rarity value appreciated by sculptors as well as painters who, especially in the early years of their careers, were concentrating on the problems of representation. Studies painted in the course of the nineteenth century thus reveal greater changes in artistic styles and techniques than in mental attitudes toward the blacks themselves, as darkly mysterious aliens. The young Eakins, as we have seen, painted one of a black woman in the polished academic manner of his French masters before he had begun to cf. fig. 140

154

evolve his individual handling of the medium. Edouard Manet's unfinished portrait of a black woman wearing a toque and décolleté dress with heavy earrings and necklace[46] is, on the other hand, an essay in his lifelong artistic struggle "to be himself and not someone else," to paint sincerely what he saw without tricks and subterfuges.

fig. 153

Manet had been struck by the picturesqueness of the non-European population of South America when, as a young sailor of sixteen and still no more than an amateur draftsman, he had visited Rio de Janeiro in 1848. " . . . The city, though rather ugly, has a special attraction for the artist," he wrote. "Three-quarters of the population is Negro, or mulatto. In general, that portion is hideous apart from a few exceptions among the Negressees and mulatto women; almost all of the latter are pretty."[47] His portrait of a black woman dates from some fourteen years later. It has generally been described as a sketch for the servant in *Olympia* but seems rather to have been conceived as an independent *étude* of the same model, identified as "Laura, a very beautiful Negress."[48] She looks straight at the artist with an expression that suggests mutual understanding. Dress and jewelry set her in the shady social milieu of artists' models—like Delacroix's *Aspasie*. Although the painting may have been intended mainly as a pictorial exercise left unfinished when its purpose was achieved—as were many other *études* by mature artists—it is also a record of the sitter's evident charm. Her individuality is, however, completely submerged in *Olympia* where she has the conventional role of a servant subsidiary to the main figure whose whiteness she sets off.

cf. fig. 115

cf. fig. 20

The painting of a black woman arranging peonies in a vase by the short-lived Frédéric Bazille has obvious similarities with *Olympia* by which it may well have been inspired in the light of Zola's formalist interpretation.[49] The same model could have posed for both. Bazille was a friend of Manet and a frequenter of the Café Guerbois where painters and writers, including Cézanne and Zola, discussed artistic problems. Early in 1870 Bazille remarked in a letter that he was employing three models whose "only shortcoming is that they are too expensive."[50] One was a French woman, "a ravishing model who is costing me an arm and a leg (ten francs a day plus bus fare for herself and her mother, who comes with her)," another "a superb Negress." These models posed for a large picture to which he referred at the time as simply "three women, including one completely nude and another almost" and later entitled *La toilette*.[51] Here the black model was depicted as an attendant with a towel round her waist kneeling to remove the slippers of the "ravishing," seated nude white woman. Two pictures of the "superb Negress" on her own, one full face and the other three-quarters profile, seem to have been prompted by her presence in the studio.[52] (The peonies that do not bloom until May indicate that they were painted after he had begun, if not finished, *La toilette*). Here her individual physiognomy is more carefully registered than in *La toilette* although her black face and hands have no more, if also no less, importance than the flowers in compositions of glowing color, evoking the warmth and burgeoning luxuriance of early summer. She figures, indeed, as an artist's model, a woman hired to pose and be painted.

fig. 154
cf. fig. 115

fig. 155

Black male models were also available for artists, especially in Paris. Paul Cézanne painted an *étude* of one named Scipion, perhaps at the Académie

fig. 156

155. Jean-Frédéric Bazille. *La toilette*. Dated 1870. 132 × 127 cm. Montpellier, Musée Fabre.

155

Suisse where, for a modest fee, artists could work in an unsupervised life class.[53] Rendered with nervously violent brushstrokes, it is a product of his early struggles with his medium, the art he admired, and the visible world. For him, the man seems to have been simply a subject to be depicted, a volume of dark flesh absorbing and reflecting light, with a darker background save for a patch of white against which one wrist and hand are perturbingly silhouetted. Unlike the dramatic subject pictures of his early years—which included his exuberant "answer" to Manet, *Une moderne Olympia*[54]—it is a kind of still life which shows him confronting the problem that was later to absorb his attention: that of reconciling his consciousness of solid form with the flat surface of the canvas. His *étude* of *Scipion* concentrates only on form, though the darkness of his body determined a somber palette without any of the bright pigments used by Manet and Bazille. At about the same time Cézanne painted a subject picture variously entitled *La Madeleine* or *La douleur* (now Musée d'Orsay, Paris) in which the pose of the heavily swathed figures is close enough to that of Scipion to suggest that the same model served for both. Artists seem often to have effected transformations of sex and color when working from an easily available model.

157

156

156. Paul Cézanne. *Le nègre Scipion*. Ca. 1866–68. 107 × 83 cm. São Paulo, Museu de Arte de São Paulo.

157. Lovis Corinth. *Un Othello*. Dated [18]84. 78 × 58.5 cm. Linz, Neue Galerie der Stadt Linz.

Scipion is said to have been also the model for a plaster statue by Philippe Solari, a friend of Cézanne and, like him, a native of Aix-en-Provence. It was entitled *Nègre endormi* and was evidently conventional enough to win admittance to the Salon, from which Cézanne's paintings were consistently excluded, though without attracting a patron to commission a marble or bronze version.[55] The plaster was destroyed, but a revealing account of it was published by Zola, who also came from Aix-en-Provence and was eager to promote Solari. In 1868, Zola wrote:

> I think Philippe Solari is one of our two or three truly modern sculptors. . . . He bid adieu to the dream of absolute beauty; he did not seek to fashion idols for a religion that ceased to exist two thousand years ago. Beauty has become for him the living expression of nature, the individual interpretation of the human body. He takes the first model to come along, expresses literally its gracefulness or strength, and in doing so makes a true work. . . .[56]

Edmond About had said much the same to explain Victor van Hove's choice of a black model for a statue more than a decade before.[57] But while praising the realism of the *Nègre endormi*, which may well have been conceived as no more than the representation of an individual model, emphasized by the title, Zola went on to set it in the context of racial theories about blacks:

> The head superb, small, flattened: the head of a human beast, stupid and mean. The body has a feline suppleness, forceful limbs, shapely and powerful loins. There are wonderful passages in the back and arms. One feels that here is an exact rendering, for everything is logical in this figure which could be the personification of the Negro race—lazy and deceitful, obtuse and cruel—race that we have transformed into beasts of burden.[58]

The words betray the disdainful attitude toward blacks which the great realist in literature shared with the general public, whether or not they also express that of painters and sculptors. Representations of black models, however naturalistic, seem almost inevitably to have been given racialist significance when transferred from the context of the studio to that of an exhibition gallery where they were surrounded by images of whites and placed before a white public.[59]

The difference in context was, however, reduced in the later nineteenth century with the gradual closing of the gap between *études* and "finished" works of art, especially in painting, and also with a decline in the demand for narrative content. The portrait of a burly black man in a seaman's ragged striped sweater is labeled as a broadly painted "picture" rather than a sketch by the boldly inscribed signature *Louis Corinth Anvers 84* and title *Un Othello*, at the top of the canvas.[60] This title gives the work a general significance endowing the man with the proud and jealous character of Shakespeare's tragic hero, though it may well have been an afterthought that emerged out of the image. There cannot be much doubt that the subject of *Un Othello* was a sailor in the port of Antwerp who had caught the artist's attention by his striking appearance and difference from the majority of academic

fig. 157

158

models. (At this date in Europe blacks were most frequently to be found in seaports.) Corinth had just completed his training at the Akademie in Munich, under artists who specialized in South German genre scenes and large historical compositions, and was on his way to Paris where he was to study under the equally conservative "Salon" painters William Bouguereau and Robert-Fleury. Later in his career he is known to have painted only one image of a black, a shadowy "eunuch" in the background of a harem scene which, without him, might appear to represent the interior of a Berlin brothel.[61]

A small painting by the Dutch artist George Hendrik Breitner is another image of a black by a young painter exercising his ability to depict an unfamiliar subject as a means of feeling his way toward the creation of an individual style. Breitner had been trained at the academy in The Hague, until he was expelled for misbehavior, and then taken up by Hendrik Wilhelm Mesdag, the Dutch realist painter and discriminating collector of contemporary French art. Reacting against the current vogue in the Netherlands for pictures of quietly comforting pastoral scenes, in 1882 he began with his friend Vincent van Gogh to explore the working class districts of The Hague in search of subjects as yet untouched by Dutch artists. (Subsequently he was to study in Paris for a while and on his return to establish himself as the leader of the so-called Amsterdam Impressionists.) In 1883–84 he and at least five other artists of the same generation employed a black model named Adolf Boutar who excited attention in much the same way that Wilson had done in London a century before.[62] He was depicted as a water seller in an Algerian street scene by Philippe Zilcken, who had recently returned from a visit to North Africa and was beginning his career as the first Dutch Orientalist. Of the several studies of Boutar by Breitner, the most notable shows him holding a sword and has been variously entitled *Deurwachter* ("Doorkeeper"), *Eunuch*, *De Afrikaanse strijder* ("The African Warrior"), and simply *Neger*.[63] But the painting itself has no pretension to be more than the image of a handsome black model, rendered with the boldness and directness that had long been usual in *études*.

fig. 158

James Ensor's *Masques regardant un nègre bateleur*, a third example of an image of a black by a young late-nineteenth-century artist, is a more complex work.[64] The figure, in a relaxed, life-class pose, dates from about 1879 when Ensor was a nineteen-year-old student at the Brussels Academy; it reveals his precocious ability in naturalistic representation. He added the masks on the right, and probably also the lamp and the turtle on the floor, a decade later.[65] By this time he had passed through a phase of painting realist subjects and emerged as a leading Symbolist-Expressionist (his famous picture, *The Entry of Christ into Brussels*, was completed in 1888). *Masques regardant un nègre bateleur* has a characteristically disturbing symbolism that demands and defies rational analysis. As in so many of his other paintings, the grotesque carnival masks, grimacing, staring, shrieking with hollow laughter, seem to symbolize the evasions, hypocrisies, and deceits of bourgeois life. Here they "regard" the natural man, stripped bare of clothing save for a posing pouch, who is, nevertheless, an artist's model impersonating a juggler or tightrope walker. But the contrast between the careful figure study and the masks painted in strident colors with expressionist verve suggests also a primarily artistic comment on the academic teaching that Ensor had received and

fig. 159

158. George Hendrik Breitner. *Deurwachter*. 1883–84. 70 × 41 cm. Amsterdam, Stedelijk Museum.

159. James Ensor. *Masques regardant un nègre bateleur*. Ca. 1879 and ca. 1889. 115 × 96 cm. Private Collection, Belgium.

159

rejected. For painters concerned more with the expression of inner feelings than with purely visual perceptions (and not at all with illusionism), *études* of blacks executed as exercises in the representation of unfamiliar subjects had begun to lose their relevance. In Ensor's title for the painting, the *masques* are given precedence over the conventionally represented image of the black man in the conventional roles of artist's model and entertainer.

A pastel sketch by Edgar Degas of the acrobat Miss La La hanging from a rope by her teeth is far removed from studies of models posed in the sequestered space of a studio. On 18 January 1879 the *Journal des Débats* reported that "the Cirque Fernando with its famous Negress Miss La La, the woman-cannon, is the greatest attraction of the day."[66] Degas went there several times, made at least four drawings of the star performer being hauled up to the roof of the hall, dated between 19 and 25 January,[67] and completed an oil painting of her act in time to show it in the Fourth Impressionist Exhibition in April.[68] These realistic, and at the same time almost hallucinatory, images of the human figure dancing in air with

fig. 160

211

160

arms and legs in contrapposto, seen from an extraordinary viewpoint, are rendered with a virtuosity to match the performer's daring feat. Convinced that all art was artifice, Degas frequented places of entertainment in search of subject matter which he depicted from the angles glimpsed by a spectator but unusual in works of art. At the Cirque Fernando he remarked to a friend—an Impressionist landscape painter—"for you, natural life is necessary; for me, artificial life." [69] The difference in attitude must have been striking when his painting of Miss La La was first exhibited in the company of no fewer than twenty-nine landscapes by Claude Monet.

Degas recorded Miss La La's dark skin and mop of black hair though he was clearly more interested in her performance than her ethnic characteristics which might easily be overlooked in his painting. Some years earlier, while visiting his relations in New Orleans in 1872, he had

160. Edgar Degas. *Miss La La at the Cirque Fernando.* 1879. 117 × 77.5 cm. London, National Gallery of Art.

161. Henri de Toulouse-Lautrec. *Footit et Chocolat.* 1895. Lithograph. 356 × 502 mm.

written: "Nothing is so pleasing as the Negresses of every shade, holding in their arms white children, ever so white. . . . And the pretty, pureblood women, the pretty quadroons, and the well-built Negresses!"[70] But he did not depict them.[71] The colorful scenes of New Orleans could, he remarked, be represented only in the manner of such an artist as Auguste Biard. The spectacle of a solitary black woman suspended high above his head in the dome of the Cirque Fernando stirred his imagination in an entirely different way. His images of her might almost seem to symbolize the isolation of the black in Europe.

Although she was billed in England as "the African Princess," Miss La La's color was no more than part of her act—one might say her costume—adding a piquant note of exoticism. The color and physiognomy of a man nicknamed Chocolat were, on the other hand, essential for his performance. He was a member of the raffish troupe of characters immortalized by Henri de Toulouse-Lautrec. In a drawing for publication in the periodical *Le Rire*, he was shown executing a loose-limbed tap dance in the Irish and American Bar of the Rue Royale in Paris.[72] His facial features and bodily movements are caricatured—in the original meaning of the word which implied exaggeration rather than ridicule—but no more than those of Yvette Guilbert, Jane Avril, or, indeed, the artist himself in his many self-portraits. Dance and costume indicate that he was Afro-American rather than African. The drawing conveys the sense of disillusioned melancholy that suffuses Lautrec's most memorable images of entertainers and prostitutes. In another drawing, however, published in the symbolist periodical *Revue Blanche*, Chocolat figures as no more than the fig. 161

161

162

butt of a knockabout turn at the Nouveau Cirque, receiving a "kick in the pants" from his white clowning partner, George Footit.[73]

In Europe, as we have seen, blacks had been part of the world of the circus, the boxing ring, and the theater since the early nineteenth century. A black man calmly seated in a Roman café, as depicted by Wilhelm Trübner, fig. 162 was a more surprising sight. Trübner, aged twenty-one, had just completed his artistic education at the Munich Akademie and was making the German artist's almost obligatory tour of Italy—studying the masterpieces of the past and picturesque scenes of contemporary life—when he encountered this man in Rome. The picture was perhaps conceived primarily as a study in color, with the central slash of white paper, yellow gloves, and orange lining of a hat making vibrant contrasts with the black of the man's skin, his somber clothes, the greenish blue sofa, and blue wall covering. The newspaper is, however, boldly entitled *La Liberta*, presumably with reference to freedom from slavery or liberty in a wider sense.[74] In Germany at this period, socialist ideas were disseminated mainly by newspapers—the freedom of the press was to be guaranteed constitutionally in 1874 but rescinded by Bismarck's reactionary legislation four years later. And the picture appears to have been entitled *Politische Studien*.[75] Whether this detail was included merely to

214

163

give the picture anecdotal content cannot be ascertained. Another painting by Trübner of the same man in profile with a bunch of peonies is clearly no more than the study of an individual who had caught the artist's attention (the similarity with Bazille's *Négresse aux pivoines* is surely fortuitous).[76] In 1873 he also painted the same model full face, placing an empty purse on the table in front of him to convert a study from life into a subject picture which he entitled *Kassensturz* ("The Reckoning").[77] He was later to write in his autobiography: "Every subject is interesting, and even the least important provides enough interest for painting. Indeed the simpler the subject the more I can depict it in an interesting and complete way by the use of paint techniques and coloration."[78] Like a number of other European images of blacks these paintings by Trübner were the work of a young artist who was never to depict such models in his later career.[79] They were demonstrations of technical ability calculated to attract attention when shown in exhibitions where the majority of paintings were of whites. Yet the artists' romantic notion of themselves as outsiders may also have prompted them to depict the people who were most obviously outside European society.

A painting by the Dutch artist Cornelis Johannes "Kees" Maks, exhibited in Amsterdam in 1912 with the simple title *Familiegroep*, is in every way

cf. fig. 154

fig. 163

215

exceptional.[80] For not only is the father of the family black and the mother white, but both are in correct evening clothes, he in a dinner jacket. They are grouped with their children—one fair, two dark—and white governess in an affluent, bourgeois interior, Persian carpet on the floor, well-supplied table, and potted palm. The mother is said to have been a friend of the painter, but otherwise little is known about the picture, not so much as the name of the family who presumably commissioned it.[81] By this date there were black families living in comfortable middle-class prosperity on both sides of the Atlantic, and marriages between them and whites were not unknown. Whites were questioning more frequently than hitherto the racial theories excogitated to rationalize their notion of their own superiority. Jean Finot wrote in 1905 at the beginning of his book on *Le préjugé des races*:

> The idea of the races, formerly so innocent, has cast a tragic shroud, so to speak, over the surface of our soil. . . . On the one hand, organic inequality (*anthropology*), based on the data of a poorly defined science that was liable to all kinds of errors; on the other hand, anthropo-psycho-sociological inequality (*anthroposociology* or *psychology*), which to the shaky foundations of the former adds a phraseology borrowed from whimsical, ephemeral doctrines.[82]

Among the general public in Europe, however, a visceral horror of "miscegenation" exacerbated by colonialist propaganda still prevailed, limiting reference to it in works of art.

ETHNOGRAPHIC MARGINALIZATION

"When we regard every production of nature as one which has had a history," Charles Darwin wrote in *On the Origin of Species*, "how far more interesting, I speak from experience, will the study of natural history become!"[83] Nearly every aspect of nineteenth-century thought was dominated by an obsession with history as a means of explaining the present and predicting the future. It underlies the various theories of evolution, by the inheritance of acquired characteristics (according to Lamarck) or by natural selection (according to Darwin). The account of "the preservation of favoured races in the struggle for life"—the subtitle of Darwin's book—provided a plot like that of a historical novel with a happy ending for a story in which the characters were fossils. But it also provided a paradigm and a rationale for European domination over the rest of the world. So far as attitudes to Africans are concerned, this "social Darwinism" (which owed little to Darwin himself) had far greater influence than the many theories about the kinship between man and apes. The theory of the descent of man from animals without divine intervention was, of course, rejected by Christians. But in order to maintain the complete separation of the human species from brute creation, they were obliged to shift their attention from physiology to mentality, finding evidence in the supposedly universal cognizance of Divinity. The beliefs of Africans thus came to be studied, especially by missionaries, no longer as devilish superstitions but as primitive forms of religious thought. For religion was now seen, by all save

164. Georg Schweinfurth. Pencil drawing of *Düd, ein Djur*. Dated 1871. 370 × 280 mm. Frankfurt on Main, Frobenius-Institut.

164

fundamentalists, to have had a history that extended from the earliest times and would eventually culminate in the worldwide acceptance of Christianity.

Africa south of the Sahara was said to have no history before the arrival of Europeans—nothing but "blank, uninteresting, brutal barbarism" according to a professor of colonial history at Oxford.[84] It had only natural history and prehistory. Africans who still maintained their traditional ways of life thus came to be assigned to the Stone Age in a system of categorization originally devised for prehistoric artifacts but subsequently extended to ethnology. There was a tendency to describe and illustrate them as interesting objects for study. A drawing by Georg August Schweinfurth of Düd, a man of the "Djur" group living on the Upper Nile, is the careful record of a well-marked ethnological specimen.[85] The man stares straight at the artist, but apparently across a gulf of mutual incomprehension. Schweinfurth's drawings of Africans, just as much as those of flora and fauna, were conceived as scientific records. When they were reproduced in his book *Im Herzen von Afrika* (Leipzig and London, 1874), however, the figures were posed against picturesque backgrounds, rather as stuffed animals were exhibited in dioramas.[86] The majority of mid-nineteenth-century explorers were more concerned with geography than ethnology, with tracing the courses of rivers than studying the people who lived on their banks. So too, it would seem, was the general public. Heinrich Barth's five-volume *Travels and Discoveries in North and Central Africa* (London, 1857–58), an enduringly valuable account of ways of life, customs, beliefs, artifacts, and languages, with neat diagrammatic illustrations, was a commercial failure.[87]

fig. 164

217

Carlo Piaggia, perhaps the most innocently observant and least prejudiced of all nineteenth-century travelers in Africa, was unable to find a publisher for his vivid but unliterary account of his life among the Zande—or Niam-Niam as they were known from fabulous tales—nor were the drawings by his companion Damin reproduced until recently.[88]

The popular demand was for exciting narratives of the tribulations, hairbreadth escapes, and final achievements of heroic European explorers. Only minor roles were assigned to Africans who, in illustrations, make up the procession of half-naked bearers in the familiar image of the fully dressed explorer, missionary, or big game hunter striding through the jungle. Visual impressions of Africa and Africans were derived mainly from engravings in books and periodicals often by Edouard Riou who could turn his hand to illustrating any part of the world despite the limited extent of his own travels.[89] The uniformity with which he drew them suggested that one jungle was very like another and that the indigenous peoples of South America, Australasia, the East Indies, and Africa were all equally "primitive." His bold signature appears on plate after plate in *Le Tour du Monde*, David Livingstone's *Last Journals in Central Africa* (London, 1874), Henry M. Stanley's *In Darkest Africa* (London, 1890), and Louis Gustave Binger's *Du Niger au Golfe de Guinée* (Paris, 1892). It is hardly surprising that he was also employed to illustrate the works of Jules Verne whose *Cinq semaines en ballon: Voyage de découvertes en Afrique* (Paris, 1863) had been the first of many popular novels on the theme of African exploration—and one in which "natives" put in no more than fitful appearances as obstacles to the explorers' transcontinental progress.

Around the beginning of the twentieth century, however, images of Africans in Africa began to undergo a change. Colonization opened the continent to ethnologists who took advantage of the protection of the occupying powers and improved facilities for travel to investigate the lives, beliefs, and arts of Africans more thoroughly than had hitherto been possible. Better equipped intellectually than the freebooting explorers of the mid-century, and technically than such notable *Afrikaforscher* as Barth and Schweinfurth (to whose pioneer work they were much indebted), they gave new dimensions to the European vision of the continent and its many diverse groups of inhabitants. Thus, paradoxically, at the moment of their lowest political degradation, Africans began to emerge from travel books and ethnological reports with rather greater independence and individuality than they had previously been accorded. Although the perceptions of ethnologists were inevitably conditioned by preconceived ideas, their aims were scientific. They made much use of photography. But, to record the colors of African costumes, to catch figures in movement, and to provide general impressions of the environment, they still needed artists.[90] Thus Leo Frobenius, perhaps the most distinguished of those who traveled extensively in Africa in the first decade of the twentieth century, assembled a small team of skilled painters to accompany him.

Frobenius traveled in style with a retinue so imposing (three hundred fifty men on one occasion) that it prevented him from making intimate contact with the Africans he went to study, nor could he converse with any of them except through interpreters. His conception of fieldwork could hardly have been more different from that of his contemporary

Bronislaw Malinowski in the Trobriand Islands. But the preconceptions in his intellectual baggage differed markedly from those of earlier explorers in Africa. In 1894, at the age of twenty-one, he had published a long and serious study of African secret societies, generally regarded at the time as nefarious, obscurantist organizations (particularly trying to colonial officials) and followed it up with an account of their masks, which had not yet begun to attract the attention of artists. His doctoral dissertation on the origins of African culture was rejected by his university, apparently because the subject was supposed to be nonexistent. In 1898 he joined the staff of the Museum für Völkerkunde in Leipzig with its large collection of Oceanic artifacts to which he directed his attention. His four-volume work *Probleme der Kultur* (Berlin, 1899–1901) was devoted mainly to Oceania, but in it he developed the revolutionary theory that non-European artists evoked rather than copied natural forms to convey meanings to the society in which they lived. When he set out on the first of his African expeditions, to the Congo in 1904, he had also begun to evolve, from Herder and Hegel, his notion of what he was later to call the *Paideuma*, the living cultural soul of each individual human group. The search for this essence gave direction to his study of every manifestation of African culture—myths and legends (some of which he was the first to record), rituals, social organization, the form and decoration of utensils and buildings, sculpture and paintings (he virtually discovered Ife sculpture and initiated the serious study of the rock art of the Atlas, the Fezzan, and southern Africa). Much of his theorizing—especially that of his later years—has now been outdated. But no one did more to destroy the belief that Africa was a cultural wilderness. According to no less an authority than Léopold Sédar Senghor, he helped Africans as well as Europeans to give the word *Négritude* "its most solid, and at the same time its most human significance."[91]

The large number of paintings and drawings by the artists who accompanied Frobenius on his travels constitute a unique visual record of life among the peoples of West Africa in the first decade of the twentieth century.[92] Frobenius chose the subjects to illustrate his ideas—he referred on one occasion to the difficulty of finding good models[93]—and his artists were merely required to depict to the best of their ability what was pointed out to them. The images are thus no less selective than those of earlier times (if no more so than photographs) though selected according to different criteria. Sometimes the artists' vision seems to have been clouded by reminiscences of how Africans had previously been represented. In the painting of a ceremonial procession of the Belo, apparently worked up from rough sketches, by Hans Martin Lemme, there is a touch of caricature suggestive of a condescending European attitude to a "savage" ritual.[94] But individual figures were rendered with the dispassionate objectivity for which European painters had been taught to strive in painting *études*. Friedrich Wilhelm Fischer-Derenburg depicted three men in the magnificent shell-work, feather, and horn ornaments of the Konkomba in Togo (now part of Ghana),[95] Carl Arriens a masked figure followed by a drummer and a piper of the Chamba.[96] Another watercolor by Arriens is entitled *Trachten der Muntschi (Nigeria)* putting the emphasis on the wearers' personal adornments, including scarification, body paint, and jewelry.[97] Frobenius collected masks, ornaments, carvings, and so on for the German ethnological

fig. 165

fig. 166
fig. 167

165

museums that financed his expeditions, and the watercolor drawings were intended partly to record their use, too often forgotten when removed from their original contexts. To this extent he served the purposes of a colonialist state. But it was no doubt due to the talent of his artists as much as to his own ideas of culture that the Africans were represented in their natural human dignity, less as "savages" to be compared with "civilized" Europeans than as men with a way of life alternative to that of the industrialized West.

These watercolors were conceived as documentary illustrations. But statues of Congolese by the English sculptor Herbert Ward were self-consciously works of art. Ward's career was unlike that of any other artist of the time. As a footloose youth he worked his way round the world and after a brief spell with the British North Borneo Company, at a station in the country of the headhunting Dyaks, was recruited by H. M. Stanley for the Société anonyme pour le Commerce du Haut-Congo recently launched by Leopold II of the Belgians. He spent five years in the Congo in various capacities but in 1889, at the age of twenty-six, returned to Europe, married, began to describe his experiences in lectures and books, illustrated in the traditional manner, took up painting, and a decade later turned his attention to sculpture. Between 1900 and 1912 he modeled eleven statues and three busts, partly from rough drawings he had made and photographs he had taken in the Belgian Congo and partly from Africans whom he found in Paris.[98] Most of them were exhibited either at the Royal Academy in London or the Salon in Paris (where he was twice awarded medals).

Ward's statues are life-size, sometimes larger, and so disturbingly lifelike that they give an impression of truth to nature—though not the whole

166

167

truth. His choice of subjects, the ways in which he posed the figures, and the facial expressions he gave them, reflect his belief that the Congolese were in a state of arrested development. His "idea was to make something symbolical," he wrote, "—not an absolutely realistic thing like wax works in an anatomical museum—but to make something which demands two different requirements; the thing must have the spirit of Africa in its broad sense, and at the same time it should fill the requirements of the art of sculpture." [99] He thus chose to represent a dancing *Charm Doctor* or medicine man flourishing a fetish, a man making fire by twisting a stick into a piece of fig. 170 wood, the glowering *Chief of the Tribe* squatting on his throne, a *Congo Artist*, legs splayed out flat on the ground as he draws a snake with his finger in the mud, an *Idol Maker* chipping at a block of wood. [100] They are images not of fig. 169 "savages" so much as of "savagery" as understood in his time—of scientific, technological, social, artistic, and religious "backwardness."

In his first book, published in 1890, Ward paid tribute to Leopold II of the Belgians who, he declared, was "actuated by the highest motives of patriotism and a desire to benefit others besides his own countrymen—to give to the poor savages of the Congo the means of coming in contact with the enlightened influences of civilization, as well as to find another outlet for the products and energies of the white man." The stations on the course of the river would, he wrote, "prove the means of opening up that great highway to the advance of commerce, and of winning the tribes along its banks to a condition of peaceful industry, and a desire to obtain the benefits they beheld the white men possessing in their midst." [101] This was the official European view of the purposes and practice of colonization, and Ward's statues reflected it well enough for four of them to be acquired for the

168

169

170

168. View of Herbert Ward's studio in Paris. Washington, D. C., National Anthropological Archives, Smithsonian Institution.

169. Herbert Ward. *The Idol Maker*. Salon, 1907. Bronze. Life-size. Washington, D. C., Smithsonian Institution, National Museum of Natural History.

170. Herbert Ward. *The Fire Maker*. Salon, 1911. Bronze. Life-size. Washington, D. C., Smithsonian Institution, National Museum of Natural History.

Belgian Musée du Congo at Tervuren outside Brussels.[102] While at work on them, however, the atrocities committed against the Congolese were revealed in horrifying detail by Roger Casement (whom Ward had known there) and E. D. Morel. The Congo had become notorious as the worst governed and most ruthlessly exploited of all colonies.[103] Ward's last statue, the larger than life-size figure of an African with bowed head was entitled *Distress*[104] and dedicated "to those who have understood, to those who love the natives of Africa." A contemporary described it as "the incarnation of the tragedy of the Congo."[105]

Ward's statues fortuitously call to mind the most powerful work of European literature with an African setting, "Heart of Darkness," by Joseph Conrad who had been employed by the Compagnie du Chemin de Fer du Congo while still a sailor in 1890 (the year after Ward returned to Europe). The narrator, describing his first encounter with the Congolese remarks :

We are accustomed to look upon the shackled form of a conquered monster, but there—there you could look at a thing monstrous and free. It was unearthly, and the men were—No, they were not inhuman. Well, you know, that was the worst of it—this suspicion of their not being inhuman. It would come slowly to one. They howled

223

and leaped, and spun, and made horrid faces; but what thrilled you was just the thought of their humanity—like yours—the thought of your remote kinship with this wild and passionate uproar. Ugly. Yes, it was ugly enough; but if you were man enough you would admit to yourself that there was in you just the faintest trace of a response to the terrible frankness of that noise, a dim suspicion of there being a meaning in it which you—you so remote from the night of first ages—could comprehend. And why not? The mind of man is capable of anything—because everything is in it, all the past as well as all the future. What was there after all? Joy, fear, sorrow, devotion, valour, rage—who can tell?—but truth—truth stripped of its cloak of time.[106]

Yet the attitudes of Conrad and Ward to the Congolese were no more than superficially alike. Ward saw them as backward people who deserved sympathy and protection. ". . . The African savage of to-day serves to indicate to us how much we ourselves have advanced from a similarly primitive state," he wrote.[107] Conrad more obliquely likened them to ancient Britons before the Roman conquest. But for him they also represented the free expression of all the primal instincts still seething in the dark heart of "civilized" man.

Ward also maintained the conventional European attitude to African culture. In the course of his five years in the Congo he accumulated a hoard of artifacts which he later augmented until it comprised 2,714 items—mainly weapons, domestic utensils, and musical instruments but also some carved images and masks. From 1906 these objects were displayed like trophies, ordered in symmetrical patterns, on the walls of his studio in Paris behind his own statues.[108] It was probably the largest private collection in Paris of fig. 168
the art that was beginning to engage the attention and admiration of such artists—of an entirely different character and caliber—as Picasso, Braque, Matisse, and Derain, with whom Ward had no contact. His statue of an African sculptor at work is alone enough to demonstrate how far he was cf. fig. 169
in every way from seeing the "new horizon" opened by African art for Braque who was to say that "Negro masks allowed me to get into touch with instinctive things, with forthright expressions that contradicted false tradition."[109] This comment expressed, however, the views of a very small minority in the first decade of the twentieth century. When Ward's sculptures were put on show with his African collection in the Smithsonian Institution in Washington in 1924, the ethnologist who catalogued them could still blandly declare: "The contrast of these sculptures heightens the interest in the works of ivory, wood, horn, iron, copper, and brass of the primitive artisan-artist who sought no less earnestly than the enlightened sculptor to achieve the intangible essence of art."[110]

In the Salon of 1904, which included a group by Ward entitled *Les Bantous*,[111] Henri Allouard exhibited a bronze bust of a *Femme Foulah*.[112] fig. 171
The addition of a striped cotton skirt carved out of onyx transformed a bust into a statuette which was acquired by the state for the Musée du Luxembourg.[113] It is at once a feat of technical dexterity and a decorative object in the tradition which stretches back beyond Charles Cordier to the cf. fig. 73
gueridons (said to have been named after a black slave) of the seventeenth and eighteenth centuries. But the frontal pose of the figure, displaying

171

her bare breasts as she walks with a water jar toward the spectator, as well as the skirt, headdress, and heavy jewelry, mark her as a native of French West Africa. A decade earlier a number of West Africans had been featured in one of the several exhibitions in the Jardin d'Acclimatation of the Muséum, where human "specimens" were put on show for the instruction and pleasure of the Parisian public.[114] They were, of course, subjects of French colonial rule. And Allouard's statue is an indication of the way in which colonialism had fragmented the old monolithic image of the "black African" into numerous ethnic groups, each with its own physical and cultural characteristics which an artist with pretensions to naturalism was bound to indicate. It would hardly have looked out of place in a museum or exhibition of colonial products. Ward's statues were more obviously conceived as combining the art of sculpture, as he practiced it, with ethnological science as he understood it. Casts of them were acquired for art galleries and for museums of natural history.

DEPARTURES

In March 1891 Paul Gauguin wrote to the French Minister for Education and the Fine Arts saying that he wished to go to Tahiti "to attempt a series of paintings of that country, my ambition being to set down its characteristics and its light." (Tahiti had been transformed from a protectorate into a colony a decade earlier.) His application, supported by Georges Clemenceau, was promptly accepted, and he was given an official mission "to study from an artistic perspective and make pictures of the country's customs and landscape." During twelve months on Tahiti and nearby islands he painted the inhabitants, drew Oceanic carvings, and studied religious cults. Applying to the minister to be repatriated free of charge, he wrote, "I hope that when I return you will be favorably impressed with my works."[115] But the works he took back to France bore no similarity to ethnographic images of the type demanded by colonial powers—and not only because he had become militantly anticolonialist. In the South Seas he fully recognized that, as he told his wife, "my artistic center is in my brain and nowhere else."[116] Travel to the periphery was a means of finding his center.

This was not the first of his voyages. In 1887, four years after giving up his profitable career as a stockbroker, but still disenchanted with a "wearisome and enervating existence," he had gone to the West Indies "to live like a savage." In a place "far removed from civilized man," he hoped to gather new artistic strength.[117] Somewhat surprisingly, he went first to Panama where he soon found that the only salable works of art were portraits of a type he was no more willing than able to paint. To support himself financially he was obliged to work among the numerous blacks and Asians digging the canal. When he was dismissed, he crossed to Martinique and established himself in a "case à nègres." To the predominantly black population of the island he responded in much the same way as Manet in Rio de Janeiro and Degas in New Orleans.[118] Ten days after his arrival he wrote to his wife:

Negroes and Negresses go about all day singing their creole tunes and chattering constantly. Don't think it's monotonous, on the contrary,

171. Henri Allouard. *Femme Foulah*. 1904. Bronze and onyx. H: 57 cm. Marseilles, Musée des Beaux-Arts.

172

quite varied. I can't tell you how excited I am about life in the French colonies. . . . Such fertile natural surroundings, hot climate relieved by cool spells. . . . Work consists of supervising a few Negroes while they pick fruit or vegetables that require no cultivation.[119]

(The West Indies were still associated with the myth of the Golden Age.) In this euphoric mood—which lasted only a few weeks—Gauguin drew and painted the seductive tropical scene. By a curious coincidence his paintings of life on the island are contemporary with some of Winslow Homer's Caribbean watercolors. Both include figures of blacks, but whereas Homer must instinctively have compared them with those he knew so well on the American mainland, they were novel subjects for Gauguin who depicted them with other ideas in mind. One of Gauguin's drawings is of a black woman seated on the ground and another carrying a basket on her head, as sturdy and self-possessed as Millet's French peasants. These figures reappear in the finest painting of his Martinique period, dominating an exuberantly fig. 172

172. Paul Gauguin. *Aux mangos. La récolte des fruits, Martinique.* Dated [18]87. 90 × 115 cm. Amsterdam, Rijksmuseum Vincent van Gogh.

173. Paul Gauguin. *Manao Tupapau (Spirit of the Dead Watching).* 1892. Oil on burlap mounted on canvas. 72.4 × 92.4 cm. Buffalo, Albright-Knox Art Gallery.

colorful landscape which affords a glimpse of the spontaneous fecundity of nature.[120] Their casual poses suggest quickly acquired familiarity with and sense of fellow feeling for the people among whom he lived and worked. And in this respect they differ from the great majority of European images of blacks, depicted as beings apart. The picture was bought by Theo van Gogh and his brother Vincent who may well have learned from it valuable lessons in figure painting as well as the handling of color and tonal intensity.

His view of Martinique as a paradise was, however, soon overcast by his ill health and also, perhaps, his failure to find the savages he had expected. He worked his way back to France as a seaman. After three years perfecting his new manner of painting he negotiated his mission to go to the farthest geographical point of the French colonies. "You are leaving for Tahiti? To paint?" a journalist asked him. "I am leaving to be alone, to slough off civilization's influence," he replied. "I only want to make simple, very simple art: to do that I need to reimmerse myself in virgin nature, to see only savages, to live as they live, with no other concern than to express my ideas, as a child would, using only the rudimentary resources of art which are the only good ones, the only true ones."[121] Still clutching an unconquerable hope, he was once again fleeing from Europe rather than to a particular place, escaping from an artistic tradition rather than seeking an alternative, and, above all, exploring his own psyche.

The picture of his first Tahitian period to which he attached the greatest importance, *Manao Tupapau*,[122] was begun, he explained in the notebook fig. 173

173

for his daughter Aline, as the painting of a young Tahitian girl lying on her stomach. "Captured by a form, a movement, I paint them with no other preoccupation than to execute a nude figure. As it is, it is a slightly indecent study of a nude, and yet I wish to make of it a chaste picture and imbue it with the spirit of the native, its character and tradition." In the expression he gave to the girl's face he saw fear—"certainly not the fear of Susanna surprised by the elders. That kind of fear does not exist in Oceania. The *tupapau* ("Spirit of the Dead") is clearly indicated. For the natives it is a constant dread. . . . Once I have found my *tupapau* I devote my attention completely to it and make it the motif of my picture. The nude sinks to a secondary level." The title, he wrote, had two meanings: "either the girl thinks of the spirit or the spirit thinks of her."[123] The painting, as much as his commentary, emphasizes the ambivalence of images and myths as mediators between the external world and the mind. They also exemplify his dependence on and struggle to free himself from European artistic schemata and ideas. The composition recalls Manet's *Olympia* of which he had painted cf. fig. 115 a copy and took a photograph with him to Tahiti. Despite the nonnaturalistic colors and nonillusionistic perspective, neither in manner of representation nor in detail does it reveal the influence of Oceanic art (the spirit with frontal eye seems to be of Egyptian extraction, the patterned cloth is of a type printed in Manchester for export).[124] And when he wrote, shortly before his death, that his purpose in Oceania had been "to get some notion of which one of us is worth more, the naïve, brutal savage or rotten, civilized man," he was reiterating a question that had been discussed for centuries— ever since Cicero had described his imaginary encounter with a Scythian.[125]

Noble savagery was more frequently associated with the Indians of North America and the Polynesians than with Africans. And Gauguin's desire to go to Tahiti may have been stimulated partly by the myth embodied in Diderot's *Supplément au voyage de Bougainville*. It had once been suggested that he should manage a business concern on Madagascar, but the project came to nothing. On his way to Tahiti, he sailed through the Suez Canal, bypassing Africa. The many photographs he took with him were of ancient Egyptian, Greek, Japanese, Javanese, and modern French, but no African, works of art (even though he may have owned two Congolese statuettes).[126] By chance or design, he painted no blacks after his months on Martinique. But a collector who was offered some of his Tahitian paintings remarked, "No, these canvases are very beautiful, but I do not want to have only figures of Negroes."[127] From such a viewpoint all people with dark pigmentation might be placed in a single, alien class. Gauguin's paintings suggest, however, the beginning of a change in attitude. It is not simply that they emphasize specifically Polynesian characteristics of skin, hair, and physiognomy. They differ from the great majority of images of blacks, posed artifically in a studio or shown in disarticulated movement, grimacing and gesticulating as they run, dance, or fight. An almost unearthly calm hangs over these paintings of Tahitians or Marquesans whose silent immobility reflects Gauguin's own meditation on the essential problems of life and death which, he believed, could be solved only at the profound level where there was no distinction between the savage and the civilized.

It was shortly after visiting the house at Atuana where Gauguin had died three months before that Victor Segalen—who acquired some of his

174. Henri Rousseau. *The Sleeping Gypsy.* Dated 1897. 129.5 × 200.7 cm. New York, Museum of Modern Art.

175. Henri Rousseau. *Virgin Forest with Setting Sun – Negro Attacked by a Jaguar.* Ca. 1910. 114 × 162.5 cm. Basel, Öffentliche Kunstsammlung, Kunstmuseum Basel.

paintings and manuscripts—began to evolve his theory of "exoticism as an aesthetic of the diverse." In the essay he planned to write on the subject, there was to be "little attention given to the tropics and palm fronds, coconut trees, betel palms, guava trees, unknown fruits and flowers; to monkeys with human faces and Negroes with monkeys' ways. . . ." He came to regard this exoticism as "the fundamental Law of the exaltation of the Senses, therefore of living. It is through Difference, and in the Diverse, that existence is exalted."[128] Blacks who had previously been the most conspicuous subjects for images of difference were too intimately associated with superficial exoticism to be given a place in Segalen's theory. Nor were Africans depicted in Africa by any artist of the caliber of Gauguin whose paintings, nevertheless, opened the way to a new art in which traditional images of blacks could have no place.

The exoticism of paintings by Henri Rousseau the "Douanier" is at first sight entirely traditional. Although he claimed to have served with the army in Mexico, he had never been out of France and went no farther than the Jardin des Plantes to find himself in an alien environment. "When I enter those greenhouses and see those strange plants from exotic lands, it seems that I am entering a dream! I feel altogether like some other person," he remarked.[129] He had no doubt read in illustrated periodicals accounts of exploration in Africa and elsewhere, also the novels of Pierre Loti whose portrait he painted. But his imaginings had closer affinities with the unrestrained fantasy of Raymond Roussel's *Impressions d'Afrique* of 1910. In his sultry, tropical scenes where birds flap their gaudy wings, monkeys chatter, and the fiercer beasts are locked in combat with one another, Rousseau released all his pent-up poetic powers in extraordinary feats of sustained imaginative transformation. While painting them, it was said, he felt their reality so intensely that he often had to open the windows to escape from his self-induced spells.[130] The late-nineteenth-century vision of a beautiful and cruel jungle beyond the pales of European civilization was never so vividly depicted, partly because he concentrated obsessively on the details and left the location vague.

Darkskinned figures appear in several of Rousseau's paintings. One is in *The Sleeping Gypsy.*[131] When offering this work for sale to the mayor of fig. 174 his native town in 1898 he described the subject: "A wandering negress, a mandolin player, lies with her jars beside her (a vase with drinking water) overcome by fatigue in a deep sleep. A lion chances to pass by, picks up her scent yet does not devour her. There is a moonlight effect, very poetic. The scene is set in a completely arid desert. The gypsy is dressed in oriental costume."[132] His initial source of inspiration appears to have been Louis Matout's *Femme de Boghari tuée par une lionne*, but he may also have had in mind paintings of lions in the desert by Gérôme and of North African women by Félix-Auguste Clément (artists he admired).[133] Such works provided, however, no more than points of departure. Whether he intended the sleeping woman to represent a "Négresse" or a gypsy— or both—he indicated that she was a musician, perhaps to personify the artist as outsider who is nevertheless unmolested by nature. In his no less dreamlike *Snake Charmer* the woman piping mysterious melodies among rank vegetation is similarly darkskinned.[134] Again the subject is a musician in harmony with nature, and there is also "an effect of moonlight, very poetic."

174

175

Jet black figures in some of his other paintings are small and sometimes diminutive, dwarfed by giant cactuses, lotuses, and other exotic plants. In one, probably dating from the last year of his life, *Virgin Forest with Setting Sun – Negro Attacked by a Wild Beast*,[135] a naked man stabs the jaguar that attempts to maul him. Rousseau perhaps remembered an engraving by Riou in *Le Tour du Monde* of a black man fighting with a leopard. But his immediate source seems to have been the illustration of a zoo keeper playing with a young jaguar, in a book on *Bêtes sauvages* that he owned.[136] As in *The Sleeping Gypsy* he changed the color of the human figure, presumably to enhance the exoticism of the scene.

fig. 175

The exhibition of some of Rousseau's paintings, including *The Sleeping Gypsy* in the Salon des Indépendants of 1897 prompted a writer in the Symbolist *Revue blanche* to remark that his relentless candor, his obstinately ingenuous simplicity, his touching clumsiness, merited "infinitely more attention than a quantity of those insipid works in the great Salons to which so many otiose comments are dedicated."[137] The innocence ascribed to "savages" was thus transferred to the artist. Rousseau was the first *naïf* painter to be taken seriously, though in his own time only by a small minority, almost a clique, of artists and writers in Paris. Although he drew inspiration from—or perhaps one should say made use of—Salon paintings like that by Matout, he revised their images conceptually to depict what he knew, or believed, or dreamed. Naïvely or intuitively, and certainly without *parti pris*, he departed still further than Gauguin from the perceptual tradition of Western art in works which won the admiration of artists reacting against not only the academicism of the Salonards but also the descriptive naturalism of the Realists, Impressionists, and Neo-Impressionists. Despite the conventionality of the received ideas they reflect, his images of blacks are distinguished if only fortuitously by his means of representation from those in the Orientalist paintings he admired. His works have a lack of sophistication that appealed mainly to such sophisticated artists and writers as Pablo Picasso and Guillaume Apollinaire, both of whom were at the same time discovering similar formal qualities in examples of *l'art nègre*—a term embracing at this date the arts of Africa and Polynesia—without reference to the intentions of their creators. The first international dealer in African sculpture, Joseph Brummer, commissioned Rousseau to paint his portrait and also marketed his works. It is no more of a coincidence that the "douanier" was regarded by the young leaders of the avant garde as an innocent, almost an overgrown child, with a combination of affection and mockery that parallels paternalistic attitudes to Africans.

WILD ARTISTS AND THEIR MODELS

In the course of the nineteenth century the quantity of African artifacts already in Europe increased at a galloping rate.[138] Cult figures, termed "fetishes" and "idols," were brought back by missionaries as trophies of their victory over the heathen (though they destroyed many more in situ); colonizers returned with similar carvings, arms, and utensils as evidence of the cultural level of the people whose lands they felt justified in occupying and exploiting. The ethnological museums in which they were displayed had

232

a historicist purpose typical of the time: to illustrate the evolution of material culture partly as a means of furthering the process. Such a museum could, as P. F. von Siebold remarked in an influential pamphlet of 1843, serve as an "elementary school" for visitors to the colonies: "Before leaving their native countries, missionaries, scholars, naturalists-travelers, military and civil personnel, merchants and sailors, all will be able to acquire through the guidebook for a museum of this type preparatory knowledge that will be invaluable in their later travels."[139] Even as late as 1918 a leading French anthropologist, René Verneau, pointed out the utility of the Trocadéro for "exporters wanting to do business with populations whose tastes they will need to know."[140] He also remarked on the value of the collection to artists but seems to have had in mind painters in search of authentic details of local color for subject pictures rather than the avant garde who had been frequenting it for a decade with very different ideas in mind.

The aesthetic merits of African artifacts had not, however, been entirely overlooked. Owen Jones in England began his *Grammar of Ornaments* (1856) with a well-illustrated chapter on "the ornament of savage tribes" in which he found purer expressions of the spirit than in the work of more sophisticated cultures—especially that of his own time and country. He believed, indeed, that as skills increase, individuality decreases. (The book was translated into German and may have had some influence on Expressionist theory.) This logical extension of romantic notions of spontaneity and individuality was, however, applied only to ornament. The first African works of art to be recognized as such were Ife and Benin sculptures which could easily be accepted within a European aesthetic—so easily indeed that they were often supposed to derive from the art of ancient Egypt or even from Europe itself.[141] What is nowadays called primitive or tribal art was studied only by ethnologists until the twentieth century. And its aesthetic revaluation—or evaluation—was a result rather than a cause of developments in European art. Gauguin was no exception: he had evolved his revolutionary manner of painting with its distortions, irrational perspective, and nonnaturalistic color before he went to the South Pacific where he tended to regard Polynesian art from an ethnologist's viewpoint.

Rival claims for the artistic discovery of *l'art nègre* are of interest mainly as an indication of the importance ascribed to it. The first painter whose experience helped him to create a new style was probably Henri Matisse, already dubbed a Fauve on account of the wild colors and distortions of his work. *The Blue Nude – Souvenir of Biskra* of 1907, which marks a turning point in his development, was inspired by Africa in two entirely different ways.[142] In the previous year he had made his first visit to Algeria, spending some days at Biskra which he was to remember as "a superb oasis, a lovely and fresh thing in the middle of the desert, with a great deal of water that snaked through the palm trees, through the gardens with their very green leaves. . . ."[143] There are palms in the background of the painting, but the figure provocatively challenges comparison with the odalisques of Ingres and the many Orientalists. Shortly after his return to Paris he bought a Congolese statuette which he included as an exotic object in a still-life painting, perhaps significantly left unfinished.[144] For it was not the exoticism of African sculptures that exerted so strong an appeal on Matisse. He was, as he later remarked, "astonished to see how they were

fig. 176

176

176. Henri Matisse. *The Blue Nude – Souvenir of Biskra*. 1907. 92.1 × 140.4 cm. Baltimore, Baltimore Museum of Art.

177. Henri Matisse. *Two Negresses*. 1908. Bronze. H: 46.7 cm. Baltimore, Baltimore Museum of Art.

178. *Deux jeunes filles Targui*. Photograph clipped from an unknown source by Henri Matisse.

177

178

conceived from the point of view of sculptural language." In comparison with European sculpture "which always took its point of departure from musculature and started from the description of the object, these Negro statues were made in terms of their material, according to invented planes and proportions."[145] He soon began to experiment with this new language in statuettes from one of which, *Reclining Nude I / Le nu couché*, modeled from memory and imagination (not from life as was his usual practice), he painted *The Blue Nude*. The restructuring of the female body in this revolutionary painting was prompted mainly by African sculpture to which there may be more direct references in the spherical breasts and exaggerated shelf of the buttocks—with perhaps a reminiscence of the cast of the body of the "Hottentot Venus" displayed in the ethnographical collection of the Trocadéro. It seems, indeed, that *The Blue Nude* was conceived as an "African" Venus: that her skin is not black is hardly of significance in view of his attitude to color.

This painting was the result of the transformation of an image in three dimensions to one in two. The process was reversed when he modeled *Two Negresses* in 1908.[146] His point of departure was a magazine photograph of two young Tuareg women.[147] Like many earlier artists, from Delacroix

fig. 177
fig. 178

235

onward, Matisse made use of photographs to supplement living models. In this instance, however, the photographic image suggested a way of solving the perennial sculptural problem of creating a three-dimensional form to be seen from an infinite number of viewpoints. He may indeed have wished to go further, to transcend the third dimension.[148] The similarity of the two women in the photograph suggested a form that could give the impression of a single figure seen simultaneously from front and back. The ethnic characteristics which the photograph was intended to illustrate are ignored in the statuette where the stocky proportions recall African sculpture more than the two slender Tuareg women.

"Photography has greatly disturbed the imagination because we have seen things removed from sentiment," Matisse remarked.

> When I wanted to rid myself of all the influences that prevent one from seeing nature in a personal way, I copied photographs. We are laden with the sentiments of artists who preceded us. Photography can free us of previous imaginations. Photography clearly divided painting as an expression of sentiment from painting as a description. The latter was rendered useless.[149]

In this way photography helped to lighten the burden of sentiments and associations with which images of blacks were loaded. For nothing did more to establish the autonomy of visual images as paintings or sculptures rather than representations of the visible world. A photograph is essentially a flat surface: it does not deceive the eye as a window onto the real world—though photographs of, for instance, North African scenes are sometimes hard to distinguish from photographs of paintings of similar subjects. It was not so much that artists felt encouraged to depict what the camera could not record, but that they were obliged to recognize more fully than ever before the artificiality of all images. And this opened their eyes to works of art outside the Western tradition of naturalistic representation, as a means of furthering their own aims. To the criticism that such paintings as *The Blue Nude* did not correspond with what Matisse saw, he replied: "If I encountered such a being on the street, I would flee in fright. Above all else, I am not creating a woman, I am making a painting."[150]

While Matisse and other artists in Paris were responding to *l'art nègre*, members of the group of artists called Die Brücke in Dresden were looking to the arts of Africa and, more especially, Oceania—albeit from somewhat different viewpoints and with entirely different results. They were perhaps influenced by the contention of Leo Frobenius that Polynesian and other sculptures and paintings were intended not so much to copy natural forms as to evoke associations which would convey meanings—almost a basic theory of Expressionism. For them this art expressed primitive emotions and impulses. They were also much inspired by Gauguin's paintings with their symbolic or expressive nonnaturalistic colors, and still more by a highly romanticized vision of his life in the South Pacific. The walls of Ernst Ludwig Kirchner's studio in Dresden were painted in chrome yellow, red, and black with motifs derived from Palau roof beams and Polynesian carvings to create an atmosphere of sultry tropical exoticism. He depicted a sleeping black woman, *Schlafende Milli*, against this background.[151]

fig. 179

179

On the other side of *Schlafende Milli* there is a slightly earlier painting of a white woman in a similarly suggestive pose but without the exotic decor. Both are products of a complex web of ideas. The program of Die Brücke called young artists to oppose "the well-established older forces," Impressionist as well as academic, and invited the collaboration of everyone "who renders with immediacy and authenticity that which drives him to creation." This driving force Kirchner identified with the sexual urge, taking up the notion expressed poetically by Walt Whitman (his favorite author) and philosophically by Nietzsche who had declared, "The demand for art and beauty is an indirect demand for the ecstasies of sexuality communicated to the brain."[152] Like other Expressionist artists he believed that a painting should communicate feelings at the expense of recording visual impressions. Evidently dissatisfied with the nude he had painted ca. 1906–9, he turned the canvas over for *Schlafende Milli*, rendered in a more brutally expressionist manner in flat color with hard outlines and exaggerating her breasts and buttocks. On the wall behind her there is a hanging with an exclamatory zigzag pattern and the painting of a nude

179. Ernst Ludwig Kirchner. *Schlafende Milli*. Ca. 1910–11. 64 × 92 cm. Bremen, Kunsthalle Bremen.

180. Karl Schmidt-Rottluff. *The Three Kings.* Dated 1917. Woodcut. 497 × 391 mm.

181. Max Slevogt. *Der Sieger (Kriegsbeute).* Dated 1912. 150 × 100 cm. Dusseldorf, Kunstmuseum Düsseldorf.

180

white woman similarly with outsize buttocks. Milli was a circus artiste whom he employed, together with a black man named Sam from the same troupe, as models for photographs as well as paintings. He depicted them together, with emphasis on the size of his penis and her breasts, and also drew six lithographs of them in poses of oral and genital intercourse.[153] There can be little doubt that he accepted the common belief in the superabundant sexuality of blacks.

In *Schlafende Milli* the woman's conical breasts recall Yoruba carvings, notably one drawn and painted by Emil Nolde, another member of the Brücke group.[154] But this seems to be no more than an associative reference and one that marks the difference between his attitude and that of Matisse who assimilated the influence of African art in *The Blue Nude* to which *Schlafende Milli* is no more than superficially similar. African and Polynesian carvings and paintings became as indispensable a part of the studio decor of the Brücke artists as North African trappings had been in those of the Orientalists not long before. They were incorporated in several still-life and subject pictures as exotic objects and evidence of the artists' advanced taste. Their influence was more obvious but less profound than that exerted by African art in France. Karl Schmidt-Rottluff carved heads in wood directly inspired by African sculpture. And in his woodcut of *The Three Kings* the face on the right, derived from a Fang reliquary head, may have been intended to represent the black Magus, though the other two also, if less conspicuously, suggest the inspiration of African carvings.[155] In another woodcut he gave the features of a Teke figure from the Congo to an Apostle.[156] He was, nevertheless, equally indebted to early German prints much valued by the Expressionists as "primitive" works of art which were

fig. 180

238

181

182

also Germanic, whereas African sculpture was admired for similar qualities sometimes, perhaps, despite its geographical origin. Few distinctions were in fact made between African and Oceanic art, both regarded as the work of *Naturvolker*.

In German art of this period there was, however, a distinction between images influenced by African art and those depicting Africans, even if the carvings and the models may have been regarded as equally exotic and primitive—albeit in different ways. *Schlafende Milli* is an exception although its debt to African sculpture is light. There is no such debt in Kirchner's several paintings of black men and women sitting in the cafés or dancing in the *Nachtlokale* of Berlin.[157] Like other *Wilden Deutschlands* (as the Expressionists were sometimes called), but unlike the Fauves, he was more concerned with content than form, and mainly with the bold expression of liberated sexuality.

At the same period in Berlin Max Slevogt painted no fewer than six figure studies and also a portrait head of a Somali named Hassanó.[158] Slevogt, who had studied in Paris in the 1880s and been inspired by the work of the Impressionists, was a somewhat older, far less militantly rebellious, artist than Kirchner and had no connection with Die Brücke. His studies of Hassanó were conceived in the long established tradition of studio work. But instead of depicting him in the frozen postures of an academic life-class model, Slevogt concentrated on catching his movements and recording his physique specifically as a Somali—crouching, squatting, standing on one leg by a dead leopard, and dancing with a lance and leopard skin—as for ethnographic illustration. In the subject picture, no less broadly handled, these objective records of visual impressions were transformed into an image of "savage," virile sexuality by the addition of three white women one of whom seems to have been abducted from Delacroix's *Death of Sardanapalus*. The picture was entitled alternatively *Der Sieger* ("The Victor") with reference to the man, or *Kriegsbeute* ("War Booty") throwing the emphasis on the women who recall the fair-skinned slaves in Orientalist harems but are here guarded by no impotent eunuch.[159] Racial preconceptions barely perceptible in the studies rise to the surface in the picture together with erotic fantasies.[160] The studio model is returned to Africa, the theater of colonial warfare and the dark continent of the European imagination.

cf. fig. 106
fig. 181

Two decades later the American sculptor Malvina Hoffman modeled a life-size statue of a Shilluk warrior in exactly the same distinctive pose as *Der Sieger*.[161] It is one of thirty-four figures and sixty-seven heads of racial types she was commissioned to execute for the "Hall of Man" in the Field Museum of Natural History in Chicago. To prepare these works, she was sent on a round-the-world tour and found that "from the six-foot nine-inch Shilluk warriors, with all their virility and grace, to the woolly-headed pigmies or the seductive young maidens of the Congo, the races of Africa supply an endless field of variety for sculptural purposes."[162] She also modeled Asians, Polynesians, indigenous Americans, and a few Europeans. A white American (from Brooklyn) was included, but Afro-Americans were unrepresented, and one can only wonder how the many living in Chicago reacted to this extraordinary display in which blacks were associated exclusively with tribal life in Africa.

fig. 182

182. Malvina Hoffman. *Shilluk Warrior (Northeast Africa)*. Ca. 1930–33. Bronze. H: 274.3 cm. Chicago, Field Museum of Natural History.

Ever since the eighteenth century the argument that blacks were "naturally inferior to whites" had been supported by the assumption that there were, as David Hume put it, "no ingenious manufactures among them, no arts, no sciences." [163] The notion that they retained natural virtues lost in civilized life was based on the same premise. Lip service was later paid to African craftsmanship to demonstrate the feasability of opening the continent to legitimate trade. It was also said to indicate that Africans were "men endued with rational and intellectual powers, and capable of being brought to as high a degree of proficiency as other men." [164] Writings by blacks were similarly cited as evidence of their potentiality to be assimilated in the European dominated world. But African sculpture came to be admired in the early twentieth century for its otherness, its freedom from European conventions (moral as well as artistic), its apparent spontaneity and sometimes roughness of workmanship—in a word for its undeveloped primitivism. That *l'art nègre* was believed to be outside history, as well as outside Europe, was another point in its favor. But, leaving the myth of savagery intact, its discovery was accompanied by no radical revision of Western attitudes to blacks. This is all too apparent in early writings on the subject.

The first book extolling African tribal art—as distinct from the court arts of Ife and Benin—for aesthetic merits was Carl Einstein's *Negerplastik* published in Leipzig in 1915 although it was probably written before the outbreak of the war, at about the same time as Vladimir Markov's *Iskusstvo Negrov* which was published later (Petrograd, 1919). Einstein had spent some time in Paris where he met Picasso, Braque, and other artists, and also Joseph Brummer, the owner of most of the pieces he illustrated. Making high claims for his subject, he declared that while European sculpture was a mixture of the "painterly and the plastic," African sculpture "represents a clear fixation on unadulterated plasticity." The essential sculptural problems had been solved by Africans and only Africans. He was, of course, incorporating such works in the history of art as seen in Europe. Sculpture had long been regarded as an earlier art form than painting and, in the course of the nineteenth century, its classical manifestations had been losing critical credit as attention shifted to archaic Greek and medieval European work. The most Einstein could say for the creators of African sculpture was—with a telltale double negative—"the Negro is not a non-evolved human." [165]

More extreme statements about Africans and their art were made by the Mexican painter and dealer Marius de Zayas. In 1914 he organized an exhibition in New York which, for the first time in the United States, showed African sculptures "solely from the point of view of art." [166] It was mounted in the gallery of the photographer Alfred Stieglitz, who also marketed paintings by Picasso and Braque. In *African Negro Art: Its Influence on Modern Art* published in New York two years later, de Zayas began with the declaration that black Africans "can be considered as being in the most primitive state of the cerebral evolution of mankind." To support this preposterous supposition, he gave most of his text to quotations from ethnologists and travel writers, including H. M. Stanley and Herbert Ward. But he ended by declaring: "The abstract representation of modern art is

unquestionably the offspring of the Negro art, which has made us conscious of a subjective state, obliterated by objective education. And, while in science the objective truths are the only ones that can give the reality of the outer world, in art it is the subjective truths that give us the reality of ourselves."[167]

Pronouncements by Einstein, and especially de Zayas, may have distorted the views of artists who had initiated the discovery of African sculpture but whose responses were rarely put into words and seem to have been intuitive rather than theoretical. For Picasso, African masks were not "just sculpture," he later told André Malraux. "They were magical objects. . . . intercessors . . . against everything, against unknown threatening spirits. . . . They were weapons, to keep people from being ruled by spirits, to help free themselves."[168] Irrational and superstitious beliefs, so often cited as a form of spiritual slavery, could now be accepted as a major source of creativity. African art helped to free Picasso and others from hidebound Western traditions. It was of major importance as a stimulant and source of artistic ideas, most beneficial when fully assimilated and least conspicuous. Picasso was an enthusiastic, rather than a discriminating, collector of African carvings, searching for them in curiosity shops and flea markets on what he called "Negro hunts." But he did not see them as representations of Africans. He did not paint them naturalistically: the masklike faces in his paintings bear no more than generic similarities to African masks.[169] Nor is he known to have depicted any image of a black between 1901 when he parodied Manet's *Olympia* and 1950 when he drew a head as the frontispiece for *Corps perdu* by the great West Indian poet Aimé Césaire. Images of blacks seem to have gone out of the window as African sculpture came in through the door.

A statue by Jacob Epstein is a rare, perhaps unique, example of imagery derived directly from African art to represent an African with, moreover, reference to the plight of black people. Epstein, born in the United States of Polish Jewish parents, had emigrated to Europe at the age of twenty-two in 1902, and studied in Paris before settling in London in 1905. He later recorded that he was deeply impressed by the "mass of primitive sculpture" in the Trocadéro and the "wonderful collections from Polynesia and Africa" in the British Museum.[170] But not until 1912 did his work begin to reveal the influence of these arts, after a return to Paris where he visited Constantin Brancusi and Amedeo Modigliani, both of whom were drawing inspiration from the same sources. At the same time he began to collect African art with unusual discernment. In a burst of activity during the next three years he created his most strongly primitive and severely formalist sculptures. One, a stone relief entitled *Birth*, apparently indebted to Oceania as much as Africa, shows a male child emerging painfuly from his mother's womb.[171] He developed the figure of the child into the freestanding plaster statue with legs like the support (often misinterpreted as legs) of a Kota reliquary figure, painted it bright scarlet, and exhibited it in 1915 with a title from the Book of Job, *Cursed Be the Day Wherein I Was Born*.[172] The head has the features fig. 183 of a black, and the scream seems to be directed to an unhearing heaven against the accidents of birth which have condemned so many millions of human beings to disdain and persecution. No image of a suffering black is more agonized and at the same time more defiant.

The statue owes much to Epstein's own background and unique

183. Jacob Epstein. *Cursed Be the Day Wherein I Was Born*. 1913–14. Plaster and wood, painted red. H: 115.5 cm. Present whereabouts unknown.

183

combination of experiences. No artist of the time was more acutely aware of the terrible consequences of racial prejudice. His parents had fled from Poland after the anti-Jewish pogroms. He grew up in America at a time when hostility to blacks was violent. And in the Jewish community of the Lower East Side, New York, he lived on a par with members of other despised ethnic minorities. As an artist he was trained in a conservative tradition, first in New York then at the Ecole des Beaux-Arts and Académie Julian in Paris, but found himself instinctively drawn to types of sculpture outside

the classically approved canon—Cycladic, Egyptian, and Iberian as well as African. He settled, however, in England where innovations in the arts were greeted with far greater disapproval than in France. One of the aims of *Cursed Be the Day Wherein I Was Born* was, no doubt, to shock the public with a display of artistic savagery as well as to protest against its other prejudices. However, the effect was limited as Epstein never transferred the plaster into a more durable medium.

Quite simply to *épater les bourgeois* pseudo-African performances were staged in the "soirées Dada" in Zurich while the rest of Europe was at war—"sounds, Negro music (trabatgea bonooooooo oo ooooo)," as one was advertised in 1916. There were also recitations of poems that Tristan Tzara found in ethnological publications and translated with variations to give a more primitive effect.[173] Dada was from the beginning socially subversive and became more obviously revolutionary in a political sense when transferred to Paris in 1920. But it was mainly an expression of the crisis in Western culture brought to a head by the First World War. Tzara's discovery of African poetry, to which he paid increasingly serious attention in the postwar years, was a result of his search for new means of literary expression. Carl Einstein and Apollinaire were similarly engaged in experimental literature before writing about *l'art nègre* and also Cubist painting. But Europeans attracted to African art and literature only for what were seen to be primitive qualities, were later to show little interest in the writings of sophisticated blacks who were redefining their own identity.

In the aftermath of the war which brought numerous blacks to Europe in the American forces—as well as the colonial regiments of the British and French armies—Afro-American jazz was introduced. Inspiring such musicians as Igor Stravinsky and Darius Milhaud, but also enjoying immense popularity especially among the young, it seemed to typify the spirit of a new age that was opening. For it was modern in every way, owing its widespread success to technological progress—the wireless, the Gramophone, and the cinema. Jazz musicians and dancers were the subjects of innumerable slick paintings and chic caricatures. Black boxers were similarly portrayed. Old stereotypes of blacks as entertainers were thus updated even though they were no longer regarded as figures of fun but admired for their exuberant vitality, their spontaneity, and instinctive expression of human passions—for much the same reasons that *l'art nègre* was prized. But the war had virtually put an end to a great period of artistic innovation which had already undermined the foundations of Western painting and sculpture. Although outstandingly fine works of art continued to be produced in the years between the wars, mainly by painters and sculptors who had reached their maturity before 1914, they did not include any notable images of blacks.

In these years the very idea of an image of "the" black typifying a vast section of the population of the world began to dissolve. Anthropologists revealed not only the variety of human groups assigned to this simplistic category, differing almost as widely in culture and physiognomy from each other as from Europeans, but also questioned the validity of the notion of race. Some whites, albeit no more than a handful at first, began to doubt previous assumptions of their own innate superiority. Violent rearguard actions were fought to preserve white supremacy and continue to this day. But the image of the black as the antithesis of a white was beginning to

lose its meaning. This radical change of attitude was, however, initiated by blacks themselves in Africa, Europe (mainly France), and the Americas. And it has had few if any reflections in the art of the West which, like that of every other part of the world, is devoted to the expression of the artist's own ideals, hopes, and fears. It has nevertheless prompted a revaluation of earlier images of blacks as savages, slaves, eunuchs, beneficiaries of white benevolence, or simply artists' models. That a proud individuality shines through some of these images, giving them an enduring relevance, is due as much to the personalities of the blacks themselves as to the abilities of painters and sculptors to record what they saw.

ABBREVIATIONS

Edinburgh, Royal Scottish Academy	Frank RINDER, *The Royal Scottish Academy 1826–1916: A Complete List of the Exhibited Works by Raeburn and by Academicians, Associates, and Hon. Members, Giving Details of Those Works in Public Galleries* (1917; reprint ed., Bath, 1975).
London, British Institution	Algernon GRAVES, *The British Institution 1806–1867: A Complete Dictionary of Contributors and their Work from the Foundation of the Institution* (1908; reprint ed., Bath, 1969).
London, Royal Academy	Algernon GRAVES, *The Royal Academy of Arts: A Complete Dictionary of Contributors and their Work from its Foundation in 1769 to 1904*, Burt Franklin: Bibliography & Reference Series 320; Art History & Art Reference 27 (1905–6; reprint ed., New York, 1972).
New York, NAD[1]	*National Academy of Design Exhibition Record 1826–1860*, comp. Bartlett COWDREY, Collections of The New-York Historical Society for the Years 1941–42: The John Watts DePeyster Publication Fund Series, 74–75 (New York, 1943).
New York, NAD[2]	*The National Academy of Design Exhibition Record 1861–1900*, comp. and ed. Maria NAYLOR (New York, 1973).
Paris, Salon	*Catalogues of the Paris Salon 1673 to 1881*, comp. H. W. JANSON (reprint ed., New York and London, 1977).

I

STUDIES

1 Paris, Musée national du Louvre, Département des Peintures, RF 2508. Paris, *Salon de 1800*, p. 41, s.v. "Mme Laville Le Roulx, (M.-G.), Femme Benoist," no. 238. See *The Age of Neo-Classicism*, Exhibition catalogue, London, Royal Academy and Victoria and Albert Museum, 9 September–19 November 1972 ([London], 1972), pp. 18–19, no. 26 and pl. 10.

2 Cf. part 1 of this volume, p. 83, fig. 37 and p. 84.

3 The list of pre-Revolutionary Amis des Noirs includes five women; cf. *Tableau des membres de la Société des Amis des Noirs. Année 1789*, reprinted in *La Révolution française et l'abolition de l'esclavage: Textes et documents* (Paris, 1968), vol. VI, *La Société des Amis des Noirs*, vol. I, 4. In England Hannah More and Anna Seward were active in the abolitionist cause before the end of the eighteenth century.

4 Tønnes Christian Bruun Neergaard, *Sur la situation des beaux-arts en France, ou lettres d'un danois à son ami* (Paris, 1801), p. 42. Marie-Juliette Ballot, *Une élève de David: La comtesse Benoist, l'Emilie de Demoustier, 1768–1826* (Paris, 1914), p. 150, quotes another contemporary critic who remarked that the painting "rappelle l'école de David."

5 It has been suggested that the bare breast symbolizes Liberty and that the head drapery "two meters long" shows that the subject cannot be a slave; cf. Gislind Nabakowski, Helke Sander, and Peter Gorsen, *Frauen in der Kunst* (Frankfurt on Main, 1980), vol. I, p. 283.

6 The print was drawn by Hippolyte Pauquet and engraved by Polydore Pauquet.

7 Houston, Menil Foundation Collection, 83-103 DJ. See Nicholas Penny, ed., *Reynolds*, Exhibition catalogue, Paris, Grand Palais, 9 October–16 December 1985; London, Royal Academy of Arts, 16 January–31 March 1986 (London, 1986), pp. 116, pl. 77, 245–46, no. 77; Ellis K. Waterhouse, "Study of a Black Man by Joshua Reynolds" in *The Menil Collection: A Selection from the Paleolithic to the Modern Era* (New York, 1987), pp.

111–15. The description of Francis Barber comes from James Boswell, *Boswell's Life of Johnson*, ed. George Birkbeck Hill, rev. and enl. L. F. Powell, vol. I (Oxford, 1934), p. 239. The most complete account of Francis Barber's life is Aleyn Lyell Reade, *Johnsonian Gleanings*, pt. II, *Francis Barber: The Doctor's Negro Servant* (1912; reprint ed., New York, 1968).

8 Cf. part 1 of this volume, p. 311 n. 63. James Northcote, *The Life of Sir Joshua Reynolds*, 2d ed. (London, 1819), vol. I, pp. 204–6 states that Reynolds's servant was the model for the black in "several" portraits, notably that of John Manners, marquess of Granby of 1764–66 (Sarasota, Ringling Museum of Art, State 389), a replica of which belongs to the Royal Collection, London. There is also a black groom in his portrait of the count of Schaumburg-Lippe of the same date (London, Royal Collection). (For these portraits see Oliver Millar, *The Later Georgian Pictures in the Collection of Her Majesty the Queen* [London, 1969], vol. I, *Text*, p. 103, no. 1022 and pp. 105–6, no. 1027; vol. II, *Plates*, pls. 93, 92.) But neither of these figures departs from the stereotyped images of black servants which hark back to the seventeenth century. The head now in the Menil Foundation Collection is posed in a different way, and his features are rendered with greater individuality.

9 James Walvin, *Black and White: The Negro and English Society 1555–1945* (London, 1973), p. 46.

10 Joseph Farington records on 19 March 1795 the sale of a "Negros Head/Paul Veronese" formerly in Reynolds's collection and reports (24 March) that Benjamin West said "the picture of the Negro when Sir Joshua bought it had a dark drapery sketched in and a dark background. Sir Joshua painted the present drapery and background"; cf. Joseph Farington, *The Diary of Joseph Farington*, Studies in British Art (New Haven and London, 1978–84), vol. II, *January 1795–August 1796*, ed. Kenneth Garlick and Angus Macintyre, pp. 316, 318. This painting was acquired by Samuel Whitbread and is still in the collection of his descendants at Southill in Biggleswade; cf. Oliver Millar, "The Pictures" in Samuel Whitbread et al., *Southill: A Regency House* (London, 1951), p. 48.

11 *A Catalogue of Portraits, Fancy Pictures, Studies and Sketches, of the Late Sir Joshua Reynolds . . .*, Sale catalogue, London, Greenwood, 14–16 April 1796 (London, 1796), p. 8, no. 53. Sir George Beaumont's painting was shown in a loan exhibition at the British Institution

in 1813 under the title *Portrait of a Black Servant of Sir Joshua Reynolds*; cf. *Catalogue of Pictures by the Late Sir Joshua Reynolds* (London, 1813), p. 20, no. 140.

12 Joshua Reynolds, "Discourse II" (1769) in *Discourses on Art* (1797), ed. Robert R. Wark (San Marino, 1959), p. 34.

13 The following versions or copies are recorded: London, Tate Gallery, 5843 and T.1892; Private Collection, Great Britain; London, Christie, Manson & Woods Ltd., sale of 5 May 1978, no. 80; London, Colnaghi & Co. (purchased at London, Sotheby's, sale of 17 December 1947, no. 112); New York, formerly at Brick Row Book Shop; New York, M. Knoedler & Co., A 6387; New York, Collection of Arturo Peralta-Ramos, Jr. In addition to these paintings by unidentified artists two watercolors by Henry Edridge are known, one in London, Victoria and Albert Museum, 2941-1876 and the other in London, British Museum, Department of Prints and Drawings, L.B.32.1891.5.11.36.

14 Detroit, Detroit Institute of Arts, 52.118. Jules David Prown, *John Singleton Copley*, The Ailsa Mellon Bruce Studies in American Art (Washington, D. C. and Cambridge, Mass., 1966), vol. II, *In England 1774–1815*, p. 402. Although there is a gap in the provenance between 1864 and 1928, there can be little doubt that the painting in the sale is that now in Detroit. See also Edgar P. Richardson "*Head of a Negro* by John Singleton Copley," *Detroit Institute of Arts Bulletin* 32, no. 3 (1952–53): 68–70.

15 Cf. part 1 of this volume, pp. 39–40, figs. 6, 7.

16 The model was so described in the catalogue of the 1864 Lyndhurst Sale, quoted in Prown, *John Singleton Copley*, vol. II, p. 402. There is a remarkable similarity between the man's features and those of Lt. Grosvenor's servant in John Trumbull's *Death of General Warren at the Battle of Bunker's Hill* (see part 1 of this volume, p. 42 and p. 44, fig. 10): the same model could have posed for both.

17 Joshua Reynolds, "The True Idea of Beauty" (10 November 1759) in *The Literary Works of Sir Joshua Reynolds*, ed. Henry William Beechey, new and improved ed. (London, 1852), vol. II, pp. 131–35, esp. p. 134.

18 Edmund Burke, *A Philosophical Enquiry into the Origin of Our Ideas of the Sublime and Beautiful, with an Introductory Discourse Concerning Taste* 4.14–15 (1756) in *The Works of the Right Honourable Edmund Burke* (London, New York, and

Toronto, [1906–7]), vol. I, pp. 188–90. See Sander L. GILMAN, *On Blackness without Blacks: Essays on the Image of the Black in Germany* (Boston, 1982), pp. 21–24.

19 REYNOLDS, "The True Idea of Beauty" in *Literary Works*, p. 134.

20 REYNOLDS, "Discourse XII" (1784) in *Discourses on Art*, p. 224.

21 *Arlequin au Muséum, ou Critique des tableaux, en vaudevilles* (Paris, 1801) quoted in BALLOT, *Une élève de David*, p. 150.

22 Linnaeus classed human beings among the primates in 1735 and presented his final categorization of their varieties in the tenth edition of his *Systema naturæ* (1758); cf. Thomas BENDYSHE, "The History of Anthropology" in *Memoirs Read Before the Anthropological Society of London* (London, 1865–70), vol. I, *1863–4*, pp. 424–25.

23 Quoted in Michèle DUCHET, *Anthropologie et histoire au siècle des Lumières: Buffon, Voltaire, Rousseau, Helvétius, Diderot* (Paris, 1971), p. 255.

24 Ibid., p. 241.

25 Johann Joachim WINCKELMANN, *Geschichte der Kunst des Alterthums* (Dresden, 1764), pt. 1, p. 32. [The German text is: ". . . welche nicht diejenige Vorzüge hatte, die den Künstler durch Ideen hoher Schönheit reizen konnten."]

26 Ibid., pp. 147–48. [The German texts are: "Die Farbe trägt zur Schönheit bey, aber sie ist nicht die Schönheit selbst, sondern sie erhebt dieselbe überhaupt und ihre Formen. . . . Ein Mohr könnte schön heissen, wenn seine Gesichtsbildung schön ist, und ein Reisender versichert, daß der tägliche Umgang mit Mohren das widrige der Farbe benimmt, und was schön an ihnen ist offenbaret; so wie die Farbe des Metalls, und das schwarzen oder grünlichen Basalts, der Schönheit alter Köpfe nicht nachtheilig ist."] The traveler to whom he refers was Francesco Carletti whose posthumously published *Ragionamenti di Francesco Carletti Fiorentino sopra le cose da lui vedute ne'suoi viaggi si dell'Indie Occidentali, e Orientali come d'altri paesi* (Florence, 1701), began with an account of his transporting slaves from Cape Verde to South America. Winckelmann, on a topic near to his heart, had nevertheless argued that a "schönen Knaben aus Aegypten" mentioned by Martial must have been of Greek parentage, "ein weisses Gesicht aus diesem Lande der braunen Farbe . . . desto mehr zu schätzen sey, je seltener es sich finde" (Johann Joachim WINCKELMANN, *Anmerkungen über die Geschichte der Kunst des Alterthums* [Dresden, 1767], pt. 1, p. 10).

27 Paul BROCA, "Tableau chromatique de la chevelure et de la peau," *Bulletins de la Société d'anthropologie de Paris* 5 (1864): 138–40, 767–73.

28 Camper's dissertation on the subject was published posthumously in Dutch and French versions, *Verhandeling van Petrus Camper, over het natuurlijk verschil der wezenstrekken in menschen van onderscheiden landaart en ouderdom* and *Dissertation Physique de Mr. Pierre Camper sur les différences réelles que présentent les traits du visage chez les hommes de différents pays et de différents ages*, both Utrecht, 1791. It was translated into English by Thomas COGAN, *The Works of the Late Professor Camper, on the Connexion between the Science of Anatomy and the Arts of Drawing, Painting, Statuary, &c. &c. in Two Books. Containing a Treatise on the Natural Difference of Features in Persons of Different Countries and Periods of Life . . .* (London, 1794); our quotations are from this translation.

29 CAMPER, *The Works of the Late Professor Camper*, p. 2. Camper states that the painting was by Abraham van den Tempel, but the only image of a black we have been able to trace in the work of this artist is the young servant in the *Portrait of Jan van Amstel and His Wife Anna Boxhoorn*, signed and dated 1671. It entered the collection of the Museum Boymans-van Beuningen, Rotterdam (1852) in 1865, but in 1740 it was in Leiden in a private collection; see H. F. WIJNMAN, "Abram van den Tempel's portretgroep van de zeekapitein Jan van Amstel en zijn vrouw Anna Boxhoorn," *Bulletin Museum Boymans-van Beuningen* 10, no. 1 (1959): 97–109. Judging from the painting, Camper's criticisms are unjustified.

30 CAMPER, *The Works of the Late Professor Camper*, p. 9.

31 Ibid., p. 32. The illustration is taken from CAMPER, *Verhandeling over het natuurlijk verschil der wezenstrekken in menschen*, Tab. I.

32 CAMPER, *The Works of the Late Professor Camper*, p. 32.

33 Quoted in Arthur O. LOVEJOY, *The Great Chain of Being: A Study of the History of an Idea* (Cambridge, Mass., 1936), p. 230. The remark comes from the opening discourse of George Louis Leclerc, comte de BUFFON and Louis Jean Marie DAUBENTON, *Histoire naturelle, générale et particulière, avec la description du Cabinet du Roy*, vol. I (Paris, 1749), p. 12, when Buffon believed that forms of life shaded into one another by "unknown gradations" and declared the notion of independent species to be artificial. But his subsequent "discovery" that hybrids were infertile led him to regard species as objective realities, "les seuls êtres de la Nature." Lovejoy's book provides the fullest account of the origin and development of these ideas. See also DUCHET, *Anthropologie et histoire au siècle des Lumières*, pp. 228–80.

34 Cf. part 1 of this volume, pp. 62–66 and figs. 23, 24.

35 The first edition of Giovanni Battista della Porta's *De humana physiognomonia* was published in Vico Equense in 1586, with subsequent editions appearing in Hanau in 1593, Naples in 1599 and 1602, Frankfurt on Main in 1618, etc. French translations were published in 1655 and 1660. The same illustrations appear without acknowledgment in Charles LE BRUN, *Conférence de M. Le Brun, premier peintre du Roi de France . . . sur l'expression générale et particulière des passions. Enrichie de figures gravées par B. Picart* (Amsterdam and Paris, 1698).

36 Johann Caspar LAVATER, *Physiognomische Fragmente zur Beförderung der Menschenkenntniß und Menschenliebe* (Leipzig and Winterthur, 1775–78), vol. IV, pl. XIX (between pp. 310 and 311) and p. 311. [The German text is: "Ein Mohr—Das Bogigte im Umriße des ganzen Gesichtes; die Breite der Augen; die Zerdrückheit der Nase; besonders aber die so stark aufgeworfenen, vorhängenden, zähen Lippen; entfernt vonaller Feinheit und Grazie—bezeichnen das Mohrische."]

37 Ibid., p. 309. [The German text is: "Welche wohlgebildete, lange, fast zu lange Gestalt! Die Stellung selbst hat nichts plumpes. Hitze und Weichheit, scharfe Sinnlichkeit ohne Nachdenken, Fülle, Beschränktheit, Behaglichkeit, Stettigkeit. Recht das Element irrdischer Leidenschaften."]

38 Until late in the eighteenth century sexual relations between blacks and whites seem to have provoked scandal from a social rather than a racial viewpoint, and no objections were raised to marriages, usually between servants; cf. WALVIN, *Black and White*, pp. 53–55.

39 Quoted by Michael J. C. ECHERUO, *The Conditioned Imagination from Shakespeare to Conrad* (New York, 1978), p. 45.

40 Charles LAMB, "On the Tragedies of Shakespeare, Considered with Reference to Their Fitness for Stage Representation" (1811) in *The Life, Letters, and*

Writings of Charles Lamb, ed. Percy FITZGERALD (London, 1892), vol. IV, p. 207.

41 He is shown in this way in Thomas Stothard's *The Return of Othello* (Stratford-upon-Avon, Royal Shakespeare Theatre Gallery, RSC No. 109) painted 1796–97 for Boydell's Shakespeare Gallery and the earliest recorded large-scale painting of a scene from the play; see T. S. R. BOASE, *The Oxford History of English Art*, vol. X, *English Art 1800–1870* (Oxford, 1959), pl. 23a. See also Winifred H. FRIEDMAN, *Boydell's Shakespeare Gallery*, Outstanding Dissertations in the Fine Arts (New York and London, 1976).

42 Immanuel KANT, *Von den verschiedenen Racen der Menschen, zur Ankündigung der Vorlesungen der physischen Geographie* (Königsberg, 1775), p. 10, quoted by GILMAN, *On Blackness without Blacks*, p. 32.

43 Johann Caspar LAVATER, *Von der Physiognomik* (Leipzig, 1772), vol. I, p. 13, quoted with commentary in GILMAN, *On Blackness without Blacks*, p. 50. Two years later Lavater reprinted the passage substituting "the head of a Labrador Indian" for "the head of a black," apparently to escape the charge that he was condoning slavery.

44 Georg Christoph LICHTENBERG, *Über Physiognomik wider die Physiognomen. Zu Beförderung der Menschenliebe und Menschenkenntniß* (1778) in *Georg Christoph Lichtenberg's vermischte Schriften* (Göttingen, 1844–47), vol. IV, pp. 33–34, quoted in GILMAN, *On Blackness without Blacks*, p. 49.

45 For discussions of the influence of physiognomic and phrenological theories see Graeme TYTLER, *Physiognomy in the European Novel: Faces and Fortunes* (Princeton, NJ, 1982) and Judith WECHSLER, *A Human Comedy: Physiognomy and Caricature in 19th Century Paris* (Chicago and London, 1982). Gall's theories were accepted by Goethe and Balzac among writers, François Gérard and P.-J. David d'Angers among artists.

46 Johann Friedrich BLUMENBACH, *Beyträge zur Naturgeschichte*, 2d ed., vol. I (Göttingen, 1806), quoted in Thomas BENDYSHE, ed. and trans., *The Anthropological Treatises of Johann Friedrich Blumenbach* (London, 1865), p. 305.

47 Ibid., p. 304. It is often incorrectly stated that he used the term *Caucasian* because of his fondness for a skull from that region in his collection. The notion of the beauty of people from the Caucasus according to European standards seems however to have been well established. Cf. Johann Joachim WINCKELMANN,

Gedanken über die Nachahmung der griechischen Werke in der Malerey und Bildhauerkunst, 2d ed. (Dresden and Leipzig, 1756), p. 7.

48 Julien Joseph VIREY, *Histoire naturelle du genre humain*, 2d ed. rev. and enl. (Paris, 1824), vol. II, pl. 8 (facing p. 42).

49 Ibid., pp. 41–42. (The English translation is taken from *Natural History of the Negro Race*, trans. J. H. GUENEBAULT, (Charleston, SC, 1837), which includes extracts from Virey, Charles White, and others.) The first appearance of Virey's book coincided with demands for the restoration of slavery in the French colonies. [The French text is: "Ces remarques sur les proportions entre le crâne et la face du nègre, entre la grosseur comparative de son cerveau et de ses nerfs, nous offrent des considérations très importantes. En effet, plus un organe se développe, plus il obtient de puissance et d'activité; de même, à mesure qu'il perd de son étendue, cette puissance est diminuée. On voit donc que si le cerveau se rapetisse, et si les nerfs qui en sortent grossissent, le nègre sera moins porté à faire usage de sa pensée qu'à se livrer à ses appétits physiques, tandis qu'il en sera tout autrement dans le blanc. Le nègre offre ses organes de l'odorat et de goût plus développés que le blanc; ces sens prendront donc un plus grand ascendant sur son moral qu'ils n'en ont sur le nôtre; le nègre sera donc plus adonné aux plaisirs corporels, nous à ceux de l'esprit. Chez nous, le front avance et la bouche semble rapetisser, se reculer, comme si nous étions destinés à penser plutôt qu'à manger; chez le nègre, le front se recule et la bouche s'avance, comme s'il était plutôt fait pour manger que pour réfléchir. Ceci se remarque à plus forte raison dans les bêtes: leur museau s'avance comme pour aller au-devant de la nourriture; leur bouche s'agrandit comme si elles n'étaient nées que pour la gloutonnerie; leur cervelle diminue de volume, et se retire en arrière; la pensée n'est plus qu'en second ordre."]

50 Charles WHITE, *An Account of the Regular Gradation in Man, and in Different Animals and Vegetables; and from the Former to the Latter* (London, 1799), p. 135, quoted by William STANTON, *The Leopard's Spots: Scientific Attitudes toward Race in America 1815–59* (Chicago, 1960), p. 17. On White see also Michael BANTON, *Race Relations* (London, 1967), p. 20.

51 Georges Louis Leclerc, comte de BUFFON, *Abrégé de l'histoire générale des singes par M. Leclerc de Buffon* (Avignon, 1820), quoted by Giacomo GIACOBINI and Riccarda GIRAUDI, "E l'uomo incontrò la scimmia," *Kos* 3, no. 23 (June 1986): 30.

52 Georges Léopold CUVIER, *Tableau élémentaire de l'histoire naturelle des animaux* (Paris, 1798), p. 71, quoted by William B. COHEN, *The French Encounter with Africans: White Response to Blacks, 1530–1880* (Bloomington and London, 1980), p. 94.

53 Johann Heinrich FÜSSLI, *Lectures on Painting, by the Royal Academicians, Barry, Opie, and Fuseli*, ed. Ralph Nicholson WORNUM, Connoisseurship, Criticism, and Art History in the Nineteenth Century (1848; reprint ed., New York and London, 1979), p. 526; see also Gert SCHIFF, *Johann Heinrich Füssli 1741–1825*, Oeuvrekataloge Schweizer Künstler, vol. 1 (Zurich and Munich, 1973), vol. I, *Text und Oeuvrekatalog*, p. 363. An instance of the artistic use of the facial angle is provided by a sheet of studies by Bertel Thorvaldsen for his relief of *Priam and Achilles* (ca. 1815) including the head of a prognathous black presumably drawn for comparison with the perpendicular profiles of Greeks that he was preparing to model; cf. Paul Ortwin RAVE, *Thorvaldsen*, Die Kunstbücher des Volkes, 44 (Berlin, 1942–47), p. 69. fig. 64. This appears to be the only image of a black in Thorvaldsen's œuvre.

54 Henri Auguste JOUIN, *David d'Angers: Sa vie, son œuvre, ses écrits et ses contemporains* (Paris, 1878), vol. II, *Ecrits du maître—Son œuvre sculpté*, pp. 97–98.

55 Cf. part 1 of this volume, p. 93.

56 Cf. part 1 of this volume, p. 167.

57 Johann Gottfried SCHADOW, *National-Physionomieen, oder Beobachtungen über den Unterschied der Gesichtszüge und die äußere Gestaltung des menschlichen Kopfes / Physionomies nationales, ou Observations sur la différence des traits du visage et sur la conformation de la tête de l'homme* (Berlin, 1835), pp. 12–15 and pls. III, IV. At an earlier date he had lithographed the head of a "Kaffir"; cf. *Johann Gottfried Schadow 1764–1850: Bildwerke und Zeichnungen*, Exhibition catalogue, Berlin, Staatliche Museen zu Berlin, Nationalgalerie, October 1964–March 1965 (Berlin, 1964), pp. 56 (illus.), 228, no. 211. This was not used in the book which illustrated the head, preserved in spirits, of another "Kaffir" who had been drowned and cast ashore when attempting to escape from southern Africa; see SCHADOW, *National-Physionomieen*, p. 13 and pl. III.

58 SCHADOW, *National-Physionomieen*, p. 29 and pl. VIII.

59 Ibid., pp. 28–32.

60 Mary C. COWLING, "The Artist as Anthropologist in Mid-Victorian England:

Frith's *Derby Day*, the *Railway Station*, and the New Science of Mankind," *Art History* 6, no. 4 (December 1983): 463 and pl. 39.

61 See, for example, images by T. R. Browne (1819) and W. H. Fernyhough (1836) reproduced in Bernard SMITH, *European Vision and the South Pacific*, 2d ed. (New Haven and London, 1985), pp. 221, fig. 142 and 269, fig. 173.

62 Stephen Rogers PECK, *Atlas of Human Anatomy for the Artist* (New York, 1968), p. 239.

63 London, Victoria and Albert Museum, 1703-1871. The print was engraved by Thomas Williamson after John Boyne's watercolor.

64 FARINGTON, *Diary*, vol. X, *July 1809–December 1810*, ed. Kathryn CAVE, p. 3713.

65 Ibid. Kenneth GARLICK, *A Catalogue of the Paintings, Drawings and Pastels of Sir Thomas Lawrence* in *Walpole Society* 39 (1962–64): 238, lists a "Study in a back view of the celebrated Molyneux, the pugilist, in black and white chalk. Large drawing on canvas," in the sale of Lawrence's effects; cf. *A Catalogue of the Remaining Part of the Valuable Collection of Modern Drawings, a Few Paintings, . . . the Property of Sir Thomas Lawrence*, Sale catalogue, London, Christie's, 19 June 1830, p. 24, no. 399. (Lot 400 of this catalogue is an oil study of the same subject.) It is possible that this was in fact the drawing of Wilson for whose name that of the well-known boxer had been substituted, but it cannot now be traced.

66 Benjamin Robert HAYDON, *The Diary of Benjamin Robert Haydon*, ed. Willard Bissell POPE (Cambridge, Mass., 1960–63), vol. I, *1808–1815*, pp. 182–89.

67 Benjamin Robert HAYDON, *The Autobiography and Memoirs of Benjamin Robert Haydon (1786–1846)*, ed. Tom TAYLOR, 2d ed. (1853; reprint ed., New York, [1926]), vol. I, pp. 106–7.

68 Cambridge, Houghton Library, Harvard University, Keats Collection, fMS Eng 1331(5) vol. III, fols. 24ᵛ, 25ʳ.

69 London, British Museum, Department of Prints and Drawings, 1881.7.9.545.

70 HAYDON, *Diary*, pp. 183, 185.

71 Ibid., p. 188.

72 Ibid., p. 189. Haydon noted: "It cannot be said certainly that because a man has a small lobe to his ears, because his body

is long, or his legs short, because his feet are flat and his ankles inverted, it cannot be proved that deficiency of intellect must follow, or that because he is finely formed—intellectual greatness must necessarily be the consequence. . . ."

73 Cf. part 1 of this volume, p. 166, fig. 99.

74 Houston, Menil Foundation Collection, 84-54 DJ. London, British Institution, p. 145, s.v. "Dawe, George," 1811, no. 92. We are grateful to William Drummond for locating this picture. The main source of information about Dawe is the brief "Biography: George Dawe, Esq. R.A.," *Library of the Fine Arts* 1, no. 1 (1831), pp. 9–17. A bitter character sketch of him (to which the biography seems to have been a kind of reply) was published by [Charles LAMB], "Peter's Net—No. 1: Recollections of a Late Royal Academician," *The Englishman's Magazine* 2, no. 1 (September 1831): 25–29, reprinted in LAMB, *The Life, Letters, and Writings of Charles Lamb*, vol. VI, pp. 165–74. Lamb suggests that Dawe's choice of models was determined by how little they charged.

75 FARINGTON, *Diary*, vol. X, pp. 3839–40; vol. XI, *January 1811–June 1812*, ed. Kathryn CAVE, pp. 3841, 3843, 3852. A few years earlier James Ward had hoped to win election to the Royal Academy on the merits of a large picture including the image of a black, *The Liboya Serpent Seizing its Prey*—similarly without success (see part 1 of this volume, p. 89, fig. 43 and pp. 90–91).

76 Cf. part 1 of this volume, pp. 66–71, figs. 25, 26. George Dawe's *Life of George Morland, with Remarks on His Works* was published in London in 1807.

77 "Biography: George Dawe, Esq. R.A.," p. 17. The sketches have not been traced.

78 According to the biography in ibid., p. 11, Dawe exhibited at the Royal Academy in 1806 a portrait of "Mrs. White, the wife of an eminent surgeon." For White's views on the superiority of Europeans, see *supra*, p. 18 and p. 250, n. 50.

79 Farington records in 1812 "the great expense of living models necessary for an Historical painter": a guardsman charged Samuel Lane a shilling an hour for sitting, six to eight hours a day. He also states that Dawe paid Wilson two guineas a week; see FARINGTON, *Diary*, vol. XII, *July 1812–December 1813*, ed. Kathryn CAVE, p. 4157; vol. X, p. 3713.

80 Avallon, Musée de l'Avallonnais, no inv. no.

81 Versailles, Musée national du Château de Versailles, MV 1497. Paris, *Salon de 1810*, p. 46, no. 369.

82 Cf. part 1 of this volume, pp. 104–6, fig. 55.

83 Cf. part 1 of this volume, p. 83.

84 Versailles, Musée national du Château de Versailles, MV 1496. Paris, *Salon de 1810*, p. 49, no. 390.

85 Joseph M. CUOQ, "Esclaves du 'Takrūr' dans les armées de Bonaparte et de Khusraw Pacha" in *Le sol, la parole et l'écrit: 2000 ans d'histoire africaine. Mélanges en hommage à Raymond Mauny*, Bibliothèque d'histoire d'outre-mer, n.s., Etudes 5–6 (Paris, 1981), vol. II, pp. 869–77. While he was in Egypt, Napoleon planned to recruit a regiment of 2,000 black African slaves.

86 Vivant DENON, *Voyage dans la basse et la haute Égypte, pendant les campagnes du Général Bonaparte* (Paris, 1802), p. 48. [The French text is: ". . . la nature avare leur a refusé tout superflu; ils n'ont ni graisse ni chair, mais seulement des nerfs, des muscles, et des tendons. . . . leur peau luisante est d'un noir transparent et ardent, semblable absolument à la patine des bronzes de l'autre siècle: ils ne ressemblent point du tout aux Negres de l'ouest de l'Afrique; leurs yeux sont profonds et étincelants, sous un sourcil surbaissé; les narines larges, avec le nez pointu. . . .] Both Gros and Girodet may have availed themselves of the several engravings of Arab and Nubian physiognomy after drawings by Denon in his supplementary volume of illustrations, especially plates 104–6.

87 Ibid., p. 26.

88 Ibid., p. 68.

89 Gros included somewhat similar figures of blacks in his painting of the Battle of Aboukir (Versailles, Musée national du Château de Versailles, MV 2276).

90 Chicago, Art Institute of Chicago, 1923.1107. François BERGOT, *Gericault: Tout l'œuvre gravé et pièces en rapport*, Exhibition catalogue, Rouen, Musée des Beaux-Arts, 28 November 1981–28 February 1982 (Rouen, 1982), pp. 34–35, no. 9.

91 The main source of information is in [Pierce EGAN], *Boxiana; or Sketches of Ancient and Modern Pugilism* (London, 1812–[14]), cited in Paul EDWARDS and James WALVIN, *Black Personalities in the Era of the Slave Trade* (Baton Rouge, 1983), pp. 186–203. See also Jeffery FARNOL, *Epics of the Fancy: A Vision of Old Fighters* (London, [1928]), pp. 83–92 and Dennis PRESTIDGE, *Tom Cribb at Thistleton Gap* (Melton Mowbray, 1971).

92 William HAZLITT, "The Fight" (1822) in *The Complete Works of William Hazlitt*, ed. Percival Presland HOWE (London and Toronto, 1930–34), vol. XVII, *Uncollected Essays*, pp. 72–86.

93 FARINGTON, *Diary*, vol. VIII, *July 1806–December 1807*, ed. Kathryn CAVE, pp. 3094–95.

94 A drawing by Henry Thomas Alken, dated 1810, representing the first match between Cribb and Molineaux is in Brodick Castle. The second match is illustrated in a colored etching dated 29 September 1811 and entitled *Rural Sports: A Milling Match*, after a drawing by Thomas Rowlandson that is also located in Brodick Castle. Another drawing by Rowlandson (London, Henry Reitlinger Collection) purports to be a portrait of the black boxer. An etching by George Cruikshank dated 1812 of *The Second Contest between Crib & Molineux, Sept. 28:1811* as well as portraits of *Richmond* and *Molineux* were illustrated in [EGAN], *Boxiana*; they are reproduced in EDWARDS and WALVIN, *Black Personalities*, pls. 5a, 5b. Two more prints dated 1812 include a colored etching of Molineaux by Robert Dighton and a mezzotint of the famous pugilist by John Young after a lost painting by Douglas Guest; cf. Paul MAGRIEL, "Portraits of the Fancy," *Apollo* 50, no. 297 (November 1949):141, fig. VI. A portrait of Molineaux by Douglas Guest was sold in London, Sotheby's, 27 June 1973, no. 108, as was another by an anonymous artist on 20 December 1978, no. 229. Finally, portraits of Molineaux and other boxers figure on the wall in the background of a sparring scene drawn by James Gillray (London, British Museum, Department of Prints and Drawings, 1865.11.11.2020); this drawing was engraved in February 1817 by Isaac Robert Cruikshank under the title *Sparring*.

95 Allan CUNNINGHAM, *The Lives of the Most Eminent British Painters* (1829–33), rev. Mrs. Charles HEATON (London, 1879–80), vol. II, p. 273.

96 Lorenz E. A. EITNER, *Géricault: An Album of Drawings in the Art Institute of Chicago* (Chicago, 1960), pp. 20–21, 25–26.

97 Noted by Charles CLÉMENT, *Géricault: Etude biographique et critique avec le catalogue raisonné de l'œuvre du maître*, 3d ed., with catalogue revised by Lorenz E. A. EITNER (1879; reprint ed., Paris, 1973), pp. 374–75.

98 The racial prejudice of the general public with which black boxers sometimes had to contend was deplored by such a true devotee of the sport as Pierce Egan who declared that it "was wrong and beneath the character of an Englishman, to abuse any individual for that he could not help—either on account of his country or his *colour*" ([EGAN], *Boxiana*, cited by EDWARDS and WALVIN, *Black Personalities*, p. 188).

99 On the face of an envelope Gericault sketched a naked black man assaulting a white woman and noted: ". . . Look at the woman's hand pushing back the negro's arm / The woman screams / the negro purses his lips. . . . It is the antique made modern." [The French text is: ". . . Regarde la main de la femme repoussant le bras du nègre / la femme gueule / le nègre pointe les lèvres. . . . C'est de l'antique modernisé."] See Patrick J. KELLEHER, "A Sculpture and Painting by Théodore Géricault," *Gallery Notes* 17, no. 1 (January 1953):5–8, 14–17. This sketch and a small terracotta group (both located in Buffalo, Albright-Knox Art Gallery, 52:8.2, 52:8.1) have been dated ca. 1818 with other erotic works by Gericault. His description of the subject as *de l'antique modernisé* may have been intended to distingiuish it from his carved stone *Nymph and Satyr* (Rouen, Musée des Beaux-Arts), an evocation of the classical world.

100 Cf. part 1 of this volume, pp. 119–25, figs. 65–69.

101 Cambridge, Fogg Art Museum, Harvard University, 1965.285; cf. Lorenz E. A. EITNER, *Géricault*, Exhibition catalogue, Los Angeles, Los Angeles County Museum of Art, 12 October–12 December 1971; Detroit, Detroit Institute of Arts, 23 January–7 March 1972; Philadelphia, Philadelphia Museum of Art, 30 March–14 May 1972 (Los Angeles, 1971), p. 155, no. 111.

102 Malibu, J. Paul Getty Museum, 85.PA.407. See CLÉMENT, *Géricault*, p. 427, no. 104bis, and Philippe GRUNCHEC, *Tout l'œuvre peint de Gericault*, Les classiques de l'art (Milan and Paris, 1978), p. 112, no. 166 and pl. XLVI.

103 Lorenz E. A. EITNER, "The Sale of Géricault's Studio in 1824," *Gazette des Beaux-Arts*, 6th ser. 53 (February 1959):121, fig. 3, lot 15.

104 Buffalo, Albright-Knox Art Gallery, 52:11. The attribution to Gericault is maintained by EITNER in his *Géricault*, p. 157, no. 113 and *Géricault: His Life and Work* (London, 1983), pp. 264, 359 n. 119. This painting, which is excluded from Gericault's work by GRUNCHEC (*Tout l'œuvre peint de Gericault*, p. 143, no. A 150) because of the "coloris du vêtement, d'un rouge inhabituel chez Gericault," was exhibited in the centennial of French art in St. Petersburg in 1912 (no. 273); cf. François MONOD, "L'exposition centennale de l'art français à Saint-Petersbourg," *Gazette des Beaux-Arts* 54, no. 1 (January–June 1912):306, 307 (illus.). Another painting of the head of a black in Châlon-sur-Saône, Musée Vivant Denon (inv. no. 27) is accepted as the work of Gericault by Eitner (*Géricault*, p. 156, no. 112) but rejected by GRUNCHEC (p. 142, no. A 149). The fact that it was acquired by the museum in 1829 from a friend of Gericault without any attribution is enough to suggest that it is by another hand.

105 See GRUNCHEC, *Tout l'œuvre peint de Gericault*, pp. 112–13, nos. 165, 166; 120–21, nos. 218, 219; 142–43, nos. A 149–A 152; 147, no. A 211. Alternative attributions for such paintings have yet to be proposed. But the pastel head of a black in profile, Rouen, Musée des Beaux Arts, 1399 (Klaus BERGER and Diane Chalmers JOHNSON, "Art as Confrontation: The Black Man in the Work of Géricault," *Massachusetts Review* 10, no. 2 [Spring 1969]:325, pl. 12) has strong similarities with a head in the altarpiece of the *Martyrdom of St. Stephen* (1817) by Alexandre-Denis Abel de Pujol in the Church of St-Thomas d'Aquin, Paris.

106 Paris, *Salon de 1819*, p. 39, no. 329. Paris, *Salon de 1824*, p. 71, no. 638. Paris, *Salon de 1827*, p. 57, no. 275. Paris, *Salon de 1830*, p. 24, no. 153; p. 95, no. 588; p. 98, no. 611.

107 Charles GABET, *Dictionnaire des artistes de l'école française au XIXᵉ siècle: Peinture, sculpture, architecture, gravure, dessin, lithographie et composition musicale* (Paris, 1831), p. 202, s.v. "Desains, Charles-Porphyre-Alexandre." Desains had been a pupil of J.-L. David about whom he wrote an interesting essay; cf. Charles-Porphyre-Alexandre DESAINS, "Souvenirs d'un élève de David," *Annales de la Société Libre des Beaux-Arts* 2 (1832):28–38.

108 Jacques Nicolas PAILLOT DE MONTABERT, *Traité complet de la peinture* (Paris, 1829), vol. I, pp. 158–59. [The French text is: On a appelé études certains morceaux d'essai en peinture, pour les distinguer des ouvrages entiers et complets. . . . Plusieurs peintres qui n'ont pas su conduire à terme une figure ou un ensemble quelconque, donnent à ces ouvrages manqués le nom d'étude, et le public y est pris assez souvent, surtout lorsque l'artiste a eu soin de laisser quelques parties non achevées, telles que le fond, et certains accessoires même des parties principales. Il est bon de signaler cet abus. . . ."]

109 Paris, *Salon de 1827*, p. 60, no. 298. Quoted by Lee JOHNSON (*The Paintings of Eugène Delacroix: A Critical Catalogue, 1816–1831* [Oxford, 1981], vol. I, *Text*, p. 60; vol. II, *Plates*, pl. 76) who identified the painting with that of a woman in a blue turban formerly on loan to the Philadelphia Museum of Art. The model for this portrait has been said to be "Aline la mulâtresse," and Johnson tends to support that identification.

110 In England the painting of a Jewish rabbi which has the appearance of a worked up *étude* was presented to the Royal Academy as a diploma piece by John Jackson. At the British Institution in 1827 Jackson exhibited a *Negro's Head*; London, British Institution, p. 298, s.v. "Jackson, John," 1827, no. 141.

111 JOHNSON, *The Paintings of Eugène Delacroix*, vol. I, p. 215, no. M1; vol. II, pl. 157. The sketchbook is in Paris, Musée national du Louvre, Cabinet des Dessins, RF 9141, fols. 37–43.

112 Paris, Musée Eugène Delacroix, RF 32268.

113 JOHNSON, *The Paintings of Eugène Delacroix*, vol. I, p. 53.

114 Eugène DELACROIX, *Journal 1822–1863*, ed. André JOUBIN, Hubert DAMISCH, and Régis LABOURDETTE, Collection Les Mémorables (Paris, 1980), p. 83.

115 These two studies of Aspasie are in the Collection of Mrs. Walter Feilchenfeldt, Zurich. See JOHNSON, *The Paintings of Eugène Delacroix*, vol. I, pp. 53–54, nos. 80–81; vol. II, pl. 71.

116 Montpellier, Musée Fabre, 868.1.36; cf. ibid., vol. I, pp. 52–53, no. 79, correcting the erroneous identification of the model as "Aline la mulâtresse." A drawing for this portrait is in Paris, Musée national du Louvre, Cabinet des Dessins, RF 23355, fol. 35.

117 See George WILDENSTEIN, *Gauguin*, L'art français (Paris, 1964), vol. I, *Catalogue*, pp. 13–14, no. 27 (illus.), mentioned by JOHNSON, *The Paintings of Eugène Delacroix*, vol. I, p. 52.

118 DELACROIX, *Journal*, pp. 815–16. [The French text is: "Le docteur Bailly met en principe: 'La preuve que nos idées sur la beauté de certains peuples ne sont pas fausses, c'est que la nature semble donner plus d'intelligence aux races qui ont davantage ce que nous regardons comme la beauté.' Mais les arts ne sont pas ainsi. . . . Nos peintres sont enchantés d'avoir un beau idéal tout fait et en poche qu'ils peuvent communiquer aux leurs et à leurs amis. Pour donner

de l'idéal à une tête d'Egyptien, ils la rapprochent du profil de l'Antinoüs. Ils disent: 'Nous avons fait notre possible, mais si ce n'est pas plus beau encore, grâce à notre correction, il faut s'en prendre à cette nature baroque, à ce nez épaté, à ces lèvres épaisses, qui sont des choses intolérables à voir'. Les têtes de Girodet sont un exemple divertissant dans ce principe; ces diables de nez crochus, de nez retroussés, etc., que fabrique la nature, le mettent au désespoir."] Delacroix presumably had in mind Girodet's *Révolte du Caire* rather than his *Portrait of Jean-Baptiste Belley* (cf. part 1 of this volume, p. 105, fig. 55).

119 A "hübsche Mohrin vom Senegal" appears in Wilhelm HEINSE, *Ardinghello und die glückseligen Inseln*, ed. Max L. BAEUMER (1787; Stuttgart, 1975), p. 230. Lorenz Michael Rathelf's tragedy *Die Mohrinn zu Hamburg* of 1775 turns on a white youth's passion for a black girl and her divided love for him and a man of her own color. Jean-Baptiste RADET and Pierre Yves BARRÉ, *La négresse; ou, Le pouvoir de la reconnaissance*, a comedy performed in Paris in 1787, is about the love of a shipwrecked French sailor for an African girl whom he finally marries. See GILMAN, *On Blackness without Blacks*, pp. 35–48, and Léon-François HOFFMANN, *Le nègre romantique: Personnage littéraire et obsession collective*, Le regard de l'histoire (Paris, 1973), pp. 105–7.

120 Charles BAUDELAIRE, "Salon de 1846" in *Curiosités esthétiques*, ed. Henri LEMAITRE (Paris, 1962), pp. 128–29. [The French text is: "En général, il ne peint pas de jolies femmes, au point de vue des gens du monde toutefois. . . . C'est non seulement la douleur qu'il sait le mieux exprimer, mais surtout,—prodigieux mystère de sa peinture,—la douleur morale!"]

121 Cf. part 1 of this volume, pp. 132–33.

122 Montauban, Musée Ingres, 867-180; cf. Marc SANDOZ, *Théodore Chassériau 1819–1856: Catalogue raisonné des peintures et estampes* (Paris, 1974), p. 134, no. 40 and pl. XXX.

123 Daniel TERNOIS, "Les collections d'Ingres," *Art de France* 2 (1962):214. [The French text of Ingres's instructions is: "On mettra d'abord la figure bien exactement au carreau sur la toile—On demande cette figure peinte d'après le modèle Joseph le nègre—Sa grandeur: figure d'atelier—La toile blanche, ou grise, servira de fond—La lumière venant de gauche à droite—On demande le portrait le plus identique du modèle, pour les formes les plus rendues et sa couleur—Redire et peindre à part le point fermé

[sic], et sans déranger (?) le bras et, dans son mouvement naturel, le point."]

124 Accounts of Joseph are in Charles CLÉMENT, *Gleyre: Etude biographique et critique avec le catalogue raisonné de l'œuvre du maître* (Paris, 1878), pp. 207–8, and E. de la BÉDOLLIÈRE "Le modèle" in *Les Français peints par eux-mêmes*, vol. II (Paris, 1840), p. 7.

125 TERNOIS, "Les collections d'Ingres," p. 214.

126 Luigi Antonio LANZI, *Storia pittorica della Italia* (Bassano, 1795–96), vol. I, p. 379.

127 New York, Collection of S. Baloga. John WITT, *William Henry Hunt (1790–1864): Life and Work with a Catalogue* (London, 1982), p. 174, no. 329 and color pl. 10.

128 Cf. *infra*, pp. 61–62 and figs. 42–43.

129 Selkirk, Collection of the Duke of Buccleuch and Queensberry, K.T. See Hugh HONOUR, *The European Vision of America*, Exhibition catalogue, Washington, D. C., National Gallery of Art, 7 December 1975–15 February 1976; Cleveland, Cleveland Museum of Art, 28 April–8 August 1976; Paris, Grand Palais, 17 September 1976–3 January 1977 (Cleveland, 1975), no. 314.

130 The painting is in Edinburgh, National Gallery of Scotland, 2114. London, Royal Academy, vol. VIII, pp. 272–73, s.v. "Wilkie, Sir David," 1837, no. 144. See John WOODWARD, *Paintings and Drawings by Sir David Wilkie 1785–1841*, Exhibition catalogue, London, Royal Academy of Arts, 17 October–10 December 1958 (London, 1958), p. 29, no. 42 and pl. 25.

131 London, Victoria and Albert Museum, Apsley House, Wellington Museum, W.M. 1469-1948. London, Royal Academy, vol. VIII, p. 268, s.v. "Wilkie, Sir David," 1822, no. 126. See William J. CHIEGO et al., *Sir David Wilkie of Scotland (1785–1841)*, Exhibition catalogue, Raleigh, North Carolina Museum of Art, 1987 (Raleigh, 1987), pp. 184–92, no. 23.

132 Allan CUNNINGHAM, *The Life of Sir David Wilkie; with His Journals, Tours, and Critical Remarks on Works of Art; and a Selection from His Correspondence* (London, 1843), vol. II, p. 443, quoted by WOODWARD, *Paintings and Drawings by Sir David Wilkie*, p. 6.

133 In the 1830s the painting by Rubens was at Langton House, Duns; it is now in Edinburgh, National Gallery of Scotland, 2193. See WOODWARD, *Paintings and Drawings by Sir David Wilkie*, p. 46, no. 104.

134 Geneva, Musée d'Art et d'Histoire, CR5; cf. Daniel BAUD-BOVY, *Peintres genevois du XVIII^{ème} et du XIX^{ème} siècle, 1702–1849* (Geneva, 1903–4), vol. II, *1766–1849: Töpffer. Massot. Agasse*, pp. 123 (illus.), 148.

135 Bern, Kunstmuseum Bern, G 1978.3. London, Royal Academy, vol. I, p. 14, s.v. "Agassé, James Laurent," 1829, no. 508. Agassé's catalogue of his own works includes a *Tête de nègre, étude* of 1803; cf. BAUD-BOVY, *Peintres genevois*, p. 146.

136 Berlin (GDR), Staatliche Museen zu Berlin, National-Galerie, AdK 103. See Gertrud HEIDER, *Carl Blechen*, Künstlerkompendium (Leipzig, 1970), p. 68, pl. 31 and p. 182, no. 31. The watercolor is inscribed: *Io sono Silvestro Baptir(?) da S^{t} Domingo Guadaloupe corporale negro a Pompeji età 65 anni.*

137 Charlottenlund, Collection of Niels Arne Ravn-Nielsen. See Dyveke HELSTED et al., *Martinus Rørbye 1803–1848*, Exhibition catalogue, Copenhagen, Thorvaldsens Museum, 18 June–30 September 1981 (Copenhagen, 1981), p. 120, no. 82. This study remained in the artist's collection, and he made two copies of it, in 1842 and 1846.

138 Liverpool, Walker Art Gallery, 1601. *Walker Art Gallery, Liverpool: Merseyside Painters, People & Places. Catalogue of Oil Paintings* (Liverpool, 1978), vol. I, *Text*, pp. 227–28, no. 1601; vol. II, *Plates*, p. 189, no. 1601.

II

THE ART OF OBSERVATION

1 Mungo PARK, *Travels in the Interior Districts of Africa; Performed under the Direction and Patronage of the African Association, in the Years 1795, 1796, and 1797* (London, 1799), p. 2.

2 Each illustration is inscribed: *J. C. Barrow del^{t} from a Sketch by M. Park*. But as he recorded, Park lost all his possessions in the course of his travels. A fanciful evocation of his account of how he was nursed back from sickness to health by a black woman was painted by Robert Smirke and reproduced in James MONTGOMERY's poem, *The West Indies, a Poem in Four Parts*, pt. 3, lines 163–74 in James MONTGOMERY, James GRAHAME, and E[lizabeth] BENGER, *Poems on the Abolition of the Slave Trade*, facing p. 24. Cf. part 1 of this volume, pp. 97, 102.

3 [George COLMAN] and [Bonnel THORNTON], *The Connoisseur* 1, no. 21, 20 June 1754, reprinted 1761, 1774, 1793, 1803, and subsequently in several editions of *The British Essayists*. Gotthold Ephraim LESSING, *Laokoon; oder, Über die Grenzen der Mahleren und Poesie* (Berlin, 1766), pt. I, pp. 250–51. See Sander L. GILMAN, *On Blackness without Blacks: Essays on the Image of the Black in Germany* (Boston, 1982), pp. 26–29.

4 Peter KOLB, *Caput BonæSpei hodiernum; das ist, Vollständige Beschreibung des africanischen Vorgebürges der Guten Hofnung / Reise aus das Capo du Bonne Esperance, oder das africanische Vorgebürge der Guten Hofnung* (Nuremberg, 1719). An English translation was abridged, altered, and published as *The Present State of the Cape of Good-Hope; or, A Particular Account of the Several Nations of the Hottentots . . .*, trans. G. MEDLEY (London, 1731). The French translation, *Description du Cap de Bonne-Espérance; Où l'on trouve tout ce qui concerne l'histoire naturelle du pays; la religion, les mœurs & les usages des Hottentots . . .* (Amsterdam, 1741), was in Voltaire's library; cf. Michèle DUCHET, *Anthropologie et histoire au siècle des Lumières: Buffon, Voltaire, Rousseau, Helvétius, Diderot* (Paris, 1971), p. 69. All these editions have the same illustrations. Kolb's account was severely criticized by Nicolas Louis de LA CAILLE, *Journal historique du voyage fait au Cap de Bonne-Espérance* (Paris, 1763).

5 Rüdiger JOPPIEN and Bernard SMITH, *The Art of Captain Cook's Voyages*, vol. II, *The Voyage of the Resolution and Adventure, 1772–1775* (New Haven and London, 1985), p. 135.

6 Fifty-six of Daniell's original drawings of African subjects, most of which seem to have been made on his journey, were exhibited at Spink & Son Ltd., London; cf. Basil TAYLOR and Shula MARKS, *Samuel Daniell: Drawings & Prints*, Exhibition catalogue, London, Spink & Son Ltd., 1973 (London, [1973]). I am grateful to Dr. Marks for drawing my attention to this. Somewhat earlier visual records of the indigenous population of South Africa are included in a collection of several hundred drawings (mainly of landscapes, plants, and animals) assembled by Robert Jacob Gordon, a Dutchman of Scottish descent in the service of the Dutch East India Company who charted the territory of the Cape Colony in a succession of expeditions 1777–80 and 1785–86. Some of these drawings may have been by Gordon himself, although he is known to have employed at least one professional draftsman; see L. C. ROOKMAAKER, "De Gordon Atlas: Achttiende eeuwse voorstellingen van het Zuidafrikaanse binnenland," *Bulletin van het Rijksmuseum* 29, no. 3 (1981):123–35 (English summary, pp. 183–84). They are of greater documentary rather than artistic interest as they are the only known representations of Hottentots, Bushmen, and Kaffirs drawn from life at this period, and the drawings clearly distinguish their different styles of life. Gordon supplied information about these people to Diderot and the vicomte de Querhoent who passed it on to Buffon; cf. DUCHET, *Anthropologie et histoire au siècle des Lumière*, p. 52.

7 On the Daniell family of artists see Thomas SUTTON, *The Daniells: Artists and Travellers* (London, 1954).

8 Present whereabouts unknown; cf. *Samuel Daniell: Drawings & Prints*, p. 3, no. 19.

9 Johannesburg, Africana Museum, 65/3995; cf. R. F. KENNEDY, *Catalogue of Pictures in the Africana Museum* (Johannesburg, 1966–72), vol. II, *C–D*, p. 178, no. D8.

10 Johannesburg, Africana Museum, 65/4023; cf. ibid., p. 183, no. D38.

11 Prints by Thomas Medland after Daniell's watercolors were also published as illustrations to John BARROW, *Voyage to Cochin China in the Years 1792 and 1793 . . . to Which Is Annexed an Account of a Journey Made in the Years 1801 and 1802, to the Residence of the Chief of the Booshuana Nation . . .* (1806;

reprint ed., London, 1975)) and *Travels into the Interior of South Africa . . .*, 2d ed. (London, 1806). A set of forty-eight uncolored soft-ground etchings by William Daniell after Samuel Daniell was published posthumously as *Sketches Representing the Native Tribes, Animals and Scenery of South Africa* (London, 1820).

12 London, British Museum, Department of Prints and Drawings, 175 e. 11, pl. 1.

13 BARROW, . . . *Journey . . . to the Residence of the Chief of the Booshuana*, pp. 400, 398, quoted in Eric AXELSON, ed., *South African Explorers*, The World's Classics 538 (London, 1954), pp. 99–100.

14 Johannesburg, Africana Museum, 4477, 4478; cf. KENNEDY, *Catalogue of Pictures in the Africana Museum*, vol. II, pp. 205–6, nos. D202, D203. On De Meillon see Alfred GORDON-BROWN, *Pictorial Africana: A Survey of Old African Paintings, Drawings, and Prints to the End of the Nineteenth Century with a Biographical Dictionary of One Thousand Artists* (Cape Town and Rotterdam, 1975), p. 146.

15 George THOMPSON, *Travels and Adventures in Southern Africa*, 2d ed. (London, 1827), vol. I, pp. v–vi.

16 Ibid., vol. I, p. 170. The illustration is inscribed *G. Thompson Esq.r del.t*, but Thompson states that he was "assisted by" De Meillon.

17 Ibid., vol. I, p. 190.

18 Cf. part 1 of this volume, p. 174, fig. 105 and p. 175.

19 THOMPSON, *Travels and Adventures in Southern Africa*, pp. 340–43.

20 Joseph FARINGTON, *The Diary of Joseph Farington*, Studies in British Art (New Haven and London, 1978–84), vol. VI, *April 1803–December 1804*, ed. Kenneth GARLICK and Angus MACINTYRE, pp. 2186–87. These people were probably brought to England when the British forces withdrew from the Cape Colony.

21 The African Institution initiated legal proceedings to have Saartjie removed from her showman-keeper and returned to her homeland, but to no avail; see Richard D. ALTICK, *The Shows of London* (Cambridge, Mass. and London, 1978), pp. 268–72, and Bernth LINDFORS, "Courting the Hottentot Venus," *Africa: Rivista trimestrale di studi e documentazione dell'Istituto Italo-Africano* 40, no. 1 (March 1985):133–48.

22 For caricatures of the "Hottentot Venus" see ALTICK, *The Shows of London*, pp.

271–72, figs. 85, 86; Bernth LINDFORS, "The Bottom Line: African Caricature in Georgian England," *World Literature Written in English* 24, no. 1 (1984):43–51; Anna H. SMITH, "Still More about the Hottentot Venus," *Africana Notes and News* 26, no. 3 (1984):95–98.

23 Georges Léopold CUVIER, "Extrait d'observations faites sur le cadavre d'une femme connue à Paris et à Londres sous le nom de Vénus Hottentotte," *Mémoires du Muséum d'Histoire naturelle* 3 (1817):259–74. For Saartjie in France see Percival R. KIRBY, "The Hottentot Venus," *Africana Notes and News* 6, no. 3 (June 1949):55–62; idem, "More about the Hottentot Venus," ibid. 10, no. 4 (September 1953):124–34; idem, "The 'Hottentot Venus' of the Musée de l'Homme, Paris," *South African Journal of Science* 50, no. 12 (July 1954):319–21.

24 For this aspect see Sander L. GILMAN, "Black Bodies, White Bodies: Toward an Iconography of Female Sexuality in Late Nineteenth-Century Art, Medicine, and Literature," *Critical Inquiry* 12, no. 1 (Autumn 1985):213–19.

25 Robert CHAMBERS, *The Book of Days: A Miscellany of Popular Antiquities in Connection with the Calendar* (London and Edinburgh, 1864), vol. II, pp. 621–22, under the date 26 November. In this very popular and several times reprinted collection of "curious information," the account of Saartjie also deplores the way in which she had been exhibited.

26 Paris, Muséum national d'Histoire naturelle, Musée de l'Homme, Laboratoire d'Anthropologie, 27.875; cf. Percival R. KIRBY, "A Further Note on the 'Hottentot Venus'," *Africana Notes and News* 11, no. 5 (December 1954):164–66.

27 Paris, Muséum national d'Histoire naturelle, Bibliothèque centrale, collection of *vélins*, vol. 69, nos. 1 and 2. These two drawings were later reworked by Jacques Christophe Werner as illustrations for Georges Léopold CUVIER's, "Femme de race Boschismanne" in Frédéric Georges CUVIER and Etienne GEOFFROY SAINT-HILAIRE, *Histoire naturelle des mammifères . . .*, vol. 1, (Paris, 1824), pp. 1–7.

28 London, Museum of Mankind, no inv. no. The painting illustrated here may have been exhibited by Ward at the British Institution in 1828 as *A Negro's Head*, 2 ft. 4 in. by 3 ft. 1 in., the slight discrepancy in measurements being accounted for by the frame; cf. London, British Institution, p. 564, s.v. "Ward, James," 1828, no. 312.

29 Cf. part 1 of this volume, p. 89, fig. 53 and pp. 90–91. In 1815 Ward more

successfully demonstrated his abilities on a grand scale with his masterpiece, *Gordale Scar* (London, Tate Gallery).

30 Johann Friedrich Blumenbach owned two busts (one of a black), as well as a number of skulls. He bequeathed them to the University of Göttingen which subsequently acquired a series of "race busts" executed "with great fidelity to nature and artistic handling," including those of "Hassa, Nubian; Abdallah, Negro; Zeno Orego, bearded negro from Guadaloupe"; cf. Rudolph WAGNER, "On the Anthropological Collection of the Physiological Institute of Göttingen" in Thomas BENDYSHE, ed., *The Anthropological Treatises of Johann Friedrich Blumenbach* (London, 1865), pp. 351–52. According to Wagner these busts were the work of "Herr von Launitz," presumably Eduard Schmidt von der Launitz. They can no longer be traced.

31 Paris, Collection of Henri Samuel.

32 Charles GABET, *Dictionnaire des artistes de l'école française au XIXe siècle: Peinture, sculpture, architecture, gravure, dessin, lithographie et composition musicale* (Paris, 1831), p. 443, s.v. "Leprince (A.-Xavier)," records that *La chasse au lion* was exhibited at the Galerie Lebrun in 1826. Gabet also records that Leprince's younger brother Léopold "tient chez lui atelier d'élèves et donne des leçons particulières." The black model was perhaps employed in this studio-school. The same model may have posed for the *étude* of a kneeling black from two viewpoints (Dijon, Musée des Beaux Arts, DG 82), at one time attributed to Gericault but now excluded from his work (cf. Philippe GRUNCHEC, *Tout l'œuvre peint de Gericault*, Les classiques de l'art [Milan and Paris, 1978], p. 147, no. A 211), and perhaps by Auguste-Xavier Leprince.

33 Avrahm YARMOLINSKY, *Picturesque United States of America 1811, 1812, 1813, Being a Memoir on Paul Svinin, Russian Diplomatic Officer, Artist and Author* (New York, 1930); Margaret JEFFERY, "As a Russian Saw Us in 1812," *Metropolitan Museum of Art Bulletin* n.s. 1, no. 3 (November 1942):134–40; Abbott GLEASON, "Pavel Svin'in" in *Abroad in America: Visitors to the New Nation 1776–1914*, ed. Marc PACHTER and Frances WEIN, Exhibition catalogue, Washington, D. C., National Portrait Gallery, Smithsonian Institution, 1976 (Washington, D. C.), pp. 12–21.

34 Quoted in YARMOLINSKY, *Picturesque United States of America*, p. 11.

35 New York, Metropolitan Museum of Art, 42.95.15.

36 New York, Metropolitan Museum of Art, 42.95.19.

37 Quaker meetings had been caricatured since the early eighteenth century. For antiabolitionist images see part 1 of this volume, pp. 73–74, fig. 29 and pp. 146, 149, fig. 88.

38 Cf. part 1 of this volume, pp. 110–12, fig. 59.

39 See Phillip S. LAPSANSKY and Emma J. LAPSANSKY, "Philadelphia and the Abolition of Slavery in the British Empire: A Dialogue in Popular Culture" (Paper delivered at the American Studies Association, Philadelphia, April 1976) and Nancy Reynolds DAVISON, "E. W. Clay: American Political Caricaturist of the Jacksonian Era" (Ph.D. diss., University of Michigan, 1980).

40 Worcester, Worcester Art Museum, The Charles E. Goodspeed Collection, 1910.48. For the complete *Life in Philadelphia* series see DAVISON, "E. W. Clay," vol. II, pp. 351–55.

41 Thomas LANDSEER, *Monkey-ana or Men in Miniature* (London, 1828), pls. 2, 9, 20, 21, also a dueling scene, pl. 8.

42 DAVISON, "E. W. Clay," vol. I, p. 90.

43 John Fanning WATSON, *Annals of Philadelphia, Being a Collection of Memoirs, Anecdotes, & Incidents of the City and its Inhabitants from the Days of the Pilgrim Founders* (Philadelphia and New York, 1830), p. 479, quoted in DAVISON, "E. W. Clay," vol. I, p. 94.

44 *Life in New York* was composed of eight or more unnumbered lithographs published by Anthony Imbert, 1830; cf. DAVISON, "E. W. Clay," vol. I, p. 93.

45 *New Comic Annual* (London, [1831]), pp. 223–37. The story is in the form of a conversation among Londoners, one of whom has been "signing a petition to the Commons, to abolish the diabolical traffic in human beings. . . ." The same volume includes verses on the "Hottentot Venus" and "Washing a Black Man White." Cf. the antiabolitionist print from this same period in part 1 of this volume, p. 149, fig. 88.

46 DAVISON, "E. W. Clay," vol. I, p. 98.

47 Present whereabouts unknown. A reproduction of this painting, entitled *The Art of Love*, appeared in an advertisement in *Apollo* 91, n.s. no. 99 (May 1970): xcix.

48 Cf. part 1 of this volume, p. 132, fig. 75.

49 Samuel REDGRAVE, *A Dictionary of Artists of the English School: Painters, Sculptors, Architects, Engravers and Ornamentists, with Notices of Their Lives and Work*, 2d ed. (London, 1878), p. 65, s.v. "Buss, Robert William."

50 The original watercolor of Hunt's *Jim Crow* is located in Port Sunlight, Lady Lever Art Gallery, WHL 320. See John WITT, *William Henry Hunt (1790–1864): Life and Work with a Catalogue* (London, 1982), p. 187, no. 477 and pp. 222–23; Tom JONES, *William Henry Hunt (1790–1864)*, Exhibition catalogue, Wolverhampton, Central Art Gallery, 2–30 May 1981 (Wolverhampton, 1981), p. 56, no. 117.

51 Tom JONES, *William Henry Hunt*, p. 25, no. 47; pp. 62–63, no. 128; WITT, *William Henry Hunt (1790–1864)*, p. 47.

52 London, British Museum, Department of Prints and Drawings, 1866.4.7.222 and 1866.4.7.223; cf. JONES, *William Henry Hunt*, p. 25, no. 46 and p. 57, no. 118.

53 The model for *Miss Jim-ima Crow—a West Indian Cinderella* is also the subject of the watercolor *The Flower Girl* now in Woodbridge, Collection of Captain Robin Sheepshanks. The youth represented as *Master James Crow* appears in a watercolor entitled *A Brown Study* (London, Victoria and Albert Museum, F.A.526) and in a pen and watercolor drawing in New Haven, Yale Center for British Art, B1975.4.583. See WITT, *William Henry Hunt (1790–1864)*, p. 190, no. 507 and pl. 19; p. 192, no. 533; p. 195, no. 574. A wood engraving after *A Brown Study* was illustrated in *Harper's Weekly* 14, no. 688 (5 March 1870): 152.

54 Charles MATHEWS, *The London Mathews; Containing an Account of This Celebrated Comedian's Trip to America* (London, 1824), pp. 11–12. The passage describing this incident (probably an invention) is quoted by Herbert MARSHALL and Mildred STOCK, *Ira Aldridge, the Negro Tragedian* (1958; Carbondale and Edwardsville: Arcturus Book Editions, 1968), pp. 40–41.

55 Although usually said to have been based on the song and dance of a black, both were almost certainly invented by Rice; cf. Sam DENNISON, *Scandalize My Name: Black Imagery in American Popular Music*, Critical Studies on Black Life and Culture, 13 (New York, 1982), pp. 45–58.

56 Houston, D. and J. de Menil Collection, P 69-290 PC. Several editions of "Jim Crow" sheet music had illustrated covers; see ibid., pp. 48–50.

57 Cf. part 1 of this volume, pp. 117–18. Ignatius Sancho in London had attempted to take up an acting career but was hindered by his "defective and incorrigible articulation"; cf. Joseph Jekyll's introduction to Ignatius SANCHO, *Letters of Ignatius Sancho, an African, to Which Are Prefixed Memoirs of His Life*, ed. Joseph JEKYLL (London, 1782), vol. I, p. x. On black interpreters of Shakespearean roles see Errol HILL, *Shakespeare in Sable: A History of Black Shakespearean Actors* (Amherst, 1984).

58 Cf. part 1 of this volume, p. 118.

59 John Dover Wilson paid tribute to Robeson's performance in his edition of *Othello*; see William SHAKESPEARE, *Othello*, The Works of Shakespeare (Cambridge, 1957), pp. ix–x. However, the stage history of the play in this volume makes no reference to Aldridge. For an account of Robeson's portrayals of Othello see HILL, *Shakespeare in Sable*, pp. 120–30.

60 Ruth COWHIG, "Actors, Black and Tawny, in the Role of Othello,—and Their Critics," *Theatre Research International*, n.s. 4, no. 2 (February 1979): 133–46.

61 For the minstrel show see Brander MATTHEWS, "The Rise and Fall of Negro-Minstrelsy," *Scribner's Magazine* 57, no. 6 (June 1915): 754–58; Hans NATHAN, *Dan Emmett and the Rise of Early Negro Minstrelsy* (Norman, 1962), esp. pp. 107–58; and Robert C. TOLL, *Blacking Up: The Minstrel Show in Nineteenth-Century America* (New York, 1974), esp. pp. 25–64. Matthews suggested that the minstrel show had almost died out, but, in fact, it survived in England, mainly as an entertainment for children until the late 1930s and was (rather self-consciously) revived on British television in the 1950s.

62 MATTHEWS, "The Rise and Fall of Negro-Minstrelsy," p. 754.

63 Ibid., p. 759. But "Negro minstrelsy" never caught on in continental Europe partly because the linguistic jokes were untranslatable.

64 A group of four blackface minstrels figures in the background of William Powell Frith's popular *Life at the Seaside (Ramsgate Sands)* (London, Royal Collection) which was exhibited at the Royal Academy in 1854 and purchased by Queen Victoria that same year; cf. London, Royal Academy, vol. III, p. 172, s.v. "Frith, William Powell," 1854, no. 157. A replica dated 1905 is in Bournemouth, Russell-Cotes Art Gallery and Museum, 8. See Jeremy MAAS, *Victorian Painters* (London, 1978), pp. 112, 118 (illus.).

65 Henry MAYHEW, *London Labour and the London Poor: A Cyclopædia of the*

Condition and Earnings of Those That Will Work, *Those That* Cannot Work, *and Those That* Will Not Work (1851–62; reprint ed., London and New York, 1967), vol. III, *The London Street-Folk Comprising Street Sellers, Street Buyers, Street Finders, Street Performers, Street Artizans, Street Labourers,* p. 191.

66 See Lizzetta LEFALLE-COLLINS and Leonard SIMONS, *The Portrayal of the Black Musician in American Art,* Exhibition catalogue, Los Angeles, California Afro-American Museum, 7 March–14 August 1987 (Los Angeles, 1987).

67 *The Banjo Man* in Richmond, Valentine Museum (OM.32), is believed to represent a slave named Sy Gilliat who, according to tradition, was a body servant to Lord Botetourt and official fiddler at state balls. This painting by an unknown artist probably dates from ca. 1810 and may thus be the earliest surviving image of this type. See Jessie POESCH, *The Art of the Old South: Painting, Sculpture, Architecture & the Products of Craftsmen 1560–1860* (New York, 1983), pp. 172–73 (illus.).

68 Philadelphia, Historical Society of Pennsylvania, Bb 61, K 89; see Milo Merle NAEVE, *John Lewis Krimmel: An Artist in Federal America,* The University of Delaware Press American Artists Series (Newark, London, and Toronto, 1987), p. 122, no. 113. The painting on which this lithograph is based was entitled *Country Frolic and Dance* and exhibited in Philadelphia in 1820; cf. Anna Wells RUTLEDGE, *Cumulative Record of Exhibition Catalogues: The Pennsylvania Academy of the Fine Arts, 1807–1870; The Society of Artists, 1800–1814; The Artists' Fund Society, 1835–1845,* Memoirs of the American Philosophical Society, 38 (Philadelphia, 1955), p. 116, s.v. "Krimmel, John Lewis," 1820, p. 6, no. 58. Both the painting (private collection) and a watercolor (Washington, D. C., Library of Congress, Prints and Photographs Division) that differ only in minor details have recently been published by Naeve (pp. 79–82, 103, nos. 8, 67 [illus.]).

69 Philadelphia, Pennsylvania Academy of the Fine Arts, 1845.3.1. Blacks similarly appear in other paintings by Krimmel: a violinist and a serving girl in *Quilting Frolic,* 1813 and two pickpockets in *Election Day in Philadelphia,* signed and dated 1815 (both in Winterthur, Henry Francis du Pont Winterthur Museum, 53.178.2 and 59.131). On these three paintings see RUTLEDGE, *Cumulative Record,* p. 116, s.v. "Krimmel, John Lewis," 1812, p. 20, no. 67; 1813, p. 21, no. 119; 1816, p. 7, no. 73; NAEVE, *John Lewis Krimmel,* pp. 67–71, 75–77, nos. 1, 2, 6 (color

reprods.) Other American paintings with blacks as minor figures include two by Francis Guy: *The Tontine Coffee House* (ca. 1797 or ca. 1803–4; New York, New-York Historical Society, 1907.32) and *Winter Scene in Brooklyn* (1818; Brooklyn, Brooklyn Museum, 97.13). On *The Tontine Coffee House* see Richard J. KOKE, comp., *American Landscape and Genre Paintings in The New-York Historical Society: A Catalog of the Collection, Including Historical, Narrative, and Marine Art* (New York and Boston, 1982), vol. II, *Earle–Mount,* pp. 83–85, no. 1123. For these two paintings and another including blacks, *"Perry Hall" Home of Harry Dorsey Gough* (1795; Winterthur, Henry Francis du Pont Winterthur Museum, 57.670), that was formerly attributed to Guy, see Stiles Tuttle COLWILL, *Francis Guy 1760–1820,* Exhibition catalogue, Baltimore, Museum and Library of Maryland History, Maryland Historical Society, 10 April–15 August 1981 (Baltimore, 1981), p. 48, no. 2; pp. 68–69, no. 22; p. 111, no. 11.

70 Svinin's *Fourth of July in Centre Square, Philadelphia,* is in New York, Metropolitan Museum of Art, 42.95.22.

71 The Metropolitan Museum of Art, New York, also owns the watercolor by Svinin entitled *Merrymaking at a Wayside Inn* (42.95.12).

72 RUTLEDGE, *Cumulative Record,* p. 225, s.v. "Svinin (Svenin), Pavel Petrovich."

73 Ibid., p. 116, s.v. "Krimmel, John Lewis," 1813, p. 21, no. 119. That Krimmel's copy of Wilkie's *The Blind Fiddler* was painted from a print was recognized when the picture was exhibited at the Pennsylvania Academy of the Fine Arts. The critic in *The Port Folio* (3d ser., vol. 2, no. 2 [August 1813]:140) commented: "This beautiful little picture is a copy from an English print, engraved by Burnet, from an original picture of the same size, by the celebrated Wilkie" (quoted in NAEVE, *John Lewis Krimmel,* p. 71, no. 3). On Wilkie's paintings see William J. CHIEGO et al., *Sir David Wilkie of Scotland (1785–1841),* Exhibition catalogue, Raleigh, North Carolina Museum of Art, 1987 (Raleigh, 1987), pp. 7–8, 115–22, no. 5, 168–72, no. 18.

74 Cf. Eric FONER, "Abolitionism and the Labor Movement in Antebellum America" in Christine BOLT and Seymour DRESCHER, eds., *Anti-Slavery, Religion, and Reform: Essays in Memory of Roger Anstey* (Folkestone and Hamden, CT, 1980), pp. 254–71.

75 An American painting of blacks on their own before mid-century is Christian

Mayr's *Kitchen Ball at White Sulphur Springs,* signed and dated 1838 (Raleigh, North Carolina Museum of Art, 52.9.23); New York, NAD¹, vol. II, p. 22, s.v. "Mayr, Christian," 1845, no. 300. See Hermann Warner WILLIAMS, JR., *Mirror to the American Past: A Survey of American Genre Painting: 1750–1900* (Greenwich, CT, 1973), pp. 77–78, fig. 58, and pl. IX.

76 Cooperstown, New York State Historical Association, Mastin Collection, F-110.54. See James Paul GOLD, "A Study of the Mastin Collection" (Master's thesis, State University College of Oneonta, NY, 1967); James Taylor DUNN and Louis C. JONES, "Crazy Bill Had a Down Look," *American Heritage* 6, no. 5 (August 1955):60–63, 108; idem, "Spiel, Broadside, and Art," *Antiques* 67, no. 2 (February 1955):146–48.

77 GOLD, "A Study of the Mastin Collection," pp. 17–59, 69–75. According to Gold (pp. 28–30) George J. Mastin was still exhibiting the paintings in the 1870s and perhaps as late as the 1890s.

78 Quoted in DUNN and JONES, "Crazy Bill Had a Down Look," p. 62.

79 Quoted in ibid., p. 108.

80 Samuel Eliot MORISON, *The Oxford History of the American People* (New York, 1965), p. 518.

81 Boston, Museum of Fine Arts, 47.1263; cf. *American Paintings in the Museum of Fine Arts, Boston* (Boston, 1969), vol. I, *Text,* p. 53, no. 224; vol. II, *Plates,* p. 165, fig. 255. See Lucretia H. GIESE, "James Goodwyn Clonney (1812–1867): American Genre Painter," *American Art Journal* 11, no. 4 (October 1979):4–31, esp. pp. 20–21, fig. 18. Giese reproduces (p. 20, fig. 19) a study of the black youth astride the horse.

82 The juxtaposition of a black figure and a white is repeated in at least two other paintings by Clonney: *In the Woodshed* (signed and dated 1838; Boston, Museum of Fine Arts, 47.1193) and *The Trappers* (signed and dated 1850; New York, Alexander Gallery). In his *Waking Up* of 1851 (Boston, Museum of Fine Arts, 47.1189) Clonney's composition includes two white children teasing a sleeping black man. *What a Catch!* of 1855 (Boston, Museum of Fine Arts, 47.1217) balances two blacks and two whites in a fishing boat. For these pictures see GIESE, "James Goodwyn Clonney," p. 8, fig. 3 and p. 12; pp. 25–26; pp. 24–25, fig. 23; pp. 26–27, fig. 27.

83 Cooperstown, New York State Historical Association, N-395.55. New York, NAD¹,

vol. II, p. 43, s.v. "Mount, William Sidney," 1846, no. 131.

84 Karen M. ADAMS, "The Black Image in the Paintings of William Sidney Mount," *American Art Journal* 7, no. 2 (November 1975): 42–58, esp. pp. 56–58, fig. 18.

85 Mount described Hector fishing in a letter to Charles Lanman on 17 November 1847, quoted in Alfred FRANKENSTEIN, *William Sidney Mount* (New York, 1975), pp. 120, 122.

86 Boston, Museum of Fine Arts, 62.215; cf. *M. & M. Karolik Collection of American Water Colors & Drawings, 1800–1875* (Boston, 1962), vol. I, p. 107, no. 149 and p. 109, fig. 50.

87 Philadelphia, Pennsylvania Academy of the Fine Arts, 1879.8.1. New York, NAD¹, vol. I, p. 83, s.v. "Clonney, James Goodwyn," 1841, no. 46. See GIESE, "James Goodwyn Clonney," p. 12, fig. 7 and p. 14.

88 "The Fine Arts: National Academy of Design," *The Knickerbocker* 18, no. 1 (July 1841): 87, quoted by GIESE, "James Goodwyn Clonney," p. 11. The writer probably had in mind the presence in the picture of whites in various stages of drunkenness.

89 Boston, Museum of Fine Arts, 48.458. New York, NAD¹, vol. II, p. 41, s.v. "Mount, William Sidney," 1830, no. 54. See FRANKENSTEIN, *William Sidney Mount*, pp. 9–10 and p. 33, pl. 1.

90 Mount writing to Benjamin Thompson on 5 December 1840, quoted by Donald D. KEYES, "The Sources for William Sidney Mount's Earliest Genre Paintings," *Art Quarterly* 32, no. 3 (1969): 259.

91 Matthew PILKINGTON, *A General Dictionary of Painters; Containing Memoirs of the Lives and Works of the Most Eminent Professors of the Art of Painting, from its Revival, by Cimabue, in the Year 1250, to the Present Time* (1770), rev. and enl. ed. (London, 1824), vol. II, p. 118, s.v. "Ostade, Adrian Van"; p. 348, s.v. "Steen, Jan." For the influence of seventeenth-century Dutch genre painting on nineteenth-century American pictures of similar subjects see H. Nichols B. CLARK, "A Taste for the Netherlands: The Impact of Seventeenth-Century Dutch and Flemish Genre Painting on American Art 1800–1860," *American Art Journal* 14, no. 2 (Spring 1982): 23–31.

92 William DUNLAP, *A History of the Rise and Progress of the Arts of Design in the United States*, 2d ed. (Boston, 1918), vol. III, p. 264.

93 For Mount's knowledge of European art see Barbara NOVAK, *American Painting of the Nineteenth Century: Realism, Idealism, and the American Experience*, 2d ed. (New York: Icon Editions, 1979), pp. 138–51.

94 Stony Brook, NY, Museums at Stony Brook, X54.8. Signed and dated 1836, *Farmers Nooning* was exhibited at the National Academy of Design in 1837; cf. New York, NAD¹, vol. II, p. 42, s.v. "Mount, William Sidney," 1837, no. 268. For the most recent account of this much discussed work see Theodore E. STEBBINS, JR., Carol TROYEN, and Trevor J. FAIRBROTHER, *A New World: Masterpieces of American Painting 1760–1910*, Exhibition catalogue, Boston, Museum of Fine Arts, 7 September–13 November 1983; Washington, D. C., Corcoran Gallery of Art, 7 December 1983–12 February 1984; Paris, Grand Palais, 16 March–11 June 1984 (Boston, 1983), pp. 256–57, no. 51 and pl. on p. 108. In the catalogue entry Carol Troyen claims that the pose of the black is derived from the antique Barberini Faun and goes on to suggest that "by association with the Faun the black figure in this picture comes to embody indolence and an open sensuality. . . ." But Mount's figure does not exactly repeat the pose of the statue and could as easily have been derived from life (it is eminently natural). In fact it is no closer to the Faun than the figure of the black in *The Power of Music* (cf. *infra*, n. 95) is to the Lansdowne antique statue of Attis.

95 In *The Breakdown*, 1835 (Chicago, Art Institute of Chicago, 1939.392); see ADAMS, "The Black Image in the Paintings of William Sidney Mount," pp. 45–46, fig. 3.

96 New York, Century Association. New York, NAD¹, vol. II, p. 43, s.v. "Mount, William Sidney," 1847, no. 158. See ADAMS, "The Black Image in the Paintings of William Sidney Mount," pp. 49–51, fig. 7.

97 Stony Brook, NY, Museums at Stony Brook, X50.3.1; ADAMS, "The Black Image in the Paintings of William Sidney Mount," pp. 49–51, fig. 6.

98 The similarity between the composition and that of Piero della Francesca's *The Flagellation* (Urbino, Galleria Nazionale delle Marche) was noted by NOVAK, *American Painting of the Nineteenth Century*, p. 107.

99 For Mount's relations with Goupil see FRANKENSTEIN, *William Sidney Mount*, pp. 152–53, 156–63, 166-67.

100 The half-length portrait of the black violinist entitled *Right and Left*, of which a colored lithograph was published in 1852, is located in Stony Brook, NY, Museums at Stony Brook, X56.19, as is the companion portrait of a white musician, *Just in Tune*. For reproductions of both see FRANKENSTEIN, *William Sidney Mount*, p. 195, pl. 30 and p. 191, pl. 26.

101 FRANKENSTEIN, *William Sidney Mount*, pp. 157–62. Mount recorded that Schaus also commissioned: "One picture cabinet size—Negro asleep in a barn—while a little boy is tickling his foot" and "Courtship—A Negro popping the question only think of that." Neither of these works appears to have been executed.

The Banjo Player (Stony Brook, NY, Museums at Stony Brook, X55.6.1) and *The Bone Player* (Boston, Museum of Fine Arts, 48.461), both signed and dated 1856, were exhibited at the National Academy of Design in 1858; cf. New York, NAD¹, vol. II, p. 44, s.v. "Mount, William Sidney," 1858, nos. 595, 600. In 1857 colored lithographs were issued of these two paintings. The third portrait of a black commissioned by William Schaus was lithographed after Mount's picture *The Lucky Throw* (present whereabouts unknown) and published in 1851 as *Raffling for a Goose*. See FRANKENSTEIN, *William Sidney Mount*, pp. 192–94, pls. 27, 28, and 29.

102 The English language titles on the lithographs suggest however that Goupil published the prints for a predominantly Anglophone market in Britain and the United States rather than continental Europe. At the same period Goupil gave French titles to prints after German paintings.

103 FRANKENSTEIN, *William Sidney Mount*, p. 157.

104 William Alfred JONES, "A Sketch of the Life and Character of William S. Mount," *American Whig Review* 14 (August 1851): 124, quoted by ADAMS, "The Black Image in the Paintings of William Sidney Mount," p. 54.

105 FRANKENSTEIN, *William Sidney Mount*, p. 164.

106 Ibid., pp. 440–41, quotes documents relating to the work, one of which declares that it represents "the Negro Politically Dead. Radical Crowing will not awake him. It is the Radical Republican—Rooster—trying to make more capital out of the Negro, but, is *about used up for their purpose;* which is glorious news for the whole country. The African needs rest." The painting, or perhaps a sketch for it, is in Stony Brook, NY, Museums at Stony Brook, X58.9.4.

107 *The Card Players*, 1846 (Detroit, Detroit Institute of Arts, 55.175); *Old '76 and Young '48*, 1849; *The Sailor's Wedding*, 1852 (both in Baltimore, Walters Art Gallery, 37.2370 and 37.142); reproduced in Francis S. GRUBAR, *Richard Caton Woodville: An Early American Genre Painter*, Exhibition catalogue, Washington, D. C., Corcoran Gallery of Art, 21 April–11 June 1967 and others (Washington, D. C., 1967), cat. nos. 7, 13, 21. On Woodville's life and career see idem, "Richard Caton Woodville: An American Artist, 1825 to 1855" (Ph.D. diss., The Johns Hopkins University, 1966).

108 New York, National Academy of Design, no inv. no. See STEBBINS, TROYEN, and FAIRBROTHER, *A New World*, pp. 259–60, no. 53 and pls. on pp. 110–11.

109 Henry David THOREAU, "Civil Disobedience" (1849) in *The Writings of Henry David Thoreau* (Boston and New York, 1896), vol. IV, *Cape Cod and Miscellanies*, pp. 356–87.

110 When the Düsseldorf Gallery opened in New York in 1849 a writer in the Art-Union's *Bulletin* commended particularly the "indefatigable and minute study of Form which characterizes the German schools . . . the decision in handling the freedom of outline, the firmness and accuracy of touch . . . completeness and unity [given] to the expression of thought on canvas"; cf. Donelson F. HOOPES, "The Düsseldorf Academy and the Americans" in *The Düsseldorf Academy and the Americans*, Exhibition catalogue, Utica, NY, Munson-Williams-Proctor Institute, 7 January–11 February 1973; Washington, D. C., National Collection of Fine Arts, 27 April–28 July 1973; Atlanta, High Museum of Art, 23 September–28 October 1973 (Atlanta, 1972), p. 23.

111 On Peter Hasenclever and Carl Wilhelm Hübner, see Hanna GAGEL, "Die Düsseldorfer Malerschule in der politischen Situation des Vormärz und 1848" in *Die Düsseldorfer Malerschule*, Exhibition catalogue, Dusseldorf, Kunstmuseum Düsseldorf, 13 May–8 July 1979; Darmstadt, Ausstellungshallen Mathildenhöhe, Städtische Kunstsammlung und Stadtmuseum, 22 July–9 September 1979 (Dusseldorf, 1979), pp. 68–85. Wolfgang Müller von Königswinter's poem, first published in 1842, is quoted in ibid., p. 345.

112 Raleigh, North Carolina Museum of Art, 52.9.12. New York, NAD¹, vol. I, p. 35, s.v. "Blauvelt, Charles F.," 1855, no. 76.

113 Samuel F. B. MORSE, *Imminent Dangers to the Free Institutions of the United States through Foreign Immigration, and the Present State of the Naturalization Laws* (1835; reprint ed., New York, 1969), p. 25, quoted in Terry COLEMAN, *Going to America* (New York, 1972), p. 220.

114 Another painting by Blauvelt exhibited at the National Academy of Design in 1847, *The Arrival* (present whereabouts unknown), may also have represented an immigrant. Immigrants figured in the following paintings exhibited at the National Academy of Design in this period: *Emigrant Family* by Asher Brown Durand, 1844; *North Carolina Emigrants. One of a Series of Pictures Representing "Poor White Folks"* by James Henry Beard, 1846; *English Emigrants, Reposing after a Day's March* by William M. Crowley, 1848; *Emigrants Escaping from the Prairie Fire* by Jefferson Beardsley, 1859; and Isaac Eugene Craig's *Emigrants's Grave*, 1859. See New York, NAD¹, vol. I, p. 35, s.v. "Blauvelt, Charles F.," 1847, no. 313; p. 137, s.v. "Durand, Asher Brown," 1844, no. 244; p. 27, s.v. "Beard, James Henry," 1846, no. 103; p. 103, s.v. "Crowley, William M.," 1848, no. 94; p. 27, s.v. "Beardsley, Jefferson," 1859, no. 10; p. 97, s.v. "Craig, Isaac Eugene," 1859, no. 331.

115 Brighton, Art Gallery and Museums, 000118. London, Royal Academy, vol. VI, p. 62, s.v. "Parrott, William," 1851, no. 150.

116 The 1835 version of *The Toy Seller* is in London, Victoria and Albert Museum, FA 149; the later version, illustrated herein, is located in Dublin, National Gallery of Ireland, 387. London, Royal Academy, vol. V, p. 324, s.v. "Mulready, William," 1837, no. 74; 1862, no. 73. See Kathryn Moore HELENIAK, *William Mulready*, Studies in British Art (New Haven and London, 1980), p. 211, no. 141; p. 221, no. 172; and pls. 103 and VIII.

117 Collection of John A. Avery. London, Royal Academy, vol. V, p. 324, s.v. "Mulready, William," 1841, no. 109. For somewhat different interpretations of this picture and *The Toy Seller*, see HELENIAK, *William Mulready*, pp. 103–9; also pp. 215–16, no. 154 and pl. 101.

118 Victor HUGO, *Les Orientales* (1829) in *Victor Hugo: Œuvres complètes*, ed. Jean MASSIN, vol. III, ([Paris], 1967), p. 498. [The French text is: "L'Orient, soit comme image, soit comme pensée, est devenu, pour les intelligences autant que pour les imaginations, une sorte de préoccupation générale. . . . Les couleurs orientales sont venues comme d'elles-mêmes empreindre toutes ses pensées, toutes ses rêveries; et ses rêveries et ses pensées se sont trouvées tour à tour, et presque sans l'avoir voulu, hébraiques, turques, grecques, persanes, arabes, espagnoles même car l'Espagne c'est encore l'Orient; l'Espagne est à demi africaine, l'Afrique est à demi asiatique."] Hugo referred not only to works of the imagination but also to the study of Oriental languages. There were, however, few points of contact between the Orientalism of his own poems and other works of imaginative literature and art, which was mainly visual and focused on North Africa and the Ottoman Empire, and the intellectual Orientalism of scholars whose translations of Persian and Sanscrit influenced European philosophy. For the latter see Raymond SCHWAB, *La Renaissance orientale* (Paris, 1950).

119 HUGO, *Les Orientales*, p. 495. [The French text is: "L'auteur de ce recueil n'est pas de ceux qui reconnaissent à la critique le droit de questionner le poète sur sa fantaisie et de lui demander pourquoi il a choisi tel sujet, broyé telle couleur, cueilli à tel arbre, puisé à telle source."]

120 Cf. *infra*, pp. 145–46 and fig. 106.

121 Eugène Delacroix writing to Jean-Baptiste Pierret, 25 January 1832; cf. Eugène DELACROIX, *Correspondance générale de Eugène Delacroix*, ed. André JOUBIN, 3d ed. (Paris, 1936–38), vol. I, *1804–1837*, p. 307. [The French text is: "Nous avons débarqué au milieu du peuple le plus étrange. . . . Je suis dans ce moment comme un homme qui rêve et qui voit des choses qu'il craint de voir lui échapper."]

122 Only four of his albums survive intact, three in the Musée national du Louvre, Cabinet des Dessins (RF 1712^bis, RF 9154, and RF 39050), the fourth in Chantilly, Musée Condé (MS. 390 [1450]); see Maurice ARAMA, *Le Maroc de Delacroix* (Paris, 1987), with numerous illustrations.

123 Delacroix writing to Edmond Duponchel, 23 February 1832; cf. DELACROIX, *Correspondance générale*, vol. I, p. 315.

124 Delacroix writing to Frédéric Villot, 29 February 1832; cf. ibid., p. 316. [The French text is: "C'est un lieu tout pour les peintres. Les économistes et les saint-simoniens auraient fort à critiquer sous le rapport des droits de l'homme et de l'égalité devant la loi. . . ."]

125 Delacroix writing to Auguste Jal, 4 June 1832; cf. ibid., pp. 329–30. [The French text is: "Si vous saviez comme on vit paisiblement sous le cimeterre des tyrans; . . . rien n'y dit que ce ne soit pas l'état le plus souhaitable de ce monde."]

126 Delacroix writing to Théodore Gudin, 23 February 1832; cf. ibid., p. 313.

127 See Eugène DELACROIX, *Journal 1822–1863*, ed. André JOUBIN, Hubert DAMISCH, and Régis LABOURDETTE, Collection Les Mémorables (Paris, 1980), p. 104.

128 Paris, Musée national du Louvre, Cabinet des Dessins, RF 39050, fol. 24ᵛ; cf. Maurice SÉRULLAZ, *Musée du Louvre. Cabinet des Dessins: Inventaire général des dessins. Ecole française. Dessins d'Eugène Delacroix, 1798–1863* (Paris, 1984), vol. II, pp. 367–68, no. 1755 (illus.).

129 Paris, Musée national du Louvre, Département des Peintures, INV. 3824. Paris, *Salon de 1834*, p. 51, no. 497. See Lee JOHNSON, *The Paintings of Eugène Delacroix: A Critical Catalogue, 1832–1863 (Movable Pictures and Private Decorations)* (Oxford, 1986), vol. III, *Text*, pp. 165–70, no. 356; vol. IV, *Plates*, pl. 170.

130 Toulouse, Musée des Augustins, Ro 67. Paris, *Salon de 1845*, pp. 57–58, no. 438. Two smaller variants of this painting were painted by Delacroix in 1856 (present location unknown) and 1862 (Zurich, Stiftung Sammlung E. G. Bührle, 124). For all three see JOHNSON, *The Paintings of Eugène Delacroix*, vol. III, pp. 181–84, no. 370; p. 202, no. 401; p. 210, no. 417; vol. IV, pls. 183, 210, 211.

131 Paris, Musée national du Louvre, Cabinet des Dessins, RF 9382; cf. Maurice SÉRULLAZ, *Mémorial de l'exposition Eugène Delacroix*, Exhibition catalogue, Paris, Musée national du Louvre, 1963 (Paris, 1963), pp. 256, 258, no. 347 (illus.), and Lee JOHNSON, "Delacroix's Road to the Sultan of Morocco," *Apollo* 115, n.s. no. 241 (March 1982):186–89.

132 DELACROIX, *Journal 1822–1863*, p. 105. [The French text is: "Grande ressemblance avec Louis-Philippe, plus jeune, barbe épaisse, médiocrement brun. Burnous fin et presque fermé par devant. Haïck par-dessous sur le haut de la poitrine et couvrant presque entièrement les cuisses et les jambes. Chapelet blanc à soies bleues autour du bras droit qu'on voyait très peu."] In a letter written the next day (23 March 1832) Delacroix remarks of the sultan's appearance only: "Il est assez bel homme. Il ressemble beaucoup à notre roi: de plus la barbe et plus de jeunesse" (DELACROIX, *Correspondance générale*, vol. I, p. 323).

133 Paris, *Salon de 1845*, p. 57, no. 438, quoted in SÉRULLAZ, *Mémorial de l'exposition Eugène Delacroix*, p. 249, no. 335.

134 Charles BAUDELAIRE, "Salon de 1845" in *Curiosités esthétiques*, ed. Henri LEMAITRE (Paris, 1962), p. 14. [The French text is: "En effet, déploya-t-on jamais en aucun temps une plus grande coquetterie musicale? Véronèse fut-il jamais plus féerique? Fit-on jamais chanter sur une toile de plus capricieuses mélodies? un plus prodigieux accord de tons nouveaux, inconnus, délicats, charmants? . . . Ce tableau est si harmonieux, malgré la splendeur des tons, qu'il en est gris—gris comme la nature—gris comme l'atmosphère de l'été, quand le soleil étend comme un crépuscule de poussière tremblante sur chaque objet."]

135 It was acquired by the Ministry of the Interior and given to the Musée des Augustins, Toulouse. Delacroix had earlier depicted the "benefits" of commercial expansion in the frieze of the Salon du Roi of Palais Bourbon (1833–38) where, according to his own account, "des nègres chargés de marchandises, échangeant contre nos denrées l'ivoire, la poudre d'or, les dattes, etc." (SÉRULLAZ, *Mémorial de l'exposition Eugène Delacroix*, p. 195).

136 Amédée DURANDE, ed., *Joseph, Carle et Horace Vernet: Correspondance et biographies* (Paris, [1864]), p. 98. [The French text is: "A la vue de tant de choses si nouvelles et si pittoresques, j'ai cru que ma tête éclaterait. Je n'étais point au bout."] See also *Horace Vernet (1789–1863)*, trans. Elena di MAJO, Exhibition catalogue, Rome, Accademia di Francia and Paris, Ecole national supérieure des Beaux-Arts, March–June 1980 (Rome, 1980).

137 DURANDE, *Joseph, Carle et Horace Vernet*, p. 100. [The French text is: ". . . il est impossible de trouver une colonie qui offre plus de chances de prospérité, et, sans vouloir pénétrer dans les secrets des gouvernements, je crois que, si on voulait ou si on pouvait en tirer parti, l'Afrique serait une mine d'or pour la France. . . . le pays est beau et riche; les indigènes ne demandent pas mieux que de nous aimer et de trafiquer avec nous. . . ."] He went on, however, to criticize the conduct of the French army.

138 London, Wallace Collection, P280. Paris, *Salon de 1834*, p. 175, no. 1895. See John INGAMELLS, *The Wallace Collection: Catalogue of Pictures* (London, 1985–86), vol. II, *French Nineteenth Century*, pp. 253–55, no. P280 (illus.).

139 DURANDE, *Joseph, Carle et Horace Vernet*, p. 98.

140 Gustav Friedrich WAAGEN, *Galleries and Cabinets of Art in Great Britain, Being an Account of more than Forty Collections of Paintings, Drawings, Sculptures, MSS., & & Visited in 1854 and 1856* (London, 1857), p. 85.

141 London, Wallace Collection, P585. Paris, *Salon de 1836*, p. 192, no. 1807. See INGAMELLS, *The Wallace Collection*, vol. II, pp. 271–72, no. P585.

142 This was the painting for which he gathered material in Algeria (cf. DURANDE, *Joseph, Carle et Horace Vernet*, p. 101). It was exhibited in the Salon of 1835 (Paris, *Salon de 1835*, p. 204, no. 2108); it is now located in Versailles, Musée national du Château de Versailles, MV 6981.

143 Versailles, Musée national du Château de Versailles, MV 2027. Paris, *Salon de 1845*, pp. 196–202, no. 1628. Decaen's copy, which is reproduced herein, is in Chantilly, Musée Condé, 629.

144 BAUDELAIRE, "Salon de 1845" in *Curiosités esthétiques*, p. 15. [The French text is: "L'unité, nulle; mais une foule de petites anecdotes intéressantes—un vaste panorama de cabaret. . . ."]

145 London, Wallace Collection, P304. Paris, *Salon de 1827*, p. 58, no. 279. See INGAMELLS, *The Wallace Collection*, vol. II, pp. 66–67, no. P304 (illus.). An earlier painting by Decamps of Arabs in front of a house is dated 1823 (Saint-Etienne, Musée d'Art et d'Industrie); cf. Dewey F. MOSBY, *Alexandre-Gabriel Decamps (1803–1860)*, Outstanding Dissertations in the Fine Arts (New York and London, 1977), vol. I, pp. 34–35; vol. II, p. 609, no. 454 and pl. 3B.

146 For Decamps's travels see MOSBY, *Alexandre-Gabriel Decamps*, vol. I, pp. 62–64.

147 The only evidence for his presence in Algeria is a drawing inscribed *DC à Constantine* (cf. ibid., vol. I, pp. 63–64; vol. II, p. 662, no. 546 and pl. 119). It may well be doubted, however, that he was able to go as far inland as Constantine at this period.

148 London, Wallace Collection, P345. See INGAMELLS, *The Wallace Collection*, vol. II, pp. 72–73, no. P345 (illus.), and MOSBY, *Alexandre-Gabriel Decamps*, vol. I, pp. 137–39; vol. II, pp. 463–64, no. 154 and pl. 35. *The Punishment of the Hooks* was begun in Rome in 1835, inscribed with the date 1837, and exhibited in Paris at the Salon of 1839 (Paris, *Salon de 1839*, p. 57, no. 501).

149 A charcoal drawing (present whereabouts unknown) which seems to be a preliminary study for the figures in the right foreground of *The Punishment of the Hooks* may have been made from life; cf. MOSBY, *Alexandre-Gabriel Decamps*, vol. II, p. 663, no. 549 and pl. 130B) Figures in the *The Punishment of the Hooks* which reappear in *Le passage du Gué* of 1849 (Algiers, Musée des Beaux Arts) and *The Night Patrol in Smyrna*

150 BAUDELAIRE, "Salon de 1846" in *Curiosités esthétiques*, p. 140.

151 Charles CLÉMENT, *Decamps*, Les artistes célèbres (Paris, 1886), p. 62.

152 Eugène Emmanuel AMAURY-DUVAL, *L'atelier d'Ingres* (1878), 2d ed. (Paris, 1924), p. 123. [The French text is: "Je fus frappé de l'éclat et de la force qu'il arrivait à mettre dans sa peinture, et peut-être vit-il mon étonnement, quand je regardai de près ces empâtements qui n'avaient aucun rapport avec notre manière de peindre. . . ."]

153 Julius MEYER, *Geschichte der modernen französischen Malerei seit 1789 zugleich in ihrem Verhältniss zum politischen Leben, zur Gesittung und Literatur* (Leipzig, 1867), p. 259. The gruesome subject matter was completely ignored by G. F. Waagen who described the picture as "a crowd of Arabian horsemen and pedestrians under the white walls of a town"; see WAAGEN, *Galleries and Cabinets of Art in Great Britain*, p. 85.

154 Comment recorded by William James Müller, 4 January 1839, quoted in N. Neal SOLLY, *Memoir of the Life of William James Müller, a Native of Bristol, Landscape and Figure Painter with Original Letters and an Account of His Travels and of His Principal Works* (London, 1875), p. 71.

155 Linda NOCHLIN, "The Imaginary Orient," *Art in America* 7, no. 5 (May 1983): 122.

156 Cf. *infra*, pp. 160–71.

157 W. J. Müller's impressions, originally published in *Art Union* in 1839, are quoted in SOLLY, *Memoir of the Life of William James Müller*, pp. 75–76.

158 Glasgow, Glasgow Art Gallery and Museum, 1139. Ibid., pp. 130–31.

159 Ibid., p. 67.

160 London, Spink & Son Ltd., K2 4273. Rubens's study of the head of a black man seen from four different angles is located in Brussels, Musées Royaux des Beaux-Arts de Belgique, Musée d'Art Ancien, 3176. Müller is unlikely to have seen this painting which in his time was still in Schloss Pommersfelden.

161 Lausanne, Musée cantonal des Beaux Arts, D.1021; cf. Charles CLÉMENT, *Gleyre: Etude biographique et critique avec le catalogue raisonné de l'œuvre du maître* (Paris, 1878), p. 392, no. 14; *Charles Gleyre ou les illusions perdues*, Exhibition catalogue, Winterthur, Kunstmuseum and others, 1974–75 (Zurich, 1974), p. 53, fig. 37 and p. 161, no. 94.

162 Gleyre was out of Europe from the spring of 1834 until October 1837; cf. Jacques-Edouard BERGER, "Gleyre et l'Orient" in *Charles Gleyre ou les illusions perdues*, pp. 50–69.

163 Lausanne, Musée cantonal des Beaux Arts, 1300; cf. CLÉMENT, *Gleyre*, p. 397, no. 32; *Charles Gleyre ou les illusions perdues*, p. 118, fig. 104 and p. 157, no. 5. Michel THÉVOZ, *L'académisme et ses fantasmes: Le réalisme imaginaire de Charles Gleyre*, Collection "Critique" (Paris, 1980), pp. 89–90, in an otherwise persuasive critical account of Gleyre's works, seems to go rather too far in remarking: "Alors que, comme nous le faisions remarquer, les peintres européens depuis Monsieur Auguste ou Bonington jusqu'à Manet tirent inlassablement parti du contraste suggestif entre l'odalisque blanche et l'esclave noire, Gleyre transpose crânement cette partition raciste sur un corps unique, l'olivâtre du bas signifiant l'exotisme, la sauvagerie, l'empire des sens, et le rose du haut, la pudeur, la civilisation, l'empire du sens. Ainsi, après une brève et dangereuse collusion, l'Orient et l'Occident regagnent leurs pôles respectifs sur le blason du corps."

164 Lausanne, Musée cantonal des Beaux Arts, 1361; cf. CLÉMENT, *Gleyre*, p. 395, no. 28; *Charles Gleyre ou les illusions perdues*, p. 157, no. 7.

165 CLÉMENT, *Gleyre*, p. 130. [The French text is: "Nous sommes des Aryens: il n'y a rien à faire là-bas pour nous. Il n'y a que de l'anecdote, du genre, du costume. Pour nous, il nous faut la beauté."]

166 Paris, Ecole nationale supérieure des Beaux-Arts, Bibliothèque, 1232; cf. *Prosper Marilhat, Vertaizon 1811–Paris 1847: Peintures, Dessins, Gravures*, Exhibition catalogue, Clermont-Ferrand, Musée Bargoin, June–September 1973 (Clermont-Ferrand, 1973), p. 20, no. 43.

167 Théophile GAUTIER, "Marilhat," *Revue des Deux Mondes* 3 (1848): 44. [The French text is: "Pour lui, la foule bigarrée des Fellahs, des Nubiens, des Cophtes, des Nègres, des Turcs, des Arabes, circulait toujours dans le pittoresque dédale du Caire avec ses armes et ses costumes bizarres; il y avait dans son imagination un perpétuel mirage de dômes d'étain, de minarets d'ivoire, de mosquées aux assises blanches et roses, de caroubiers trapus et de dattiers sveltes, de flamants s'enfuyant dans les roseaux, de vols de colombes égrenées dans l'air comme des colliers de perles; quoique son corps fût ici, il n'avait pas, à vrai dire, quitté l'Orient. . . ."]

168 Several harem scenes had been painted in the eighteenth century. One of the first nineteenth-century pictures of this type appears to have been *L'interno di un Harem* painted by the Piedmontese artist Giovanni Migliara "per commissione pure del sig. Carl' Antonio Bertoglio," shown at the Brera, Milan in 1830; cf. *Discorso letto nella grande aula dell'Imperiale regio palazzo delle scienze ed arti* (Milan, 1830), p. 58. The present whereabouts of the picture is unknown.

169 London, Victoria and Albert Museum, P.1-1949. Lewis's account of the subject was printed in the catalogue of the exhibition at the Edinburgh, Royal Scottish Academy (p. 213, s.v. "Lewis, John Frederick," 1853, no. 494) when the picture was reexhibited in 1853; cf. Kenneth Paul BENDINER, "The Portrayal of the Middle East in British Painting 1835–1860" (Ph.D. diss., Columbia University, 1979), pp. 188–93.

170 "Fine Arts: Society of Painters in Water Colours," *The Athenæum*, no. 1175 (4 May 1850): 480, quoted by BENDINER, "The Portrayal of the Middle East in British Painting," p. 318.

171 "Exhibition of the Old Water-Colour Society," *Illustrated London News* 16, no. 424 (4 May 1850): 300, quoted by BENDINER, "The Portrayal of the Middle East in British Painting," p. 192.

172 Cf. *infra*, chapter 3.

173 Birmingham, City Museum and Art Gallery, P 14.49. J. Michael LEWIS, *John Frederick Lewis R. A., 1805–1876* (Leigh-on-Sea, 1978), p. 99, no. 625 and fig. 68.

174 In the Salon of 1849, however, a mature sculptor, Pierre-Alexandre-Victor Aubry, exhibited a *Tête d'expression: Nègre africain*; cf. Paris, *Salon de 1849*, p. 182, no. 2096.

175 See part 1 of this volume, pp. 103–4, fig. 54; pp. 165, 167, fig. 98; pp. 179–80, fig. 109.

176 About 1834 Barye was commissioned to model five groups of men hunting animals and four of combats between animals as a very elaborate *surtout de table* for the duc d'Orléans. In that of the lion hunt the men are Arabs. At about the same time, however, he also modeled a python crushing a horse

and its rider—a man in Arab costume with negroid features. See Peter FUSCO and H. W. JANSON *The Romantics to Rodin: French Nineteenth-Century Sculpture from North American Collections*, Exhibition catalogue, Los Angeles, Los Angeles County Museum of Art, 4 March–25 May 1980; Minneapolis, Minneapolis Institute of Arts, 25 June–21 September 1980; Detroit, Detroit Institute of Arts, 27 October 1980–4 January 1981; Indianapolis, Indianapolis Museum of Art, 22 February–29 April 1981 (Los Angeles, 1980), pp. 134–35, no. 21 (illus.).

177 Paris, Musée Carnavalet, S 1156.

178 Louis HUART, *Musée Dantan: Galerie des charges et croquis des célébrités de l'époque* (Paris, 1839), p. 50, remarked that if the caricature was not exactly like Dumas "il faut reconnaître pourtant qu'il a du sang africain dans les veines et la chevelure peu soyeuse. Du reste, ce n'est pas un mal: c'est peut être pour participer un peu du climat des tropiques et pour avoir été bruni par son soleil de feu, qu'Alexandre Dumas a été doué de cette verve et de cette chaleur qui le distinguent si spécialement de tous les écrivains et de tous les auteurs dramatiques de notre époque." A portrait medal of Dumas by Pierre-Jean David d'Angers of 1829 (Paris, Musée national du Louvre) shows him with similar hair but less prognathism. Alexandre Dumas *fils* is nevertheless said to have regarded Dantan's caricature as the best likeness of his father; cf. Janet SELIGMAN, *Figures of Fun: The Caricature-Statuettes of Jean-Pierre Dantan* (London, 1957), p. 56.

179 SELIGMAN, *Figures of Fun*, p. 105.

180 Paris, *Salon de 1837*, p. 199, no. 1888; Paris, *Salon de 1846*, p. 246, no. 2137. Cumberworth had exhibited a group of *Paul et Virginie* in the Salon of 1844; cf. Paris, *Salon de 1844*, p. 268, no. 2184. A fine example of the statuette of *Marie* is in the Collection of James Holderbaum who kindly directed our attention to it. Baudelaire wrote: "Puis les Caraïbes du chenet, de la pendule, de l'écritoire, etc., comme M. Cumberworth, dont la *Marie* est une femme *à tout faire*, au Louvre et chez Susse, statue ou candélabre" (BAUDELAIRE, "Salon de 1846" in *Curiosités esthétiques*, p. 189). This suggests that small bronze figures of blacks were still being incorporated in the decoration of clocks like those produced in the Directory period.

181 Paris, *Salon de 1848*, p. 341, no. 4619; p. 355, no. 4787; p. 347, no. 4676; p. 346, no. 4663. Neither Chatrousse's work nor those by Isidore Bonheur and Théodore Hébert have been traced. Several Orientalist paintings were in the same Salon including *Café nègre (Constantine)* by Edmond Hédouin (p. 160, no. 2199).

182 Memoir composed by Charles Cordier. [The French text is: "Un superbe Soudannais paraît à l'atelier. En 15 jours je fis ce buste. Nous le transportâmes un camarade et moi dans ma chambre près de mon lit, je couvais l'œuvre une fois éclose, je la fis mouler et l'envoyai au Salon ne doutant pas d'être reçu. Mais la révolution de 1848 éclatait le Jury fut nommé à l'élection. En tremblant, j'osai envoyer le buste représentant le Soudannais, ce fut une révélation pour tout le monde artistique."] This text is in the possession of Cordier's family and was kindly communicated to us by Mme Jeannine Durand-Revillon. We are much indebted to Mme Durand-Revillon for a copy of her unpublished École du Louvre dissertation on Cordier from which much of the information about him in the present chapter is derived. The memoir is also discussed in Jeannine DURAND-REVILLON, "Un promoteur de la sculpture polychrome sous le Second Empire, Charles-Henri-Joseph Cordier (1827–1905)," *Bulletin de la Société de l'Histoire de l'Art français* (1982):181–98.

183 Paris, Muséum national d'Histoire naturelle, Musée de l'Homme, Laboratoire de l'Anthropologie, MH 27.051/1977.207. Paris, *Salon de 1850*, p. 265, no. 3270.

184 Paris, Muséum national d'Histoire naturelle, Musée de l'Homme, Laboratoire de l'Anthropologie, MH 27.058/1977.214. Paris, *Salon de 1855*, p. 467, no. 4289. The plaster model of this bust was exhibited at the Salon of 1852; cf. Paris, *Salon de 1852*, p. 209, no. 1337.

185 Only one *Bust in bronze, on a column, a negro from Timbuctoo* is listed in the *Great Exhibition of the Works of Industry of all Nations, 1851: Official Descriptive and Illustrated Catalogue* (London, 1851), vol. III, *Foreign States*, p. 1200, no. 460. But casts of this bust and also the *Vénus africaine* are in the Royal Collection at Osborne House.

186 Quotations from Cordier's memoir (cf. *supra*, n. 182). [The French text is: "Mon genre avait l'actualité d'un sujet nouveau, la révolte contre l'esclavage, l'anthropologie à sa naissance, on sentait une sensation dans mes œuvres. . . . Je rénovais la valeur dans la sculpture et je créais l'étude des races élargissant le cercle de la beauté par son ubiquité."] He appears to have composed the memoir shortly before his death in 1905. Some of the dates recorded in it are slightly inaccurate.

187 Cordier writing to M. Romieu, directeur des Beaux-Arts, on 10 September 1852 (Paris, Archives nationales, F 21 72), transcribed by Jeannine Durand-Revillon). [The French text is: "Je fis ce travail sans qu'il me fut commandé me confiant ainsi que ces messieurs [Dumeril and Serres] à votre sentiment de l'art et à l'utilité pour la science, pour la France d'avoir des types sérieux qui sont ébauchés partout, mais ce que j'ai fait avec toute la conscience de l'artiste de manière à rendre à saisir la physionomie du pays."]

188 Cordier writing to Achille Fould, Ministre d'état and directeur des Beaux-Arts, on 28 January 1854, (Paris, Archives nationales, F 21 72, transcribed by Jeannine Durand-Revillon). [The French text is: "Permettez-moi de mettre encore une fois sous vos yeux, une demande tendant à passer six mois en Algérie, pour y reproduire les différents types qui sont au moment de se fondre dans celui d'un seul et même peuple."]

189 Paris, *Salon de 1857*, p. 358, nos. 2808–19. Paris, Muséum national d'Histoire naturelle, Musée de l'Homme, Laboratoire de l'Anthropologie, MH 27.048/1977.204, MH 27.049/1977.205, MH 27.044/1977.200. The busts acquired from the Muséum were transferred to the Laboratoire de l'Anthropologie of the Musée de l'Homme in 1900.

190 Paris, Musée d'Orsay, RF 2996. Paris, *Salon de 1857*, p. 358, no. 2818. See *The Second Empire, 1852–1870: Art in France under Napoleon III*, Exhibition catalogue, Philadelphia, Philadelphia Museum of Art, 1 October–26 November 1978; Detroit, Detroit Institute of Arts, 15 January–18 March 1979; Paris, Grand Palais, 24 April–2 July 1979 (Philadelphia, 1978), pp. 224–25, no. V-16 and color plate on p. 22. Napoleon III subsequently bought two more busts by Cordier, but the later history of all four is complicated by inadequate inventory descriptions. That described originally as *Nègre du Soudan* and *Nègre en costume algérien* is probably identical with the bust at the Musée d'Orsay and reproduced herein.

191 Letter dated 13 April 1858 from the Ministère d'Etat, [Direction des] Beaux-Arts to Charles Cordier (Paris, Archives nationales, F 21 2285), transcribed by Jeannine Durand-Revillon.

192 Marc TRAPADOUX, *L'œuvre de M. Cordier: Galerie anthropologique et ethnographique pour servir à l'histoire des races . . . Catalogue descriptif* (Paris, 1860), p. 7. [The French text is: C'est non-seulement aux artistes, c'est encore à l'anthropologue, à l'ethnographe, à l'anatomiste, au philosophe et à l'historien, que s'adressent les œuvres de M. Cordier."] Although

Trapadoux's name is given as the author and presumably he wrote the introductory essay, the entries in the catalogue appear to be by Cordier whose experiences in modeling the various works are recorded in the first person.

193 Ibid., pp. 13–15. [The French text regarding *Le Nègre du Soudan* is: ". . . une noblesse native qui lui donne cet air d'empereur romain. . . . la sculpture le déclare roi dans le monde des formes"; concerning *Le Nègre nubien*: ". . . avec la fierté répandue sur tous ses traits, . . . celui-ci m'apparaît comme un Spartacus, comme un Toussaint Louverture. Le sentiment de la dignité humaine, la révolte contre l'injustice, la haine de l'esclavage sillonnent profondément ce noble visage; le reflet d'une âme ardente, l'éclair de l'intelligence illuminent ce front orageux qui commande le respect . . ."; describing the *Négresse des côtes d'Afrique*: "Beauté sombre, a dit notre grand poète Th. Gautier: beauté fatale, pourrais-je ajouter, beauté diabolique qui doit ravager les sens et les coeurs. . . ."]

194 Charles Cordier writing to Achille Fould, Ministre d'Etat et de la Maison de l'Empereur, undated letter, probably early 1858 (Paris, Archives nationales, F 21 2285, transcribed by Jeannine Durand-Revillon). The French text is: "Au point de vue ethnographique, comme au point de vue de l'art, l'Algérie m'a fourni des types franchement accusés; le Kabyle berbère, l'arabe d'el aghouat, les Mauresques, etc., m'ont offert des caractères inattendus de force, de noblesse et de grâce. Cependant, les races algériennes ne possèdent pas cette perfection de la forme que les artistes grecs ont trouvée chez une race privilégiée. C'est donc en Grèce, Monsieur le Ministre, ou plutôt au centre du berceau humain en Géorgie, que je voudrais maintenant poursuivre l'imitation consciencieuse de la beauté humaine en exécutant des 'nuds' entiers."]

195 The collection is described in the introduction to Thomas BENDYSHE, ed. and trans., *The Anthropological Treatises of Johann Friedrich Blumenbach*, p. xii. See also WAGNER, "On the Anthropological Collection of the Physiological Institute of Göttingen" in ibid., pp. 347-55.

196 Charles CORDIER, "Types ethniques représentés par la sculpture," *Bulletin de la Société d'anthropologie de Paris* 3 (1862): 65–68. [The French text is: "J'ai sculpté ces bustes d'après nature, en m'aidant d'un procédé géométrique qui assure l'exactitude de la reproduction, des dimensions et des formes. . . . J'examine d'abord et compare entre eux un grand nombre d'individus, j'étudie la forme de leur tête, les traits de leur visage, l'expression de leur physionomie; je m'attache

à saisir les caractères communs à la race que je désire représenter, je les apprécie dans leur ensemble comme dans leurs détails, j'embrasse pour chacun d'eux, l'étendue des variations individuelles, j'arrive à concevoir l'idéal ou plutôt le type de chacun de ces caractères, puis groupant tous ces types partiels, je constitue dans mon esprit un type d'ensemble où se trouvent réunies toutes les beautés spéciales à la race que j'étudie."] Cordier's process of selection corresponds with that recommended by Toussaint Bernard EMÉRIC-DAVID, *Recherches sur l'art statuaire considéré chez les anciens et chez les modernes*, rev. and corr. ed. (Paris, 1863), pp. 132–34, 317–18.

197 At the very beginning of the century Antonio Canova occasionally added gilded ornaments to his statues. Pierre Charles Simart made the first recorded attempt to emulate the lost works of Pheidias with a chryselephantine statue of Minerva completed in 1851 and exhibited in the Exposition universelle, Paris, in 1855; cf. Paris, *Salon de 1855*, p. 506, no. 4574. At about the same time the English sculptor John Gibson was executing his notorious *Tinted Venus* completed in 1856 and shown in the International Exhibition in London in 1862; cf. *International Exhibition, 1862: Official Catalogue of the Fine Art Department* (London, [1862]), p. 146. Polychromatic mixed-media statues were increasingly produced in the later nineteenth century but devoted mainly to traditional European subjects.

198 Benedict READ, *Victorian Sculpture* (New Haven and London, 1982), pp. 174–75, fig. 220. The bust is in the British Royal Collection, Osborne House.

199 See Anne PINGEOT, "Atlantes et cariatides," *Monuments historiques*, no. 101 (1979): 63, 65 (illus.).

200 Paris, *Salon de 1870*, p. 578, no. 4377.

201 Léon LAGRANGE, "Bulletin mensuel: Janvier 1865," *Gazette des Beaux-Arts* 18, no. 2 (February 1865): 189. [The French text is: "A cette sculpture de luxe, il faut de luxueuses habitations."]

202 *Esposizione delle opere di Belle Arti nelle Gallerie del Palazzo nazionale di Brera nell' anno 1867* (Milan, 1867), p. 37, no. 259 (*Otello; busto in marmo e bronzo*); Paris, *Salon de 1870*, p. 570, no. 4318 (*Othello; buste, marbre et bronze*); London, Royal Academy, vol. I, p. 384, s.v. "Calvi, Pietro," 1872, no. 1526 (*Othello*).

203 Paris, *Salon de 1870*, p. 623, no. 4714. The subject of the bust was in fact an Arab encountered by the sculptor

in Rome. The first version with bronze head and neck and white marble drapery, shown in the Salon of 1870, cannot be traced; a later version in green marble with some of the drapery in gilded bronze and pewter is in Fribourg, Fondation Marcello, S 38. Versions wholly of marble are in Fribourg, Musée d'Art et d'Histoire, M 9 and Paris, Dépôt des Sculptures de l'Etat, 7568; cf. Henriette BESSIS, *Marcello Sculpteur* (Fribourg, 1980), pp. 152–57.

204 Paris, *Salon de 1877*, p. 500, no. 3847. François-Guillaume DUMAS, *Catalogue illustré du Salon, 1885* (Paris, [1885]), p. lxvi, no. 3995.

205 In 1861 Cordier showed at the Salon a bronze and marble bust entitled *"La Capresse" ou négresse des colonies* now located in Paris, Musée d'Orsay, RF 2997; cf. Paris, *Salon de 1861*, p. 401, no. 3251. But when a second version of this work was shown in the International Exhibition in London in 1862 the subject was associated with a British colony, as *Bust of a Negress of the Cape*; cf. *International Exhibition, 1862*, p. 175, no. 340.

206 See Jean Charles DAVILLIER, *Fortuny: Sa vie, son œuvre, sa correspondance* (Paris, 1875), pp. 18–34, 147; Edward J. SULLIVAN, "Mariano Fortuny y Marsal and Orientalism in Nineteenth-Century Spain," *Arts Magazine* 55, no. 8 (April 1981): 96–101.

207 Barcelona, Museo de Arte Moderno, 10695; cf. *Mariano Fortuny*, Exhibition catalogue, Barcelona, Museo de Arte Moderno, November 1974; Madrid, Salas de Exposiciones de la Dirección General de Bellas Artes, December 1974; Reus, Excmo. Ayuntamiento, January 1975 (Barcelona, [1974]), no. 1773 (illus.).

208 Houston, Menil Foundation Collection, 80-20 DJ. See William R. JOHNSTON, "W. H. Stewart, the American Patron of Mariano Fortuny," *Gazette des Beaux-Arts* 77, no. 3 (March 1971): 183–88, esp. p. 185.

209 On permanent loan to the Museum of Fine Arts, Boston, 35.1981. See Gerald M. ACKERMAN, *La vie et l'œuvre de Jean-Léon Gérôme*, Les Orientalistes 4 (Courbevoie, 1986), pp. 79 (illus.), 226, no. 193; MaryAnne STEVENS, *The Orientalists: Delacroix to Matisse. European Painters in North Africa and the Near East*, Exhibition catalogue, London, Royal Academy of Arts; Washington, D. C., National Gallery of Art, 1984 (London, 1984), pp. 90 (illus.), 143–44, no. 34.

210 *L'almée* (Dayton, Dayton Art Institute), *Un café du Caire* (New York, Metropoli-

tan Museum of Art), *Bachi-Bouzouk chantant* (Baltimore, Walters Art Gallery), *Bachi-Bouzouk* (Private Collection), etc.; ACKERMAN, *La vie et l'œuvre de Jean-Léon Gérôme*, pp. 63 (illus.), 214, no. 144; pp. 252–53, no. 317 (illus.); pp. 83 (illus.), 224, no. 185; pp. 78 (illus.), 226, no. 192.

211 J. F. B., "Gérôme the Painter," *The California Art Gallery* (1873), quoted by NOCHLIN, "The Imaginary Orient," p. 122.

212 Théophile GAUTIER, "Salon de 1857: IV. MM. Gérôme, Mottez," *L'Artiste*, n.s. 1, no. 14 (5 July 1857):246.

213 Léon LAGRANGE, "Salon de 1861," *Gazette des Beaux-Arts* 11, no. 1 (July 1861):67. [The French text is: "M. Dehodencq possède au plus haut degré l'art de caractériser les types; on croirait qu'il a toujours vécu chez les peuples barbares, et qu'il a pu étudier à loisir toutes les manifestations de leurs passions bestiales. . . ."]

214 The first version of *L'exécution de la Juive* was destroyed by the collapse of Dehodencq's studio in Tangier, but he painted two reprises. One, which was exhibited in the Salon of 1861 (Paris, *Salon de 1861*, p. 100, no. 819), was sold at auction at Sotheby Parke Bernet & Co., London, 24 June 1981, lot 197. The second, painted about 1862, whose present whereabouts is unknown, is reproduced in Gabriel SÉAILLES, *Alfred Dehodencq: L'homme et l'artiste* (Paris, 1910), facing p. 113. A study for this work, illustrated herein, is located in Paris, Musée des Arts africains et océaniens, AF 12943.

215 A full account of the event is provided by SÉAILLES, *Alfred Dehodencq*, pp. 112–16.

216 Ibid., p. 130. [The French text is: "Le romantisme, cher monsieur, pour lequel j'ai la plus grande vénération (c'est mon père), n'entre pour rien dans la composition de ces toiles. C'est un hymne au soleil, que je ne cesserai de chanter, c'est l'ivresse du mouvement et de la vie, puisée aux vraies sources."]

217 Paris, Musée d'Orsay, RF 2587. Paris, *Salon de 1874*, p. 79, no. 557. SÉAILLES, *Alfred Dehodencq*, p. 199, no. 202.

218 Minneapolis, Minneapolis Institute of Arts, 73.42.3; cf. JOHNSON, *The Paintings of Eugène Delacroix*, vol. III, pp. 171–73, no. 360; vol. IV, pl. 176. Dehodencq could have seen this work when it passed through the sale rooms in Paris in 1869 and 1870.

219 SÉAILLES, *Alfred Dehodencq*, p. 118. This work appears to have been written soon after Dehodencq's death in 1882 although not published until 1910. [The French text is: "Comme ils dansent, les bons nègres, sous le grand ciel bleu, sans souci du soleil ni des grâces! . . . Les chemises blanches, serrées à la taille par un gros cordon vert, les larges turbans blancs qui couronnent les têtes, donnent un éclat bizarre à tout ce qu'on voit de ces corps d'un noir luisant d'ébène. Leur rire béat de bête inconsciente sabre leurs faces noires de la blancheur éclatante de leurs dents. Ils frappent à grands coups le tambourin d'un morceau de bois recourbé en croissant; ils sautent, bondissent, se tordent et grimacent, ils font mille contorsions, ils tournent jusqu'au vertige. On entend les cris sortir de leurs grosses lèvres tombantes."]

220 Paris, Musée national du Louvre, Cabinet des Dessins, RF 30028. This drawing is a study for *Les fils du Pacha* (Paris, Galerie Jonas in 1983; present whereabouts unknown) which was exhibited in the Salon of 1880; cf. Paris, *Salon de 1880*, p. 103, no. 1042; Lynne THORNTON, *The Orientalists: Painter-Travellers, 1828-1908*, The Orientalists 1 (Paris, 1983), pp. 104–5 (illus.).

221 Saint-Omer, Musée de l'Hôtel Sandelin, 102 CM. The present whereabouts of the painting exhibited at the Salon (Paris, *Salon de 1864*, p. 24, no. 132) is unknown. For both the study and the final work see *Léon Belly (Saint-Omer 1827–Paris 1877): Rétrospective*, Exhibition catalogue, Saint-Omer, Musée de l'Hôtel Sandelin, 5 November–26 December 1977 (Saint-Omer, 1977), pp. 30–31, nos. 46, 49 (illus.).

222 Bridgman's *Towing on the Nile*, signed and dated 1875, was exhibited at the Royal Academy in 1877; cf. London, Royal Academy, vol. I, p. 280, s.v. "Bridgman, Frederic Arthur," 1877, no. 344. Its current location is unknown. For a reproduction of the picture see *Nineteenth Century European Paintings and Drawings*, Sale catalogue, London, Sotheby Parke Bernet & Co., 21 June 1983 (London, 1983), no. 22 (illus.).

223 Léon LAGRANGE, "Le Salon de 1864," *Gazette des Beaux-Arts* 17, no. 1 (July 1864):18. [The French text is: "C'est surtout l'Orient qui est devenu la patrie des artistes voyageurs. Tout ce que la nature italienne a perdu, la nature orientale l'a regagné. Depuis Alger jusqu'à Constantinople, l'art a pris possession de ces rivages, de ces campagnes, de ces fleuves, de ces villes, de ces déserts qu'illumine un soleil sans nuages."]

224 Delacroix writing to Auguste Jal, 4 June 1832; cf. DELACROIX, *Correspondance générale*, vol. I, p. 330. Not until the end of the second half of the century, however, were painters who won the *prix de Rome* allowed to spend some of their time outside Italy, Frédéric-Auguste La Guillermie traveling in the "Orient" in 1867, Henri Regnault visiting Spain and Morocco in 1868–69 and 1870; see Henry LAPAUZE, *Histoire de l'Académie de France à Rome* (Paris, 1924), vol. II, pp. 384, 392–403.

225 New York, *Forbes* Magazine Collection, P72005. Paris, *Salon de 1876*, p. 28, no. 214. The *Head of a Black Man* attributed to Bonnat in the William Hayes Ackland Memorial Art Center (77.47.1) may be a study for *Le Barbier nègre à Suez*; cf. John Minor WILSON, *French Nineteenth Century Oil Sketches: David to Degas*, Exhibition catalogue, Chapel Hill, William Hayes Ackland Memorial Art Center, University of North Carolina at Chapel Hill, 5 March–16 April 1978 (Chapel Hill, 1978), pp. 14–16, no. 3 (illus.).

226 Charles YRIARTE, "Le Salon de 1876," *Gazette des Beaux-Arts*, 2d ser. 13, no. 6 (June 1876):699.

227 Ernest A. HAMY, "Toukou le Haoussa," *Bulletins et Mémoires de la Société d'anthropologie de Paris*, 5th ser. 7 (1906):490–96.

228 Toulouse, Musée des Augustins, PE5994. Paris, *Salon de 1876*, p. 60, no. 476.

229 Eugène FROMENTIN, *Une année dans le Sahel* (first published in articles, 1857; as a book, 1859) in *Œuvres complètes*, ed. Guy SAGNES, Bibliothèque de la Pléiade, 313 (Paris, 1984), pp. 320, 321, 322. [The French texts are: "L'Orient est très particulier. . . . Il s'impose avec tous ses traits: avec la nouveauté de ses aspects, la singularité de ses costumes, l'originalité de ses types, l'âpreté de ses effets, le rythme particulier de ses lignes, la gamme inusitée de ses couleurs." "J'entends par documents le signalement d'un pays, ce qui le distingue, ce qui le rend lui-même, ce qui le fait revivre pour ceux qui le connaissent, ce qui le fait connaître à ceux qui l'ignorent; je veux dire le type exact de ses habitants, fût-il exagéré par le sang nègre, et n'eût-il pas d'autre intérêt que son extravagance, leurs costumes étrangers et étranges, leurs attitudes, leur maintien, leurs coutumes, leur démarche, qui n'est pas la nôtre." ". . . Beaucoup de gens . . . demanderont alors à la peinture ce que donne exclusivement un récit de voyage; ils voudront des tableaux composés comme un inventaire, et le goût de l'ethnographie finira par se confondre avec le sentiment du beau."]

230 Mario PROTH, *Voyage au pays des peintres: Salon de 1877* (Paris, 1877), p. 12, quoted in Olivier LÉPINE, *Equivoques: Peintures françaises du XIXᵉ siècle*, Exhibition catalogue, Paris, Musée des arts décoratifs, 9 March–14 May 1973 (Paris, 1973), s.v. "Fromentin (Samuel-Auguste-Eugène)." [The French text is: "Fromentin . . . fut un grand peintre en littérature, un remarquable écrivain en peinture."]

231 Eugène FROMENTIN, *Lettres de jeunesse*, ed. Pierre BLANCHON (Paris, 1909), p. 172. [The French text is: ". . . plus j'étudie cette nature, plus je crois que malgré Marilhat et Decamps, l'Orient reste à faire."]

232 FROMENTIN, *Une année dans le Sahel* in *Œuvres complètes*, pp. 323–24, 325. [The French text is: ". . . l'un a fait avec l'Orient du paysage, l'autre du paysage et du genre, le troisième du genre et de la grande peinture. . . . Le troisième est monté d'un échelon sur l'escalier presque sans fin du grand art, et dans l'Orient il a vu les spectacles humains."]

233 Ibid., p. 315.

234 Ibid., pp. 299–303.

235 *Bateleurs nègres dans les tribus* figured in the Salon of 1859 (Paris, *Salon de 1859*, p. 141, no. 1172) and perhaps also in the one of 1867 (Paris, *Salon de 1867*, p. 84, no. 618). This painting was offered at auction at Sotheby's, London, 17 June 1986; cf. *Nineteenth Century European Paintings, Drawings and Sculpture*, Sale catalogue, London, Sotheby's, 17 June 1986 (London, 1986), p. 45, no. 30 (illus.). See James THOMPSON, "Eugène Fromentin: Painter and Writer" (Ph.D. diss., University of North Carolina at Chapel Hill, 1984), vol. II, pp. 62, 199–200, no. 123, who mentions two studies, one located in Princeton, Art Museum, Princeton University, 49-108, the other in Norfolk, Chrysler Museum, 50.48.56.

236 FROMENTIN, *Carnet de voyage en Algérie (Janvier–avril 1848)* in *Œuvres complètes*, p. 941. [The French text is: "Arrivée de musiciens ambulants, deux nègres et trois bourricots . . . Oiseau empaillé, guitares à cordes avec archets de crins. Vêtement de calicot blanc rayé de bleu. Turbans blancs."]

237 FROMENTIN, *Un été dans le Sahara* (first published in *Revue de Paris*, 1854; in book form, 1857) in *Œuvres complètes*, pp. 165–66. [The French text is: ". . . nous vîmes venir à nous deux voyageurs à pied, conduisant trois petits ânes. . . . Les hommes étaient nègres, mais de vrais nègres, pur sang, d'un noir de jais,

avec des rugosités sur les jambes et des plissures sur le visage, que le hâle du désert avait rendues grisâtres: on eût dit une écorce. Ils étaient en turban, en jaquette et en culotte flottante, tout habillés de blanc, de rose et de jonquille, avec d'étranges bottines ressemblant à de vieux brodequins d'acrobates. C'étaient presque des vieillards, et la gaieté de leur costume, l'effet de ces couleurs tendres accompagnant ces corps de momies me surprirent tout de suite infiniment. L'un avait au cou un chapelet de flûtes en roseau, comme le fou de D'jelfa; il tenait à la main une musette en bois travaillé, incrustée de nacre et fort enjolivée de coquillages. L'autre portait en sautoir une guitare formée d'une carapace de tortue, emmanchée dans un bâton brut. . . . Imagine, mon cher ami, ce qui peut sortir de la fantaisie d'un nègre, quand il s'amuse à refaire des oiseaux avec des peaux cousues, des pattes et des têtes rapportées."] The *fou D'jelfa* was described earlier in the book.

238 Eugène FROMENTIN, *Un été dans le Sahara* in *Œuvres complètes*, p. 8, from his preface to the 1874 edition of his travel books. [The French text is: ". . . la vérité en dehors de l'exactitude, et la ressemblance en dehors de la copie conforme."]

239 Théophile GAUTIER, "Exposition de 1859: VI. M. Eugéne Fromentin," *Le Moniteur universel*, 28 May 1859, quoted by Edmond FARAL, "Deux pages de Fromentin et de Théophile Gautier," *Revue d'Histoire littéraire de la France* 18 (1911): 672. [The French text is: ". . . les noirs spectres bariolés de guenilles éclatantes . . . gesticulant comme des singes ivres . . . La sueur ruisselle sur leurs masques de bronze, et leurs grosses lèvres épanouies par de larges rires laissent briller des lueurs de nacre."]

240 Houston, Menil Foundation Collection, 83-105 DJ; cf. James THOMPSON and Barbara WRIGHT, *La vie et l'œuvre d'Eugène Fromentin*, Les Orientalistes, 6 (Courbevoie, 1987), p. 220 (illus.). He went to Egypt in 1869 to be present at the opening of the Suez Canal and sailed up the Nile. But the picture reproduced here seems to have an Algerian rather than an Egyptian setting.

241 FROMENTIN, *Une année dans le Sahel* in *Œuvres complètes*, pp. 205–6. [The French text is: "Quant aux Négresses, ce sont, comme les Nègres, des êtres à part. Elles arpentent les rues lestement, d'un pas viril, ne bronchant jamais sous leur charge, et marchant avec l'aplomb propre aux gens dont l'allure est aisée, le geste libre et le cœur à l'abri des tristesses. Elles ont beaucoup de gorge,

le buste long, les reins énormes: la nature les a destinées à leurs doubles fonctions de nourrices et de bêtes de somme. *Anesse le jour, femme la nuit*, dit un proverbe local, qui s'applique aux Négresses aussi justement qu'à la femme arabe. Leur maintien, composé d'un dandinement difficile à décrire, met encore en relief la robuste opulence de leurs formes, et leurs haiks quadrillés de blanc flottent, comme un voile nuptial, autour de ces grands corps immodestes."] The passage is slightly expanded from that in his travel record of 1848 (p. 970).

242 Eugène FROMENTIN, *Correspondance et fragments inédits*, ed. Pierre BLANCHON, 3d ed. (Paris, 1912), p. 77. [The French text is: "Tu verras que mes souvenirs valent mieux et, en somme, c'est toujours avec mes souvenirs beaucoup plus qu'avec mes notes que j'ai produit."]

243 Eugène FROMENTIN, *Les maîtres d'autrefois* (1876) in *Œuvres complètes*, p. 669.

244 Paris, *Salon de 1861*, pp. 168–69, nos. 1404, 1405, 1406. Paris, *Salon de 1863*, p. 107, nos. 858, 859. Paris, *Salon de 1865*, p. 129, nos. 987, 988. The *Marché arabe dans la plaine de Tocria* (illustrated herein) is located in Lille, Musée des Beaux-Arts, 614.

245 Notably Gustave Achille GUILLAUMET, "Tableaux algériens," *La Nouvelle Revue* 1 (1879): 144–58.

246 FROMENTIN, *Un été dans le Sahara* in *Œuvres complètes*, p. 3. [The French text is: "Les lieux ont beaucoup changé. Il y en a, parmi ceux que je cite, qui pouvaient alors passer pour assez mystérieux; tous ont perdu l'attrait de l'incertitude, et depuis longtemps."]

247 See STEVENS, *The Orientalists: Delacroix to Matisse*, pp. 85 (illus.), 215, no. 102; Friedrich von BOETTICHER, *Malerwerke des neunzehnten Jahrhunderts: Beitrag zur Kunstgeschichte* (1891–1901; reprint ed., Hofheim am Taunus, 1979), vol. II, pt. 1, p. 103, s.v. "Müller, Leopold Karl," no. 22. This picture was on the art market in 1985; cf. *Important Orientalist Paintings from the Collection of Coral Petroleum, Inc.*, Sale catalogue, New York, Sotheby's, 22 May 1985 (New York, 1985), no. 20.

248 Vienna, Österreichische Galerie, LG 353, on loan from Vienna, Gemäldegalerie der Akademie der bildenden Kunste. See Gerbert FRODL, "Wiener Orientmalerei im 19. Jahrhundert," *Alte und moderne Kunst* 26, nos. 178–79 (1981): 19–25. *Markt in Kairo* was exhibited in Vienna in 1878; cf. BOETTICHER, *Malerwerke des neunzehnten Jahrhunderts*, vol. I, pt. 1, p. 103, s.v. "Müller, Leopold Karl," no. 25.

249 FRODL, "Wiener Orientmalerei," p. 19.

250 Cf. *infra*, chapter 3, esp. pp. 174–76.

251 Quoted in Gustave GEFFROY, *Claude Monet: Sa vie, son temps, son œuvre* (Paris, 1922), p. 24. [The French text is: "Cela m'a fait le plus grand bien sous tous les rapports. . . . Je ne pensais plus qu'à peindre, grisé que j'étais par cet admirable pays. . . ."]

252 See, for example, Renoir's *Fête arabe à Alger. La Casbah* (Paris, Musée d'Orsay, RF 1957-8) in STEVENS, *The Orientalists: Delacroix to Matisse*, pp. 107 (illus.), 222, no. 109.

253 Jules Antoine CASTAGNARY, "Salon de 1876," *Salons* (Paris, 1892), p. 224, quoted in STEVENS, *The Orientalists: Delacroix to Matisse*, p. 22.

254 The term *Orientmaler* was used to categorize Adolf von Meckel, who devoted himself to Near Eastern scenes from 1883, and Charles Wilda, known only for North African scenes exhibited from 1887, in BOETTICHER, *Malerwerke des neunzehnten Jahrhunderts*, vol. II, pt. 1, pp. 2–4, s.v. "Meckel, Adolf von"; vol. II, pt. 2, p. 1018, s.v. "Wilda, Charles."

255 Versailles, Musée national du Château de Versailles, MV 6976. Paris, *Salon de 1846*, p. 156, no. 1367. For Vernet's *Prise de la smalah d'Abd-el-Kader*, cf. *supra*, pp. 89–90. Our thanks to Roland Bossart who is in charge of documentation at the château de Versailles, for making us aware of this work.

256 PRINCE DE JOINVILLE, *Vieux souvenirs de Mgr le Prince de Joinville, 1818–1848*, ed. Daniel MEYER, Le temps retrouvé (Paris, 1986), pp. 214–41.

257 For the history of Senegal, see Joseph KI-ZERBO, *Histoire de l'Afrique noire: D'hier à demain* (Paris, 1972), pp. 231–33 (with an ample bibliography), and Bernard SCHNAPPER, *La politique et le commerce français dans le Golfe de Guinée, 1838–1887* (Paris, 1961).

258 David BOILAT, *Esquisses Sénégalaises* (1853; reprint ed., Paris, 1984), p. vii. [The French text is: "Il est peu de contrées sur notre globe, offrant tant de variétés de l'espèce humaine, tant d'objets d'étude de tout genre, tant de matières de recherches scientifiques."]

259 Ibid., p. xi. [The French text is: "Voulez-vous visiter la campagne, parcourir les nombreuses branches de nos fleuves? . . . vous voyez s'étaler devant vous des palétuviers qui s'élèvent dans l'air avec une verdure ravissante; dans leur feuillage et autour d'eux, gazouillent et voltigent des oiseaux au riche plumage et dont nos bouquets aux couleurs belles et variées ne nous retraceraient qu'une image bien imparfaite. Contemplez ces sites, ces bosquets plantés par la nature, ces vastes prairies où paissent des troupeaux de boeufs à bosse, des moutons à poils longs et soyeux et des cabris; vous pensez malgré vous trouver au fond de ce paysage un château antique qui rappelle la perfection des beaux-arts. C'est tout au plus si vous rencontrez quelques cases en roseaux où une vieille négresse sera occupée à piler le mil qui doit entrer dans la préparation de son kouskou."]

260 Ibid., p. xiii. [The French text is: ". . . Nous y trouverons matière à des études, à des recherches des plus curieuses et des plus intéressantes, au point de vue scientifique. Dans une seule contrée, quelle variété d'hommes, de mœurs, de croyances et de langage! Les uns sont d'un noir d'ébène, les autres d'une nuance un peu plus claire, d'autres sont d'un cuivre foncé, d'autres rougeâtres, d'autres enfin sont simplement basanés."]

261 Ibid., p. xv. [The French text is: "Ce *je ne sais quoi* qui caractérise la physionomie d'une race est réservé à l'art du peintre, et encore ce n'est pas sur des copies ni sur des dessins d'imagination qu'on peut le trouver, mais sur les portraits mêmes des individus. Il appartient au peintre de saisir la nature sur place et de la reporter, dans toutes les parties du monde, en caractères que tous ceux qui ont des yeux peuvent lire et comprendre."]

262 Darondeau appears to have spent a short time on the African coast. Louis-Edouard BOUËT-WILLAUMEZ, *Description nautique des côtes de l'Afrique occidentale comprises entre le Sénégal et l'Equateur . . . commencée en 1838 et terminée en 1845* (Paris, 1846), includes ten illustrations with his signature. A pencil drawing by him of a *notable noir* is in the Musée des Arts africains et océaniens, Paris, AF 14988. Hubert LAVIGNE, *Etat civil d'artistes français: Billets d'enterrement ou de décès depuis 1823 jusqu'à nos jours* (Paris, 1881), records that he died at Brest in July 1842, not 1841 as is sometimes stated.

263 Paris, *Salon de 1845*, p. 153, nos. 1271, 1272. In the Salon catalogue that quotation is said to come from an unpublished work on the voyage of the *Nisus*. Bouët's *Description nautique des côtes de l'Afrique occidentale* published in the following year was illustrated with ten outline engravings after Nousveaux, but not including the *Exposition de cadavres à Aura*.

264 PRINCE DE JOINVILLE, *Notes sur l'état des forces navales de la France* (Paris, 1844). Queen Victoria's comments on the pamphlet were in a letter to Leopold I, king of the Belgians, 24 May 1844; cf. QUEEN VICTORIA, *The Letters of Queen Victoria: A Selection from Her Majesty's Correspondence between the Years 1837 and 1861*, ed. Arthur Christopher BENSON and Viscount ESHER (London, 1907), vol. II, *1844–1853*, p. 12.

265 Paris, *Salon de 1845*, p. 240, no. 1955. Paris, *Salon de 1847*, p. 219, no. 1911. Each year nine watercolors were exhibited under a single number.

266 Paris, Musée des Arts africains et océaniens, AF 14663.

267 Paris, Musée des Arts africains et océaniens, AF 7599.

268 Paris, *Salon de 1848*, p. 251, no. 3466 ("*Ile de Saint-Louis du Sénégal*; vue prise de la plage de Guetidar en face du palais du gouvernement et des deux casernes. Défilé des troupes de Sénégal sous les yeux du gouverneur, Edouard Bouët, au moment où elles arrivent d'une expédition contre les tribus révoltées du haut du fleuve, le 7 août 1843").

269 Henri-Nicolas FREY, *Côte occidentale d'Afrique: Vues–Scènes–Croquis* (Paris, 1890), pp. 3–5, 12–13, 20–21, 252–53, 368.

270 George French ANGAS, *Savage Life and Scenes in Australia and New Zealand: Being an Artist's Impressions of Countries and People at the Antipodes*, 2d ed. (London, 1847), vol. I, p. vii.

271 London, British Museum, Department of Prints and Drawings, 1876.5.10.502 and 1876.5.10.499.

272 For an account of the publication see GORDON-BROWN, *Pictorial Africana*, p. 113. An earlier book on the Zulu, by Allen F. GARDINER, *Narrative of a Journey to the Zoolu Country, in South Africa* (London, 1836), has somewhat naive, though ethnographically informative, illustrations.

273 Cf. *supra*, pp. 49–50 and fig. 32.

274 Johannesburg, Africana Museum, 54/525; cf. KENNEDY, *Catalogue of Pictures in the Africana Museum*, vol. III, p. 175, no. I.82. On I'Ons's life and career see J. J. REDGRAVE and Edna BRADLOW, *Frederick I'Ons, Artist* (Cape Town, 1958).

275 Johannesburg, Africana Museum, 54/528, 55/941; cf. KENNEDY, *Catalogue of the Pictures in the Africana Museum*, vol. III, p. 176, nos. I.84, I.85.

276 Port Elizabeth, City Hall, on loan from Port Elizabeth, King George VI Art Gallery, 0-16.

277 Johannesburg, Africana Museum, 484; cf. KENNEDY, *Catalogue of the Pictures in the Africana Museum*, vol. I, p. 40, no. B109.

278 Thomas BAINES, *Journal of Residence in Africa, 1842–1853*, ed. R. F. KENNEDY, Van Riebeeck Society Publications, 42, 45 (Cape Town, 1961–64), quoted in KENNEDY, *Catalogue of the Pictures in the Africana Museum*, vol. I, p. 40.

279 For the fullest account see J. P. R. WALLIS, *Thomas Baines: His Life and Explorations in South Africa, Rhodesia and Australia 1820–1875*, 2d ed., ed. F. R. BRADLOW (Cape Town and Rotterdam, 1976).

280 London, Royal Geographical Society.

281 Review of *Explorations in South West Africa* by Thomas Baines, *Anthropological Review* 4 (1866):249.

282 London, Museum of Mankind, no inv. no.

283 London, Royal Geographical Society, 35; see WALLIS, *Thomas Baines*, p. 113.

284 Thomas BAINES, *Explorations in South-West Africa; Being an Account of a Journey in the Years 1861 and 1862 from Walvisch Bay, on the Western Coast, to Lake Ngami and the Victoria Falls* (London, 1864), pp. 148–49.

285 Johannesburg, Africana Museum, 3489; cf. KENNEDY, *Catalogue of the Pictures in the Africana Museum*, vol. I, pp. 108–9, no. B435.

286 Cf. part 1 of this volume, pp. 284–90.

287 Baines had served as war artist with the British troops in the Eighth Xhosa War and contributed illustrations to Robert GODLONTON and Edward IRVING, *Narrative of the Kaffir War 1850–51* (London and Grahamstown, 1851).

288 In a review of Baines's *Explorations in South-West Africa* (cf. *supra*, n. 281) the author says (p. 252) that Baines executed "a series of oil paintings representing the various natives of Kaffraria—South-Eastern and South-Western Africa—the majority of these are faithful portraits, actually finished while the native sat, more or less willingly, to the artist as he worked under the shadow of the wagon awning, or perchance a rude grass-covered hut, far in the interior of the country. They have all at various times been exhibited before the Anthropological or Royal Society." These works cannot now be traced.

289 For instance, those of Canada by Cornelius Krieghoff, of Australia by George French Angas, Conrad Martens, and John Skinner Prout, of South America by Johann Moritz Rugendas.

290 South Africa, Private Collection; cf. *Catalogue of Topographical Paintings, Drawings and Prints Particularly of American, Canadian, South African, Australian and New Zealand Interest*, Sale catalogue, London, Sotheby & Co., 14 May 1970 (London, 1970), pp. 46-47, no. 52.

291 Prince Albert writing to Baron von Stockmar in 1860, quoted in QUEEN VICTORIA, *The Letters of Queen Victoria*, vol. III, *1854–1861*, p. 522.

292 London, British Museum (Natural History), Manuscript Collection, 1778/PRNF 46/80, MSS BAI.

293 Cf. *supra*, pp. 52–55.

294 Hamburg, Hamburger Kunsthalle, 1277. Eva Maria KRAFFT and Carl-Wolfgang SCHÜMANN *Katalog der Meister des 19. Jahrhunderts in der Hamburger Kunsthalle* (Hamburg, 1969), p. 218, no. 1277.

295 The performance was accompanied by a lecture printed as a pamphlet; C. H. CALDECOTT, *Descriptive History of the Zulu Kafirs, Their Customs and Their Country, with Illustrations* (London, 1853). A smaller group of "Kafirs" had been exhibited in London in 1850. These shows seem to have been prompted by the success of George Catlin's exhibitions of American Indians in the 1840s. For contemporary reactions to them see ALTICK, *The Shows of London*, pp. 281–83.

296 "Caffre Exhibition," *Spectator* 26, no. 1299 (21 May 1853):485.

297 Charles DICKENS, "The Noble Savage," *Household Words* 7, no. 168 (11 June 1853):337–39.

298 "Our Weekly Gossip," *The Athenæum*, no. 1335 (28 May 1853):650, quoted by ALTICK, *The Shows of London*, p. 282.

299 Hanau, Historisches Museum, B 1982/41; cf. BOETTICHER, *Malerwerke des neunzehnten Jahrhunderts*, vol. I, pt. 1, p. 200, s.v. "Cornicelius, Georg," no. 7. See Karl SIEBERT, *Georg Cornicelius: Sein Leben und seine Werke*, Studien zur deutschen Kunstgeschichte, 63 (Strassburg, 1905), pp. 64–68 and pl. III; idem, *Verzeichnis der Werke des Malers Georg Cornicelius*, Studien zur deutschen Kunstgeschichte, 171 (Strassburg, 1914), pp. 15, and 52, no. 121. In his earlier publication Siebert notes (p. 65) that a black boy named Mustafa, brought to Hanau from Brazil by a friend of the artist, served as the model for the cymbal player in *Musizierende Kunstreiterbuben*.

300 Aachen, Suermondt-Ludwig-Museum, GK 318; cf. BOETTICHER, *Malerwerke des neunzehnten Jahrhunderts*, vol. II, pt. 1, p. 48, s.v. "Meyerheim, Paul Friedrich," no. 30.

301 Carl HAGENBECK, *Von Tieren und Menschen: Erlebnisse und Erfahrungen*, new ed. (Berlin, 1909).

302 Dresden, Staatliche Kunstsammlungen, Gemäldegalerie Neue Meister, 2455.

303 PLINY THE ELDER *Naturalis historia* 8.17.42.

304 John M. MACKENZIE, *Propaganda and Empire: The Manipulation of British Public Opinion, 1880–1960* (Manchester, 1984), p. 104.

305 Ibid., p 116. See also Annie E. S. COOMBES, "'For God and for England': Contributions to an Image of Africa in the First Decade of the Twentieth Century," *Art History* 8, no. 4 (December 1985):453–66.

306 Adam Sedgwick quoted by J. W. Burrow in his introduction to Charles DARWIN, *On the Origin of Species by Means of Natural Selection; or, The Preservation of Favoured Races in the Struggle for Life* (1859; Harmondsworth, 1968), p. 29.

III

THE SEDUCTIONS
OF SLAVERY

1 Paris, Musée national du Louvre, Département des Peintures, RF 2346. Paris, *Salon de 1827*, p. 234, no. 1630. See Lee JOHNSON, *The Paintings of Eugène Delacroix: A Critical Catalogue, 1816–1831* (Oxford, 1981), vol. I, *Text*, pp. 114–21, no. 125; vol. II, *Plates*, pl. 109.

2 All the known drawings are reproduced in Jack J. SPECTOR, *Delacroix: The Death of Sardanapalus*, Art in Context (London, 1974); see esp. p. 29. The drawing bearing the inscriptions "les Ethiopiens farouches, têtes de marabouts, d'africains, de nubiens" and "croquis exagérés d'après le nègre" is in Paris, Musée national du Louvre, Cabinet des Dessins, RF 5278.

3 Paris, Musée national du Louvre, Cabinet des Dessins, RF 29665; cf. Maurice SÉRULLAZ, *Mémorial de l'exposition Eugène Delacroix*, Exhibition catalogue, Paris, Musée national du Louvre, 1963 (Paris, 1963), pp. 67–68, no. 101 (illus.).

4 Paris, Musée national du Louvre, Département des Peintures, INV. 3824. Paris, *Salon de 1834*, p. 51, no. 497. See Lee JOHNSON, *The Paintings of Eugène Delacroix: A Critical Catalogue, 1832–1863 (Movable Pictures and Private Decorations)* (Oxford, 1986), vol. III, *Text*, pp. 165–70, no. 356; vol. IV, *Plates*, pl. 170.

5 Cf. *supra*, pp. 82–84.

6 Quoted in SÉRULLAZ, *Mémorial de l'exposition Eugène Delacroix*, p. 149. [The French text is: ". . . Delacroix était comme enivré du spectacle qu'il avait sous les yeux. . . . De temps en temps, Delacroix s'écriait: 'C'est beau. C'est comme au temps d'Homère! La femme dans le gynécée s'occupant de ses enfants, filant la laine ou brodant de merveilleux tissus. C'est la femme comme je la comprends!'"]

7 The study of the black female figure is in Paris, Musée national du Louvre, Cabinet des Dessins, RF 9290; cf. ibid., pp. 153–54, no. 207 (illus.).

8 Ibid., p. 149. [The French text is: "Cette toile est, à mon avis, le plus éclatant triomphe que M. Delacroix ait jamais obtenu. . . . C'est de la peinture et rien de plus; de la peinture franche, vigoureuse, vivement accusée, une hardiesse toute vénitienne et qui pourtant n'a rien à rendre aux maîtres qu'elle rappelle."] The painting does not nowadays appear quite as Planche saw it. Before the end of the nineteenth century the brilliant colors had begun to darken as Renoir recorded; cf. René HUYGHE, *Delacroix*, trans. Jonathan GRIFFIN (London, 1963), p. 286.

9 Charles BAUDELAIRE, "Salon de 1846" in *Curiosités esthétiques*, ed. Henri LEMAITRE (Paris, 1962), p. 128. [The French text is: "Ce petit poème d'intérieur, plein de repos et de silence, encombré de riches étoffes et de brimborions de toilette, exhale je ne sais quel haut parfum de mauvais lieu qui nous guide assez vite vers les limbes insondés de la tristesse."]

10 Cambridge, Fogg Art Museum, Harvard University, 1943.251. See Marjorie B. COHN and Susan L. SIEGFRIED, *Works by J.-A.-D. Ingres in the Collection of the Fogg Art Museum*, Fogg Art Museum Handbooks, 3 (Cambridge, Mass., 1980), pp. 116–18, no. 41 (illus.). The signature and date of 1839 in the lower left corner were repainted by Ingres over a partially legible signature and the date 1840.

11 Paris, *Salon de 1819*, p. 68, no. 619.

12 Paris, Musée national du Louvre, Département des Peintures, RF 1728.

13 Ingres writing to Charles Marcotte d'Argenteuil, 16 January 1836, quoted in Hans NAEF, *Die Bildniszeichnungen von J.-A.-D. Ingres* (Bern, 1977–80), vol. II, p. 519. [The French text is: "Je dois vous prévenir que ce ne sera peut-être pas le tableau de Madame Marcotte, car il est galant, mais honnête il est vrai. Enfin, je mets toutes ces considérations sur votre conscience. Nous serons peut-être battus, prenons garde!"]

14 Montauban, Musée Ingres, 867.2029; cf. *Ingres*, Exhibition catalogue, Paris, Petit Palais, 27 October 1967–29 January 1968 (Paris, 1967), pp. 242–43, no. 177 (illus.). [The French text is: ". . . Le repos de la sultane/une sultane au repos entourée de ses femmes/une Sultane et ses femmes/le Sommeil/femme italienne/Italienne faisant la sieste/la Siesta une guittarre. . . ."]

15 Baltimore, Walters Art Gallery, 37.887. William R. JOHNSTON, *The Nineteenth Century Paintings in the Walters Art Gallery* (Baltimore, 1982), pp. 27 (color plate), 37–38, no. 6.

16 Montpellier, Musée Fabre, 868.1.38. Paris, *Salon de 1849*, p. 48, no. 506. See JOHNSON, *The Paintings of Eugène Delacroix*, vol. III, pp. 191–93, no. 382; vol. IV, pl. 171.

17 Eugène FROMENTIN, *Une année dans le Sahel* (first published in articles, 1857; as a book, 1859) in *Œuvres complètes*, ed. Guy SAGNES, Bibliothèque de la Pléiade, 313 (Paris, 1984), p. 276. [The French text is: "C'est aussi charmant. Ce n'est pas plus beau. Dans la nature, la vie est plus multiple, le détail plus imprévu; les nuances sont infinies. Il y a le bruit, les odeurs, le silence, la succession du geste et la durée. Dans le tableau, le caractère est définitif, le moment déterminé, le choix parfait, la scène fixée pour toujours et absolue. C'est la formule des choses, ce qui doit être vu plutôt que ce qui est, la vraisemblance du vrai plutôt que le vrai. . . . Arrivée devant la chambre de sa maîtress, la noire servante tourna la tête à demi de mon côté, et fit exactement le geste que tu peux voir dans le tableau de Delacroix, pour écarter le rideau de mousseline à fleurs."]

18 The statement that Auguste traveled in Greece, Syria, and Egypt, first made in 1910 and often repeated—with geographical expansion—may have been derived simply from the subject matter of his works. Donald A. ROSENTHAL, "Jules-Robert Auguste and the Early Romantic Circle" (Ph.D. diss., Columbia University, 1978), pp. 47–53, suggests that he could have been out of Europe at some time between 1815 and 1817, or 1817 and 1820, but admits that there is no positive evidence.

19 Victor HUGO, *Les Orientales* (1829) in *Victor Hugo: Œuvres complètes*, ed. Jean MASSIN, vol. III, ([Paris], 1967), p. 502.

20 Paris, Musée national du Louvre, Cabinet des Dessins, RF 1942-12; ROSENTHAL, "Jules-Robert Auguste," pp. 292–94, no. III–4 and fig. 49.

21 Paris, Musée national du Louvre, Cabinet des Dessins, RF 5189. The other version, in pastel combined with gouache, is in Paris, Musée des Arts Africains et Océaniens, AF 14613. On both see ROSENTHAL, "Jules-Robert Auguste," pp. 296–300, nos. III-8, III-9, and figs. 44, 45.

22 Metz, Musée d'Art et d'Histoire de Metz, 869, on loan from Paris, Musée national du Louvre, Département des Peintures, RF 3883; cf. Marc SANDOZ, *Théodore Chassériau 1819–1856: Catalogue raisonné des peintures et estampes* (Paris, 1974), pp. 250–52, no. 118 and pl. CVIII.

23 Cf. *supra*, pp. 16–17. On this topic see Ruth COWHIG, "The Importance of Othello's Race," *Journal of Commonwealth Literature* 12, no. 2 (December 1977):153–61;

idem, "Actors, Black and Tawny, in the Role of Othello,—and Their Critics," *Theatre Research International*, n.s. 4, no. 2 (February 1979):133–46.

24 Ottawa, National Gallery of Canada/ Galerie nationale du Canada. Paris, *Salon de 1849*, p. 48, no. 507. See JOHNSON, *The Paintings of Eugène Delacroix*, vol. III, pp. 116–18, no. 291; vol. IV, pl. 110.

25 Jay M. FISHER, *Théodore Chassériau: Illustrations for Othello*, Exhibition catalogue, Baltimore, Baltimore Museum of Art, 11 November 1979–6 January 1980 (Baltimore, 1979).

26 Heinrich HEINE, *Shakspeares Maedchen und Frauen* (Paris and Leipzig, 1839), p. 134. [The German text: ". . . eine mächtige Magie war Schuld daran, dass sich das bange zarte Kinnd zu dem Mohren bingezogen fühlte und jene hässlich schwarze Larve nicht fürchtete, welche der grosse Haufe für das wirkliche Gesicht Othellos hielt. . . . Sie ist die wahre Tochter des Südens, zart, empfindsam, geduldig, wie jene schlanken, grossäugigen Frauenlichter, die aus sanskrittischen Dichtungen so lieblich, so sanft, so träumerisch hervorstrahlen."]

27 Paris, Musée national du Louvre, Département des Peintures, RF 3900. Paris, *Salon de 1842*, p. 42, no. 346. See SANDOZ, *Théodore Chassériau*, pp. 188–90, no. 89 and pl. LXXII.

28 The entry for the picture in the Salon catalogue quoted from Esther 2:15: "Egée, eunuque qui gardait les jeunes filles, lui donna pour sa parure tout ce qu'elle voulut; car elle était très belle, et son visage d'une grâce si parfaite qu'elle paraissait aimable et ravissante à tous ceux qui la voyaient."

29 Paris, Musée national du Louvre, Département des Peintures, RF 3885; cf. SANDOZ, *Théodore Chassériau*, pp. 288–89, no. 146 and pl. CXXXVI.

30 Pau, Musée des Beaux Arts, 46-2-23. Paris, *Salon de 1844*, p. 18, no. 99. See Marie-Madeleine AUBRUN, *Léon Benouville, 1821–1859: Catalogue raisonné de l'œuvre* ([Paris], 1981), pp. 75–76, no. 27 (illus.).

31 Albert de la FIZELIÈRE, "Salon de 1844," *Bulletin de l'ami des arts* 2, no. 15 (1844):420, quoted in AUBRUN, *Léon Benouville*, p. 76. [The French text is: "*Esther*, par M. Benouville, ressemble plus à une courtisane qu'à la chaste héroïne de la captivité des Juifs."]

32 London, Tate Gallery, N03053.

33 Virginia SURTEES, *The Paintings and Drawings of Dante Gabriel Rossetti (1828–1882): A Catalogue Raisonné* (Oxford, 1971), vol. I, *Text*, pp. 104–5, no. 182; vol. II, *Plates*, pl. 263. Three drawings for the black are in the Birmingham City Museum and Art Gallery (473'04, 472'04, 404'04); cf. idem, *Dante Gabriel Rossetti*, vol. I, p. 106, nos. 182E, 182F, 182G; vol. II, pls. 268, 269.

34 William Michael ROSSETTI, comp., *Rossetti Papers 1862 to 1870* (London, 1903), p. 175.

35 Dante Gabriel Rossetti writing to Ellen Heaton, 2 and 4 July 1863, quoted in SURTEES, *Dante Gabriel Rossetti*, vol. I, p. 105.

36 Paris, Musée d'Orsay, RF 644. Paris, *Salon de 1865*, p. 188, no. 1428. See Françoise CACHIN and Charles S. MOFFETT, *Manet 1832–1883*, Exhibition catalogue, Paris, Galeries nationales du Grand Palais, 22 April–8 August 1983; New York, Metropolitan Museum of Art, 10 September–27 November 1983 (New York, 1983), pp. 174–83, no. 64.

37 Emile ZOLA, "Une nouvelle manière en peinture, Edouard Manet," *Revue du XIXᵉ siècle* 4, no. 10 (1 January 1867):58–59. [The French text is: ". . . Un tableau pour vous est un simple prétexte à analyse. Il vous fallait une femme nue, et vous avez choisi Olympia, la première venue; il vous fallait des taches claires et lumineuses, et vous avez mis un bouquet; il vous fallait des taches noires, et vous avez placé dans un coin une négresse et un chat. Qu'est-ce que tout cela veut dire? vous ne le savez guère, ni moi non plus. Mais je sais, moi, que vous avez admirablement réussi à faire une œuvre de peintre, et de grand peintre. . . ."]

38 The portrait of Zola, 1868, is in the Musée d'Orsay, Paris. For this work and the etchings of *Olympia* see CACHIN and MOFFETT, *Manet*, pp. 186–89, nos. 68, 69 and pp. 280–85, no. 106.

39 For accounts of the reception of the painting and various interpretations see Theodore REFF, *Manet: Olympia*, Art in Context (London, 1976) and T. J. CLARK, *The Painting of Modern Life: Paris in the Art of Manet and His Followers* (New York, 1985), pp. 79–146.

40 Emile ZOLA, *Edouard Manet: Etude biographique et critique* (1867) reprinted in *Les œuvres complètes*, ed. Maurice LE BLOND, vol. XXXVIII (Paris, 1928), pp. 269–70. [The French text is: ". . . c'est une jeune fille de seize ans, sans doute un modèle qu'Edouard Manet a tranquillement copié tel qu'il était. Et tout le monde a crié: on a trouvé ce corps nu indécent; cela devait être, puisque c'est là de la chair, une fille que l'artiste a jetée sur la toile dans sa nudité jeune et déjà fanée. Lorsque nos artistes nous donnent des Vénus, ils corrigent la nature, ils mentent. Edouard Manet s'est demandé pourquoi mentir, pourquoi ne pas dire la vérité; il nous a fait connaître Olympia, cette fille de nos jours, que vous rencontrez sur les trottoirs et qui serre ses maigres épaules dans un mince châle de laine déteinte."] The passage quoted here appears only in the final version of Zola's description of *Olympia* which he had mentioned briefly in *L'Evènement* (7 mai 1866).

41 Quoted in REFF, *Manet: Olympia*, p. 95. In the novel *La fille Elisa*, published by Edmond de Goncourt in 1877—and arousing protests similar to those provoked by *Olympia*—there was, however, to be no more than a brief description (p. 135) of a black woman nicknamed Peau-de-Casimir in the last brothel where Elisa lives.

42 David Roberts writing to his daughter, 24 September 1838, in James BALLANTINE, *The Life of David Roberts, R.A., Compiled from His Journals and Other Sources* (Edinburgh, 1866), pp. 81–82, quoted by Kenneth Paul BENDINER, "The Portrayal of the Middle East in British Painting 1835–1860" (Ph.D. diss., Columbia University, 1979), p. 124.

43 Quoted by BENDINER, "The Portrayal of the Middle East in British Painting," p. 124.

44 David ROBERTS, *Egypt and Nubia from Drawings Made on the Spot* (London, 1846–49), vol. I, pls. 4, 27; vol. III, pl. 27.

45 N. Neal SOLLY, *Memoir of the Life of William James Müller, a Native of Bristol, Landscape and Figure Painter with Original Letters and an Account of His Travels and of His Principal Works* (London, 1875), p. 77–78.

46 Victor SCHŒLCHER, *L'Egypte en 1845* (Paris, 1846), p. 1: "Deux intérêts puissants nous firent entreprendre un voyage en Orient (novembre 1844): le désir d'étudier l'esclavage musulman pour le comparer à l'esclavage chrétien; l'espérance de contempler en Egypte un spectacle unique dans l'histoire, celui d'un peuple régénéré par son maître." But most of his book is devoted to an exposure of misgovernment under Mohammed Ali, with less said about slaves than the fellahin whose condition seemed to Schœlcher even worse than that of slaves in the Americas.

47 London, Guildhall Art Gallery, 828. *Slave Market, Cairo* is the subject of two related works: a watercolor drawing in Manchester, Whitworth Art Gallery, University of Manchester (D.120.1892) and an oil on wood panel signed and dated 1840 in Leicester, Leicestershire Museum and Art Gallery (3A1907).

48 SOLLY, *Memoir of the Life of William James Müller*, p. 333, records "five or six copies, various sizes" of *Slave Market, Cairo.*

49 Present whereabouts unknown. London, British Institution, p. 391, s.v. "Muller, William James," 1840, no. 363.

50 London, Royal Academy, vol. V, p. 320, s.v. "Müller, William James," 1841, no. 35. London, British Institution, p. 391, s.v. "Muller, William James," 1841, no. 63; 1842, no. 380. SOLLY, *Memoir of the Life of William James Müller*, p. 333.

51 Cf. part 1 of this volume, pp. 149–51, fig. 89 and pp. 162–64, fig. 97.

52 SOLLY, *Memoir of the Life of William James Müller*, p. 78.

53 The present location of *Sklavenmarkt in Kairo* is unknown. It was sold at Sotheby's, London, 21–22 March 1984, no. 23. Friedrich von BOETTICHER, *Malerwerke des neunzehnten Jahrhunderts: Beitrag zur Kunstgeschichte* (1891–1901; reprint ed., Hofheim am Taunus, 1979), vol. I, pt. 1, p. 397, s.v. "Gentz, Karl Wilhelm," no. 2.

54 The poem was written about 1822 but not published until 1912; cf. Paul R. SWEET, *Wilhelm von Humboldt: A Biography* (Columbus, 1978–80), vol. II, *1808–1835*, pp. 481–82.

55 Williamstown, Sterling and Francine Clark Art Institute, 53. Paris, *Salon de 1867*, p. 87, no. 642. See Gerald M. ACKERMAN, *La vie et l'œuvre de Jean-Léon Gérôme*, Les Orientalistes, 4 (Courbevoie, 1986), pp. 62 (illus.), 218–19, no. 162.

56 Cf. part 1 of this volume, p. 52, fig. 15.

57 Naples, Museo e Gallerie Nazionali di Capodimonte, P.S. 24; see Caroline JULER, *Les Orientalistes de l'école italienne*, Les Orientalistes, 5 (Courbevoie, 1987), pp. 170–71 (illus.).

58 Vincenzo MARINELLI, *Intorno al Cesare Mormile, dipinto dato nel concorso municipale di Napoli del 1863* [Naples, 1863], p. 13.

59 Léon LAGRANGE, "Le Salon de 1864," *Gazette des Beaux-Arts* 16, no. 6 (June 1864):529, referring to a painting by Gérôme in which he found the dancers lacking "the seductiveness of plastic beauty."

60 Solothurn, Museum der Stadt Solothurn, A 185; cf. Peter VIGNAU-WILBERG, *Museum der Stadt Solothurn: Gemälde und Skulpturen*, Schweizerisches Institut für Kunstwissenschaft, Zurich, Kataloge Schweizer Museen und Sammlungen, 2 (Solothurn, 1973), pp. 71–72, no. 59 (illus.). For a painting of a white woman in the same setting (Selzach, Private Collection) see Hugh HONOUR, *The European Vision of America*, Exhibition catalogue, Washington, D. C., National Gallery of Art, 7 December 1975–15 February 1976; Cleveland, Cleveland Museum of Art, 28 April–8 August 1976; Paris, Grand Palais, 17 September 1976–3 January 1977 (Cleveland, 1975), no. 334.

61 Douai, Musée de la Chartreuse, 819.

62 Jeannine DURAND-REVILLON, "Charles-Henri-Joseph Cordier, Sculpteur (1827–1905)" (Mémoire, Ecole du Louvre, 1980), vol. I, p. 27, citing a tradition in Cordier's family. The same Salon included a bronze bust of an *Egyptien de la suite du roi d'Egypte* by Augustin Courtet; plaster busts of a *Mauresque d'Alger* and *Juive d'Alger* by Louis-Guillaume Fulconis; paintings of *Un nègre* by Charles Monginot, *Femme Fellah* by Anna Reille, and *Crispin Nègre* by Louis Rœdler. See Paris, *Salon de 1869*, p. 467, no. 3335; p. 482, nos. 3446, 3447; p. 232, no. 1731; p. 271, no. 2015; p. 277, no. 2034.

63 Cf. part 1 of this volume, pp. 259–62.

64 Paris, *Salon de 1869*, p. 459, no. 3283. Several versions of this bust are known including the terracotta reproduced here; a plaster in Paris, Musée du Petit Palais (P.P.S. 1540); a patinated plaster in Valenciennes, Musée des Beaux-Arts (10); a marble in Copenhagen, Ny Carlsberg Glyptothek (I.N. 1671). The version exhibited in the Salon of 1869 was described as marble in the catalogue but bronze by Louis AUVRAY, *Exposition des Beaux-Arts: Salon de 1869* (Paris, 1869), p. 90, followed by Victor BEYER and Annie BRAUNWALD, *Sur les traces de Jean-Baptiste Carpeaux*, Exhibition catalogue, Paris, Grand Palais, 11 March–5 May 1975 (Paris, 1975), no. 333. Auvray makes no reference to the inscription which may not have been on the example shown in the Salon.

65 Cf. part 1 of this volume, pp. 34–37.

66 Antoinette LE NORMAND, *La tradition classique & l'esprit romantique: Les sculpteurs de l'Académie de France à Rome de 1824 à 1840*, Académie de France à Rome, 3 (Rome, 1981), pp. 234–35, no. 59 and fig. 57. Debay's statue is now in Valence, Musée des Beaux-Arts.

67 Cf. Linda HYMAN, "*The Greek Slave* by Hiram Powers: High Art as Popular Culture," *Art Journal* 35, no. 3 (Spring 1976):216–23, and Vivien M. GREEN, "Hiram Powers's *Greek Slave*: Emblem of Freedom," *American Art Journal* 14, no. 4 (Autumn 1982):31–39. Tenniel's engraving appeared in *Punch, or the London Charivari* 20 (1851):236; it is reproduced in GREEN, "Hiram Powers's *Greek Slave*," p. 37. The caricature was prompted by the inclusion of *The Greek Slave* in the Great Exhibition of 1851.

68 Quoted by Albert TenEyck GARDNER, *Yankee Stone Cutters: The First American School of Sculpture, 1800–1850* (New York, 1945), p. 14.

69 John Rogers in the United States made the model for a marble statue to be entitled *The Flight of the Octoroon* in 1861 but destroyed it; cf. David H. WALLACE, *John Rogers: The People's Sculptor* (Middletown, CT, 1967), pp. 200–201, no. 86.

70 Blackburn, Town Hall, on loan from Blackburn, Blackburn Museum and Art Gallery, 1876-36. London, Royal Academy, vol. I, p. 174, s.v. "Bell, John," 1868, no. 932.

71 The first appears to have been Richard HILDRETH, *The Slave; or, Memoirs of Archy Moore* (Boston, 1836), reissued as *The White Slave; or, Memoirs of a Fugitive* (Boston, 1852); cf. GREEN, "Hiram Powers's *Greek Slave*," p. 36. Gustave de BEAUMONT, *Marie, ou l'esclavage aux Etats-Unis: Tableau de mœurs américaines* (Paris, 1835), which enjoyed great popularity (a fifth edition was published in 1842) was, despite the title, the tragic story of a free octoroon.

72 *R. Accademia di Belle Arti di Milano: Esposizione delle opere di Belle Arti nel Palazzo di Brera, Anno 1874*, (Milan, 1874), p. 55, no. 524. *Official Catalogue of the International Exhibition of 1876*, 2d rev. ed. (Philadelphia, 1876), part II, *Art Gallery, Annexes, and Out-Door Works of Art. Department IV: Art*, p. 118, no. 452. *Esposizione nazionale in Milano nel 1881. Belle Arti: Catalogo ufficiale illustrato* [Milan, 1881], p. 32, no. 19.

73 "Belle Arti: La schiava denudata, statua in marmo di Michele Boninsegna," *Emporio Pittoresco* 26 (1877):290–91. Images of female slaves were peculiarly popular in later nineteenth-century Italy. The Esposizione nazionale in Milan 1881 included, in addition to the *La schiava*

denudata by Michele Boninsegna, *Piccola schiava*, bronze and marble bust by Raimondo Pereda; *La schiava al mercato*, plaster statue by Adolfo Galducci; *La schiava*, statuette by Carlo Santamaria; *Schiava*, small figure painting by Gerolamo Induno. There was however only one male slave, *Testa di schiavo*, in plaster by Ernesto Bazzaro. Cf. *Esposizione nazionale in Milano nel 1881*, pp. 43, no. 78; 53, no. 65; 56, no. 23; 102, no. 17; 54, no. 76.

74 Solothurn, Museum der Stadt Solothurn, B 64. See Gottfried WÄLCHLI, *Frank Buchser 1828–1890: Leben und Werk*, Monographien zur schweizer Kunst, 9 (Zurich and Leipzig, 1941), pp. 202–3, fig. 87.

75 Pierre LOTI [pseud.], *Le roman d'un spahi* (Paris, [1881]), pp. 180–81. [The French text is: ". . . sa figure fine et régulière prenait par instants quelque chose de la beauté mystérieuse d'une idole en ébène poli: ses grands yeux d'émail bleu qui se fermaient à demi, son sourire noir, découvrant lentement ses dents blanches, tout cela avait une grâce de nègre, un charme sensuel, une puissance de séduction matérielle, quelque chose d'indéfinissable, qui semblait tenir à la fois du singe, de la jeune vierge et de la tigresse,—et faisait passer dans les veines du spahi des ivresses inconnues."]

76 Naples, Museo e Gallerie Nazionali di Capodimonte, N. 168 PS; cf. Bruno MOLAJOLI, *Notizie su Capodimonte: Catalogo delle Gallerie e del Museo* (Naples, 1960), p. 71. The Pinacoteca of Varallo Sesia has a plaster version of this statue.

77 Costantino ABBATECOLA, *Guida e critica della grande esposizione nazionale di Belle Arti di Napoli del 1877* (Naples, 1877), p. 104.

78 London, Guildhall Art Gallery, 1014. London, Royal Academy, vol. VI, p. 197, s.v. "Poynter, Sir Edward James," 1867, no. 434. See Patrick CONNER, ed., *The Inspiration of Egypt: Its Influence on British Artists, Travellers and Designers, 1700–1900*, Exhibition catalogue, Brighton, Brighton Museum, 7 May–17 July 1983; Manchester, City of Manchester Art Galleries, 4 August–17 September 1983 (Brighton, 1983), pp. 137–38, no. 343.

79 "Fine Arts," *Athenæum*, no. 2063 (11 May 1867):628, quoted in CONNER, *The Inspiration of Egypt*, p. 138.

80 *Royal Academy of Arts Bicentenary Exhibition*, Exhibition catalogue, London, Royal Academy of Arts, 14 December 1968–2 March 1969 (London, 1968), pp. 133–34, no. 345.

81 Tunis, Ministère des Affaires Culturelles (in 1974). Paris, *Salon de 1872*, p. 146, no. 966. See Geneviève LACAMBRE, *Le Musée du Luxembourg en 1874*, Exhibition catalogue, Paris, Grand Palais, 31 May–18 November 1974 (Paris, 1974), pp. 120–21, no. 151 (illus.).

82 Théophile GAUTIER, *Roman de la momie* (Paris, 1858), pp. 207–9. [The French text is: "Planant par l'œil de la pensée sur cette ville démesurée dont il était le maître absolu, Pharaon réfléchissait tristement aux bornes du pouvoir humain. . . . Un second messager roula à côté du premier. Un troisième eut le même sort."]

83 Gautier remarked of Henri Regnault's *Exécution sans jugement sous les rois maures de Grenade* (Paris, Musée d'Orsay) that the executioner had "un regard indéfinissable à la fois dédaigneux et mélancolique, d'une férocité douce et rêveuse, et empreint du fatalisme oriental"; quoted in Henri REGNAULT, *Correspondance de Henri Regnault*, ed. Arthur DUPARC (Paris, 1872), p. 389.

84 Paul MANTZ, "Salon de 1872," *Gazette des Beaux-Arts*, 2d ser., 5 (June 1872):462. [The French text is: "Le costume de Pharaon est irréprochable, les perspectives de la ville égyptienne sont scrupuleusement dessinées; mais combien cet art est glacé!"]

85 Paris, Collection of Pierre Bergé. Paris, *Salon de 1877*, p. 161, no. 1267. See MaryAnne STEVENS, *The Orientalists: Delacroix to Matisse. European Painters in North Africa and the Near East*, Exhibition catalogue, London, Royal Academy of Arts; Washington, D. C., National Gallery of Art, 1984 (London, 1984), pp. 99 (color reprod.), 200, no. 86.

86 Malibu, J. Paul Getty Museum, 78.PB.362.

87 Jeddah, Collection of Mr. and Mrs. Waleed Y. Zahid.; cf. Lynne THORNTON, *The Orientalists: Painter-Travellers, 1828–1908*, The Orientalists, 1 (Paris, 1983), pp. 210, 213 (illus.).

88 Kassel, Staatliche und Städtische Kunstsammlungen, Neue Galerie, L 86, on loan from the Federal Republic of Germany. BOETTICHER, *Malerwerke des neunzehnten Jahrhunderts*, vol. I, pt. 2, pp. 958–59, s.v. "Makart, Hans," no. 43. See Gerbert FRODL, *Hans Makart: Monographie und Werkverzeichnis* (Salzburg, 1974), pp. 40–41, 350, no. 253 and pl. 59.

89 Iras was, however, white skinned in another version of the picture recorded in a photograph of Makart's studio, reproduced in Gerbert FRODL and Gerald

SCHLAG, *Hans Makart und der Historismus in Budapest, Prag und Wien*, Exhibition catalogue, Schloss Halbturn, 29 April–26 October 1986 (Eisenstadt, 1986), unpaginated.

90 Pau, Musée des Beaux-Arts, 80.1.1. The painting reproduced here is a reduced replica of *Les Chérifas* in Carcassonne, Musée des Beaux-Arts, 283, which was exhibited in the Salon of 1884; see François-Guillaume DUMAS, *Catalogue illustré du Salon, 1884* (Paris, 1884), p. xix, no. 588. On both works see Philippe COMTE, *Les peintres orientalistes (1850–1914)*, Exhibition catalogue, Pau, Musée des Beaux-Arts, May–June 1983; Dunkerque, Musée des Beaux-Arts, July–August 1983; Douai, Musée de la Chartreuse, September–October 1983 (Pau, 1983), s.v. "Benjamin Constant" (illus.).

91 Eugène MONTROSIER, *Les artistes modernes* (Paris, 1881–84), vol. IV, *Peintres divers*, pp. 129–30. [The French text is: "M. Benjamin nous introduit dans un harem d'une architecture élégante et d'un ameublement somptueux. Partout de riches tentures; des meubles de prix, des bibelots sur lesquels l'Orient a prodigué les ressources de son art fantaisiste. Sur les lits de repos, plusieurs figures d'attitudes diverses. D'abord, à l'extrêmité d'un divan, tout à fait à droite, le maître montrant sur sa face d'un noir à rendre jaloux Othello, toute l'hébétude que l'abus des plaisirs sexuels imprime à l'homme. Près de lui une esclave est renversée dans un énervement stupide. Plus loin, une autre victime des mœurs orientales se replie sur elle-même. Enfin, la troisième femme, assise sur des coussins, se tient droite, faisant saillir la partie supérieure de son corps dans un mouvement qui met en relief les seins qu'on dirait coulés en bronze. La tête, expressive et volontaire, regarde le maître rassasié de jouissance et comme abruti. . . ."]

92 Quoted by Lynne THORNTON, *Eastern Encounters: Orientalist Painters of the Nineteenth Century*, Exhibition catalogue, London, Fine Art Society, 26 June–28 July 1978 (London, 1978), p. 65.

93 Toulouse, Musée des Augustins, PE5994. Paris, *Salon de 1876*, p. 60, no. 476.

94 Emile ZOLA, "Deux expositions d'art au mois de mai" (June 1876) in *Salons*, ed. F. W. J. HEMMINGS and Robert J. NIESS, Publications romanes et françaises, 63 (Geneva, 1959), p. 179.

95 Léonce BÉNÉDITE, *Les chefs d'œuvre de la peinture au Musée du Luxembourg* (Paris, n.d.), s.v. "Constant, Benjamin." *La justice du Chérif* was removed from the Luxembourg in 1937 and is now

located in Lunéville, Musée de Lunéville, Del. 7.

96 Ibid.

97 For example, *Idle Hours in the Harem*, reproduced in THORNTON, *Eastern Encounters*, p. 66, no. 107.

98 DUMAS, *Catalogue illustré du Salon, 1884*, p. xiv, no. 280. Idem, *Catalogue illustré du Salon, 1886* (Paris, 1886), p. 23, no. 271. *Catalogue illustré du Salon, 1898* (Paris, 1898), no. 239.

99 London, MacConnal-Mason Gallery.

100 In, for instance, Cormon's *Jalousie au Sérail* exhibited in the Salon of 1874 (Besançon, Musée des Beaux-Arts, D.875-2-1), a black removing drapery from a sleeping odalisque seems intended to represent a eunuch, a fellow slave; cf. *Les peintres orientalistes*, s.v. "Fernand Piestre, called Cormon"; Paris, *Salon de 1874*, p. 66, no. 451. An oil sketch for this work is on loan to the Art Museum, University of New Mexico, Albuquerque.

101 Marseilles, Musée des Beaux-Arts, C 229; cf. *Les orientalistes provençaux*, L'Orient des Provençaux, Exhibition catalogue, Marseilles, Musée des Beaux-Arts, November 1982–February 1983 (Marseilles, 1982), p. 17, no. 17 (illus.).

102 John M. MACKENZIE, *Propaganda and Empire: The Manipulation of British Public Opinion, 1880–1960* (Manchester, 1984), pp. 78–79.

103 Melbourne, National Gallery of Victoria, 201/2. London, Royal Academy, vol. III, p. 391, s.v. "Hare, St. George," 1891, no. 489.

104 *Les deux perles* was offered at auction in New York, Christie, Manson & Woods, Sale of 25 February 1983, no. 23. *Salon de 1889. Catalogue illustré: Peinture & sculpture* (Paris, 1889), p. 27, no. 1665 and p. 141 (illus.).

105 Rome, Galleria Nazionale d'Arte Moderna, 1242-45.

106 *Terza esposizione internazionale d'arte della Città di Venezia, 1899: Catalogo illustrato*, 2d ed. (Venice, 1899), pp. 75–76, no. 17. [The Italian text is: "L'autore ha inteso di esprimere miticamente due aspetti della profonda vanità della esistenza umana. Da una parte è la Gorgone, che ha la forma ammaliante della Bellezza ed è Vita e Morte nel tempo stesso, perchè suscita ed abbatte gli eroi. Dall'altra è la Diana d'Efeso, dalle cento mammelle, quale nutrice degli uomini e delle loro chimere. 'Gli uomini, dice il poeta, sono

fatti della sostanza medesima dei loro sogni', ed essi vengono qui rappresentati come dormienti, che stringono nelle mani i simboli delle proprie ambizioni."]

107 The figure is a reconstruction of the famous statue at Ephesus, based on a marble statue in Museo Pio Clementino, Vatican, but with reference also to others with black basalt or bronze heads and arms.

108 Velletri, A. L. Sartorio collection; reproduced in Luigi CARLUCCIO, *The Sacred and Profane in Symbolist Art*, Exhibition catalogue, Toronto, Art Gallery of Ontario, 1 November–26 November 1969 (Toronto, 1969), p. LII, no. 272 and p. 238, no. 272. This is apparently a sketch for a picture entitled *Ein Bacchanal* exhibited at the International Kunstausstellung, Stuttgart, 1891; cf. BOETTICHER, *Malerwerke des neunzehnten Jahrhunderts*, vol. II, pt. 2, p. 522, s.v. "Sartorio, Aristide," no. 1.

IV

THE NEW NEGRO

1 *Official Catalogue of the International Exhibition of 1876*, 2d rev. ed. (Philadelphia, 1876), part II, *Art Gallery, Annexes, and Out-Door Works of Art. Department IV: Art*, p. 61, no. 45. Fildes's painting is located in Egham, Royal Holloway College; for a reproduction see Jeremy MAAS, *Victorian Painters* (London, 1978), p. 239.

2 Cf. part 1 of this volume, pp. 237, 244–46.

3 San Francisco, Fine Arts Museums of San Francisco, 1966.41. Lloyd GOODRICH, *Thomas Eakins: His Life and Work* (1933; reprint ed., New York, 1970), p. 161, no. 30. In his letter of 26 April 1985 Lloyd Goodrich kindly furnished us the text on this portrait that he intended to publish in the catalogue raisonné of Eakins's works.

4 See Gerald M. ACKERMAN, "Thomas Eakins and His Parisian Masters, Gérôme and Bonnat," *Gazette des Beaux-Arts*, 6th ser., 73, no. 1203 (April 1969):235–56.

5 Cf. *supra*, pp. 35–36.

6 New York, Metropolitan Museum of Art, 25.97.1. See GOODRICH, *Thomas Eakins: His Life and Work*, p. 172, no. 124; idem, *Thomas Eakins*, The Ailsa Mellon Bruce Studies in American Art, 2 (Cambridge, Mass. and London, 1982), vol. I, pp. 108–11, fig. 46 and p. 165; vol. II, p. 161.

7 For a summary of the reactions to *The Gross Clinic*, see Theodore E. STEBBINS, JR., Carol TROYEN, and Trevor J. FAIRBROTHER, *A New World: Masterpieces of American Painting 1760–1910*, Exhibition catalogue, Boston, Museum of Fine Arts, 7 September–13 November 1983; Washington, D. C., Corcoran Gallery of Art, 7 December 1983–12 February 1984; Paris, Grand Palais, 16 March–11 June 1984 (Boston, 1983), pp. 176–77 (illus.), 324–25, no. 98.

8 Both are now in Upperville, VA, Collection of Mr. and Mrs. Paul Mellon. The oil sketches are reproduced in GOODRICH, *Thomas Eakins*, vol. I, pp. 110–11, figs. 47, 48.

9 In his images of sports a black man named William Robinson figures in *Whistling for Plover* (Brooklyn, Brooklyn Museum, 25.656), another in *Pushing for Rail* (New York, Metropolitan Museum of Art, 16.65) and *William Schuster and Blackman Going Shooting for Rail* (New Haven, Yale University Art Gallery, 1961. 18.21). On the latter see STEBBINS, TROYEN, and FAIRBROTHER, *A New World*, pp. 119 (illus.), 269, no. 59. See also GOODRICH, *Thomas Eakins*, vol. I, p. 109, fig. 45; p. 92, fig. 35 (color); p. 107, fig. 44.

10 Washington, D. C., National Museum of American Art, Smithsonian Institution, 1909.7.28. This painting was exhibited in Paris in 1878 and in New York in 1880; cf. *Exposition universelle internationale de 1878 à Paris. Catalogue officiel*, 4th ed. (Paris, 1878), vol. I, Groupe I, *Œuvres d'art*, p. 204, no. 59; New York, NAD², vol. II, p. 452, s.v. "Homer, Winslow," 1880, no. 327. An entirely different view of a similar subject had been presented by the southern artist William L. Sheppard in a wood engraving *Christmas in Virginia: A Present from the Great House* with obsequious blacks receiving the gift, published in *Harper's Weekly* 15, no. 783 (30 December 1871):1220; reproduced in James Edward Fox, "Iconography of the Black in American Art (1710–1900)" (Ph.D. diss., University of North Carolina at Chapel Hill, 1979), pl. 9-16. This was probably seen by Homer who also contributed drawings for *Harper's Weekly*.

11 Cf. part 1 of this volume, pp. 226–69.

12 On Homer's trips to Virginia and his paintings from this period, see Gordon HENDRICKS, *The Life and Work of Winslow Homer* (New York, 1979), pp. 104–5; Mary Ann CALO, "Winslow Homer's Visits to Virginia During Reconstruction," *American Art Journal* 12, no. 1 (Winter 1980):4–27; Michael QUICK, "Homer in Virginia," *Los Angeles County Museum of Art Bulletin* 24 (1978):60–81.

13 New York, Metropolitan Museum of Art, 22.220. See Natalie SPASSKY, *American Paintings in the Metropolitan Museum of Art*, vol. II, *A Catalogue of Works by Artists Born between 1816 and 1845* (New York, 1985), pp. 461–65.

14 For the interpretation of this picture I am much indebted to Peter H. WOOD, "Waiting in Limbo: A Reconsideration of Winslow Homer's *The Gulf Stream*" in Walter J. FRASER, JR. and Winfred B. MOORE, JR, eds., *The Southern Enigma: Essays on Race, Class, and Folk Culture*, Contributions in American History, 105 (Westport, CT and London, 1983), pp. 82–83.

15 Ibid.

16 "Exhibition of the Academy of Design," *Art Amateur* 2, no. 6 (May 1880):112, quoted in STEBBINS, TROYEN, and FAIRBROTHER, *A New World*, p. 274 n. 4.

17 Los Angeles, Los Angeles County Museum of Art, M.77.68. London, Royal Academy, vol. IV, p. 140, s.v. "Homer, Winslow," 1878, no. 60. See QUICK, "Homer in Virginia."

18 George William SHELDON, *American Painters* (New York, 1879), p. 29.

19 "Royal Academy Exhibition: Sixth Notice," *Illustrated London News* 72, no. 2033 (15 June 1878):551. The picture was nevertheless acquired by a collector in England.

20 San Francisco, Fine Arts Museums of San Francisco, 1943.1. On Hovenden's life and career, see Lee M. EDWARDS, "Noble Domesticity: The Paintings of Thomas Hovenden," *American Art Journal* 19, no. 1 (1987):4–38, esp. pp. 21–23, fig. 19. Professor Anne G. Terhune is preparing a study of this artist's depictions of blacks.

21 Another scene of life among urban blacks by Hovenden, *Their Pride* (New York, Union League Club, no inv. no.), was exhibited at the National Academy of Design in 1888; cf. New York, NAD², vol. I, p. 458, s.v. "Hovenden, Thomas," 1888, no. 364. It shows a young woman trying on a fashionable hat surrounded by admiring but poorly dressed members of her family. The elderly black man who figures in both *Sunday Morning* and *Their Pride* reappears on his own in another picture by Hovenden with a suggestion of mockery in its title, *"Dat 'Possum Smell Pow'ful Good"* (Burlington, VT, University of Vermont, Robert Hull Fleming Museum, 1956.49.3), which was exhibited at the National Academy of Design in 1881; cf. New York, NAD², vol. I, p. 457, s.v. "Hovenden, Thomas," 1881, no. 510. On both of these works see EDWARDS, "Noble Domesticity," pp. 23, 24, figs. 20, 21. In a more serious vein he painted *The Last Moments of John Brown* (New York, Metropolitan Museum of Art, 97.5) which was strongly influenced by Thomas Satterwhite Noble's painting of the same subject but with less prominence given to the black mother; cf. SPASSKY, *American Paintings in the Metropolitan Museum of Art*, vol. II, pp. 539–44. (A two-thirds size replica dating from ca. 1884 is located in San Francisco, Fine Arts Museums of San Francisco, 1979.7.60.) For *John Brown's Blessing* by Noble, see part 1 of this volume, p. 253, fig. 160.

22 Private Collection; cf. Ellwood PARRY, *The Image of the Indian and the Black Man in American Art 1590–1900* (New York, 1974), pp. 152–53, fig. 108.

23 Joseph Decker exhibited still-life paintings at the Brooklyn Art Academy from 1877 to 1884; cf. Hermann Warner WILLIAMS, JR., *Mirror to the American Past: A Survey of American Genre Painting, 1750–1900* (Greenwich, CT, 1973), pp. 193–94, fig. 185. Poor children in the city streets were depicted by other artists, notably John George Brown, an English immigrant who specialized in them. Brown's *Card Tricks* (Omaha, Joslyn Art Museum, 1944.14) shows a black child entertaining a group of ragged but well-scrubbed white children.

24 Washington, D. C., Corcoran Gallery of Art, 99.6. The work is dated 1878 (not 1870 as is often stated) and was exhibited at the National Academy of Design in New York in 1879; cf. New York, NAD², vol. I, p. 77, s.v. "Bonham, Horace," 1879, no. 104. See Edward J. NYGREN, Peter C. MARZIO, and Julie R. MYERS, *Of Time and Place: American Figurative Art from the Corcoran Gallery*, Exhibition catalogue, Washington, D. C., Corcoran Gallery of Art, 19 Septembmer–15 November 1981 ([Washington, D. C.], 1981), pp. 60–61, no. 17 (illus.). Another version of this painting with eleven rather than thirteen figures is located in York, PA, Historical Society of York County, B76.2.231. On both versions see Carol KEARNEY, "Horace Bonham: York's Forgotten Artist" (Master's thesis, Pennsylvania State University, 1984), pp. 297–317. We are grateful to Ms. Kearney for allowing us to read her thesis.

25 The man was identified as the coachman of Judge Jeremiah Black in the *York Gazette*, 16 February 1899, cited by KEARNEY, "Horace Bonham," p. 298a, fig. 57.

26 Cf. part 1 of this volume, p. 236, fig. 148.

27 Edward J. Nygren (*Of Time and Place*, p. 61) and Carol Kearney ("Horace Bonham," pp. 306–12) suggest that the painting alluded specifically to the election of 1876.

28 Washington, D. C., National Gallery of Art, 1944.13.1. See E. A. CARMEAN, JR. et al., *Bellows: The Boxing Pictures*, Exhibition catalogue, Washington, D. C., National Gallery of Art, 5 September 1982–2 January 1983 (Washington, D. C., 1982), pp. 27–36, 77-78, no. 3, fig. 29, and color pl. 5.

29 For both paintings see ibid., pp. 73–77, nos. 1, 2, figs. 25, 28, and color pls. 7, 4.

30 Ibid., pp. 55–56, fig. 61. A drawing entitled *A Knock Down* and lithograph

based on it, *The White Hope*, published in 1921, may allude to the unsuccessful attempt of the "white hope," James J. Jeffries, to wrest the championship from Jack Johnson; cf. Lauris MASON and Joan LUDMAN, *The Lithographs of George Bellows: A Catalogue Raisonné* (Millwood, NY, 1977), p. 138, no. M. 96 (illus.).

31 He evoked the violence of slum life in a drawing entitled *Tin Can Battle, San Juan Hill, New York* (1907) (Lincoln, University of Nebraska Art Galleries, Sheldon Memorial Art Gallery, F. M. Hall Collection, H-272) in which the figures appear to be blacks, apart from one in the act of throwing a tin can.

32 For Fuseli's painting see part 1 of this volume, p. 92, fig. 45. Lynching is the subject of Bellows's lithograph entitled *The Law Is Too Slow*, published in 1923 as an illustration of a short story by Mary JOHNSTON, "Nemesis," *Century Magazine* (May 1923); cf. MASON and LUDMAN, *The Lithographs of George Bellows*, p. 189, no. M. 147.

33 See Patti HANNAWAY, *Winslow Homer in the Tropics* (Richmond, 1973); Helen A. COOPER, *Winslow Homer Watercolors*, Exhibition catalogue, Washington, D. C., National Gallery of Art, 2 March–11 May 1986; Fort Worth, Amon Carter Museum, 6 June–27 July 1986; New Haven, Yale University Art Gallery, 11 September–2 November 1986 (Washington, D. C., New Haven, and London, 1986), pp. 130–57, 159–61, 208–37.

34 Washington, D. C., National Gallery of Art, B-28, 409.

35 Cf. part 1 of this volume, p. 230, fig. 142.

36 Minneapolis, Minneapolis Institute of Arts, 15.137; cf. COOPER, *Winslow Homer Watercolors*, pp. 139–41, fig. 129.

37 New York, Metropolitan Museum of Art, 06.1234. In *The Gulf Stream* Homer integrated images he had drawn separately some years earlier, all of which are noted and reproduced in SPASSKY, *American Paintings in the Metropolitan Museum of Art*, vol. II, pp. 482–90.

38 Cf. part 1 of this volume, pp. 220–22, fig. 137 and pp. 196–99, fig. 124.

39 Cf. part 1 of this volume, pp. 91–92.

40 For a full discussion of the imagery see WOOD, "Waiting in Limbo."

41 For these three paintings see part 1 of this volume, pp. 37–41, figs. 6, 7; pp. 119–20, 122, 124, figs. 65, 68; pp. 162–64, fig. 97.

42 Glens Falls, NY, Hyde Collection, 1971.16. On Tanner's life and work, see Marcia M. MATHEWS, *Henry Ossawa Tanner, American Artist*, Negro American Biographies and Autobiographies (Chicago and London, 1969); Lynda Roscoe HARTIGAN, *Sharing Traditions: Five Black Artists in Nineteenth-Century America*, Exhibition catalogue, Washington, D. C., National Museum of American Art, 15 January–7 April 1985 (Washington, D. C., 1985), pp. 99–116.

43 A peculiarly distasteful account of the way he was treated was published (without mentioning Tanner's name) by Joseph PENNELL, *The Adventures of an Illustrator Mostly in Following His Authors in America & Europe* (Boston, 1925), pp. 53–54, quoted by PARRY, *The Image of the Indian and the Black Man*, pp. 163, 165.

44 Undated letter in the collection of the Pennsylvania School for the Deaf, Philadelphia, quoted in PARRY, *The Image of the Indian and the Black Man*, p. 167.

45 See, for example, *The Thankful Poor* (Greenfield, Collection of Dr. and Mrs. William H. Cosby, Jr.), reproduced in PARRY, *The Image of the Indian and the Black Man*, p. 168.

46 Private Collection.

47 Edouard Manet writing to Jules Dejouy, 26 February 1849; see Edouard MANET, *Lettres de jeunesse, 1848–1849: Voyage à Rio* (Paris, [1928]), p. 58. [The French text is: ". . . la ville quoiqu'assez laide présente à l'artiste un cachet particulier, la population est au trois quarts nègre, ou mulâtre, cette partie est généralement affreuse sauf quelques exceptions parmi les négresses et les mulâtresses; ces dernières sont presque toutes jolies."] In another letter of early February 1849, this one to his mother (p. 52), he wrote: "Dans ce pays tous les nègres sont esclaves; tous ces malheureux ont l'air abruti; le pouvoir qu'ont sur eux les blancs est extraordinaire; j'ai vu un marché d'esclaves, c'est un spectacle assez révoltant pour nous; les nègres ont pour costume un pantalon, quelquefois une vareuse en toile, mais il ne leur est pas permis comme esclaves de porter des souliers. Les négresses sont pour la plupart nues jusqu'à la ceinture, quelques-unes ont un foulard attaché au cou et tombant sur la poitrine, elles sont généralement laides, cependant j'en ai vu d'assez jolies; elles se mettent avec beaucoup de recherche."

48 Theodore REFF, *Manet: Olympia*, Art in Context (London, 1976), p. 93. Reff states that the same model appears in Manet's *La nymphe surprise* (Oslo,

Nasjonalgalleriet), though none of the figures is in fact black, and in *Enfants aux Tuileries* (Providence, Rhode Island School of Design) where a black *bonne* is, however, too sketchily painted to be identified. Manet is often said to have portrayed Jeanne Duval, a mulatto, in a painting in Budapest, Szépművészeti Múzeum, but this identification cannot be maintained; see Jean ADHÉMAR, "A propos de *La maîtresse de Baudelaire* par Manet (1862), un problème," *Gazette des Beaux-Arts*, 6th ser., 102, no. 1378 (November 1983):178.

49 Montpellier, Musée Fabre, 18.1.3. See *Les chefs-d'œuvre du musée de Montpellier*, Exhibition catalogue, Paris, Musée de l'Orangerie, March–April 1939 ([Paris], 1939), p. 20, no. 8; François DAULTE, *Frédéric Bazille et son temps* (Geneva, 1952), p. 188, no. 51 (illus.); J. Patrice MARANDEL and François DAULTE, *Frédéric Bazille and Early Impressionism*, Exhibition catalogue, Chicago, Art Institute of Chicago, 4 March–30 April 1978 (Chicago, 1978), pp. 112–13, no. 55 (illus.); *The Second Empire, 1852–1870: Art in France under Napoleon III*, Exhibition catalogue, Philadelphia, Philadelphia Museum of Art, 1 October–26 November 1978; Detroit, Detroit Institute of Arts, 15 January–18 March 1979; Paris, Grand Palais, 24 April–2 July 1979 (Philadelphia, 1978), pp. 251–52, no. VI-4 (illus.).

50 Frédéric Bazille writing to his mother, undated letter, quoted in MARANDEL and DAULTE, *Frédéric Bazille and Early Impressionism*, p. 209.

51 Bazille writing to his mother in a letter dated 26 May 1870, quoted in ibid. The letter, however, appears to be incorrectly dated since it refers to events in January and to work on the picture which was completed for submission for the jury of the Salon on 20 March 1870. *La toilette* is located in Montpellier, Musée Fabre, 18.1.2; cf. MARANDEL and DAULTE, *Frédéric Bazille and Early Impressionism*, p. 112, no. 54 and color reprod. on p. 14.

52 The version not illustrated here is in Washington, D. C., National Gallery of Art, 1983.1.6; cf. DAULTE, *Frédéric Bazille et son temps*, p. 188, no. 52 (illus.).

53 São Paulo, Museu de Arte de São Paulo, 85. The model was first identified as Scipion by Ambroise VOLLARD, *Paul Cézanne* (Paris, 1914), p. 23 and pl. 4. We are grateful to John Rewald for allowing us to read a draft of the entry that will be published in his forthcoming catalogue of Cézanne's works.

54 REFF, *Manet: Olympia*, pp. 32–33, fig. 11.

55 In the catalogue of the Salon of 1868 the sculptor's name was misprinted *Salari*; cf. Paris, *Salon de 1868*, p. 497, no. 3843.

56 Emile ZOLA, "Mon Salon" (May 1868) in *Salons*, ed. F. W. J. HEMMINGS and Robert J. NIESS, Publications romanes et françaises, 63 (Geneva, 1959), p. 143. [The French text is: "Je trouve dans Philippe Solari un de nos deux ou trois sculpteurs vraiment modernes. . . . Il a dit adieu au rêve de beauté absolue, il ne cherche pas à tailler des idoles pour une religion qui n'existe plus depuis deux mille ans. La beauté pour lui est devenue l'expression vivante de la nature, l'interprétation individuelle du corps humain. Il prend le premier modèle venu, le traduit littéralement dans sa grâce ou sa force, et fait ainsi une œuvre vraie. . . ."]

57 Cf. part 1 of this volume, pp. 154–55, fig. 92.

58 ZOLA, "Mon Salon," pp. 143–44. [The French text is: "La tête est superbe, petite, aplatie: une tête de bête humaine, idiote et méchante. Le corps a une souplesse féline, des membres nerveux, des reins cambrés et puissants. Il y a d'admirables morceaux dans le dos et les bras. On sent que c'est là une interprétation exacte, car tout est logique dans cette figure qui pourrait être la personnification de cette race nègre, paresseuse et sournoise, obtuse et cruelle, dont nous avons fait une race de bêtes de somme."]

59 Maurice Le Blond in a footnote to Zola's letter of 8 June 1868 to Philippe Solari, declares that Solari's statue représented an "esclave nègre poursuivi par des chiens"; see Emile ZOLA, *Les œuvres complètes*, ed. Maurice LE BLOND, vol. XLVIII (Paris, 1928), *Correspondance (1858–1871)*, p. 335 n. 2. Although it was entitled in the Salon catalogue simply *Nègre endormi*, this interpretation may have been placed on it.

60 Linz, Neue Galerie der Stadt Linz, 23; cf. *Symboles et réalités: La peinture allemande 1848–1905*, Exhibition catalogue, Paris, Musée du Petit Palais, 12 October 1984–13 January 1985 (Paris, 1984), pp. 110–11, no. 14 (illus.).

61 Corinth's *Harem* is located in Darmstadt, Hessisches Landesmuseum, GK 1141, F 62: 6051.

62 For the model Wilson see *supra*, pp. 22–27 and figs. 9–12.

63 Amsterdam, Stedelijk Museum, 2206. See Paulus Hendrik HEFTING, *G. H. Breitner in zijn Haagse Tijd*, Orbis artium: Utrechtse Kunsthistorische Studiën, 12 (Utrecht, 1970), pp. 52, 108 n. 29. The other artists who drew or painted Boutar were: Suze Robertson (Otterlo, Rijksmuseum Kröller-Müller, 1124-43), Willem de Zwart (Otterlo, Rijksmuseum Kröller-Müller, 234 Kl.106), Tony Offermans, and Marius van der Maarel.

64 Private Collection, Belgium.

65 Cf. Marcel DE MAEYER, "De genese van masker-, travestie- en skeletmotieven in het œuvre van James Ensor," *Bulletin des Musées royaux des Beaux-Arts de Belgique* 12 (1963):69–88.

66 *Journal des Débats* (18 January 1879), quoted in Martin DAVIES, *National Gallery Catalogues: French School*, 2d ed. (London, 1957), p. 73.

67 Of the four pastel drawings one is in London, Tate Gallery (No4710), a second in Birmingham, Barber Institute, and the other two in private collections; for reproductions see Paul André LEMOISNE, *Degas et son œuvre*, Les artistes et leurs œuvres: Etudes et documents (Paris, 1946–49), vol. II, *Peintures et pastels, 1853–1882*, pp. 294–97, nos. 522–25.

68 London, National Gallery of Art, 4121; cf. DAVIES, *National Gallery Catalogues: French School*, pp. 72–74, no. 4121; Fiorella MINERVINO, *Tout l'œuvre peint de Degas*, trans. Simone DARSES, Les classiques de l'art (Paris, 1974), pp. 112, no. 560.

69 Theodore REFF, *Degas: The Artist's Mind* (New York, 1976), p. 171.

70 Edgar Degas writing to Lorentz Frölich, [27 November 1872]; see Hilaire-Germain-Edgar DEGAS, *Lettres de Degas*, ed. Marcel GUÉRIN, Les cahiers verts, 7 (Paris, 1931), p. 5. [The French text is: "Rien ne me plaît comme les négresses de toute nuance, tenant dans leurs bras des petits blancs, si blancs . . . Et les jolies femmes de sang pur et les jolies quarteronnes et les négresses si bien plantées!"] His remark regarding Biard is in a letter (pp. 9–10) to Henri Rouart dated 5 December 1872.

71 The one known exception is Degas's painting *Enfants assis sur le seuil d'une maison* (Charlottenlund, Ordrupgaardsamlingen) with a black woman in its lower left-hand corner. See *Katalog over Ordrupgaardsamlingen* (Copenhagen, 1982), no. 31, and MINERVINO, *Tout l'œuvre peint de Degas*, p. 102, no. 346 and pl. XIX. We are grateful to George T. M. Shackelford for bringing this picture to our attention.

72 *Le Rire*, 2, no. 73 (28 March 1896):12. The drawing is in Albi, Musée Toulouse-Lautrec; see Maurice JOYANT, *Henri de Toulouse-Lautrec, 1864–1901* (Paris, 1926–27), vol. II, *Dessins, estampes, affiches*, p. 219.

73 Baltimore, Baltimore Museum of Art, BMA 1952.52.25; see Loys DELTEIL, *Le peintre-graveur illustré (XIXᵉ et XXᵉ siècles)*, vol. X, *H. de Toulouse-Lautrec* (1920; reprint ed., New York, 1969)), pt. 1, pl. 98.

74 Frankfurt on Main, Städelsches Kunstinstitut, 1352; cf. Joseph August BERINGER, *Trübner: Des Meisters Gemälde*, Klassiker der Kunst in Gesamtausgaben, 26 (Stuttgart and Berlin, 1917), pp. xix, 32 (illus.). The only contemporary newspaper with this title appears to have been the orthodox *Libertà Cattolica* published in Naples. The title may have been an invention of the artist.

75 A painting by Trübner with this title was exhibited in Munich in 1890; cf. Friedrich von BOETTICHER, *Malerwerke des neunzehnten Jahrhunderts: Beitrag zur Kunstgeschichte* (1891–1901; reprint ed., Hofheim am Taunus, 1979), vol. II, pt. 2, p. 902, s.v. "Trübner, Heinrich Wilhelm," no. 27. It is probable but not certain that this was the picture of the man reading a newpaper which was acquired from the artist by the Städelsches Kunstinstitut in 1900 and entitled *Kulturbeleckt*; see Ernst HOLZINGER and Hans-Joachim ZIEMKE, *Kataloge der Gemälde im Städelschen Kunstinstitut, Frankfurt am Main* (Frankfurt-am-Main, 1972), vol. I, *Die Gemälde des 19. Jahrhunderts: Textband*, pp. 437–38; *Bildband*, pl. 220.

76 Heidelberg, Kurpfälzisches Museum, G 2134; see BERINGER, *Trübner*, p. 30 (illus.).

77 Hanover, Niedersächsische Landesgalerie, PNM 358; ibid., p. 31 (illus.). *Kasensturz* was exhibited at the Berlin Academy in 1874 and in Munich in 1888; see BOETTICHER, *Malerwerke des neunzehnten Jahrhunderts*, vol. II, pt. 2, p. 902, s.v. "Trübner, Heinrich Wilhelm," nos. 1, 17.

78 [Heinrich] Wilhelm TRÜBNER, *Personalien und Prinzipien*, 2d and 3d ed. (Berlin, [1918]), quoted by Ulrich FINKE, *German Painting from Romanticism to Expressionism* (London, 1974), p. 154.

79 For example, Puvis de Chavannes's *Négrillon à l'épée* (1850) and *"Petit nègre, marchand de tortues à Venise"* (1854), both in private collections in France; see *Puvis de Chavannes 1824–1898*, Exhibition catalogue, Paris, Grand Palais, 26 November 1976–14 February 1977; Ottawa, Galerie nationale du Canada, 18 March–1 May 1977 (Paris, 1976), p. 32, no. 2 and p. 34, fig. 2; pp. 44–45, no. 16 (illus.).

80 Amsterdam, Private Collection.

81 Hans REDEKER and Adriaan VENEMA, *C. J. Maks* (Amsterdam, 1976), p. 26, mention it simply as the first painting by the artist to be seen in Amsterdam. It was exhibited at the gallery of Frans Buffa & Zonen, Amsterdam, February 1912, with eight other paintings which included several of theatrical subjects: *Danseuses, Balletteuses,* and *Chanteuse Légère.* The widow of the artist states that the portrait was painted in Amsterdam in 1905 (information supplied by Leo van Heijningen). Black men and women were the subjects of several later paintings by C. J. Maks, including his three-quarter-length portrait of a Zulu in an English colonial army uniform (Deurne, Museum Dinghuis Deurne, on loan from The Hague, Dienst Verspreide Rijkscollecties, AB.2038).

82 Jean FINOT, *Le préjugé des races,* 2d ed. (Paris, 1905), pp. 1–2. [The French text is: "La conception jadis si innocente des races a jeté comme un linceul tragique sur la surface de notre sol. . . . D'un côté, l'inégalité organique (*anthropologie*) basée sur des données d'une science mal définie et sujette à toutes sortes d'erreurs; de l'autre, l'inégalité anthropo-psycho-sociologique (*anthropo-sociologie* ou *psychologie*), qui ajoute aux fondements chancelants de la première une phraséologie empruntée à des doctrines fantaisistes et éphémères."] Unfortunately this work is distinguished more by the author's desire to overcome prejudice than his reasoning, based on supposedly scientific notions as outdated as those of the racists.

83 Charles DARWIN, *On the Origin of Species by Means of Natural Selection; or, The Preservation of Favoured Races in the Struggle for Life* (1859; Harmondsworth, 1968), p. 456.

84 H. E. Egerton quoted in Basil DAVIDSON, *Africa in History: Themes and Outlines,* rev. ed. (London: Collier Books, 1974), p. 51.

85 Frankfurt on Main, Frobenius-Institut, 2227.

86 The book was translated into English (*The Heart of Africa* [New York, 1874]), into French (*Au cœur de l'Afrique* [Paris, 1875]), and into Italian (*Nel cuore dell'Africa* [Milan, 1875]). Some of the illustrations in the Italian edition are signed by Alexandre de Bar who had been on an earlier expedition up the Nile.

87 Philip D. CURTIN, *The Image of Africa: British Ideas and Action, 1780–1850,* 2 vols. in one (Madison, 1964), vol. II, p. 319.

88 Carlo PIAGGIA, *Nella terra dei Niam-Niam (1863–1865) da i "Viaggi di Carlo Piaggia nell'Africa Centrale",* ed. Ezio BASSANI ([Lucca], 1978) and *Carlo Piaggia e l'Africa. Mostra fotografica: Catalogo,* Exhibition catalogue, Lucca, Istituto Storico Lucchese, 1979 (Lucca, 1979).

89 Riou began to illustrate travel books before he had been out of France. He was in Egypt 1869–73 but is not known to have gone farther south. For his career see Marcus OSTERWALDER, *Dictionnaire des illustrateurs 1800–1914 (Illustrateurs, caricaturistes et affichistes)* (Paris, 1983), pp. 895–96.

90 Léon Dardenne, a Belgian painter, went on the scientific Katanga mission led by Charles Lemaire, which crossed the continent from the mouth of the Zambezi to that of the Congo in 1898–1900; cf. E.-J. DEVROEY and C. NEUHUYS-NISSE, *Léon Dardenne, 1865–1912: Peintre de la Mission scientifique du Katanga (1898–1900)* (Tervuren, 1965). Franz Thorbecke, while preparing his three-volume book on the Cameroon highlands, was accompanied by his wife, Marie-Pauline, a talented painter of watercolors, several of which are now in Mannheim, Städtisches Reiß-Museum.

91 Quoted in Eike HABERLAND, ed., *Leo Frobenius 1873–1973: An Anthology,* trans. Patricia CRAMPTON (Wiesbaden, 1973), p. viii.

92 Now in Frankfurt on Main, Frobenius-Institut. Some were reproduced in the book by Leo FROBENIUS, *Im Schatten des Kongostaates; Bericht über den Verlauf der ersten Reisen der D. I. A. F. E. von 1904–1906, über deren Forschungen und Beobachtungen auf geographischem und kolonialwirtschaftlichem Gebiet* (Berlin, 1907).

93 Ute LUIG, *Leo Frobenius: Von Schreibtisch zum Äquator* (Frankfurt on Main, 1982), p. 49.

94 The painting was probably worked up in Europe for illustration in FROBENIUS, *Im Schatten des Kongostaates,* pl. IV (facing p. 48). Frobenius described the ceremony (p. 74) as follows: "Mittlerweile wird mir mitgeteilt, was diese Zeremonie vorstellt. Diese Damen werden der Fruchtbarkeit entgegengebracht. Die auf der Kitanda vorn saß, ist eine Frau des Häuptlings von Belo, die ihr Eheglück durch langanhaltende Kinderlosigkeit bedroht sah— was man übrigens nach der mächtigen Entwicklung ihres Busens kaum geahnt hätte—und die nun in einer Hütte sechs Monate eingeschlossen und zurückgezogen gelebt hat, um sich auf die heutige Nacht gebührend vorzubereiten. Denn heute wird sie wieder mit ihrem edlen Gatten Hochzeit halten, nachdem sie, wie gesagt, sechs Monate von ihm geschieden war, nachdem heute Abend die Tänze wohl und gut ausgeführt und die Schultern der auf glückliches Mutterleben Bedachten genügend mit Öl begossen worden sind. Demnach wird dem Feste sicherlich ein Kronprinz im Schulzenamte zu Belo entspringen. Nr. 2 auf der Kitanda ist eine Leidensgefährtin, Nr. 3 auf den Schultern des Mannes eine Dienerin von Nr. 1."

95 Frankfurt on Main, Frobenius-Institut, 310.

96 Frankfurt on Main, Frobenius-Institut, 676.

97 Frankfurt on Main, Frobenius-Institut, 529.

98 His first book *Five Years with the Congo Cannibals* (London, 1890) has twenty-one illustrations signed or initialed by Ward. *The Antics of the Charm-Doctor* (p. 41), signed W. B. Davis, provided the pose for his statue of 1902 (see *infra,* n. 100). For his statue *Defiance* of 1909 (Washington, D. C., Smithsonian Institution, Museum of Natural History, Department of Anthropology, 323,736) he employed a model in Paris described as a "mild mannered negro"; cf. *Smithsonian Institution: The Herbert Ward African Collection* (Washington, D. C., 1924), p. 26.

99 *Smithsonian Institution: The Herbert Ward African Collection,* p. 20. The approach of a later sculptor, Malvina Hoffman, who modeled statues of a wide range of ethnic "types," including several Africans, for the Hall of Man, Field Museum, Chicago, in 1930–33 was similar, as described in her *Heads and Tales* (New York, 1936). See *infra,* p. 240, fig. 182.

100 Washington, D. C., Smithsonian Institution, Museum of Natural History, Department of Anthropology, 323,732, 323,730, 323,737, 323,731, 323,735. Bronze casts of all of Ward's statues are in the Smithsonian Institution. For reproductions of several of his sculptures see Gaston-Denys PÉRIER, "Le Congo interprété par les artistes," *La Nervie,* special issue no. 7–8 (1927):1–12.

101 WARD, *Five Years with the Congo Cannibals,* p. 128.

102 Tervuren, Musée Royal de l'Afrique Centrale, RG 804/383, RG 804/A 384, RG 804/385, RG 804/386 (all in plaster).

103 Cf. part 1 of this volume, pp. 297–98.

104 Washington, D. C., Smithsonian Institution, Museum of Natural History, Department of Anthropology, 323,734.

105 Sarita WARD, *A Valiant Gentleman, Being the Biography of Herbert Ward, Artist*

and Man of Action (London, 1927), pp. 168–69 (illus.). The plaster version of the statue was exhibited in Paris in the Salon of 1912 and the bronze in the Salon of 1913; cf. *Société des artistes français. Exposition annuelle des Beaux-Arts: Salon de 1912* (Paris, 1912), p. 378, no. 4147; *Société des artistes français. Exposition annuelle des Beaux-Arts: Salon de 1913*, 3d ed. (Paris, 1913), p. 378, no. 4136. The bronze was acquired by the Africana Museum of Johannesburg.

106 Joseph CONRAD, "Heart of Darkness" (1899) in *Youth: A Narrative, Heart of Darkness, The End of the Tether*, Everyman's Library, 1694 (London, 1974), pp. 96–97.

107 Herbert WARD, *A Voice from the Congo* (London, 1910), p. 287.

108 The photograph of Ward's studio reproduced herein is one of several belonging to the Smithsonian Institution, Museum of Natural History, Department of Anthropology, as do the art and artifacts from his collection. See also *L'Orientalisme & l'Africanisme dans l'art belge, 19ᵉ & 20ᵉ siècles*, Exhibition catalogue, Brussels, Galerie CGER, 14 September–11 November 1984 (Brussels, 1984), p. 93, fig. 2.

109 Quoted by Dora VALLIER, "Braque, la peinture et nous," *Cahiers d'art* 29, no. 1 (October 1954):14. [The French text is: "Les masques nègres aussi m'ont ouvert un horizon nouveau. Ils m'ont permis de prendre contact avec des choses instinctives, des manifestations directes qui allaient contre la fausse tradition. . . ."]

110 Walter HOUGH, "An Appreciation of the Scientific Value of the Herbert Ward African Collection" in *Smithsonian Institution: The Herbert Ward African Collection*, p. 49.

111 Washington, D. C., Smithsonian Institution, Museum of Natural History, Department of Anthropology, 323,729. *Le Salon: CXXIIᵉ Exposition officielle* (Paris, 1904), p. 363, no. 3368.

112 Ibid., p. 280, no. 2622.

113 Paris, Musée du Luxembourg, no. 219; today in Marseilles, Musée des Beaux-Arts, on loan from Paris, Musée d'Orsay, RF 1415.

114 William H. SCHNEIDER, *An Empire for the Masses: The French Popular Image of Africa, 1870–1900*, Contributions in Comparative Colonial Studies, 11 (Westport, CT and London, 1982), pp. 136–46. Schneider notes (p. 148) an exhibition of Fulani craftsmen in Lyons in 1894.

115 Quoted by Michel HOOG, "Questions sur Gauguin" in *Le chemin de Gauguin: Genèse et rayonnement*, 2d ed., Exhibition catalogue, Saint-Germain-en-Laye, Musée départemental du Prieuré, 7 October 1985–2 March 1986 (Saint-Germain-en-Laye, 1985), p. 13.

116 Paul Gauguin writing to his wife Mette Gauguin in March 1892; cf. Paul GAUGUIN, *Lettres de Gauguin à sa femme et à ses amis*, ed. Maurice MALINGUE (Paris, 1946), p. 221. [The French text is: "Mon centre artistique est dans mon cerveau et pas ailleurs. . . ."]

117 Gauguin writing to his wife in March and early April 1887; cf. ibid., pp. 99, 101.

118 Cf. *supra*, pp. 206, 212–13.

119 Gauguin writing to his wife 20 June 1887; cf. GAUGUIN, *Lettres de Gauguin*, pp. 109–10. [The French text is: "Des nègres et négresses circulent toute la journée avec leurs chansons créoles et un bavardage éternel. Ne pas croire que c'est monotone, au contraire très varié. Je ne pourrai te dire mon enthousiasme de la vie dans les colonies françaises. . . . La nature la plus riche, le climat chaud mais avec intermittence de fraîcheur. . . . Pour tout travail surveiller quelques nègres pour la récolte des fruits et des légumes sans aucune culture."]

120 The present location of Gauguin's drawing is unknown; see Roger CUCCHI, *Gauguin à la Martinique: Le musée imaginaire complet de ses peintures, dessins, sculptures, céramiques, les faux, les lettres, les catalogues d'expositions* (Vaduz, 1979), pl. X. The painting belongs to the Rijksmuseum Vincent van Gogh, Amsterdam [B 3396 (S 221 V)]. See Gabriele Mandel SUGANA, *Tout l'œuvre peint de Gauguin*, trans. Simone DARSES, Les classiques de l'art (Paris, 1981), p. 90, no. 67 (illus.); Belinda THOMSON, *Gauguin*, World of Art (London, 1987), pp. 50, 52 and pp. 54–55, figs. 43, 44.

121 Jules HURET, "Paul Gauguin devant ses tableaux," *L'Echo de Paris* (23 February 1891), quoted in *Le chemin de Gauguin*, p. 139. [The French text is: "Je pars pour être tranquille, pour être débarrassé de l'influence de la civilisation. Je ne veux faire que de l'art simple, très simple; pour cela, j'ai besoin de me retremper dans la nature vierge, de ne voir que des sauvages, de vivre de leur vie, sans autre préoccupation que de rendre, comme le ferait un enfant, les conceptions de mon cerveau avec l'aide seulement des moyens d'art primitifs, les seuls bons, les seuls vrais."]

122 Buffalo, Albright-Knox Art Gallery, 65:1.

123 Paul GAUGUIN, *Cahier pour Aline*, ed. Suzanne DAMIRON (Paris, 1963), an unpaginated facsimile of the original manuscript in the Université de Paris, Bibliothèque d'art et d'archéologie.

124 Kirk VARNEDOE, "Gauguin" in William RUBIN, ed., *"Primitivism" in 20th Century Art: Affinity of the Tribal and the Modern*, Exhibition catalogue, New York, Museum of Modern Art; Detroit, Detroit Institute of Arts; Dallas, Dallas Museum of Art, 1984 (New York, 1984), vol. I, p. 208 n. 60. Our account of Gauguin is much indebted to Varnedoe's essay.

125 Gauguin writing to Daniel de Monfreid, May 1902; see Paul GAUGUIN, *Lettres à Daniel de Monfreid* (Paris, 1950), ed. Victor SEGALEN, p. 188. [The French text is: ". . . savoir un peu lequel de nous deux valait le mieux: du sauvage naïf et brutal ou le civilisé pourri."]

126 VARNEDOE, "Gauguin," pp. 207–8 n. 49.

127 Daniel de Monfreid writing to Gauguin, 9 June 1903, quoted by Jean-Claude BLACHÈRE, *Le modèle nègre: Aspects littéraires du mythe primitiviste au XXᵉ siècle chez Apollinaire, Cendrars, Tzara* (Dakar, Abidjan, and Lomé, 1981), p. 10. [The French text is: "Non; ces toiles sont très belles; mais je ne veux pas avoir uniquement des figures de nègres."]

128 Victor SEGALEN, *Essai sur l'exotisme: Une esthétique du divers (Notes)* (Montpellier, 1978), pp. 66, 75. This volume includes the various notes made by Segalen between 1904 and 1918 for the essay which he never wrote. [The French texts are: "Il sera peu question de tropiques et de palmes, de cocotiers, aréquiers, goyaviers, fruits et fleurs inconnus; de singes à face humaine et de nègres à façons de singes. . . ." "la Loi fondamentale . . . de l'exaltation du Sentir; donc de vivre. C'est par la Différence, et dans le Divers que s'exalte l'existence."]

129 Brief article by Arsène ALEXANDRE in *Comœdia* (19 March 1910), quoted by Germain VIATTE, "Lettres inédites à Ambroise Vollard," *Art de France*, no. 2 (1962):335. [The French text is: "Quand je pénètre dans ces serres et que je vois ces plantes étranges des pays exotiques, il me semble que j'entre dans un rêve! je me sens moi-même un tout autre homme."]

130 Wilhelm UHDE, *Henri Rousseau* (Paris, 1911), p. 43. The story was repeated by Guillaume APOLLINAIRE, *Il y a*, Collection La Phalange (Paris, 1925), p. 170.

131 New York, Museum of Modern Art, 646.39. See Roger SHATTUCK et al., *Henri*

Rousseau, Exhibition catalogue, Paris, Galeries nationales du Grand Palais, 14 September 1984–7 January 1985; New York, Museum of Modern Art, 21 February–4 June 1985 (New York, 1985), pp. 140–43, no. 19 (illus.).

132 Henri Rousseau writing to the mayor of Laval, 19 July 1898, quoted in SHATTUCK et al., *Henri Rousseau*, p. 140.

133 Rousseau could have seen Matout's painting before 1889 as he had a *carte de copiste* for the French national museums from 1884; see Geneviève LACAMBRE, *Le Musée du Luxembourg en 1874*, Exhibition catalogue, Paris, Grand Palais, 31 May–18 November 1974 (Paris, 1974), pp. 134–36, no. 172 (illus.). Matout's painting is now in Mâcon, Musée Municipal des Ursulines, on loan from Paris, Musée national du Louvre, Département des Peintures, RF 610. On the parallels with Gérôme and Clément, see SHATTUCK et al., *Henri Rousseau*, p. 140 and p. 141, fig. 1.

134 Paris, Musée national d'Art moderne, Centre national d'Art et de Culture Georges Pompidou, on loan from Paris, Musée d'Orsay, RF 1937-7; cf. SHATTUCK et al., *Henri Rousseau*, pp. 181–83, no. 36 (illus.).

135 Basel, Öffentliche Kunstsammlung, Kunstmuseum Basel, 2225; cf. ibid., pp. 242–44, no. 63 (illus.).

136 *La lutte de Jumah avec le léopard* by E. Riou in *Le Tour du Monde*, no. 1 (1888) and the photograph of a "young jaguar" in *Bêtes sauvages. Environ 200 illustrations amusantes de la vie des animaux* (Paris; Grands Magasins "Aux Galeries Lafayette," [after 1906]), p. 152, are both reproduced in Yann LE PICHON, *The World of Henri Rousseau*, trans. Joachim NEUGROSCHEL (New York, 1982), p. 156.

137 Thadée NATANSON, "Petite gazette d'art: L'art des Salons," *La revue blanche* 12, no. 94 (1 May 1897):559. [The French text is: "Parmi d'autres, il faudrait parler surtout de M. Henri Rousseau, dont la naïveté acharnée parvient comme à un style et dont la simplicité, ingénue, entêtée, a la gloire de faire songer, sans rapport aucun que la bonne volonté, à des œuvres primitives. Sa gaucherie, touchante, mérite sans doute infiniment plus d'attention que quantité d'œuvres insipides qui, dans les grands Salons, motivent tant d'oiseaux commentaires."]

138 In addition to West African ivory carvings, most of which seem to have been executed for Europeans, there were various artifacts including a carved wood Ife divination tray in the collection of Christoph Weickmann before 1659 (now in the museum in Ulm) and two wooden statuettes of uncertain West African origin in the Collection of Cardinal Giorgio Cornaro at Padua, ca. 1695; see Ezio BASSANI, *Scultura africana nei musei italiani*, Musei d'Italia, Meraviglie d'Italia, 12 (Bologna, 1977), pp. xiv–xv, 96–97, figs. 446–51. For the best account of the collections of African sculptures in the nineteenth and early twentieth centuries, see Jean-Louis PAUDRAT, "From Africa" in RUBIN, *"Primitivism" in 20th Century Art*, vol. I, pp. 125–75.

139 Philipp Franz von SIEBOLD, *Lettre sur l'utilité des musées ethnographiques et sur l'importance de leur création dans les états européens qui possèdent des colonies, ou qui entretiennent des relations commerciales avec les autres parties du monde* (Paris, 1843), p. 17. [The French text is: "Missionnaires, savants, voyageurs-naturalistes, employés militaires ou civils, marchands et marins, tous pourront, avant de quitter le pays natal, et sous la simple direction d'un catalogue raisonné, acquérir, dans un musée de ce genre, des connaissances préparatoires qui seront d'un prix inestimable pour leurs travaux ultérieurs."]

140 René VERNEAU, "Le Musée d'Ethnographie du Trocadéro," *L'anthropologie* 29 (1918–19):557. [The French text is: "Les artistes qui traitent des sujets exotiques ne sauraient se passer des documents réunis au Trocadéro, pas plus que les commerçants exportateurs qui désirent entrer en relations avec des populations dont ils ont besoin de connaître les goûts."]

141 See, for example, Felix von LUSCHAN, "Altertümer von Benin," *Staatliche Museen zu Berlin: Veröffentlichungen aus dem Museum für Völkerkunde* 8 (1919):146 ff.

142 Baltimore, Baltimore Museum of Art, BMA 1950.228. See MaryAnne STEVENS, *The Orientalists: Delacroix to Matisse. European Painters in North Africa and the Near East*, Exhibition catalogue, London, Royal Academy of Arts; Washington, D. C., National Gallery of Art, 1984 (London, 1984), pp. 108 (color reprod.), 210–11, no. 98.

143 Quoted by Jack D. FLAM, "Matisse and the Fauves" in RUBIN, *"Primitivism" in 20th Century Art*, vol. I, p. 226.

144 Private Collection; cf. ibid., p. 214 (illus.).

145 Ibid., p. 216.

146 Baltimore, Baltimore Museum of Art, BMA 1950.430.

147 The photograph of the Tuareg women, which was cut out of a magazine by Matisse, belongs to the Matisse Archives. We are grateful to Isabelle Monod-Fontaine for making it available to us.

148 See Meyer SCHAPIRO, "Matisse and Impressionism," *Androcles* 1 (February 1932) and Isabelle MONOD-FONTAINE, *The Sculpture of Henri Matisse*, trans. David MACEY (London, 1984), p. 15.

149 TÉRIADE, "Emancipation de la peinture," *Minotaure* 1, no. 3–4 (1933), reprinted in Henri MATISSE, *Écrits et propos sur l'art*, ed. Dominique FOURCADE (Paris, 1972), p. 126. [The French texts are: "La photographie a beaucoup dérangé l'imagination, parce qu'on a vu les choses en dehors du sentiment." "Quand j'ai voulu me débarrasser de toutes les influences qui empêchent de voir la nature d'une façon personnelle, j'ai copié des photographies. Nous sommes encombrés des sentiments des artistes qui nous ont précédés. La photographie peut nous débarrasser des imaginations antérieures. La photographie a déterminé très nettement la peinture traduction de sentiments de la peinture descriptive. Cette dernière est devenue inutile."]

150 Henri MATISSE, "Notes d'un peintre sur son dessin," *Le Point*, no. 21 (July 1939) in MATISSE, *Écrits et propos sur l'art*, p. 163. [The French text is: "Si j'en rencontrais des pareilles dans la rue, je me sauverais épouvanté. Avant tout, je ne crée pas une femme, je fais un tableau."]

151 Bremen, Kunsthalle Bremen, 838-1961/9. See Gerhard GERKENS and Ursula HEIDERICH, eds., *Katalog der Gemälde des 19. und 20. Jahrhunderts in der Kunsthalle Bremen* (Bremen, 1973), vol. I, *Text*, pp. 153–54; vol. II, *Abbildungen*, pl. 416; Donald E. GORDON, *Ernst Ludwig Kirchner* (Cambridge, Mass., 1968), p. 274, no. 58v and p. 423, fig. 58v.

152 Friedrich NIETZSCHE, *The Will to Power* (1901), trans. Walter KAUFMANN and R. J. HOLLINGDALE (New York, 1967), p. 424, quoted by Donald E. GORDON, "German Expressionism" in RUBIN, *"Primitivism" in 20th Century Art*, vol. II, p. 371.

153 The painting is lost but known from a lithograph; cf. GORDON, *Ernst Ludwig Kirchner*, p. 292, no. 187.

154 The Yoruba carving is lost. For Nolde's drawing (Neukirchen, Stiftung Seebüll Ada und Emil Nolde, Z.Stud.2) and his painting *The Missionary* (Solingen-Oligs, Collection of Berthold Glauerdt), see Martin URBAN, *Emil Nolde: Catalogue Raisonné of the Oil-Paintings*, vol. I, *1895–1914* (London and New York, 1987), pp. 432 (color reprod.), 434–35, no. 497.

155 New York, Museum of Modern Art, 13.45; cf. GORDON, "German Expressionism," pp. 394–95 (illus.).

156 Ibid., pp. 395, 397 (illus.).

157 GORDON, *Ernst Ludwig Kirchner*, pp. 276, 292, 297, nos. 74, 186, 220. Kirchner's expressive use of color, however, sometimes makes it difficult to determine whether the figures are intended to represent blacks or whites.

158 Hans Albert PETERS, *Die Gemälde des 19. Jahrhunderts mit Ausnahme der Düsseldorfer Schule*, Kataloge des Kunstmuseums Düsseldorf: Malerei, 1 (Mainz am Rhein, 1981), pp. 246–48, no. 183 (illus.).

159 Dusseldorf, Kunstmuseum Düsseldorf, 5466.

160 In 1913–14, after completing *Der Sieger*, Slevogt visited Egypt and painted a number of oil sketches of an entirely different character with Africans figuring as part of the brilliantly sunlit scene, their black skins contrasted with staring white draperies, blue skies, and darker blue water. For several of these works see *Gemäldegalerie Neue Meister, Staatliche Kunstsammlungen Dresden*, 7th ed. (Dresden, 1982), pp. 94–95.

161 Chicago, Field Museum of Natural History, no inv. no.

162 HOFFMAN, *Heads and Tales*, p. 156.

163 David HUME, "Of National Characters" in *Essays Moral, Political, and Literary*, ed. Eugene F. MILLER (1741–42; Indianapolis, 1985), p. 208.

164 Wilson ARMISTEAD, *A Tribute for the Negro: Being a Vindication of the Moral, Intellectual, and Religious Capabilities of the Coloured Portion of Mankind; with Particular Reference to the African Race* (Manchester and New York, 1848), p. 111. The words were ascribed to Czar Alexander I.

165 Carl EINSTEIN, *Negerplastik* (1915) in *Gesammelte Werke*, ed. Ernst NEF (Wiesbaden, 1962), pp. 81, 92.

166 PAUDRAT, "From Africa" p. 153. For commentary on the exhibition see Marius de ZAYAS, "How, When, and Why Modern Art Came to New York," ed. Francis M. NAUMANN, *Arts Magazine* 54, no. 8 (April 1980): 109–12.

167 Marius de ZAYAS, *African Negro Art: Its Influence on Modern Art* (New York, 1916), pp. 6, 41. In common with other writers of the time de Zayas used the term *abstract* to cover Cubist painting.

168 André MALRAUX, *La tête d'obsidienne* (Paris, 1974), p. 18, quoted in William RUBIN, "Picasso" in RUBIN, *"Primitivism" in 20th Century Art*, vol. I, p. 255.

169 In his *Portrait of Daniel-Henry Kahnweiler* (Chicago, Art Institute of Chicago) two "background" configurations suggest a Polynesian carving and an African mask, possibly objects owned by the sitter; cf. RUBIN, "Picasso," p. 310. We are much indebted to Rubin's study of Picasso in this work.

170 Quoted in Alan G. WILKINSON, "Paris and London: Modigliani, Lipchitz, Epstein and Gaudier-Brzeska" in RUBIN, *"Primitivism" in 20th Century Art*, vol. II, p. 430.

171 Ibid., p. 432 (illus.); also Richard CORK, *Vorticism and Abstract Art in the First Machine Age* (London, 1976), vol. II, *Synthesis and Decline*, p. 461. The carving is in Toronto, Art Gallery of Ontario.

172 Present whereabouts unknown. Reproduced from Bernard van DIEREN, *Epstein* (London, 1920), pl. V. See Evelyn SILBER, *The Sculpture of Epstein with a Complete Catalogue* (Oxford, 1986), pp. 28, 31, 134, no. 51 (illus.). We are grateful to Dr. Silber for allowing us to see extracts from this book before publication.

173 BLACHÈRE, *Le modèle nègre*, p. 136.

1 Joshua Reynolds (1723–92). *Study of a Black Man.* Ca. 1770. Canvas. 78.7 × 63.7 cm. Houston, Menil Foundation Collection, 83-103 DJ.

2 Marie-Guilhelmine Benoist (1768–1826). *Portrait d'une négresse.* Signed. Paris, Salon, 1800, no. 238. Canvas. 81 × 65 cm. Paris, Musée national du Louvre, Département des Peintures, RF 2508.

3 John Singleton Copley (1738–1815). *Head of a Negro* (perhaps a study for *Watson and the Shark*). 1777–83. Canvas. 53.3 × 41.3 cm. Detroit, Detroit Institute of Arts, Gibbs-Williams Fund, 52.118.

4 Petrus Camper, fec. (1722–89). Reinier Vinkeles, sculp. (1741–1816). Illustration for Petrus Camper, *Verhandeling van Petrus Camper over het natuurlijk verschil der wezenstrekken in Menschen* . . . (Utrecht, 1791), Tab. I, figs. I–IV. Signed. Dated 1768 and 1785. Copper engraving. 275 × 460 mm. London, British Library, 1502/116(2).

5 Daniel Nikolaus Chodowiecki, del. (1726–1801). Johann Heinrich Lips, sculp. (1758–1817). Illustration for Johann Caspar Lavater, *Physiognomische Fragmente zur Beförderung der Menschenkenntniß und Menschenliebe* (Leipzig, 1775–78), vol. IV, pl. XIX, between pp. 310 and 311: *Nationalgesichter. Ein Spanier, Holländer, Mohr, Virginier.* 1775. Etching. 202 × 177 mm. Paris, Bibliothèque nationale, Département des Imprimés, V 1914.

6 Mme Migneret, sculp. Illustration for Julien Joseph Virey, *Histoire naturelle du genre humain,* 2d ed. (Paris, 1824), vol. II, pl. 8 (facing p. 42): *Espèces. 1. Blanche, angle facial 90°; 2. Nègre Eboë* . . . *75°; 3. Orang. (Singe)* . . . *65°.* Etching. 126 × 80 mm. New Haven, Yale University, Sterling Memorial Library, Nk 24801 VB.

7 Johann Gottfried Schadow (1764–1850). Illustration for Johann Gottfried Schadow, *National-Physionomieen* . . . (Berlin, 1835), pl. VIII. Lithograph. 590 × 450 mm. London, British Library, 562ˣh 23(2).

8 John Boyne (1750–1810). *A Meeting of Connoisseurs.* Signed. Ca. 1807. Watercolor on paper. 413 × 555 mm. London, Victoria and Albert Museum, 1703-1871.

9,10 Benjamin Robert Haydon (1786–1846). *Diary,* vol. III, fols. 24ᵛ and 25ʳ: sketches of Wilson, the black model. September 1810. Ink on paper. 322 × 189 mm. Cambridge, Houghton Library, Harvard University, Keats Collection, fMS Eng 1331(5) vol. III.

11 Benjamin Robert Haydon (1786–1846). Study of Wilson, the black model, seen from behind. Dated 1810. Chalk on paper. Approx. 394 × 520 mm. London, British Museum, Department of Prints and Drawings, 1881.7.9.545.

12 George Dawe (1781–1829). *A Negro Overpowering a Buffalo—A Fact Which Occurred in America, 1809.* British Institution, London, 1811, no. 92. Canvas. 203.8 × 204.4 cm. Houston, Menil Foundation Collection, 84–54 DJ.

13 Anne-Louis Girodet de Roucy-Trioson, called Girodet-Trioson (1767–1824). Study for *La révolte du Caire* exhibited in 1810. Pastel and pencil on paper. 455 × 585 mm. Avallon, Musée de l'Avallonnais, no inv. no.

14 Antoine-Jean Gros (1771–1835). *Harangue du général Bonaparte avant la bataille des Pyramides, 21 juillet 1798* (minus later additions). Signed. Paris, Salon, 1810, no. 390. Canvas. Current dims.: 389 × 511 cm. Versailles, Musée national du Château de Versailles, MV 1496.

15 Théodore Gericault (1791–1824). *Boxers.* 1818. Lithograph. 352 × 416 mm. Chicago, Art Institute of Chicago, The Avery Collection, 1923.1107.

16 Théodore Gericault (1791–1824). *Negro Soldier Holding a Lance.* 1822–23. Ink and wash over graphite on paper. 335 × 249 mm. Cambridge, Fogg Art Museum, Harvard University, Bequest of Meta and Paul J. Sachs, 1965.285.

17 Théodore Gericault (1791–1824). *Portrait of a Black Man (Joseph)*. Ca. 1818–19. Canvas. 46.5 × 38 cm. Malibu, J. Paul Getty Museum, 85.PA.407.

18 Eugène Delacroix (1798–1863). *Head of a Black Wearing a Turban*. Pastel on paper. 470 × 380 mm. Paris, Musée Eugène Delacroix, RF 32268.

19 French/19th century. *Portrait Study of a Negro*. Oil on paper mounted on canvas. 54.6 × 46.2 cm. Buffalo, Albright-Knox Art Gallery, 52:11.

20 Eugène Delacroix (1798–1863). *Portrait of Aspasie, the Mulatto Woman*. Ca. 1824. Canvas. 80 × 65 cm. Montpellier, Musée Fabre, 868.1.36.

21 Théodore Chassériau (1819–56). *Study of a Nude Black*. Ca. 1836–38. Canvas. 54.8 × 73.3 cm. Montauban, Musée Ingres, 867-180.

22 William Henry Hunt (1790–1864). Full-length study of a black model. Signed. Ca. 1830. Watercolor. 355 × 242 mm. New York, Collection of S. Baloga.

23 David Wilkie (1785–1841). Study for *The Empress Josephine and the Fortune-Teller*. Signed. Dated 1836. Watercolor on paper. 431 × 342 mm. Selkirk, Collection of the Duke of Buccleuch and Queensberry, K.T., Bowhill.

24 Jacques-Laurent Agasse (1767–1849). Study for *The Contrast: La négresse Albinos*. 1825. Canvas. 34 × 30 cm. Geneva, Musée d'Art et d'Histoire, Collection Gustave Revilliod, CR 5.

25 Jacques-Laurent Agasse (1767–1849). *The Contrast*. Monogrammed. Royal Academy, London, 1829, no. 508. Canvas. 92 × 70.5 cm. Bern, Kunstmuseum Bern, G 1978.3.

26 Carl Blechen (1798–1840). *Der Negerkorporal*. 1828–29. Watercolor and graphite on paper. 293 × 203 mm. Berlin (GDR), Staatliche Museen zu Berlin, Nationalgalerie, AdK 103.

27 Martinus Christian Wesseltoft Rørbye (1803–48). *Seated Nubian*. Monogrammed. Dated 1839. Canvas. 75 × 61 cm. Charlottenlund, Collection of Niels Arne Ravn-Nielsen.

28 William Lindsay Windus (1822–1907). *Black Boy*. 1844. Canvas. 76.1 × 63.5 cm. Liverpool, Walker Art Gallery, 1601.

29 Samuel Daniell (1775–1811). *Korah Man with a Spear in a Landscape*. Dated 12 January 1802. Pencil and sepia wash on paper. 262 × 183 mm. Present whereabouts unknown.

30 Samuel Daniell (1775–1811). *Bell and Daniell Albums*, vol. III, p. 50: *Bushmen Hottentots Armed for an Expedition*. Ca. 1802. Watercolor and pencil on paper. 127 × 177 mm. Johannesburg, Africana Museum, 65/3995.

31 Samuel Daniell (1775–1811). *Bell and Daniell Albums*, vol. III, p. 45: *Booshuana Women Manufacturing Earthen Ware*. Ca. 1802. Watercolor and pencil on paper. 159 × 216 mm. Johannesburg, Africana Museum, 65/4023.

32 Samuel Daniell (1775–1811). Illustration for *African Scenery and Animals*, pl. 1: *A Korah Hottentot Village on the Left Bank of the Orange River*. Dated 1 January 1804. Colored aquatint. 325 × 455 mm. London, British Museum, Department of Prints and Drawings, 175 e. 11, pl. 1.

33 Henry Clifford De Meillon (doc. 1823–32; died ca. 1856). *Portrait of Peclu*. Signed. Dated 1824. Oil on wood. 30.5 × 22.2 cm. Johannesburg, Africana Museum, 4477.

34 Henry Clifford De Meillon (doc. 1823–32; died ca. 1856). *Portrait of Hanacom*. Signed. Dated 1824. Oil on wood. 30.5 × 22.2 cm. Johannesburg, Africana Museum, 4478.

35 Nicolas Huet le Jeune (ca. 1770–?). Profile view of Saartjie Baartman, the "Hottentot Venus." Signed. Dated March 1815. Watercolor on vellum. 440 × 307 mm. Paris, Muséum national d'Histoire naturelle, Bibliothèque centrale, Collection des vélins, vol. 69, no. 2.

36 Léon de Wailly (act. 1801–24). Frontal view of Saartjie Baartman, the "Hottentot Venus." Signed. Dated January 1815. Watercolor on vellum. 483 × 335 mm. Paris, Muséum national d'Histoire naturelle, Bibliothèque centrale, Collection des vélins, vol. 69, no. 1.

37 James Ward (1769–1859). *Three Views of the Head of a Native, Probably a Sakalava, Madagascar*. Signed. Dated 1815. Canvas. 59.7 × 80.5 cm. London, Museum of Mankind, no inv. no.

38 Auguste-Xavier Leprince (1799–1826). *Lion Hunt*. Signed. Dated 1826. Canvas. 46.5 × 38 cm. Paris, Collection of Henri Samuel.

39 Pavel Petrovich Svinin (1787–1839). *"Worldly Folk" Questioning Chimney Sweeps and Their Master before Christ Church Philadelphia*. 1811–13. Watercolor on paper. 251 × 175 mm. New York, Metropolitan Museum of Art, Rogers Fund, 1942, 42.95.15.

40 Pavel Petrovich Svinin (1787–1839). *Negro Methodists Holding a Meeting in Philadelphia*. 1811–13. Watercolor on paper. 168 × 254 mm. New York, Metropolitan Museum of Art, Rogers Fund, 1942, 42.95.19.

65 William James Müller (1812–45). *Eastern Letter Writer*. Signed. Dated 1841. Oil on wood. 31.8 × 24.1 cm. Glasgow, Glasgow Art Gallery and Museum, 1139.

66 William James Müller (1812–45). *A Study of Five Negro Heads*. Ca. 1840. Canvas. 50.2 × 68.6 cm. London, Spink & Son Ltd., K2 4273.

67 Marc-Charles-Gabriel Gleyre (1806–74). *Nubienne*. 1835. Gouache on paper. 285 × 211 mm. Lausanne, Musée cantonal des Beaux-Arts, D.1021.

68 Georges-Antoine-Prosper Marilhat (1811–47). *La sultane noire*. Lead pencil on paper. 230 × 191 mm. Paris, Ecole nationale supérieure des Beaux-Arts. Bibliothèque, 1232.

69 John Frederick Lewis (1805–76). *The Harem*. Ca. 1876. Oil on wood. 89 × 112 cm. Birmingham, City Museum and Art Gallery, P 14.49.

70 Jean-Pierre Dantan, called Dantan jeune (1800–1869). *Gala*. Signed. Dated 1848. Plaster. H (without base): 26.3 cm. Paris, Musée Carnavalet, S 1156.

71 Charles Cordier (1827–1905). *Nègre du Darfour*, also entitled *Nègre de Tombouctou*. Signed. Dated 1848. Bronze. H: 83 cm. Paris, Muséum national d'Histoire naturelle, Musée de l'Homme, Laboratoire d'anthropologie, MH 27.051/1977.207.

72 Charles Cordier (1827–1905). *Vénus africaine*, later entitled *Négresse des côtes d'Afrique*. Signed. Dated 1851. Bronze. H: 82 cm. Paris, Muséum national d'Histoire naturelle, Musée de l'Homme, Laboratoire d'anthropologie, MH 27.058/1977.214.

73 Charles Cordier (1827–1905). *Nègre en costume algérien*. Signed. Paris, Salon, 1857, no. 2818. Bronze, onyx, and marble. H: 75 cm. Paris, Musée d'Orsay, RF 2996.

74 Jean-Léon Gérôme (1824–1904). *Bashi-Bazouk*. Signed. 1869. Canvas. 81 × 65.8 cm. On permanent loan to Boston, Museum of Fine Arts, 35.1981.

75 Mariano Fortuny y Marsal (1838–74). *Portrait of a Moroccan Black, perhaps Farragi*. Signed. After 1861. Canvas. 46.1 × 36.8 cm. Houston, Menil Foundation Collection, 80–20 DJ.

76 Alfred Dehodencq (1822–82). *L'exécution de la Juive*. Study for the painting exhibited in Paris, Salon, 1861, no. 819. Signed. Canvas. 62 × 44.5 cm. Paris, Musée des Arts africains et océaniens, AF 12943.

77 Alfred Dehodencq (1822–82). *Danse des nègres à Tanger*. Signed. Paris, Salon, 1874, no. 557. Canvas. 152 × 202 cm. Paris, Musée d'Orsay, RF 2587.

78 Alfred Dehodencq (1822–82). *Black Musician*. 1854–63. Charcoal on paper. 333 × 210 mm. Paris, Musée national du Louvre, Cabinet des Dessins, RF 30028.

79 Léon Belly (1827–77). Study for the painting *Fellahs halant une dahbiek (Egypte)* exhibited in Paris, Salon, 1864, no. 132. Canvas. 55 × 40 cm. Saint-Omer, Musée de l'Hôtel Sandelin, 102 CM.

80 Léon-Joseph-Florentin Bonnat (1833–1922). *Barbier nègre, à Suez*. Signed. Paris, Salon, 1876, no. 214. Canvas. 80 × 58.5 cm. New York, *Forbes* Magazine Collection, P 72005.

81 Eugène Fromentin (1820–76). *Bateleurs nègres dans les tribus*. Signed. Paris, Salon, 1859, no. 1172; Paris, Salon, 1867, no. 618. Canvas. 96 × 137.5 cm. Private Collection.

82 Eugène Fromentin (1820–76). *Femmes arabes en voyage* (detail of figure 83).

83 Eugène Fromentin (1820–76). *Femmes arabes en voyage*. Signed. Dated [18]73. Oil on wood. 49.5 × 61.6 cm. Houston, Menil Foundation Collection, 83–105 DJ.

84 Gustave Achille Guillaumet (1840–87). *Marché arabe dans la plaine de Tocria*. Signed. Dated 1865. Canvas. 153 × 323 cm. Lille, Musée des Beaux-Arts, 614.

85 Gustave Achille Guillaumet. *Marché arabe dans la plaine de Tocria* (detail of figure 84).

86 Leopold Carl Müller (1834–92). *Markt in Kairo*. Signed. Dated 1878. Canvas. 136 × 216.5 cm. Vienna, Österreichische Galerie, LG 353, on loan from Vienna, Gemäldegalerie der Akademie der bildenden Künste.

87 Edouard-Auguste Nousveaux (1811–67). *Le prince de Joinville assistant à une danse nègre à l'Ile de Gorée (Sénégal), décembre 1842*. Signed. Dated 1846. Canvas. 131 × 178 cm. Versailles, Musée national du Château de Versailles, MV 6976.

88 Edouard-Auguste Nousveaux (1811–67). *Village de Diodoumé. (Fleuve du Sénégal)*. Signed. Ca. 1845. Canvas. 47 × 72 cm. Paris, Musée des Arts africains et océaniens, AF 14663.

89 Edouard-Auguste Nousveaux (1811–67). *Maison d'esclaves à Gorée*. Signed. Dated 1848. Watercolor on paper. 330 × 405 mm. (sight). Paris, Musée des Arts africains et océaniens, AF 7599.

90 George French Angas (1822–86). Preliminary drawing for George French Angas, *The Kafirs Illustrated* (London, 1849), p. 95: *A Zulu in Visiting Dress*. Signed. Dated 1847. Watercolor on paper. 327 × 237 mm. London, British Museum, Department of Prints and Drawings, 1876.5.10.502.

115 Edouard Manet (1832–83). *Olympia*. Signed. Dated 1863. Canvas. 130.5 × 190 cm. Paris, Musée d'Orsay, RF 644.

116 William James Müller (1812–45). *Slave Market, Cairo*. Signed. Dated 1841. Oil on wood. 61 × 104.1 cm. London, Guildhall Art Gallery, 828.

117 Karl Wilhelm Gentz (1822–90). *Sklavenmarkt in Kairo*. Signed. Dated 1851. Canvas. 187 × 147 cm. London, Sotheby's, Sale of 21–22 March 1984, no. 23.

118 Jean-Léon Gérôme (1824–1904). *Slave Market*. Signed. Paris, Salon, 1867, no. 642. Canvas. 84.3 × 63 cm. Williamstown, Sterling and Francine Clark Art Institute, 53.

119 Vincenzo Marinelli (1820–92). *Il Ballo dell'Ape*. Signed. Dated 1862. Canvas. 188 × 270 cm. Naples, Museo e Gallerie Nazionali di Capodimonte, P.S. 24.

120 Frank Buchser (1828–90). *Negermädchen im Bach*. Signed. 1867. Canvas. 76.5 × 64 cm. Solothurn, Museum der Stadt Solothurn, A 185.

121 Jean-Baptiste Carpeaux (1827–75). *Pourquoi naître esclave*. Signed. Dated 1868. Terracotta. H: 56 cm. Douai, Musée de la Chartreuse, 819.

122 John Bell (1811–95). *The Octoroon*. Signed. Royal Academy, London, 1868, no. 932. Marble. H: 159.6 cm. Blackburn, Town Hall, on loan from Blackburn, Blackburn Museum and Art Gallery, 1876-36.

123 Frank Buchser (1828–90). *Nackte Sklavin*. Signed. May-June 1880. Canvas. 54 × 33.5 cm. Solothurn, Museum der Stadt Solothurn, Bequest of Dr. J. Buchser, B 64.

124 Giacomo Ginotti (1837–97). *L'emancipazione dalla schiavitù*. Signed. Dated 1877. Marble. H: 155 cm. Naples, Museo e Gallerie Nazionali di Capodimonte, N. 168 PS.

125 Edward John Poynter (1836–1919). *Israel in Egypt*. Monogrammed. Dated 1867. Canvas. 137.1 × 316.8 cm. London, Guildhall Art Gallery, 1014.

126 Edward John Poynter (1836–1919). *Israel in Egypt* (detail of figure 125).

127 Edward John Poynter (1836–1919). *Israel in Egypt* (detail of figure 125).

128 Jules-Jean-Antoine Lecomte du Nouy (1842–1923). *Les porteurs de mauvaises nouvelles*. Signed. Dated 1871. Canvas. 74 × 121 cm. Tunis, Ministère des Affaires Culturelles.

129 Jules-Jean-Antoine Lecomte du Nouy (1842–1923). *La porte du sérail: Souvenir du Caire*. Signed. Dated 1876. Canvas. 74 × 130 cm. Paris, Collection of Pierre Bergé.

130 Ludwig Deutsch (1855–1935). *Nubian Guard*. Signed. Dated 1895. Oil on wood. 50.5 × 33 cm. Malibu, J. Paul Getty Museum, 78.PB.362.

131 Ludwig Deustch (1855–1935). *The Guards of the Harem*. Signed. Canvas. 78.7 × 96.5 cm. Jeddah, Collection of Mr. and Mrs. Waleed Y. Zahid.

132 Hans Makart (1840–84). *Death of Cleopatra*. Signed. 1875. Canvas. 191 × 255 cm. Kassel, Staatliche und Städtische Kunstsammlungen, Neue Galerie, L 86, on loan from the Federal Republic of Germany.

133 Jean-Joseph-Benjamin Constant, called Benjamin-Constant (1845–1902). Reduced replica of the painting exhibited in Paris, Salon of 1884, no. 588: *Les Chérifas* (detail). Canvas. 114 × 195 cm. Pau, Musée des Beaux-Arts, 80.1.1.

134 Rudolph Ernst (1854–1932). *The Master's Favorite*. Signed. Oil on wood. 46.5 × 33.5 cm. London, MacConnal-Mason Gallery.

135 Maurice Bompard (1857–1936). *Harem Scene*. Canvas. 40 × 56 cm. Marseilles, Musée des Beaux-Arts, C 229.

136 St. George Hare (1857–1933). *The Victory of Faith*. Signed. Royal Academy, London, 1891, no. 489. Canvas. 123.3 × 200 cm. Melbourne, National Gallery of Victoria, 201/2.

137 Fernand Le Quesne (1856–after 1928). *Les deux perles*. Signed. Salon, Paris, 1889, no. 1665. Canvas. 194.3 × 162.5 cm. New York, Christie, Manson & Woods, Sale of 25 February 1983, no. 23.

138,139 Aristide Sartorio (1860–1932). Diptych: *Diana d'Efeso e gli schiavi* and *La Gorgone e gli eroi*. Venice, Biennale, 1899. Canvas. 300 × 420 cm. (each). Rome, Galleria Nazionale d'Arte Moderna, 1242-45.

140 Thomas Eakins (1844–1916). *Portrait of a Black Woman*, formerly entitled *Negress*. 1867-69. Canvas. 58.4 × 50.2 cm. San Francisco, Fine Arts Museums of San Francisco, Mildred Anna Williams Fund, 1966.41.

141 Thomas Eakins (1844–1916). *Negro Boy Dancing*, initially entitled *The Negroes*. Signed. Dated [18]78. Watercolor on paper. 464 × 575 mm. New York, Metropolitan Museum of Art, Fletcher Fund, 1925, 25.97.1.

167 Carl Arriens (1869– ?). *Trachten der Muntschi (Nigeria)*. 1911. Watercolor on paper. 305 × 450 mm. Frankfurt on Main, Frobenius-Institut, 529.

168 View of Herbert Ward's studio in Paris. Washington, D. C., National Anthropological Archives, Smithsonian Institution.

169 Herbert Ward (1863–1919). *The Idol Maker*. Signed. Salon, Paris, 1907, no. 3462. Bronze. Life-size. Washington, D. C., Smithsonian Institution, National Museum of Natural History, Department of Anthropology, 323,735.

170 Herbert Ward (1863–1919). *The Fire Maker*. Salon, Paris, 1911, no. 3892. Bronze. Life-size. Washington, D. C., Smithsonian Institution, National Museum of Natural History, Department of Anthropology, 323,730.

171 Henri Allouard (1844–1929). *Femme Foulah*. 1904. Bronze and onyx. H: 57 cm. Marseilles, Musée des Beaux-Arts, on loan from Paris, Musée d'Orsay, RF 1415.

172 Paul Gauguin (1848–1903). *Aux mangos. La récolte des fruits, Martinique*. Signed. Dated [18]87. Canvas. 90 × 115 cm. Amsterdam, Rijksmuseum Vincent van Gogh, B 3396 (S 221 V).

173 Paul Gauguin (1848–1903). *Manao Tupapau (Spirit of the Dead Watching)*. 1892. Oil on burlap mounted on canvas. 72.4 × 92.4 cm. Buffalo, Albright-Knox Art Gallery, A. Conger Goodyear Collection, 1965, 65:1.

174 Henri Julien Rousseau, called Le Douanier (1844–1910). *The Sleeping Gypsy*. Signed. Dated 1897. Canvas. 129.5 × 200.7 cm. New York, Museum of Modern Art, Gift of Mrs. Simon Guggenheim, 646.39.

175 Henri Julien Rousseau, called Le Douanier (1844–1910). *Virgin Forest with Setting Sun – Negro Attacked by a Jaguar*. Signed. Ca. 1910. Canvas. 114 × 162.5 cm. Basel, Öffentliche Kunstsammlung, Kunstmuseum Basel, 2225.

176 Henri Matisse (1869–1954). *The Blue Nude – Souvenir of Biskra*. Signed. 1907. Canvas. 92.1 × 140.4 cm. Baltimore, Baltimore Museum of Art, The Cone Collection, formed by Dr. Claribel Cone and Miss Etta Cone of Baltimore, Maryland, BMA 1950.228.

177 Henri Matisse (1869–1954). *Two Negresses*. Signed. 1908. Bronze. H: 46.7 cm. Baltimore, Baltimore Museum of Art, The Cone Collection, formed by Dr. Claribel Cone and Miss Etta Cone of Baltimore, Maryland, BMA 1950.430.

178 *Deux jeunes filles Targui*. Photograph clipped from an unknown source by Henri Matisse.

179 Ernst Ludwig Kirchner (1880–1938). *Schlafende Milli*. Ca. 1910–11. Canvas. 64 × 92 cm. Bremen, Kunsthalle Bremen, 838–1961/9.

180 Karl Schmidt-Rottluff (1884–1976). *The Three Kings*. Signed. Dated 1917. Woodcut (on linden wood), printed in black through rubbing. 497 × 391 mm. New York, Museum of Modern Art, 13.45.

181 Max Slevogt (1868–1932). *Der Sieger (Kriegsbeute)*. Signed. Dated 1912. Canvas. 150 × 100 cm. Dusseldorf, Kunstmuseum Düsseldorf, 5466.

182 Malvina Hoffman (1887–1966). *Shilluk Warrior (Northeast Africa)*. Ca. 1930–33. Bronze. H: 274.3 cm. Chicago, Field Museum of Natural History, no inv. no.

183 Jacob Epstein (1880–1959). *Cursed Be the Day Wherein I Was Born*. 1913–14. Plaster and wood, painted red. H: 115.5 cm. Present whereabouts unknown.

PERMISSIONS

PHOTO CREDITS

AACHEN Anne Gold : *104*
ALLSCHWIL Colorphoto Hans Hinz : *175*
AMSTERDAM Collection Stedelijk Museum, Amsterdam : *158*
 Vincent van Gogh Foundation / National Museum Vincent van Gogh, Amsterdam : *172*
ANTWERP Fonds Mercator, photographe Bernd Urban : *159*
BALTIMORE The Baltimore Museum of Art: Nelson and Juanita Greif Gutman Collection, by
 exchange BMA 1952.52.25 : *161*; The Cone Collection, formed by Dr. Claribel Cone and
 Miss Etta Cone of Baltimore, Maryland, BMA 1950.228 : *176*; BMA 1950.430, photograph
 by Joel Breger : *177*
 Walters Art Gallery, Baltimore : *109*
BERLIN (GDR) Staatliche Museen zu Berlin, Nationalgalerie : *26*
BERN Kunstmuseum Bern : *25*
BIRMINGHAM Birmingham City Museum and Art Gallery : *69*
BOSTON Courtesy, Museum of Fine Arts, Boston : *48, 50, 74*
BRACHTTAL Foto: Reinhard Franz : *103*
BREMEN Kunsthalle Bremen : *179*
BRIGHTON The Royal Pavilion, Art Gallery and Museum, Brighton : *57*
BUFFALO Albright-Knox Art Gallery, Buffalo, New York : James G. Forsyth and Charles W.
 Goodyear Funds, 1952 : *19*; A. Conger Goodyear Collection, 1965 : *173*
CAMBRIDGE, MASS. Courtesy of The Harvard University Art Museums (Fogg Art Museum) : *16*
 By permission of the Houghton Library : *9, 10*
CANNES Pierre Kill : *13*
CHICAGO © 1987 The Art Institute of Chicago. All Rights Reserved : *15*
 Field Museum of Natural History (Neg. #MH10) and the artist, Malvina Hoffman : *182*
COOPERSTOWN New York State Historical Association, Cooperstown : *47, 49*
COPENHAGEN Thorvaldsens Museum : *27*
DETROIT © 1987 The Detroit Institute of Arts : *3*
Reproduced from Bernard van Dieren, *Epstein* (New York, 1920), pl. V : *183*
DRESDEN Deutsche Fotothek Dresden : *105*
DUBLIN Courtesy of the National Gallery of Ireland, Dublin : *56*
DÜSSELDORF Landesbildstelle Rheinland, Düsseldorf : *181*
EDINBURGH Tom Scott of Edinburgh : *23*
FRANKFURT ON MAIN Ursula Edelman : *162*
 Ethnographisches Bildarchiv, Frobenius-Institut, Frankfurt/Main : *164, 165, 166, 167*
GLASGOW Glasgow Art Gallery & Museum : *65*
THE HAGUE P. B. van Voorst van Beest : *163*
HAMBURG Ralph Kleinhempel GmbH & Co. : *102*
JOHANNESBURG Africana Museum, Johannesburg : *30, 31, 33, 34, 92, 93, 94, 96, 99*
KASSEL Staatliche Kunstsammlungen Kassel : *132*
LINZ Neue Galerie der Stadt Linz : *157*
LIVERPOOL Courtesy of the Trustees of the National Museums and Galleries on Merseyside
 (Walker Art Gallery) : *28*
LONDON Bennison Fabrics Ltd. : *42*
 By permission of the British Library : *4, 7*
 Reproduced by courtesy of the Trustees of the British Museum : *11, 32, 37, 43, 44, 90, 91, 97*
 By courtesy of the Trustees of the British Museum (Natural History) : *101*
 Photograph courtesy of Christie, Manson & Woods : *29, 131*
 AC Cooper Ltd, London : *29, 131*
 Reproduced by courtesy of the Trustees, The National Gallery, London : *160*
 Royal Geographical Society Collection : *98*
 Photograph courtesy of Sotheby's, London : *100, 117, 134*
 Spink & Son Ltd. : *66*
 Tate Gallery, London : *114*
 By courtesy of the Board of Trustees of the Victoria and Albert Museum : *8*

Cordier, Nicolas, 105

Corinth, Lovis, 209–10, 275 n. 61, *fig. 157*

Cork, Richard, 279 n. 171

Cormon, Fernand-Anne Piestre, called, 272 n. 100

Cornicelius, Georg, 140, *fig. 103*

Courbet, Gustave, 160

Courtet, Xavier-Marie-Auguste, called Augustin, 270 n. 62

Cowhig, Ruth, 256 n. 60, 268–69 n. 23

Cowling, Mary C., 250 n. 60

Cowper, William, 202

Craig, Isaac Eugene, 259 n. 114

Crampton, Patricia, 276 n. 91

Cribb, Tom, 30, 252 n. 94

Crowley, William M., 259 n. 114

Cruikshank, George, 58, 252 n. 94

Cruikshank, (Isaac) Robert, 58, 252 n. 94

Cuba, 199

Cucchi, Roger, 277 n. 120

Cumberworth, Charles, 100, 262 n. 180

Cunningham, Allan, 252 n. 95, 253 n. 132

Cuoq, Joseph M., 251 n. 85

Curtin, Philip D., 276 n. 87

Cuvier, Frédéric Georges, 255 n. 27

Cuvier, Georges Léopold Chrétien Frédéric Dagobert, baron, 17, 19, 20, 52, 55, 102, 250 n. 52, 255 nn. 23, 27

Dahomey, 143

Damin, traveler, 218

Damiron, Suzanne, 277 n. 123

Damisch, Hubert, 253 n. 114, 260 n. 127

Daniell, family of artists, 254 n. 7

Daniell, Samuel, 48–51, 128, 254 n. 6, 254–55, n. 11, *figs. 29, 30, 31, 32*

Daniell, William, 255 n. 11

Dantan, Antoine-Laurent, 100

Dantan, Jean Pierre, called Dantan jeune, 100, 262 n. 178, *fig. 70*

Dante Alighieri, 157

Dardenne, Léon, 276 n. 90

Darfur, 20, 101, 102

Darmstadt, Hessisches Landesmuseum, 275 n. 61

Darondeau, Stanislas-Henri-Benoît, 125–26, 266 n. 262

Darses, Simone, 275 n. 68, 277 n. 120

Darwin, Charles Robert, 104, 144, 216, 267 n. 306, 276 n. 83

Daubenton, Louis Jean Marie, 249 n. 33

Daulte, François, 274 nn. 49, 50, 51, 52

David, Jacques-Louis, 7, 8, 12, 248 n. 4, 252 n. 107

David d'Angers, Pierre-Jean, 19, 99, 250 n. 45, 262 n. 178

Davidson, Basil, 276 n. 84

Davies, Martin, 275 nn. 66, 68

Davillier, Jean Charles, 263 n. 206

Davis, W. B., 276 n. 98

Davison, Nancy Reynolds, 256 nn. 39, 40, 42, 43, 44, 46

Dawe, George, 23, 26–27, 251 nn. 74, 76, 78, 79, *fig. 12*

Dayton, Dayton Art Institute, 263 n. 210

Debay, Jean-Baptiste-Joseph II, 169, 270 n. 66

Decaen, Alfred-Charles, 89, 260 n. 143, *fig. 63*

Decaisne, Henri. *See* Caisne, Henri de

Decamps, Alexandre-Gabriel, 90–92, 114, 122, 125, 260 nn. 145, 146, 265 n. 231, *fig. 64*

Decker, Joseph, 195, 273 n. 23, *fig. 146*

Degas, Hilaire Germain Edgar de Gas, called, 183, 211–13, 225, 275 nn. 70, 71, *fig. 160*

Dehodencq, Alfred, 108–11, 264 nn. 214, 218, 219, *figs. 76, 77, 78*

Dejouy, Jules, 274 n. 47

Delacroix, Eugène, 36, 38, 82–86, 92, 94, 98, 111, 112, 114, 122, 125, 145–52, 153, 155, 160, 176, 180, 181, 206, 235, 240, 253 nn. 114, 118, 259 nn. 121, 123, 124, 125, 126, 260 nn. 127, 130, 132, 135, 264 n. 224, 268 nn. 6, 8, 17, *figs. 18, 20, 58, 59, 106, 107, 108, 110*

Delaware, 79

Delécluze, Etienne, 122

Delteil, Loys, 275 n. 73

De Maeyer, Marcel, 275 n. 65

De Meillon, Henry Clifford, 50–52, 255 nn. 14, 16, *figs. 33, 34*

Denis, king of Gabon, 128

Dennison, Sam, 256 n. 55

Denon, Dominique Vivant, baron, 28, 251 nn. 86, 87, 88

Derain, André, 224

Desains, Charles-Porphyr-Alexandre, 35–36, 252 n. 107

Desdemona, 17, 155, 182

Detroit, Detroit Institute of Arts, 248 n. 14, 259 n. 107, *fig. 3*

Deurne, Museum Dinghuis Deurne, 276 n. 81

Deutsch, Ludwig, 177, 181, *figs. 130, 131*

Devil, 82

Devroey, E.-J., 276 n. 90

Dewey, Rev. Mr., 169

Diana of Ephesus, 184, *fig. 138*

Dickens, Charles, 45, 61, 140, 267 n. 297

Diderot, Denis, 228, 254 n. 6

Dieren, Bernard van, 279 n. 172

Dighton, Robert, 252 n. 94

Dijon, Musée des Beaux Arts, 255 n. 32

Dingaan. *See* Dingane, Zulu ruler

Dingane, Zulu ruler, 137

Diodoumé, 126

Djelfa, 116

Djur, 217

Douai, Musée de la Chartreuse, 270 n. 61, *fig. 121*

Drescher, Seymour, 257 n. 74

Dresden, 236
 Staatliche Kunstsammlungen, Gemäldegalerie Neue Meister, 267 n. 302, *fig. 105*

Drummond, William, 251 n. 74

Dublin, National Gallery of Ireland, 259 n. 116, *fig. 56*

Duchet, Michèle, 249 nn. 23, 24, 33, 254 nn. 4, 6

Dūd, 217, *fig. 164*

Dumas, Alexandre, *fils*, 262 n. 178

Dumas, Alexandre Davy de la Pailleterie, 100, 262 n. 178

Dumas, François-Guillaume, 263 n. 204, 271 n. 90, 272 n. 98

Dumeril, Constant, 102, 262 n. 187

Dunlap, William, 258 n. 92

Dunn, James Taylor, 257 nn. 76, 78, 79

Duns, Langton House, 253 n. 133

Duparc, Arthur, 271 n. 83

Duponchel, Edmond, 259 n. 123

Durand, Asher Brown, 259 n. 114

Durande, Amédée, 260 nn. 136, 137, 139, 142

Durand-Revillon, Jeannine, 262 nn. 182, 187, 188, 191, 263 n. 194, 270 n. 62

Duras, Claire Louise de Kersaint, duchesse de, 38

Durban, 133

Dusseldorf, 75, 76, 78
 Kunstmuseum Düsseldorf, 279 n. 159, *fig. 181*

Dutch, 47, 48, 254 n. 6

Dutch East India Company, 254 n. 6

Duval, Jeanne, 274 n. 48

Dyaks, 220

Dyck, Anton van, 8, 10